NEOCLASSICISM AND ROMANTICISM,
1750-1850

By the author of

An Outline of 19th Century European Painting
Volume I—Text
Volume II—Plates

Neoclassicism and Romanticism,

1750-1850

An Anthology of
Sources and Documents

Lorenz Eitner

Icon Editions

HARPER & ROW, PUBLISHERS, New York
Cambridge, Philadelphia, San Francisco, London
Mexico City, São Paulo, Sydney

First ICON EDITION published 1989.

Library of Congress Cataloging-in-Publication Data

Neoclassicism and romanticism: 1750-1850 : source documents on
 neoclassical and romantic art / Lorenz Eitner. — 1st Icon ed.
 p. cm. — (Icon editions)
 Reprint. Originally published: Englewood Cliffs, N.J. : Prentice
 Hall, 1970.
 Includes index.
 ISBN 0-06-430186-9 (pbk.)
 1. Neoclassicism (Art) 2. Art, Modern—17th-18th centuries.
 3. Art. Modern—19th century. I. Eitner, Lorenz
 N6425.N4N45 1989 89-2197
 709.03'41—dc20

89 90 91 92 93 HC 10 9 8 7 6 5 4 3 2 1

For Trudi Eitner
and in memory of W.E.

Contents

3. Restoration

4. Twilight of Humanism

Index *325*

Preface

The following selection of documents and literary sources attempts to give a picture of the world of art in the period which began with Winckelmann and ended with Baudelaire. Equivalent to the active life-spans of four generations of artists, the years from 1750 to 1850 comprised two distinct eras, the one leading to, the other descending from Revolution. The great changes which were then about to transform the world affected every sphere of art. Movements and countermovements arose in rapid succession, the artists vacillated between innovation and nostalgia for the past, and their institutions rapidly passed through stages of reform, overthrow, and revival.

In the arts, no less than in politics, the age produced an abundance of theoretical speculation, polemic, and dogma. Surrounded by general change, art itself had become problematical. The shadow of doubt fell on its purpose, its rules and standards, and its relationship with beauty, morality, and nature. Where formerly common sense and routine had seemed sufficient, criticism now found open questions. But much of the discussion which came to center around art reflected in fact other. more general concerns. To the distress of artists, an ever-increasing number of laymen invaded their world, to criticize and speculate.

In making my selection, I have given preference to those writings which seemed to me to have a direct relevance to art itself, to its actual practice and physical reality, rather than to the philosophical debates about it. Much art, even in an argumentative period, enters the world quietly and leaves no literary record. A documentary anthology bound to favor the eloquent doctrinaire over the silent practitioner, can hardly avoid giving a biased view of the true situation. It is wise to use caution in judging the influence of pure theory on art, and to remember that the more mundane or practical problems which confronted artists—matters of money, position, patronage, and training—usually weighed more heavily on them than matters of doctrine. I have tried to keep some balance in this regard, but am aware that, by giving prominence to the large issues, I have slighted many smaller circumstances which, in their sum, were probably of equal importance.

In grouping the selected texts, I have chosen an historical, rather than topical, sequence which continues without interruption through

the four chapters of this book. These chapters represent four distinct periods, or generation-spans, within which various strains of ideology appear together, in mutual interaction. Each of the periods had a peculiar character of its own which expressed itself in various forms. Instead of isolating and tracing one by one the separate strands of ideology which ran through them, I have chosen to characterize the periods themselves, and to treat the different ideas which each produced as manifestations of a common historical situation. As a result, the labels of "classicist" or "romantic" under which the ideological factions of the time are usually grouped are not so prominent in the following pages as the title of the book might lead readers to expect, nor do these labels govern the arrangement of the text. In the quoted passages, Romanticism and Classicism appear, rather, as constantly changing, alternative expressions of states of thought and feeling which are tied to periods, rather than to doctrines. By leaving the documents in the context of their time, rather than forcing them into schematic alignments, I have tried to preserve something of their original freshness and competitive energy. Read together, the writings of supposedly antagonistic contemporaries will be found to show hidden affinities: the year of an artist's or writer's birth often tells more about him than the party label he bears.

The translations used in this volume, unless credited to other authors in the accompanying footnotes, are my own. The footnotes contain the essential bibliography. The Index gives concise identifications and dates of individuals merely named in the text.

LORENZ EITNER

I

Enlightenment

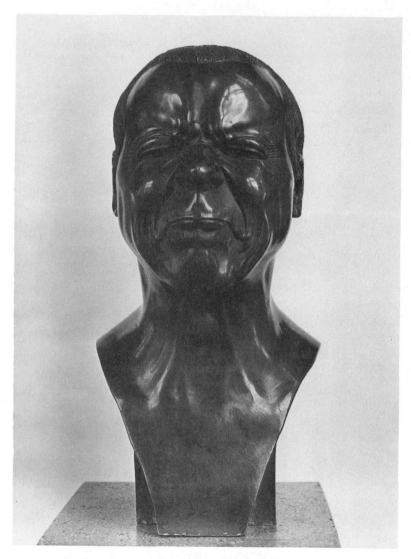

F. X. Messerschmidt, Grimacing Self-Portrait, *c. 1780*,
Oesterreichische Galerie, Vienna

INTRODUCTION

In describing the intellectual climate of his time, the philosopher and mathematician d'Alembert (1717–1783) wrote of a "lively fermentation of minds which, spreading through nature in all directions like a river bursting its dams, has violently swept along everything in its way . . . from the principles of the natural sciences to the foundations of revealed religion, from metaphysics to taste, from music to morals, from theological disputes to questions of trade, from the laws of princes to those of peoples: everything has been discussed, analyzed, or at least brought up" (1758).[1] The ferment which d'Alembert observed accompanied the decline of an old order and the emergence of a new state of society. The fateful inevitability of this process was not then apparent to the men who, like d'Alembert, directly participated in it. To them, it seemed to be a deliberate effort of reform, directed against dangerous survivals from the dark past, the rubbish of decaying political and religious establishments, and the superstitions which had for too many centuries enslaved mankind. Their ideal was a renewal of society through the application of scientific methods and a return to moral health, in other words, through reason and nature, twin aspects of one great reality before which the old errors would vanish like a dream. The program which was to bring about this secular salvation was conceived in utilitarian and social terms. It rested on the optimistic assumption that careful planning, general education, and improved institutions could produce a universal advance. The reformers envisioned an ideal society which would function with the regularity and predictability of a vast machine, working in harmony with the even greater mechanism of nature.

The transformation which d'Alembert witnessed was bound to affect art, by changing the atmosphere in which it existed, the economic base on which it rested, the institutions which sustained and regulated it, and the minds of artists and public. The documents which follow illustrate the condition of the arts in the period of the Enlightenment. They have been arranged in such a way as to bring out three characteristic aspects: a guiding idea—the imitation of Antiquity; an exemplary institution—the Academy; and a representative individual—the lay critic of art.

[1] J. leRond d'Alembert, *Elements de Philosophie*, I, *Mélanges de litterature, d'histoire et de philosophie*, Amsterdam, 1758, IV, 1.

ANTIQUITY

The belief in the perfectibility of man and the general progress of the human race, two notions deeply imbedded in the ideology of the Enlightenment, needed the support of history: it was important to be able to look back to the reality of a Golden Age in the past to feel confidence in the promise of a future Utopia. Antiquity provided the example of a state of humanity so exalted that a future worth striving for could be conceived in its image. This gave the movement of progress a concrete goal, and it suggested, at the same time, a practical method for reaching it: the systematic study and imitation of Antiquity, that historical moment of human perfection which, having once before been realized, could be attained again, though it was not likely to be surpassed. The belief in the superiority of the Ancients became, in the minds of some, a substitute for a guiding religious faith. It was a rational enthusiasm, supported by the evidence of history, literature, and art, rather than by supernatural authority. This evident agreement with terrestrial reality gave it a special attraction; to follow the example of the Greeks was to find harmony in nature, but in a nature ennobled by reason. In the search for the true spirit of Antiquity, the study of ancient art inevitably played an important role, for art furnished not only the essential documents, it offered models for emulation. In art, the lesson of Antiquity could be most closely read, and most directly applied. Archaeological discovery and the history of ancient art therefore caught the interest of a large lay audience. The excavations at Herculaneum (begun in 1737) and at Pompeii (begun in 1748), and the writings of Winckelmann had an influence which rapidly went beyond the study and the studio, and was soon felt in many fields of practical application, from the planning of towns to the designing of furniture.

Johann Joachim Winckelmann (1717–1768)

"The news of Winckelmann's death struck us like a bolt from the blue, I still remember the spot where I heard the news." [2] *With these words Goethe recalled, many years later, the shock which was felt throughout Europe when Winckelmann was murdered. The career which was brought to an end by a common assassin, at an inn in Trieste, had been one of the*

[2] J. W. Goethe, *Dichtung und Wahrheit*, I, in *Goethes Werke* (Sophien Ausgabe), Weimar, 1896, I Abtheilung, XXVII, 184.

most spectacular of the period. It had led in a steep rise from the provincial obscurity of Stendal, in Prussia, where Winckelmann was born as the son of a shoemaker, through the confinement of theological and philological studies, and the meagerness of a schoolmaster's life in the backwoods of Protestant Germany, to a position of high distinction in the Papal city and to eminence in the world of letters. Along the way, Winckelmann had served as librarian to the historiographer of the Holy Roman Empire, Count Bünau at Nöthnitz, in Saxony, and taken advantage of the nearness of Dresden to study the royal collections, guided by the painter Oeser who was later to perform a similar service for Goethe. Throughout these early years, Winckelmann's practical acquaintance with works of ancient sculpture remained small; it is remarkable that he should have drawn from so limited a source the courage to become a polemical author, and some of the insights which enabled him in later years, when he found himself among the rich collections of Rome, to write the first systematic history of ancient art. His early pamphlet Thoughts on the Imitation of Greek Works in Painting and Sculpture *(1755) was written in Dresden, before he had seen Rome or had come face to face with an original work of Greek art, except for coins, gems, and vases. The pamphlet is an attack on the civilization of the Rococo; the picture of a beautiful humanity which it paints is meant to offer the sharpest possible contrast to 18th century reality. It is as revolutionary in its ultimate implications as Rousseau's fantasy of a primitive state of natural virtue. To accept Winckelmann's advice on the imitation of the Greeks was to affirm the need for radical change; there was no comfortable road from Rococo Dresden to the elevation, beauty, and pagan nudity of the Ancients. Winckelmann's vision of Greek art, drawn from intuition and vast reading, rather than direct observation, had the intensity of daydream. It was this wishful ideality which gave to his first book its special force, lifted it above the plodding antiquarianism of the scholars, and brought it to the attention of educated laymen throughout Europe. That he intended to reach this wide audience is evident from the deliberate elegance and vigor of his style which has little in common with the professorial jargon of the period. The following excerpts from Henry Fuseli's translation (London, 1765) preserve the sound of Winckelmann's language better than the more recent renderings.*[3]

[3] *Reflections on the Painting and Sculpture of the Greeks . . . Translated from the German Original of the Abbe Winckelmann* by Henry Fuseli, A.M., London, 1765, pp. 1 ff.

From *Thoughts on the Imitation of Greek Works in Painting and Sculpture*
(1755)

I. Nature

There is but one way for the moderns to become great, and per-
haps unequalled; I mean, by imitating the ancients. And what we are told
of *Homer,* that whoever understands him well, admires him, we find no
less true in matters concerning the ancient, especially the Greek arts. But
then we must be as familiar with them as with a friend, to find Laocoon
as inimitable as *Homer.* By such intimacy our judgment will be that of
Nicomachus: Take these eyes, replied he to some paltry critic, censuring
the Helen of Zeuxis, *Take my eyes, and she will appear a goddess.*

With such eyes *Michael Angelo, Raphael,* and *Poussin,* considered
the performances of the ancients. They imbibed taste at its source; and
Raphael particularly in its native country. We know, that he sent young
artists to Greece, to copy there, for his use, the remains of antiquity.

It is not only *Nature* which the votaries of the Greeks find in their
works, but still more, something superior to nature; ideal beauties, brain-
born images, as *Proclus* says.

The most beautiful body of ours would perhaps be as much inferior
to the most beautiful Greek one, as Iphicles was to his brother Hercules.
The forms of the Greeks, prepared to beauty, by the influence of the
mildest and purest sky, became perfectly elegant by their early exercises.
Take a Spartan youth, sprung from heroes, undistorted by swaddling-
clothes; whose bed, from his seventh year, was the earth, familiar with
wrestling and swimming from his infancy; and compare him with one of
our young Sybarites, and then decide which of the two would be deemed
worthy, by an artist, to serve for the model of a Theseus, an Achilles, or
even a Bacchus. The latter would produce a Theseus fed on roses, the
former a Theseus fed on flesh, to borrow the expression of *Euphranor.*

The grand games were always a very strong incentive for every
Greek youth to exercise himself. Whoever aspired to the honours of these
was obliged, by the laws, to submit to a trial of ten months at Elis, the
general rendezvous; and there the first rewards were commonly won by
youths, as *Pindar* tells us. *To be like the God-like Diagoras,* was the fond-
est wish of every youth.

Behold the swift Indian outstripping in pursuit the hart: how briskly
his juices circulate! how flexible, how elastic his nerves and muscles! how
easy his whole frame! Thus *Homer* draws his heroes, and his Achilles he
eminently marks for "being swift of foot."

By these exercises the bodies of the Greeks got the great and manly Contour observed in their statues, without any bloated corpulency. The young Spartans were bound to appear every tenth day naked before the Ephori, who, when they perceived any inclinable to fatness, ordered them a scantier diet; nay, it was one of *Pythagoras*'s precepts, to beware of growing too corpulent; and, perhaps for the same reason, youths aspiring to wrestling-games were, in the remoter ages of Greece, during their trial, confined to a milk diet.

They were particularly cautious in avoiding every deforming custom; and *Alcibiades*, when a boy, refusing to learn to play on the flute, for fear of its discomposing his features, was followed by all the youth of Athens.

In their dress they were professed followers of nature. No modern stiffening habit, no squeezing stays hindered Nature from forming easy beauty; the fair knew no anxiety about their attire, and from their loose and short habits the Spartan girls got the epithet of Phænomirides.

Those diseases which are destructive of beauty, were moreover unknown to the Greeks. There is not the least hint of the small-pox, in the writings of their physicians; and *Homer,* whose portraits are always so truly drawn, mentions not one pitted face. Venereal plagues, and their daughter the English malady, had not yet names.

And must we not then, considering every advantage which nature bestows, or art teaches, for forming, preserving, and improving beauty, enjoyed and applied by the Grecians; must we not then confess, there is the strongest probability that the beauty of their persons excelled all we can have an idea of?

Art claims liberty: in vain would nature produce her noblest offsprings, in a country where rigid laws would choke her progressive growth, as in Egypt, that pretended parent of sciences and arts: but in Greece, where, from their earliest youth, the happy inhabitants were devoted to mirth and pleasure, where narrow-spirited formality never restrained the liberty of manners, the artist enjoyed nature without a veil.

The Gymnasies, where, sheltered by public modesty, the youths exercised themselves naked, were the schools of art. These the philosopher frequented, as well as the artist. *Socrates* for the instruction of a Charmides, Autolycus, Lysis; *Phidias* for the improvement of his art by their beauty. Here he studied the elasticity of the muscles, the ever varying motions of the frame, the outlines of fair forms, or the Contour left by the young wrestler on the sand. Here beautiful nakedness appeared with such a liveliness of expression, such truth and variety of situations, such a noble air of the body, as it would be ridiculous to look for in any hired model of our academies.

Truth springs from the feelings of the heart. What shadow of it

therefore can the modern artist hope for, by relying upon a vile model, whose soul is either too base to feel, or too stupid to express the passions, the sentiment his object claims? unhappy he! if experience and fancy fail him.

The beginning of many of *Plato*'s dialogues, supposed to have been held in the Gymnasies, cannot raise our admiration of the generous souls of the Athenian youth, without giving us, at the same time, a strong presumption of a suitable nobleness in their outward carriage and bodily exercises.

The fairest youths danced undressed on the theatre; and *Sophocles,* the great *Sophocles,* when young, was the first who dared to entertain his fellow-citizens in this manner. *Phryne* went to bathe at the Eleusinian games, exposed to the eyes of all Greece, and rising from the water became the model of Venus Anadyomene. During certain solemnities the young Spartan maidens danced naked before the young men: strange this may seem, but will appear more probable, when we consider that the christians of the primitive church, both men and women, were dipped together in the same font.

Then every solemnity, every festival, afforded the artist opportunity to familiarize himself with all the beauties of Nature.

These frequent occasions of observing Nature, taught the Greeks to go on still farther. They began to form certain general ideas of beauty, with regard to the proportions of the inferiour parts, as well as of the whole frame: these they raised above the reach of mortality, according to the superiour model of some ideal nature.

Thus *Raphael* formed his Galatea, as we learn by his letter to Count Baltazar Castiglione, where he says, "Beauty being so seldom found among the fair, I avail myself of a certain ideal image."

According to those ideas, exalted above the pitch of material models, the Greeks formed their gods and heroes: the profile of the brow and nose of gods and goddesses is almost a straight line. The same they gave on their coins to queens, &c. but without indulging their fancy too much. Perhaps this profile was as peculiar to the ancient Greeks, as flat noses and little eyes to the Calmucks and Chinese; a supposition which receives some strength from the large eyes of all the heads on Greek coins and gems.

From the same ideas the Romans formed their Empresses on their coins. Livia and Agrippina have the profile of Artemisia and Cleopatra.

We observe, nevertheless, that the Greek artists in general, submitted to the law prescribed by the Thebans: "To do, under a penalty, their best in imitating Nature." For, where they could not possibly apply their easy profile, without endangering the resemblance, they followed Nature,

as we see instanced in the beauteous head of Julia, the daughter of Titus, done by *Euodus*.

But to form a "just resemblance, and, at the same time, a handsomer one," being always the chief rule they observed, and which *Polygnotus* constantly went by; they must, of necessity, be supposed to have had in view a more beauteous and more perfect Nature. And when we are told, that some artists imitated *Praxiteles,* who took his concubine *Cratina* for the model of his Cnidian Venus; or that others formed the graces from *Lais;* it is to be understood that they did so, without neglecting these great laws of the art. Sensual beauty furnished the painter with all that nature could give; ideal beauty with the awful and sublime; from that he took the *Humane,* from this the *Divine.*

Let any one, sagacious enough to pierce into the depths of art, compare the whole system of the Greek figures with that of the moderns, by which, as they say, nature alone is imitated; good heaven! what a number of neglected beauties will he not discover!

For instance, in most of the modern figures, if the skin happens to be any where pressed, you see there several little smart wrinkles: when, on the contrary, the same parts, pressed in the same manner on Greek statues, by their soft undulations, form at last but one noble pressure. These masterpieces never show us the skin forcibly stretched, but softly embracing the firm flesh, which fills it up without any tumid expansion, and harmoniously follows its direction. There the skin never, as on modern bodies, appears in plaits distinct from the flesh.

Modern works are likewise distinguished from the ancient by parts; a crowd of small touches and dimples too sensibly drawn. In ancient works you find these distributed with sparing sagacity, and, as relative to a completer and more perfect Nature, offered but as hints, nay, often perceived only by the learned.

The probability still increases, that the bodies of the Greeks, as well as the works of their artists, were framed with more unity of system, a nobler harmony of parts, and a completeness of the whole, above our lean tensions and hollow wrinkles.

Such as would fain deny to the Greeks the advantages both of a more perfect Nature and of ideal Beauties, boast of the famous *Bernini,* as their great champion. He was of opinion, besides, that Nature was possessed of every requisite beauty: the only skill being to discover that. He boasted of having got rid of a prejudice concerning the Medicean Venus, whose charms he at first thought peculiar ones; but, after many careful researches, discovered them now and then in Nature.

He was taught then, by the Venus, to discover beauties in common Nature, which he had formerly thought peculiar to that statue, and but

for it, never would have searched for them. Follows it not from thence, that the beauties of the Greek statues being discovered with less difficulty than those of Nature, are of course more affecting; not so diffused, but more harmoniously united? and if this be true, the pointing out of Nature as chiefly imitable, is leading us into a more tedious and bewildered road to the knowledge of perfect beauty, than setting up the ancients for that purpose: consequently *Bernini,* by adhering too strictly to Nature, acted against his own principles, as well as obstructed the progress of his disciples.

The imitation of beauty is either reduced to a single object, and is *individual,* or, gathering observations from single ones, *composes of these one whole.* The former we call copying, drawing a portrait; 'tis the straight way to Dutch forms and figures; whereas the other leads to general beauty, and its ideal images, and is the way the Greeks took. . . .

Their imitation discovering in the one every beauty diffused through Nature, showing in the other the pitch to which the most perfect Nature can elevate herself, when soaring above the senses, will quicken the genius of the artist, and shorten his discipleship: he will learn to think and draw with confidence, seeing here the fixed limits of human and divine beauty.

Building on this ground, his hand and senses directed by the Greek rule of beauty, the modern artist goes on the surest way to the imitation of Nature. The ideas of unity and perfection, which he acquired in meditating on antiquity, will help him to combine, and to ennoble the more scattered and weaker beauties of our Nature. Thus he will improve every beauty he discovers in it, and by comparing the beauties of nature with the ideal, form rules for himself.

Nothing would more decisively prove the advantages to be got by imitating the ancients, preferably to Nature, than an essay made with two youths of equal talents, by devoting the one to antiquity, the other to Nature: this would draw Nature as he finds her; if Italian, perhaps he might paint like *Caravaggio;* if Flemish, and lucky, like *Jac. Jordans;* if French, like *Stella:* the other would draw her as she directs, and paint like *Raphael.*

II. Contour

But even supposing that the imitation of Nature could supply all the artist wants, she never could bestow the precision of Contour, that characteristic distinction of the ancients.

The noblest Contour unites or circumscribes every part of the most perfect Nature, and the ideal beauties in the figures of the Greeks; or rather, contains them both. *Euphranor,* famous after the epoch of *Zeuxis,* is said to have first ennobled it.

Many of the moderns have attempted to imitate this Contour, but very few with success. The great *Rubens* is far from having attained either its precision or elegance, especially in the performances which he finished before he went to Italy, and studied the antiques.

The line by which Nature divides completeness from superfluity is but a small one, and, insensible as it often is, has been crossed even by the best moderns; while these, in shunning a meagre Contour, became corpulent, those, in shunning that, grew lean.

Among them all, only *Michael Angelo*, perhaps, may be said to have attained the antique; but only in strong muscular figures, heroic frames; not in those of tender youth; nor in female bodies, which, under his bold hand, grew Amazons.

The Greek artist, on the contrary, adjusted his Contour, in every figure, to the breadth of a single hair, even in the nicest and most tiresome performances, as gems. . . .

III. Drapery

By Drapery is to be understood all that the art teaches of covering the nudities, and folding the garments; and this is the third prerogative of the ancients.

The Greek Drapery, in order to help the Contour, was, for the most part, taken from thin and wet garments, which of course clasped the body, and discovered the shape. The robe of the Greek ladies was extremely thin; thence its epithet of Peplon.

In modern times the artists were forced to heap garments, and sometimes heavy ones, on each other, which of course could not fall into the flowing folds of the ancients. Hence the large-folded Drapery, by which the painter and sculptor may display as much skill as by the ancient manner. *Carlo Marat* and *Francis Solimena* may be called the chief masters of it: but the garments of the new Venetian school, by passing the bounds of nature and propriety, became stiff as brass.

IV. Expression

The last and most eminent characteristic of the Greek works is a noble simplicity and sedate grandeur in Gesture and Expression. As the bottom of the sea lies peaceful beneath a foaming surface, a great soul lies sedate beneath the strife of passions in Greek figures.

'Tis in the face of Laocoon this soul shines with full lustre, not confined however to the face, amidst the most violent sufferings. Pangs piercing every muscle, every labouring nerve; pangs which we almost feel ourselves, while we consider—not the face, nor the most expressive parts—

only the belly contracted by excruciating pains: these however, I say, exert not themselves with violence, either in the face or gesture. He pierces not heaven, like the Laocoon of *Virgil;* his mouth is rather opened to discharge an anxious overloaded groan, as *Sadolet* says; the struggling body and the supporting mind exert themselves with equal strength, nay balance all the frame.

Laocoon suffers, but suffers like the Philoctetes of *Sophocles:* we weeping feel his pains, but wish for the hero's strength to support his misery.

The Expression of so great a soul is beyond the force of mere nature. It was in his own mind the artist was to search for the strength of spirit with which he marked his marble. Greece enjoyed artists and philosophers in the same persons; and the wisdom of more than one Metrodorus directed art, and inspired its figures with more than common souls.

Had Laocoon been covered with a garb becoming an ancient sacrificer, his sufferings would have lost one half of their Expression. *Bernini* pretended to perceive the first effects of the operating venom in the numbness of one of the thighs.

Every action or gesture in Greek figures, not stamped with this character of sage dignity, but too violent, too passionate, was called "Parenthyrsos."

For, the more tranquillity reigns in a body, the fitter it is to draw the true character of the soul; which, in every excessive gesture, seems to rush from her proper centre, and being hurried away by extremes becomes unnatural. Wound up to the highest pitch of passion, she may force herself upon the duller eye; but the true sphere of her action is simplicity and calmness. In Laocoon sufferings alone had been Parenthyrsos; the artist therefore, in order to reconcile the significative and ennobling qualities of his soul, put him into a posture, allowing for the sufferings that were necessary, the next to a state of tranquillity: a tranquillity however that is characteristical: the soul will be herself—this individual—not the soul of mankind; sedate, but active; calm, but not indifferent or drowsy.

What a contrast! how diametrically opposite to this is the taste of our modern artists, especially the young ones! on nothing do they bestow their approbation, but contorsions and strange postures, inspired with boldness; this they pretend is done with spirit, with *Franchezza.* Contrast is the darling of their ideas; in it they fancy every perfection. They fill their performances with comet-like excentric souls, despising every thing but an Ajax or a Capaneus.

Arts have their infancy as well as men; they begin, as well as the artist, with froth and bombast. . . .

In all human actions flutter and rashness precede, sedateness and solidity follow: but time only can discover, and the judicious will admire these only: they are the characteristics of great masters; violent passions run away with their disciples.

This noble simplicity and sedate grandeur is also the true characteristic mark of the best and maturest Greek writings, of the epoch and school of *Socrates*. Possessed of these qualities *Raphael* became eminently great, and he owed them to the ancients.

That great soul of his, lodged in a beauteous body, was requisite for the first discovery of the true character of the ancients: he first felt all their beauties, and (what he was peculiarly happy in!) at an age when vulgar, unfeeling, and half-moulded souls overlook every higher beauty.

From *The History of Ancient Art* (1764)

After his arrival in Rome, in 1755, Winckelmann spent nine years in the intensive study of Egyptian, Etruscan, Greek, and Roman works which he found in the galleries, vaults, and gardens of Roman palaces, at Naples, and at the new excavations of Herculaneum. The result of his boundless diligence was the great History *which eclipsed all the antiquarian researches that had preceded it. Winckelmann's superiority rested on two main achievements. He was the first to put into systematic order the bewildering accumulation of sculptures, frescoes, decorative fragments, gems and coins, by bringing to bear on it not only his knowledge of literature, but also his powers of disciplined observation and critical comparison. More important still, he was able to gather the separate monuments and individual artists into one developmental sequence, the guiding principle of which was the progressive unfolding of style. This he saw as an irreversible and regular process, the typical main stages of which were most evident in the history of Greek art.*

At the center of his theory of art was the idea of beauty as a timeless, life-giving force, of which the evolving style merely presented temporal embodiments. Winckelmann's notion of beauty had little in common with the schemata of conventional art-philosophy. Though he theorized about unity and harmony, and acknowledged that beauty ultimately rested in God, his actual standard was concrete and natural: it was the human body, nude, and in the smoothness of adolescence. On it, he lavished his most enthusiastic praise and his finest descriptive passages. His idealism was a sublimated sensuousness. His language, even when employed in the expression of abstract ideas, is rich in images. He believed that "God had meant to make him a painter, and a great one at that," and

it is clear that he had the gift of evoking visual form: his word-paintings of the Apollo of Belvedere, the Torso, and the Niobids contributed to the formation of the neoclassical style in art.[4]

On Beauty

Beauty, as the loftiest mark and the central point of art, demands some preliminary discussion, in which I should wish to satisfy both myself and the reader; but this is a wish of difficult gratification in either respect.

For beauty is one of the great mysteries of nature, whose influence we all see and feel; but a general, distinct idea of its essential must be classed among the truths yet undiscovered. If this idea were geometrically clear, men would not differ in their opinions upon the beautiful, and it would be easy to prove what true beauty is; still less could there be one class of men of so unfortunate sensibility, and another of so perverse self-conceit, that the former would create for themselves a false beauty, and the latter refuse to receive a correct idea of true beauty.

Why Opinions on Beauty Differ

This difference of opinion is shown still more strongly in the judgment passed upon the beauties impersonated by art, than upon those in nature itself. The cause lies in our passions, which with most men are excited by the first look, and the senses are already gratified, when reason, unsatisfied, is seeking to discover and enjoy the charm of true beauty. It is not, then, beauty which captivates us, but sensuality. Consequently, young persons, in whom the passions are in a state of excitement and ferment, will look upon those faces as divine, which, though not strictly beautiful, have the charm of tender and passionate expression; and they will be less affected by a truly beautiful woman, even with the shape and majesty of Juno, whose gestures and actions evince modesty and decorum.

The ideas of beauty with most artists are formed from their first crude impressions, which are seldom weakened or destroyed by loftier beauties, especially when they cannot improve their minds by recurring to the beauties of the ancients.

In others, the climate has not allowed the gentle feeling of pure beauty to mature; it has either been confirmed in them by art,—that is, by constantly and studiously employing their scientific knowledge in the

[4] The translation used is that of G. Henry Lodge, *The History of Ancient Art,* Boston, 1880. The particular sections quoted are "On Beauty," I, 302; "Opinions on Beauty," I, 304; "Color," I, 308; "Unity," I, 310; "Generality," I, 311; "The Shape of Beauty," I, 311; "The Torso," II, 263; "Apollo," II, 312.

representation of youthful beauties—as in Michael Angelo, or become in time utterly corrupted, as was the case with Bernini by a vulgar flattery of the coarse and uncultivated, in attempting to render everything more intelligible to them. The former busied himself in the contemplation of lofty beauty; this is evident from his poems, some of which have been published; in them his thoughts relative to it are expressed in elevated language, worthy of the subject. In powerful figures he is wonderful; but, from the cause before mentioned, his female and youthful figures are in shape, action, and gesture, creatures of another world. The very course which led Michael Angelo to impassable places and steep cliffs plunged Bernini, on the contrary, into bogs and pools; for he sought to dignify, as it were, by exaggeration, forms of the most ordinary. His figures are those of vulgar people who have suddenly met with good fortune, and their expression is oftentimes opposed to the action, as when Hannibal laughed in the extremity of his grief. Yet this artist long held undisputed sway, and homage is paid to him even now.

But we ourselves differ as to beauty—probably more than we do even in taste and smell—whenever our ideas respecting it are deficient in clearness. It will not be easy to find a hundred men who would agree as to all the points of beauty in any one face—I speak of those who have not thought profoundly on the subject. The handsomest man that I have seen in Italy was not the handsomest in the eyes of all, not even of those who prided themselves on being observant of the beauty of our sex. . . .

Color

Color assists beauty; generally, it heightens beauty and its forms, but it does not constitute it; just as the taste of wine is more agreeable, from its color, when drunk from a transparent glass, than from the most costly golden cup. Color, however, should have but little share in our consideration of beauty, because the essence of beauty consists, not in color, but in shape, and on this point enlightened minds will at once agree. As white is the color which reflects the greatest number of rays of light, and consequently is the most easily perceived, a beautiful body will, accordingly, be the more beautiful the whiter it is, just as we see that all figures in gypsum, when freshly formed, strike us as larger than the statues from which they are made. A Negro might be called handsome, when the conformation of his face is handsome. A traveller assures us that daily association with Negroes diminishes the disagreeableness of their color, and displays what is beautiful in them; just as the color of bronze and of the black and greenish basalt does not detract from the beauty of the antique heads.

Unity

The highest beauty is in God; and our idea of human beauty advances towards perfection in proportion as it can be imagined in conformity and harmony with that highest Existence which, in our conception of unity and indivisibility, we distinguish from matter. This idea of beauty is like an essence extracted from matter by fire; it seeks to beget unto itself a creature formed after the likeness of the first rational being designed in the mind of the Divinity. The forms of such a figure are simple and flowing, and various in their unity; and for this reason they are harmonious, just as a sweet and pleasing tone can be extracted from bodies the parts of which are uniform. All beauty is heightened by unity and simplicity, as is everything which we do and say; for whatever is great in itself is elevated, when executed and uttered with simplicity. It is not more strictly circumscribed, nor does it lose any of its greatness, because the mind can survey and measure it with a glance, and comprehend and embrace it in a single idea; but the very readiness with which it may be embraced places it before us in its true greatness, and the mind is enlarged, and likewise elevated, by the comprehension of it. Everything which we must consider in separate pieces, or which we cannot survey at once, from the number of its constituent parts, loses thereby some portion of its greatness, just as a long road is shortened by many objects presenting themselves on it, or by many inns at which a stop can be made. The harmony which ravishes the soul does not consist in arpeggios, and tied and slurred notes, but in simple, long-drawn tones. This is the reason why a large palace appears small, when it is overloaded with ornament, and a house large, when elegant and simple in its style.

Generality

From unity proceeds another attribute of lofty beauty, the absence of individuality; that is, the forms of it are described neither by points nor lines other than those which shape beauty merely, and consequently produce a figure which is neither peculiar to any particular individual, nor yet expresses any one state of the mind or affection of the passions, because these blend with it strange lines, and mar the unity. According to this idea, beauty should be like the best kind of water, drawn from the spring itself; the less taste it has, the more healthful it is considered, because free from all foreign admixture.

Since, however, there is no middle state in human nature between pain and pleasure, and the passions are the winds which impel our bark

over the sea of life, pure beauty alone cannot be the sole object of our consideration; we must place it also in a state of action and of passion, which we comprehend in art under the term *Expression*.

The Shape of Beauty

The shape of beauty is either *individual*—that is, confined to an imitation of one individual—or it is a selection of beautiful parts from many individuals, and their union into one, which we call *ideal*.

The conformation of beauty commenced with individual beauty, with an imitation of a beautiful male form, even in the representation of the gods; and, in the blooming days of sculpture, the statues of goddesses were actually made after the likeness of beautiful women, even of those whose favors were venal.

Among beautiful youths, artists found the cause of beauty in unity, variety, and harmony. For the forms of a beautiful body are determined by lines the centre of which is constantly changing, and which, if continued, would never describe circles. They are, consequently, more simple, but also more complex, than a circle, which, however large or small it may be, always has the same centre, and either includes others, or is included in others. This diversity was sought after by the Greeks in works of all kinds; and their discernment of its beauty led them to introduce the same system even into the form of their utensils and vases, whose easy and elegant outline is drawn after the same rule, that is, by a line which must be found by means of several circles, for all these works have an elliptical figure, and herein consists their beauty. The greater unity there is in the junction of the forms, and in the flowing of one out of another, so much the greater is the beauty of the whole.

From this great unity of youthful forms, their limits flow imperceptibly one into another, and the precise point of height of many, and the line which bounds them, cannot be accurately determined. This is the reason why the delineation of a youthful body, in which everything is and is yet to come, appears and yet does not appear, is more difficult than that of an adult or aged figure. In the former of these two, the adult, nature has completed, and consequently determined, her work of formation; in the latter, she begins again to destroy the structure; in both, therefore, the junction of the parts is clearly visible. To deviate from the outline in bodies having strongly developed muscles, or to strengthen or exaggerate the prominence of muscles or other parts, is not so great an error as the slightest deviation in youthful figures.

But nature and the structure of the most beautiful bodies are rarely without fault. They have forms which can either be found more perfect in other bodies, or which may be imagined more perfect. In conformity

to this teaching of experience, those wise artists, the ancients, acted as a skillful gardener does, who ingrafts different shoots of excellent sorts upon the same stock; and, as a bee gathers from many flowers, so were their ideas of beauty not limited to the beautiful in a single individual, but they sought to unite the beautiful parts of many beautiful bodies. They purified their images from all personal feelings, by which the mind is diverted from the truly beautiful.

The Apollo of Belvedere

Among all the works of antiquity which have escaped destruction the statue of Apollo is the highest ideal of art. The artist has constructed this work entirely on the ideal, and has employed in its structure just so much only of the material as was necessary to carry out his design and render it visible. This Apollo exceeds all other figures of him as much as the Apollo of Homer excels him whom later poets paint. His stature is loftier than that of man, and his attitude speaks of the greatness with which he is filled. An eternal spring, as in the happy fields of Elysium, clothes with the charms of youth the graceful manliness of ripened years, and plays with softness and tenderness about the proud shape of his limbs. Let thy spirit penetrate into the kingdom of incorporeal beauties, and strive to become a creator of a heavenly nature, in order that thy mind may be filled with beauties that are elevated above nature; for there is nothing mortal here, nothing which human necessities require. Neither blood-vessels nor sinews heat and stir this body, but a heavenly essence, diffusing itself like a gentle stream, seems to fill the whole contour of the figure. He has pursued the Python, against which he uses his bow for the first time; with vigorous step he has overtaken the monster and slain it. His lofty look, filled with a consciousness of power, seems to rise far above his victory, and to gaze into infinity. Scorn sits upon his lips, and his nostrils are swelling with suppressed anger, which mounts even to the proud forehead; but the peace which floats upon it in blissful calm remains undisturbed, and his eye is full of sweetness as when the Muses gathered around him seeking to embrace him. The Father of the gods in all the images of him which we have remaining, and which art venerates, does not approach so nearly the grandeur in which he manifested himself to the understanding of the divine poet, as he does here in the coun-tenance of his son, and the individual beauties of the other deities are here as in the person of Pandora assembled together, a forehead of Jupiter, pregnant with the Goddess of Wisdom, and eyebrows the contractions of which express their will, the grandly arched eyes of the queen of the gods, and a mouth shaped like that whose touch stirred with delight the loved Branchus. The soft hair plays about the divine head as if agitated by a

gentle breeze, like the slender waving tendrils of the noble vine; it seems
to be anointed with the oil of the gods, and tied by the Graces with pleas-
ing display on the crown of his head. In the presence of this miracle of art
I forget all else, and I myself take a lofty position for the purpose of look-
ing upon it in a worthy manner. My breast seems to enlarge and swell with
reverence, like the breasts of those who were filled with the spirit of
prophecy, and I feel myself transported to Delos and into the Lycæan
groves—places which Apollo honored by his presence—for my image
seems to receive life and motion, like the beautiful creation of Pygmalion.
How is it possible to paint and describe it! Art itself must counsel me, and
guide my hand in filling up hereafter the first outlines which I here have
sketched. As they who were unable to reach the heads of the divinities
which they wished to crown deposited the garlands at the feet of them,
so I place at the feet of this image the conception which I have presented
of it.

The Torso

In this period, I believe, must be placed Apollonius, son of Nestor of
Athens, and master of the so-called Torso in the Belvedere, that is, of the
stump of a reposing and deified Hercules.

Abused and mutilated to the utmost, and without head, arms, or
legs, as this statue is, it shows itself even now to those who have the
power to look deeply into the secrets of art with all the splendor of its
former beauty. The artist has presented in this Hercules a lofty ideal of a
body elevated above nature, and a shape at the full development of man-
hood, such as it might be if exalted to the degree of divine sufficiency. He
appears here purified from the dross of humanity, and after having at-
tained immortality and a seat among the gods; for he is represented
without need of human nourishment, or further use of his powers. No
veins are visible, and the belly is made only to enjoy, not to receive, and
to be full without being filled. The right arm was placed over the head,
as we are able to determine from the position of the fragment which
remains, for the purpose of representing him in repose after all his toils—
this attitude indicating repose.

In this position, with the head turned upwards, his face probably had
a pleased expression as he meditated with satisfaction on the great deeds
which he had achieved; this feeling even the back seems to indicate, which
is bent, as if the hero was absorbed in lofty reflections. In that powerfully
developed chest we behold in imagination the breast against which the
giant Geryon was squeezed and in the length and strength of the thigh
we recognize the unwearied hero who pursued and overtook the brazen-
footed stag, and travelled through countless lands even to the very
confines of the world.

The artist may admire in the outlines of this body the perpetual flowing of one form into another, and the undulating lines which rise and fall like waves, and become swallowed up in one another. He will find that no copyist can be sure of correctness, since the undulating movement which he thinks he is following turns imperceptibly away, and leads both the hand and eye astray by taking another direction. The bones appear covered with a fatty skin, the muscles are full without superfluity, and no other statue can be found which shows so well balanced a plumpness; we might indeed say that this Hercules seems to be the production of an earlier period of art even more than the Apollo.

Gotthold Ephraim Lessing (1729–1781)

A dramatic author of high rank, comparable to Diderot in his choice of modern, middle-class themes, Lessing brought to the criticism of art insights which he had gained in his own literary practice. The immediate stimulus for his essay on Laocoon *came from the passage in Winckelmann's* Thoughts on the Imitation of Greek Works, *which he quotes at the outset. But his main purpose was not to refute Winckelmann, with whom he agreed on most essentials; he meant, rather, to disentangle the confusion of literary and pictorial values which generations of theorists had perpetrated under the slogan of "ut pictura poesis." This confusion had misled some artists into painted literature or stale allegory, and it had betrayed many critics into nonsense. It had caused Winckelmann to compare the marble group in the Vatican with some lines in Virgil's* Aeneid, *and to draw from this comparison, a conclusion about the style and quality of Greek sculpture. Lessing not only demonstrated the falsity of the comparison and of the conclusion; he also proved that the difference between the Greek sculpture and the Latin poem was rooted in their fundamental formal dimensions, in space and time, rather than their particular stylistic character. His analysis went deeper than that of other critics, and touched on the reality of the psychological experience of mass and motion, duration and sequence which defines the different modes of artistic expression.*

But Lessing himself was not free from literary preconceptions about art. He took for granted, as did Winckelmann, that the Laocoon *exemplified the "noble simplicity and quiet greatness" of high classical Greek art, while it actually resembles, in its melodramatic animation, the Baroque style which Lessing, no less than Winckelmann, held in contempt. What he had read about Laocoon's greatness of soul imposed itself on his vision as he studied engravings of the tangled group, and veiled for him the work's unclassical character.*[5]

[5] Translated by Ellen Frothingham, *Laocoon, An Essay Upon the Limits of Painting and Poetry*, New York, The Noonday Press, 1957.

I.

The chief and universal characteristic of the Greek masterpieces in painting and sculpture consists, according to Winckelmann, in a noble simplicity and quiet grandeur, both of attitude and expression. [Lessing's reference is to Winckelmann's description of the Laocoon, quoted on p. 11.] . . .

The remark which lies at the root of this criticism—that suffering is not expressed in the countenance of Laocoon with the intensity which its violence would lead us to expect—is perfectly just. That this very point, where a shallow observer would judge the artist to have fallen short of nature and not to have attained the true pathos of suffering, furnishes the clearest proof of his wisdom, is also unquestionable. But in the reason which Winckelmann assigns for this wisdom, and the universality of the rule which he deduces from it, I venture to differ from him. . . .

A cry is the natural expression of bodily pain. Homer's wounded heroes not infrequently fall with a cry to the ground. Venus screams aloud at a scratch, not as being the tender goddess of love, but because suffering nature will have its rights. Even the iron Mars, on feeling the lance of Diomedes, bellows as frightfully as if ten thousand raging warriors were roaring at once, and fills both armies with terror.

High as Homer exalts his heroes in other respects above human nature, they yet remain true to it in their sensitiveness to pain and injuries and in the expression of their feelings by cries or tears or revilings. Judged by their deeds they are creatures of a higher order; in their feelings they are genuine human beings. . . .

I come now to my conclusion. If it be true that a cry, as an expression of bodily pain, is not inconsistent with nobility of soul, especially according to the views of the ancient Greeks, then the desire to represent such a soul cannot be the reason why the artist has refused to imitate this cry in his marble. He must have had some other reason for deviating in this respect from his rival, the poet, who expresses it with deliberate intention.

II.

. . . The Greek artist represented nothing that was not beautiful. "Who would want to paint you when no one wants to look at you?" says an old

epigrammatist to a misshapen man. Many a modern artist would say, "No matter how misshapen you are, I will paint you. Though people may not like to look at you, they will be glad to look at my picture; not as a portrait of you, but as a proof of my skill in making so close a copy of such a monster."

The fondness for making a display with mere manual dexterity, ennobled by no worth in the subject, is too natural not to have produced among the Greeks a Pauson and a Pyreicus. They had such painters, but meted out to them strict justice. Pauson, who confined himself to the beauties of ordinary nature, and whose depraved taste liked best to represent the imperfections and deformities of humanity, lived in the most abandoned poverty; and Pyreicus, who painted barbers' rooms, dirty workshops, donkeys, and kitchen herbs, with all the diligence of a Dutch painter, as if such things were rare or attractive in nature, acquired the surname of Rhyparographer, the dirt-painter. The rich voluptuaries, indeed, paid for his works their weight in gold as if by this fictitious valuation to atone for their insignificance.

Even the magistrates considered this subject a matter worthy their attention, and confined the artist by force within his proper sphere. The law of the Thebans commanding him to make his copies more beautiful than the originals, and never under pain of punishment less so, is well known. This was no law against bunglers, as has been supposed by critics generally, and even by Junius himself, but was aimed against the Greek Ghezzi, and condemned the unworthy artifice of obtaining a likeness by exaggerating the deformities of the model. It was, in fact, a law against caricature.

We laugh when we read that the very arts among the ancients were subject to the control of civil law; but we have no right to laugh. Laws should unquestionably usurp no sway over science, for the object of science is truth. Truth is a necessity of the soul, and to put any restraint upon the gratification of this essential want is tyranny. The object of art, on the contrary, is pleasure, and pleasure is not indispensable. What kind and what degree of pleasure shall be permitted may justly depend on the law-giver.

The plastic arts especially, besides the inevitable influence which they exercise on the character of a nation, have power to work one effect which demands the careful attention of the law. Beautiful statues fashioned from beautiful men reacted upon their creators, and the state was indebted for its beautiful men to beautiful statues. With us the susceptible imagination of the mother seems to express itself only in monsters. . . .

There are passions and degrees of passion whose expression produces the most hideous contortions of the face, and throws the whole body into

such unnatural positions as to destroy all the beautiful lines that mark
it when in a state of greater repose. These passions the old artists either
refrained altogether from representing, or softened into emotions which
were capable of being expressed with some degree of beauty.

Anguish was softened into sadness. Where that was impossible, and
where the representation of intense grief would belittle as well as disfigure,
how did Timanthes manage? There is a well-known picture by him of
the sacrifice of Iphigenia, wherein he gives to the countenance of every
spectator a fitting degree of sadness, but veils the face of the father, on
which should have been depicted the most intense suffering.

Apply this to the Laocoon and we have the cause we were seeking.
The master was striving to attain the greatest beauty under the given
conditions of bodily pain. Pain, in its disfiguring extreme, was not com-
patible with beauty, and must therefore be softened. Screams must be
reduced to sighs, not because screams would betray weakness, but because
they would deform the countenance to a repulsive degree. Imagine
Laocoon's mouth open, and judge. Let him scream, and see. It was, be-
fore, a figure to inspire compassion in its beauty and suffering. Now it is
ugly, abhorrent, and we gladly avert our eyes from a painful spectacle,
destitute of the beauty which alone could turn our pain into the sweet
feeling of pity for the suffering object.

The simple opening of the mouth, apart from the violent and repul-
sive contortion it causes in other parts of the face, is a blot on a painting
and a cavity in a statue productive of the worst possible effect.

III.

But, as already observed, the realm of art has in modern times been
greatly enlarged. Its imitations are allowed to extend over all visible
nature, of which beauty constitutes but a small part. Truth and expres-
sion are taken as its first law. As nature always sacrifices beauty to higher
ends, so should the artist subordinate it to his general purpose, and not
pursue it further than truth and expression allow. Enough that truth and
expression convert what is unsightly in nature into a beauty of art.

Allowing this idea to pass unchallenged at present for whatever it is
worth, are there not other independent considerations which should set
bounds to expression, and prevent the artist from choosing for his imita-
tion the culminating point of any action?

The single moment of time to which art must confine itself, will
lead us, I think, to such considerations. Since the artist can use but a single
moment of ever-changing nature, and the painter must further confine
his study of this one moment to a single point of view, while their works
are made not simply to be looked at, but to be contemplated long and

often, evidently the most fruitful moment and the most fruitful aspect of that moment must be chosen. Now that only is fruitful which allows free play to the imagination. The more we see the more we must be able to imagine; and the more we imagine, the more we must think we see. But no moment in the whole course of an action is so disadvantageous in this respect as that of its culmination. There is nothing beyond, and to present the uttermost to the eye is to bind the wings of Fancy, and compel her, since she cannot soar beyond the impression made on the senses, to employ herself with feebler images, shunning as her limit the visible fullness already expressed. When, for instance, Laocoon sighs, imagination can hear him cry; but if he cry, imagination can neither mount a step higher, nor fall a step lower, without seeing him in a more endurable, and therefore less interesting, condition. We hear him merely groaning, or we see him already dead.

Again, since this single moment receives from art an unchanging duration, it should express nothing essentially transitory. All phenomena, whose nature it is suddenly to break out and as suddenly to disappear, which can remain as they are but for a moment; all such phenomena, whether agreeable or otherwise, acquire through the perpetuity conferred upon them by art such an unnatural appearance, that the impression they produce becomes weaker with every fresh observation, till the whole subject at last wearies or disgusts us. . . . Pain which is so violent as to extort a scream, either soon abates or it must destroy the sufferer. Again, if a man of firmness and endurance cry, he does not do so unceasingly, and only this apparent continuity in art makes the cry degenerate into womanish weakness or childish impatience. This, at least, the sculptor of the Laocoon had to guard against, even had a cry not been an offence against beauty, and were suffering without beauty a legitimate subject of art. . . .

IV.

A review of the reasons here alleged for the moderation observed by the sculptor of the Laocoon in the expression of bodily pain, shows them to lie wholly in the peculiar object of his art and its necessary limitations. Scarce one of them would be applicable to poetry.

When Virgil's Laocoon screams, who stops to think that a scream necessitates an open mouth, and that an open mouth is ugly? Enough that "clamores horrendos ad sidera tollit" is fine to the ear, no matter what its effect on the eye. Whoever requires a beautiful picture has missed the whole intention of the poet.

Further, nothing obliges the poet to concentrate his picture into a single moment. He can take up every action, if he will, from its origin,

and carry it through all possible changes to its issue. Every change, which would require from the painter a separate picture, costs him but a single touch; a touch, perhaps, which, taken by itself, might offend the imagination, but which, anticipated, as it has been, by what preceded, and softened and atoned for by what follows, loses its individual effect in the admirable result of the whole. . . .

Who blames the poet, then? Rather must we acknowledge that he was right in introducing the cry, as the sculptor was in omitting it. . . . In art the difficulty appears to lie more in the execution than in the invention, while with poetry the contrary is the case. There the execution seems easy in comparison with the invention. Had Virgil copied the twining of the serpents about Laocoon and his sons from the marble, then his description would lose its chief merit; for what we consider the more difficult part had been done for him. The first conception of this grouping in the imagination is a far greater achievement than the expression of it in words. But if the sculptor have borrowed the grouping from the poet, we still consider him deserving of great praise, although he have not the merit of the first conception. For to give expression in marble is incalculably more difficult than to give it in words. We weigh invention and execution in opposite scales, and are inclined to require from the master as much less of one as he has given us more of the other.

There are even cases where the artist deserves more credit for copying Nature through the medium of the poet's imitation than directly from herself. The painter who makes a beautiful landscape from the description of a Thomson, does more than one who takes his picture at first hand from nature. The latter sees his model before him; the former must, by an effort of imagination, think he sees it. One makes a beautiful picture from vivid, sensible impressions, the other from the feeble, uncertain representations of arbitrary signs.

From this natural readiness to excuse the artist from the merit of invention, has arisen on his part an equally natural indifference to it. Perceiving that invention could never be his strong point, but that his fame must rest chiefly on execution, he ceased to care whether his theme were new or old, whether it had been used once or a hundred times, belonged to himself or another. He kept within the narrow range of a few subjects, grown familiar to himself and the public, and directed all his invention to the introducing of some change in the treatment, some new combination of the old objects. . . . Considering now these two points: first, that invention and novelty in the subject are by no means what we chiefly require from the painter; and secondly, that a familiar subject helps and quickens the effect of his art, I think we . . . may even be inclined to praise as a wise and, as far as we are concerned, a beneficent forbearance on the part of the artist, what seemed to us at first a deficiency

in art and a curtailment of our enjoyment. If it be true that painting employs wholly different signs or means of imitation from poetry—the one using forms and colors in space, the other articulate sounds in time—and if signs must unquestionably stand in convenient relation with the thing signified, then signs arranged side by side can represent only objects existing side by side, or whose parts so exist, while consecutive signs can express only objects which succeed each other, or whose parts succeed each other, in time.

Objects which exist side by side, or whose parts so exist, are called bodies. Consequently bodies with their visible properties are the peculiar subjects of painting.

Objects which succeed each other, or whose parts succeed each other in time, are actions. Consequently actions are the peculiar subjects of poetry.

All bodies, however, exist not only in space, but also in time. They continue, and, at any moment of their continuance, may assume a different appearance and stand in different relations. Every one of these momentary appearances and groupings was the result of a preceding, may become the cause of a following, and is therefore the centre of a present, action. Consequently painting can imitate actions also, but only as they are suggested through forms.

Actions, on the other hand, cannot exist independently, but must always be joined to certain agents. In so far as those agents are bodies or are regarded as such, poetry describes also bodies, but only indirectly through actions.

Painting, in its coexistent compositions, can use but a single moment of an action, and must therefore choose the most pregnant one, the one most suggestive of what has gone before and what is to follow.

Poetry, in its progressive imitations, can use but a single attribute of bodies, and must choose that one which gives the most vivid picture of the body as exercised in this particular action.

Giovanni Battista Piranesi (1720–1778)

Among the antiquarians whose researches gave momentum to the classical revival, Piranesi occupied a peculiar position. He was a print-maker of powerful originality, whose views of Roman ruins, no less than his own architectural fantasies, carry a sense of mystery and menace quite unlike the pallor of most classicist work. In his intensity, he resembled Winckelmann, that other eccentric, though he sharply disagreed with Winckelmann's praise of Greek over Roman art. Rather than by any beauty or harmony of form, Piranesi was moved by the hard grandeur and boldness of Roman work. Horace Walpole wrote of Piranesi in 1771:

"*This delicate redundance of ornament growing into our architecture might perhaps be checked, if our artists would study the sublime dreams of Piranesi, who seems to have conceived visions of Rome beyond what it boasted even in the meridian of its splendor. Savage as Salvator Rosa, fierce as Michael Angelo, and exuberant as Rubens, he has imagined scenes that would startle geometry, and exhaust the Indies to realize. He piles palaces on bridges, and temples on palaces, and scales heaven with mountains of edifices. Yet what taste in his boldness! what grandeur in his wildness! what labour and thought both in his rashness and details! Architecture, indeed, has in a manner two sexes: its masculine dignity can only exert its muscle in public works and at public expense; its softer beauties come better within the compass of private residence and enjoyment.*" [6] *Piranesi's publication of plates of Roman ruins, entitled* Magnificenza ed Architettura de' Romani *(1761–1762), reflected his intensive archaeological and topographical studies and at the same time pursued a polemical aim, stated in the Preface from which the following excerpts are taken. It was Piranesi's intention to defend the claim of Roman architecture to high excellence and originality against those scholars who, like Winckelmann, looked on Roman art as essentially imitative of and inferior to the Greek. His line of argument strangely combines Enlightenment rationality—the high value placed on the utility of engineering work —and an irrational enthusiasm for the sheer grandeur of Roman works and the dignity of national past.*[7]

From *Magnificenza ed Architettura de' Romani* (1761–1762)

I certainly should never have imagined that the Romans might some day be accused of being small-minded and crude. The majority of their works, to be sure, have been destroyed by the ravages of time and war, but whenever I see their magnificent monuments in Rome and throughout Italy, I am astonished that such a judgment should have occurred to men possessing any instruction at all. Yet people who attribute everything to the Greeks do hold this opinion of the Romans, and since this opinion is spreading more and more among foreign nations, I deem it to be fitting for one of my profession to examine the whole matter more thoroughly, so that, when all the arguments have been weighed, it will become easier for the fair-minded to decide what judgment he should make.

. . . The Etruscan nation, because of its antiquity and wealth, had the time and leisure to bring all the arts to their highest perfection. As to its antiquity, Dionysius, citing the various opinions of ancient writers who

[6] From the "Advertisement" of Horace Walpole's *Anecdotes of Painting*, 4th edition, London, 1786, IV, 398.

[7] G. B. Piranesi, *Della Magnificenza ed Architettura de' Romani*, ed. Firmin-Didot, Paris, 1836, pp. 4 ff.

had written about the origins of the Etruscans before him, supports those who regarded them as indigenous to Italy: "Clearly, this nation is very ancient and evidently had nothing in common with other nations, either in customs or in language."

. . . From sources such as these, the other arts and, together with them, the proper way of building came to Rome, since it is usual that men try to imitate the best of others, as soon as they have the time. The Romans, seeing the admirable edifices of the Etruscans . . . could not help but be delighted with what they had seen, and wanted to have this kind of building in Rome for themselves, now that they had grown in importance and achieved a greater reputation than any of their neighbors. In the year CCLX, they therefore established the magistracy of the *Ediles* whose first responsibility it was to care for the public buildings. Anyone who has read Roman history knows how rapidly the number of these buildings increased from the very beginning, and particularly the temples of the gods which the Romans built, motivated either by their own superstitions or by some vow uttered in time of great danger. I am certain that, had these buildings been mere hovels or modest huts, the Romans would not have created an illustrious magistrate to preside over this work. I will admit that the majority of Rome's citizens did not have magnificent dwellings in those early times. They sacrificed their private means for the good of the Republic, but when there was a question of erecting or repairing public works and temples, they would disregard expense and not allow anything to be done which might be criticized as being unworthy of the Roman people and the honor of the gods.

. . . After considering these matters which show clearly that the Romans had enough art to provide for utility and public embellishments, I shall turn to other, even more remarkable works. The first of these will be the *Cloaca Maxima,* which allows us to remark that even where there seemed to be little need for magnificence, as in this structure which was hidden from view, the Romans chose nonetheless to display magnificence all the more. . . . Dionysius writes of Priscus: "Tarquinius Priscus also undertook the excavation of the sewers which are underground canals that carry to the Tiber all the waters from the streets. One can hardly express how marvellous these works are. I certainly count among the three most magnificent works of Rome, among those which particularly show the grandeur of her Empire, the aqueducts, the paved roads, and the sewers, bearing in mind not only their usefulness but also their cost. . . ."

. . . The other truly wonderful work which enhances the magnificence of Rome is the system of aqueducts. From Frontinus we learn that, of the nine main streams which in ancient times flowed into Rome, three had already been artificially channelled before Rome subjugated Greece, namely the Appia, the old Anione, and the Marcia.

These three conduits, taken together, comprise 110 miles of underground river and about 16 miles of construction above ground which consist partly of foundations, partly of arches. The ruins of some of these conduits in Rome proper and in the environs of Rome show that both the substructures and the arches were made in part of stone, in part of brick, and that the subterranean channels were made large enough for the workmen to move about easily. . . .

. . . There remains the third class of work which Dionysius used as an argument for the grandeur of the Roman Empire, namely the paved roads.

Considering only these three kinds of monuments, we might reflect on the question of whether they could have been undertaken by men who were crude and had no feeling for art. Seeing that all these works required men of the greatest talent and deeply conversant with architecture, we might further investigate whether the Romans used Greek art in achieving these works. Before coming to any decision, we ought to listen to what Strabo has to say: "While it appears that the Greeks reached the highest level in building cities, because of their concern for beauty, for fortifications, harbors, and the general welfare of the country, the Romans strove, on the other hand, to do the things which the Greeks had neglected, namely the paving of highways, the channelling of streams, and the construction of underground sewers to carry the city's refuse into the Tiber. They paved the roads in the countryside, razing the hills and levelling the valleys, so that ship cargoes could be transported overland in carts; and they built sewers with stone vaults which are wide enough in some places to let through a cart loaded with hay."

. . . Leaving aside the loftier sciences: where, if not in Italy did Latin poetry arise, for which reason Petrarch was crowned in Rome? Where were sculpture and painting reborn, if not in the work of Giotto, Michelangelo, and Raphael who not only revived them but brought them to perfection? Finally, where was Greek architecture revived, buried as it had been in the ruins and hidden in the codices, if not in the work of Bramante, Baldassare da Siena, the same Michelangelo, Palladio, and those many others who brought it back to the open light? . . ."

ACADEMY

Academies of art, regardless of whether or not they are capable of producing artists, can be effective instruments for the central control of education and patronage. Originally established for this purpose, in an

age of absolutism, they acquired new importance under the more liberal auspices of enlightened monarchy, as self-governing, professional bodies, empowered to legislate in the arts and to mediate between the demands of society and the interest of artists. The advent of Neoclassicism, itself a product of the Enlightenment, gave a further stimulus to the development of academies, since the scholarly and theoretical bent of this movement deeply suited the academic preference for the intellectual over the technical or craftsmanlike approach to art. The number of academic foundations increased sharply; in 1740, Europe had fewer than 40, in 1790 it had more than 100 academies.

The official character of the academy, its claim to authority and desire for stability were bound to make it conservative. Academic doctrine rested ultimately on principles not open to debate. The range of academic thought therefore was narrow, and remained confined to a small repertory of ideas to which the Enlightenment contributed little that was new or substantial. The limitation and fixity of academic doctrine accounts for its remarkable coherence, but it also makes clear why it had to come into conflict with the more dynamic thought of the period. Doctrinal confinement led academies to adopt the peculiar style of teaching which came to be their trademark. It made them deal with reality, both in nature and in art, as if it were composed of static quantities which could be taken apart, judged separately, and recombined at will; it misled them into mechanical routine, tight specialization, and imitative eclecticism.

Anton Raphael Mengs (1728–1778)

Mengs' father, a court painter at Dresden, dedicated his infant son to art, and mercilessly whipped the boy into precocious virtuosity. Mengs rose to be a European celebrity, a thoroughly cosmopolitan artist whose fame outshone that of the two geniuses whose careers crossed his own— Tiepolo and Goya. The Parnassus *ceiling in the Villa Albani (1761), masterpiece of his Roman period, was a manifesto of Neoclassicism and a challenge to the dying Rococo; Winckelmann believed that Raphael would have bowed before it. And it was at the suggestion of Winckelmann, as whose mentor and artistic advisor Mengs had acted in Rome, that he published his* Thoughts on Beauty and Taste in Painting *(1762). Dry, and rather poorly written, this treatise was nevertheless an influential instrument of academic teaching in its time. It rests on a theory of beauty, the elements of which are derived from Bellori and the French Academy. The wisdom of the ancients, according to Mengs, had extracted the idea of beauty from nature and given it a nearly perfect visible form in art. The great masters of the Renaissance rediscovered partial aspects of beauty*

and embodied them in their less perfect works. Modern artists can do no
better than to search for beauty in earlier art, gathering its various parts
from different sources, as the bee gathers honey from many flowers, and
make it their own by a judicious choice and blending of borrowed ele-
ments. Salomon Gessner wrote appreciatively:

> How priceless is Mengs' little book! It contains more food for thought
> on art than many a heavy tome. Though as a philosopher he is not always clear,
> when he speaks as an artist he expresses himself with as much force, lucidity,
> purity of taste, and fine philosophical observation as one could wish for from a
> contemporary artist.

From *Thoughts on Beauty and Taste in Painting* (1762)

The History of Taste [8]

When order finally returned to the world, the arts, too, reemerged
from the void. In the beginning, the descendants of the oppressed Greeks
brought painting back to Italy, but their knowledge of this art was limited
to the use of pictures in Catholic worship, and it was so imperfect as to
show merely their good will: they were too poor and too despised to
raise the art. But when painting became popular among the Italians,
who were then rich and happy, art was raised a little from darkness by
certain men, most of all by Giotto. Discrimination, however, comes only
with knowledge. All artists who preceded Raphael, Titian, and Correggio
sought only pure imitation, hence there was no taste at all in this period.
A painting was like chaos. Some painters wanted to imitate nature, but
could not; others could imitate nature and wanted to exercise some
choice, but could not do that either. In the time of the three great
luminaries of painting, Raphael, Correggio, and Titian, painting was
finally raised to the level of discrimination, as was sculpture by Michel-
angelo, and through discrimination taste returned to the arts. But since
art is an imitation of the whole of nature, it is too vast for the human
mind, and will always be less than perfect in the hands of men. Painters
at first differed from one another in their ignorant omission of this ele-
ment or that, or in making a poor choice from nature. The three lumina-
ries selected certain aspects of nature which they were the first to distin-
guish. Each of these great masters chose a special aspect, thinking that it
was the essence of art. Raphael chose significance, finding it in composi-
tion and drawing. Correggio chose grace which he found in certain forms,
particularly in light and shade. Titian chose the appearance of truth and

[8] The translation is based on Anton Raphael Mengs, *Gedanken über die Schön-
heit und über den Geschmack in der Malerei*, Leipzig (Reklam), 1876. An early English
translation, not used in the text, is available in the form of Chev. Don Joseph Nicholas
d'Azara, *The Works of Anthony Raphael Mengs*, London, 1796.

found it chiefly in color. Raphael, therefore, was the greatest of them, for he possessed the greatest part; and since significance is unquestionably the only useful part of painting, Raphael is unquestionably the greatest painter. After this comes grace, which makes Correggio the second greatest painter. Truth, on the other hand, is an obligation, rather than an ornament, hence Titian is the third.

The Two Ways Leading to Correct Taste

There are two ways which lead the rational seeker to good taste; one of these is more difficult than the other. The more difficult is to select the most essential and beautiful from nature itself; the other, easier way is to learn from works of art in which such selection has already taken place.

By the first of these two ways, the ancients found perfection, i.e., beauty and good taste. Most of those who followed after the three luminaries aforementioned (Raphael, Correggio, and Titian) arrived at good taste by the second way. But these three achieved it partly by the first, partly by a compromise of nature and imitation. To achieve good taste through nature is much more difficult than to achieve it through imitation of art, because it requires a philosophical intellect to judge what is good, better, or best in nature, while it is easier to determine this in imitating works of art, since it is easier to understand the works of men than the works of nature. Nevertheless, it is important to use the latter method properly, in order not to get caught up in superficialities and miss the deeper cause of beauty in works of art.

The Education of the Artist

To begin with, the student should consider only the best works, and never tolerate or examine, or even imitate anything ugly. He should copy beautiful works correctly, without questioning at the start the reasons for their beauty. This will train the justness of his eye, the most essential instrument of art. Once he has reached this point, he should begin to examine critically the works of the greatest masters and to inquire into their causes. This is to be done as follows: the painter might examine, for example, all the works of Raphael, Titian, and Correggio, and see what beauties he finds in each work. If in all the works of a particular master he finds certain features consistently well observed and beautifully executed, he can take this as a sign that these features indicate the master's main intention and choice. But if he should find them so in only certain works and not in others, this means that they were not the master's strength and were not part of his intention or taste, and therefore cannot be the reason for the beauty of his work and taste.

Comparison of the Ancients with the Moderns

Nearly all painters have chosen particular specialities in which to attain perfection; the ancients did the same. But all artists since the Renaissance have actually been prompted by a single cause and intent, namely the imitation of nature. This was the main goal toward which they strove along different ways. The ancient Greeks, too, had one main aim, despite their diversity, but this was much more elevated than the aim of the moderns. Since their conceptions were capable of attaining perfection of themselves, they set as their aim the mean between high perfection and humanity, namely beauty, and took only the significant from truth. For this reason, there is beauty in all their works, and even significance is never so much emphasized as to extinguish beauty. I venture therefore to call their taste that of beauty and perfection. Though, being human, their works are imperfect, they nevertheless have the flavor of perfection. Just as wine, even when mixed with water, always retains the flavor of wine, their works, though diminished by their humanity, taste of perfection, for which reason I call them thus. The works of the ancients in fact differ considerably in their quality and significance, but not in their taste. There are three main classes of ancient monuments; in other words, the statues which have been preserved show three degrees of beauty. The least among them still have the taste of beauty, but only in their essential parts. Works of the second grade have beauty in the useful parts as well. Works of the highest grade have beauty in all parts, from the essential to the superfluous, and are therefore perfectly beautiful. Beauty in itself is nothing other than the perfection of every concept, for which reason the most perfect things, invisible as well as visible, are called beautiful. This should guide us in looking at the works of the ancients: their beauty does not always consist of the same part, but lies in the fact that that part which the Idea has chosen has been represented most beautifully. The most beautiful works of the first class are the Laocoon and the Torso, the highest of the second class the Apollo and the Borghese Gladiator, those of the third class are numberless, and of the inferior works I shall not speak at all.

Eclectic Style

I conclude therefore that the painter who wants to discover the good, that is to say, the best taste, must learn about taste from these four: from the ancients the taste for beauty; from Raphael the taste for

significance or expression; from Correggio the taste for the graceful or harmonious; from Titian the taste for truth or color. But all of this he must search for in life, for all I have written and explained is intended to give young artists the touchstone for judging their own taste. . . . These exemplars have often been imitated by other great men, but none has surpassed them, which confirms the truth that the great masters who I have named above took the proper road to perfection. This is why I have used them as models and shown the way of understanding and truly imitating them: whoever will exercise his head and hand diligently and reflect on what I have said, will some day take pleasure in his work and effort, and find good taste.

Sir Joshua Reynolds (1723–1792)

On the occasions of the British Royal Academy's distributions of prizes, the President, Sir Joshua Reynolds, was in the habit of presenting formal speeches to the assembled staff and student body. He began in 1769, one year after the foundation of the Academy, and spoke for the last time in 1790, having given fifteen Discourses *in the intervening years. These constitute the most coherent and systematic statement in the English language of the principles of academic training.*

It is important to remember that the institution for which Reynolds spoke was new and had not yet proven itself in England. The confidence which rings in the Discourses *must have been, at least in part, assumed. It was certainly not based on teaching successes, nor was there any substantial body of experience in the doctrine itself. Distilled and strained out of literature, out of the long, plagiaristic pamphleteering tradition, and fed by literati, dilettanti, and antiquarians, its body had only rarely been refreshed by the infusion of practical wisdom from the studio. Few, if any, artists had ever been formed by academic prescriptions. "Raphael, it is true, had not the advantage of studying in an Academy," as Reynolds remarked, but neither had Reynolds or any of his British colleagues. The seeming finality and orderliness of his pronouncements* ex cathedra *show him in his academic robes; but he was also, unlike most Academy presidents, a great painter. As an artist, he was familiar with the doubts which beset the practitioner and which mere theory cannot dispel. This knowledge saved him from schematic dogmatizing, and gave to his* Discourses *the dramatic interest of an inner conflict and a gradual shift of attitude. In the moving praise of Michelangelo with which he concluded his last* Discourse, *he appears on the point of giving way to the "promptings of great and irresistible impulse," in paying tribute to a "divine energy" beyond rules. But despite this final bow to genius, Reynolds throughout the* Discourses *remains steadfast in the conviction that art can be taught,*

that it is, in other words, a matter of knowledge and application. Success in the arts comes from the conscious observation of principles which, given a normal intelligence and the proper instruction, any person can acquire. In his first Discourse *he therefore recommends "that an implicit obedience to the Rules of Art, as established by the practice of the great Masters, should be exacted from the young Students; that those models, which have passed through the approbation of ages, should be considered by them as perfect and infallible guides." Intelligent imitation and hard, long study make artists, not enthusiasm or innate talent. Even Raphael was no exception; though he "had not the advantage of studying in an Academy, . . . all Rome, and the works of Michelangelo in particular, were to him an Academy." To which William Blake, a generation later, replied in an angry annotation: "I do not believe that Raphael taught Mich. Angelo, or that Mich. Angelo taught Raphael, any more than I believe that the Rose teaches the Lily how to grow, or the Apple tree teaches the Pear tree how to bear Fruit."*

Sir Joshua Reynolds' Opinion of the Discourses (from *Discourse* XV) [9]

I am truly sensible how unequal I have been to the expression of my own ideas. To develop the latent excellencies, and draw out the interior principles, of our art, requires more skill and practice in writing, than is likely to be possessed by a man perpetually occupied in the use of the pencil and the pallet. It is for that reason, perhaps, that the sister Art has had the advantage of better criticism. Poets are naturally writers of prose. They may be said to be practising only an inferior department of their own art, when they are explaining and expatiating upon its most refined principles. But still such difficulties ought not to deter Artists who are not prevented by other engagements from putting their thoughts in order as well as they can, and from giving to the publick the result of their experience. The knowledge which an Artist has of his subject will more than compensate for any want of elegance in the manner of treating it, or even of perspicuity, which is still more essential; and I am convinced that one short essay written by a Painter, will contribute more to advance the theory of our art, than a thousand volumes such as we sometimes see; the purpose of which appears to be rather to display the refinement of the Author's own conceptions of impossible practice, than to convey useful knowledge or instruction of any kind whatever. An Artist knows what is, and what is not, within the

[9] Sir Joshua Reynolds, *Discourses on Art* (ed. Robert R. Wark), The Huntington Library, San Marino, 1959. The sections quoted will be found under *Discourse III*, pp. 41 ff.; *Discourse V*, pp. 81 ff.; and *Discourse XV*, pp. 267 ff.

province of his art to perform, and is not likely to be for ever teasing the poor Student with the beauties of mixed passions, or to perplex him with an imaginary union of excellencies incompatible with each other. . . .

In reviewing my Discourses, it is no small satisfaction to be assured that I have, in no part of them, lent my assistance to foster *newly hatched unfledged* opinions, or endeavoured to support paradoxes, however tempting may have been their novelty, or however ingenious I might, for the minute, fancy them to be; nor shall I, I hope, any where be found to have imposed on the minds of young Students declamation for argument, a smooth period for a sound precept. I have pursued a plain and *honest method;* I have taken up the art simply as I found it exemplified in the practice of the most approved Painters. That approbation which the world has uniformly given, I have endeavoured to justify by such proofs as questions of this kind will admit; by the analogy which Painting holds with the sister Arts, and consequently by the common congeniality which they all bear to our nature. And though in what has been done, no new discovery is pretended, I may still flatter myself, that from the discoveries which others have made by their own intuitive good sense and native rectitude of judgment, I have succeeded in establishing the rules and principles of our Art on a more firm and lasting foundation than that on which they had formerly been placed.

A central theme which runs through the Discourses *is the discussion of the proper management of the visual forms that nature provides. True to classicist principle, Reynolds warned his listeners against simple imitation, and advocated, instead, a reasoned choice of only the best and most durable forms in nature. He advised artists to cut through the trivial variety of particular, external appearance, in order to enable them to reach the timeless generality of nature's "central form." It was this aspect of his doctrine that drew down on him the most persistent attacks of later critics, and united against him the spokesmen of romanticism and naturalism (see Blake's comments, page 120, the observations of Hazlitt, pages 249–250, and those of Ruskin, page 230).*

From *Discourse III: The Great Leading Principles of the Grand Style.—Of Beauty.— The Genuine Habits of Nature to be Distinguished from those of Fashion*

Gentlemen,

The first endeavours of a young Painter, as I have remarked in a former discourse, must be employed in the attainment of mechanical dexterity, and confined to the mere imitation of the object before him. Those who have advanced beyond the rudiments, may, perhaps, find advantage in reflecting on the advice which I have likewise given them, when I recommended the diligent study of the works of our great predeces-

sors; but I at the same time endeavoured to guard them against an im-
plicit submission to the authority of any one master however excellent; or
by a strict imitation of his manner, precluding themselves from the
abundance and variety of Nature. I will now add that Nature herself is
not to be too closely copied. There are excellencies in the art of painting
beyond what is commonly called the imitation of nature: and these
excellencies I wish to point out. The students who, having passed through
the initiatory exercises, are more advanced in the art, and who, sure of
their hand, have leisure to exert their understanding, must now be told,
that a mere copier of nature can never produce any thing great; can
never raise and enlarge the conceptions, or warm the heart of the specta-
tor.

The wish of the genuine painter must be more extensive: instead of
endeavouring to amuse mankind with the minute neatness of his imita-
tions, he must endeavour to improve them by the grandeur of his ideas;
instead of seeking praise, by deceiving the superficial sense of the spectator,
he must strive for fame, by captivating the imagination.

The principle now laid down, that the perfection of this art does
not consist in mere imitation, is far from being new or singular. It is,
indeed, supported by the general opinion of the enlightened part of
mankind. The poets, orators, and rhetoricians of antiquity, are con-
tinually enforcing this position; that all the arts receive their perfection
from an ideal beauty, superior to what is to be found in individual
nature. They are ever referring to the practice of the painters and
sculptors of their times, particularly Phidias (the favourite artist of
antiquity) to illustrate their assertions. As if they could not sufficiently
express their admiration of this genius by what they knew, they have
recourse to poetical enthusiasm. They call it inspiration; a gift from
heaven. The artist is supposed to have ascended the celestial regions, to
furnish his mind with this perfect idea of beauty. "He," says Proclus,
"who takes for his model such forms as nature produces, and confines
himself to an exact imitation of them, will never attain to what is per-
fectly beautiful. For the works of nature are full of disproportion, and
fall very short of the true standard of beauty. So that Phidias, when he
formed his Jupiter, did not copy any object ever presented to his sight;
but contemplated only that image which he had conceived in his mind
from Homer's description." And thus Cicero, speaking of the same
Phidias: "Neither did this artist," says he, "when he carved the image
of Jupiter or Minerva, set before him any one human figure, as a pattern,
which he was to copy; but having a more perfect idea of beauty fixed in
his mind, this he steadily contemplated, and to the imitation of this all
his skill and labour were directed."

The Moderns are not less convinced than the Ancients of this supe-

rior power existing in the art; nor less sensible of its effects. Every language has adopted terms expressive of this excellence. The *gusto grande* of the Italians, the *beau ideal* of the French, and the *great style, genius,* and *taste* among the English, are but different appellations of the same thing. It is this intellectual dignity, they say, that ennobles the painter's art; that lays the line between him and the mere mechanick; and produces those great effects in an instant, which eloquence and poetry, by slow and repeated efforts, are scarcely able to attain.

Such is the warmth with which both the Ancients and Moderns speak of this divine principle of the art; but, as I have formerly observed, enthusiastick admiration seldom promotes knowledge. Though a student by such praise may have his attention roused, and a desire excited, of running in this great career; yet it is possible that what has been said to excite, may only serve to deter him. He examines his own mind, and perceives there nothing of that divine inspiration, with which, he is told, so many others have been favoured. He never travelled to heaven to gather new ideas; and he finds himself possessed of no other qualifications than what mere common observation and a plain understanding can confer. Thus he becomes gloomy amidst the splendour of figurative declamation, and thinks it hopeless, to pursue an object which he supposes out of the reach of human industry.

But on this, as upon many other occasions, we ought to distinguish how much is to be given to enthusiasm, and how much to reason. We ought to allow for, and we ought to commend, that strength of vivid expression, which is necessary to convey, in its full force, the highest sense of the most complete effect of art; taking care at the same time, not to lose in terms of vague admiration, that solidity and truth of principle, upon which alone we can reason, and may be enabled to practise.

It is not easy to define in what this great style consists; nor to describe, by words, the proper means of acquiring it, if the mind of the student should be at all capable of such an acquisition. Could we teach taste or genius by rules, they would be no longer taste and genius. But though there neither are, nor can be, any precise invariable rules for the exercise, or the acquisition, of these great qualities, yet we may truly say that they always operate in proportion to our attention in observing the works of nature, to our skill in selecting, and to our care in digesting, methodizing, and comparing our observations. There are many beauties in our art, that seem, at first, to lie without the reach of precept, and yet may easily be reduced to practical principles. Experience is all in all; but it is not every one who profits by experience; and most people err, not so much from want of capacity to find their object, as from not knowing what object to pursue. This

great ideal perfection and beauty are not to be sought in the heavens, but upon the earth. They are about us, and upon every side of us. But the power of discovering what is deformed in nature, or in other words, what is particular and uncommon, can be acquired only by experience; and the whole beauty and grandeur of the art consists, in my opinion, in being able to get above all singular forms, local customs, particularities, and details of every kind.

All the objects which are exhibited to our view by nature, upon close examination will be found to have their blemishes and defects. The most beautiful forms have something about them like weakness, minuteness, or imperfection. But it is not every eye that perceives these blemishes. It must be an eye long used to the contemplation and comparison of these forms; and which, by a long habit of observing what any set of objects of the same kind have in common, has acquired the power of discerning what each wants in particular. This long laborious comparison should be the first study of the painter, who aims at the greatest style. By this means, he acquires a just idea of beautiful forms; he corrects nature by herself, her imperfect state by her more perfect. His eye being enabled to distinguish the accidental deficiencies, excrescences, and deformities of things, from their general figures, he makes out an abstract idea of their forms more perfect than any one original; and what may seem a paradox, he learns to design naturally by drawing his figures unlike to any one object. This idea of the perfect state of nature, which the Artist calls the Ideal Beauty, is the great leading principle, by which works of genius are conducted. By this Phidias acquired his fame. He wrought upon a sober principle, what has so much excited the enthusiasm of the world; and by this method you, who have courage to tread the same path, may acquire equal reputation.

This is the idea which has acquired, and which seems to have a right to the epithet of *divine;* as it may be said to preside, like a supreme judge, over all the productions of nature; appearing to be possessed of the will and intention of the Creator, as far as they regard the external form of living beings. When a man once possesses this idea in its perfection, there is no danger, but that he will be sufficiently warmed by it himself, and be able to warm and ravish every one else.

Thus it is from a reiterated experience, and a close comparison of the objects in nature, that an artist becomes possessed of the idea of that central form, if I may so express it, from which every deviation is deformity. But the investigation of this form, I grant, is painful, and I know but of one method of shortening the road; this is, by a careful study of the works of the ancient sculptors; who, being indefatigable in the school of nature, have left models of that perfect form behind them, which an artist would prefer as supremely beautiful, who had

spent his whole life in that single contemplation. But if industry carried them thus far, may not you also hope for the same reward from the same labour? We have the same school opened to us, that was opened to them; for nature denies her instructions to none, who desire to become her pupils.

This laborious investigation, I am aware, must appear superfluous to those who think every thing is to be done by felicity, and the powers of native genius. Even the great Bacon treats with ridicule the idea of confining proportion to rules, or of producing beauty by selection. "A man cannot tell," says he, "whether Apelles or Albert Dürer were the more trifler: whereof the one would make a personage by geometrical proportions; the other, by taking the best parts out of divers faces, to make one excellent. . . . The painter, [he adds], must do it by a kind of felicity, . . . and not by rule."

It is not safe to question any opinion of so great a writer, and so profound a thinker, as undoubtedly Bacon was. But he studies brevity to excess; and therefore his meaning is sometimes doubtful. If he means that beauty has nothing to do with rule, he is mistaken. There is a rule, obtained out of general nature, to contradict which is to fall into deformity. Whenever any thing is done beyond this rule, it is in virtue of some other rule which is followed along with it, but which does not contradict it. Every thing which is wrought with certainty, is wrought upon some principle. If it is not, it cannot be repeated. If by felicity is meant any thing of chance or hazard, or something born with a man, and not earned, I cannot agree with this great philosopher. Every object which pleases must give us pleasure upon some certain principles; but as the objects of pleasure are almost infinite, so their principles vary without end, and every man finds them out, not by felicity or successful hazard, but by care and sagacity.

To the principle I have laid down, that the idea of beauty in each species of beings is an invariable one, it may be objected, that in every particular species there are various central forms, which are separate and distinct from each other, and yet are undeniably beautiful; that in the human figure, for instance, the beauty of Hercules is one, of the Gladiator another, of the Apollo another; which makes so many different ideas of beauty.

It is true, indeed, that these figures are each perfect in their kind, though of different characters and proportions; but still none of them is the representation of an individual, but of a class. And as there is one general form, which, as I have said, belongs to the human kind at large, so in each of these classes there is one common idea and central form, which is the abstract of the various individual forms belonging to that class. Thus, though the forms of childhood and age differ

exceedingly, there is a common form in childhood, and a common form in age, which is the more perfect, as it is more remote from all peculiarities. But I must add further, that though the most perfect forms of each of the general divisions of the human figure are ideal, and superior to any individual form of that class; yet the highest perfection of the human figure is not to be found in any one of them. It is not in the Hercules, nor in the Gladiator, nor in the Apollo; but in that form which is taken from them all, and which partakes equally of the activity of the Gladiator, of the delicacy of the Apollo, and of the muscular strength of the Hercules. For perfect beauty in any species must combine all the characters which are beautiful in that species. It cannot consist in any one to the exclusion of the rest: no one, therefore, must be predominant, that no one may be deficient.

The knowledge of these different characters, and the power of separating and distinguishing them, is undoubtedly necessary to the painter, who is to vary his compositions with figures of various forms and proportions, though he is never to lose sight of the general idea of perfection in each kind.

There is, likewise, a kind of symmetry, or proportion, which may properly be said to belong to deformity. A figure lean or corpulent, tall or short, though deviating from beauty, may still have a certain union of the various parts, which may contribute to make them on the whole not unpleasing.

When the Artist has by diligent attention acquired a clear and distinct idea of beauty and symmetry; when he has reduced the variety of nature to the abstract idea; his next task will be to become acquainted with the genuine habits of nature, as distinguished from those of fashion. For in the same manner, and on the same principles, as he has acquired the knowledge of the real forms of nature, distinct from accidental deformity, he must endeavour to separate simple chaste nature, from those adventitious, those affected and forced airs or actions, with which she is loaded by modern education.

However the mechanick and ornamental arts may sacrifice to fashion, she must be entirely excluded from the Art of Painting; the painter must never mistake this capricious changeling for the genuine offspring of nature; he must divest himself of all prejudices in favour of his age or country; he must disregard all local and temporary ornaments, and look only on those general habits which are every where and always the same. He addresses his works to the people of every country and every age; he calls upon posterity to be his spectators, and says with Zeuxis, *in æternitatem pingo.*

The neglect of separating modern fashions from the habits of nature, leads to that ridiculous style which has been practised by some painters,

who have given to Grecian Heroes the airs and graces practised in the court of Lewis the Fourteenth; an absurdity almost as great as it would have been to have dressed them after the fashion of that court.

To avoid this error, however, and to retain the true simplicity of nature, is a task more difficult than at first sight it may appear. The prejudices in favour of the fashions and customs that we have been used to, and which are justly called a second nature, make it too often difficult to distinguish that which is natural, from that which is the result of education; they frequently even give a predilection in favour of the artificial mode; and almost every one is apt to be guided by those local prejudices, who has not chastised his mind, and regulated the instability of his affections by the eternal invariable idea of nature.

Here then, as before, we must have recourse to the Ancients as instructors. It is from a careful study of their works that you will be enabled to attain to the real simplicity of nature; they will suggest many observations, which would probably escape you, if your study were confined to nature alone. And, indeed, I cannot help suspecting, that in this instance the ancients had an easier task than the moderns. They had, probably, little or nothing to unlearn, as their manners were nearly approaching to this desirable simplicity; while the modern artist, before he can see the truth of things, is obliged to remove a veil, with which the fashion of the times has thought proper to cover her.

Having gone thus far in our investigation of the great stile in painting; if we now should suppose that the artist has formed the true idea of beauty, which enables him to give his works a correct and perfect design; if we should suppose also, that he has acquired a knowledge of the unadulterated habits of nature, which gives him simplicity; the rest of his task is, perhaps, less than is generally imagined. Beauty and simplicity have so great a share in the composition of a great stile, that he who has acquired them has little else to learn. It must not, indeed, be forgotten, that there is a nobleness of conception, which goes beyond any thing in the mere exhibition even of perfect form; there is an art of animating and dignifying the figures with intellectual grandeur, of impressing the appearance of philosophick wisdom, or heroick virtue. This can only be acquired by him that enlarges the sphere of his understanding by a variety of knowledge, and warms his imagination with the best productions of ancient and modern poetry.

A hand thus exercised, and a mind thus instructed, will bring the art to an higher degree of excellence than, perhaps, it has hitherto attained in this country. Such a student will disdain the humbler walks of painting, which, however profitable, can never assure him a permanent reputation. He will leave the meaner artist servilely to suppose that those are the best pictures, which are most likely to deceive the spec-

tator. He will permit the lower painter, like the florist or collector of shells, to exhibit the minute discriminations, which distinguish one object of the same species from another; while he, like the philosopher, will consider nature in the abstract, and represent in every one of his figures the character of its species.

If deceiving the eye were the only business of the art, there is no doubt, indeed, but the minute painter would be more apt to succeed: but it is not the eye, it is the mind, which the painter of genius desires to address; nor will he waste a moment upon those smaller objects, which only serve to catch the sense, to divide the attention, and to counteract his great design of speaking to the heart.

This is the ambition which I wish to excite in your minds; and the object I have had in my view, throughout this discourse, is that one great idea, which gives to painting its true dignity, which entitles it to the name of a Liberal Art, and ranks it as a sister of poetry.

It may possibly have happened to many young students, whose application was sufficient to overcome all difficulties, and whose minds were capable of embracing the most extensive views, that they have, by a wrong direction originally given, spent their lives in the meaner walks of painting, without ever knowing there was a nobler to pursue. Albert Dürer, as Vasari has justly remarked, would, probably, have been one of the first painters of his age (and he lived in an era of great artists), had he been initiated into those great principles of the art, which were so well understood and practised by his contemporaries in Italy. But unluckily having never seen or heard of any other manner, he, without doubt, considered his own as perfect.

As for the various departments of painting, which do not presume to make such high pretensions, they are many. None of them are without their merit, though none enter into competition with this universal presiding idea of the art. The painters who have applied themselves more particularly to low and vulgar characters, and who express with precision the various shades of passion, as they are exhibited by vulgar minds (such as we see in the works of Hogarth), deserve great praise; but as their genius has been employed on low and confined subjects, the praise which we give must be as limited as its object. The merry-making, or quarrelling, of the Boors of Teniers; the same sort of productions of Brouwer, or Ostade, are excellent in their kind; and the excellence and its praise will be in proportion, as, in those limited subjects, and peculiar forms, they introduce more or less of the expression of those passions, as they appear in general and more enlarged nature. This principle may be applied to the Battle-pieces of Bourgognone, the French Gallantries of Watteau, and even beyond the exhibition of animal life, to the Landscapes of Claude Lorrain, and the Sea-Views of Vandervelde. All these

painters have, in general, the same right, in different degrees, to the name of a painter, which a satirist, an epigrammatist, a sonneteer, a writer of pastorals, or descriptive poetry, has to that of a poet.

In the same rank, and perhaps of not so great merit, is the cold painter of portraits. But his correct and just imitation of his object has its merit. Even the painter of still life, whose highest ambition is to give a minute representation of every part of those low objects which he sets before him, deserves praise in proportion to his attainment; because no part of this excellent art, so much the ornament of polished life, is destitute of value and use. These, however, are by no means the views to which the mind of the student ought to be *primarily* directed. Having begun by aiming at better things, if from particular inclination, or from the taste of the time and place he lives in, or from necessity, or from failure in the highest attempts, he is obliged to descend lower, he will bring into the lower sphere of art a grandeur of composition and character, that will raise and ennoble his works far above their natural rank.

A man is not weak, though he may not be able to wield the club of Hercules; nor does a man always practise that which he esteems the best; but does that which he can best do. In moderate attempts, there are many walks open to the artist. But as the idea of beauty is of necessity but one, so there can be but one great mode of painting; the leading principle of which I have endeavoured to explain.

I should be sorry, if what is here recommended, should be at all understood to countenance a careless or indetermined manner of painting. For though the painter is to overlook the accidental discriminations of nature, he is to exhibit distinctly, and with precision, the general forms of things. A firm and determined outline is one of the characteristics of the great style in painting; and let me add, that he who possesses the knowledge of the exact form which every part of nature ought to have, will be fond of expressing that knowledge with correctness and precision in all his works.

Raphael and Michaelangelo Compared (from *Discourse V*)

Raphael, who stands in general foremost of the first painters, owes his reputation, as I have observed, to his excellence in the higher parts of the art: his works in *Fresco*, therefore, ought to be the first object of our study and attention. His *easel*-works stand in a lower degree of estimation; for though he continually, to the day of his death, embellished his performances more and more with the addition of those lower ornaments, which entirely make the merit of some painters, yet

he never arrived at such perfection as to make him an object of imitation. He never was able to conquer perfectly that dryness, or even littleness of manner, which he inherited from his master. He never acquired that nicety of taste in colours, that breadth of light and shadow, that art and management of uniting light to light, and shadow to shadow, so as to make the object rise out of the ground with that plenitude of effect so much admired in the works of Correggio. When he painted in oil, his hand seemed to be so cramped and confined, that he not only lost that facility and spirit, but I think even that correctness of form, which is so perfect and admirable in his *Fresco*-works. I do not recollect any pictures of his of this kind, except perhaps the Transfiguration, in which there are not some parts that appear to be even feebly drawn. That this is not a necessary attendant on Oil-painting, we have abundant instances in more modern painters. Lodovico Carracci, for instance, preserved in his works in oil the same spirit, vigour, and correctness, which he had in *Fresco*. I have no desire to degrade Raphael from the high rank which he deservedly holds; but by comparing him with himself, he does not appear to me to be the same man in Oil as in Fresco.

From those who have ambition to tread in this great walk of the art, Michael Angelo claims the next attention. He did not possess so many excellencies as Raphael, but those which he had were of the highest kind. He considered the art as consisting of little more than what may be attained by Sculpture; correctness of form, and energy of character. We ought not to expect more than an artist intends in his work. He never attempted those lesser elegancies and graces in the art. Vasari says, he never painted but one picture in oil, and resolved never to paint another, saying, it was an employment only fit for women and children.

If any man had a right to look down upon the lower accomplishments as beneath his attention, it was certainly Michael Angelo; nor can it be thought strange, that such a mind should have slighted or have been withheld from paying due attention to all those graces and embellishments of art, which have diffused such lustre over the works of other painters.

It must be acknowledged, however, that together with these, which we wish he had more attended to, he has rejected all the false, though specious ornaments, which disgrace the works even of the most esteemed artists; and I will venture to say, that when those higher excellencies are more known and cultivated by the artists and the patrons of arts, his fame and credit will increase with our increasing knowledge. His name will then be held in the same veneration as it was in the enlightened age of Leo the tenth: and it is remarkable that the reputation of this truly great man has been continually declining as the art

itself has declined. For I must remark to you, that it has long been much on the decline, and that our only hope of its revival will consist in your being thoroughly sensible of its depravation and decay. It is to Michael Angelo, that we owe even the existence of Raphael: it is to him Raphael owes the grandeur of his style. He was taught by him to elevate his thoughts, and to conceive his subjects with dignity. His genius, however formed to blaze and to shine, might, like fire in combustible matter, for ever have lain dormant, if it had not caught a spark by its contact with Michael Angelo: and though it never burst out with *his* extraordinary heat and vehemence, yet it must be acknowledged to be a more pure, regular, and chaste flame. Though our judgement must upon the whole decide in favour of Raphael, yet he never takes such a firm hold and entire possession of the mind as to make us desire nothing else, and to feel nothing wanting. The effect of the capital works of Michael Angelo perfectly corresponds to what Bouchardon said he felt from reading Homer; his whole frame appeared to himself to be enlarged, and all nature which surrounded him, diminished to atoms.

If we put these great artists in a light of comparison with each other, Raphael had more Taste and Fancy, Michael Angelo more Genius and Imagination. The one excelled in beauty, the other in energy. Michael Angelo has more of the Poetical Inspiration; his ideas are vast and sublime; his people are a superior order of beings; there is nothing about them, nothing in the air of their actions or their attitudes, or the style and cast of their limbs or features, that reminds us of their belonging to our own species. Raphael's imagination is not so elevated; his figures are not so much disjoined from our own diminutive race of beings, though his ideas are chaste, noble, and of great conformity to their subjects. Michael Angelo's works have a strong, peculiar, and marked character: they seem to proceed from his own mind entirely, and that mind so rich and abundant, that he never needed, or seemed to disdain, to look abroad for foreign help. Raphael's materials are generally borrowed, though the noble structure is his own. The excellency of this extraordinary man lay in the propriety, beauty, and majesty of his characters, the judicious contrivance of his Composition, his correctness of Drawing, purity of Taste, and skilful accommodation of other men's conceptions to his own purpose. Nobody excelled him in that judgement, with which he united to his own observations on Nature, the Energy of Michael Angelo, and the Beauty and Simplicity of the Antique. To the question therefore, which ought to hold the first rank, Raphael or Michael Angelo, it must be answered, that if it is to be given to him who possessed a greater combination of the higher qualities of the art than any other man, there is no doubt but Raphael is the first. But if, as Longinus thinks, the sublime, being the highest excel-

lence that human composition can attain to, abundantly compensates the absence of every other beauty, and atones for all other deficiencies, then Michael Angelo demands the preference.

The Sublimity of Michaelangelo, Last Words Pronounced by Sir Joshua Reynolds from the Presidential Chair of the Academy (from *Discourse XV*)

I would ask any man qualified to judge of such works, whether he can look with indifference at the personification of the Supreme Being in the center of the Capella Sestina, or the figures of the Sybils which surround that chapel, to which we may add the statue of Moses; and whether the same sensations are not excited by those works, as what he may remember to have felt from the most sublime passages of Homer?

The sublime in Painting, as in Poetry, so overpowers, and takes such a possession of the whole mind, that no room is left for attention to minute criticism. The little elegancies of art in the presence of these great ideas thus greatly expressed, lose all their value, and are, for the instant at least, felt to be unworthy of our notice. The correct judgment, the purity of taste, which characterise Raphael, the exquisite grace of Correggio and Parmegiano, all disappear before them.

That Michael Angelo was capricious in his inventions, cannot be denied; and this may make some circumspection necessary in studying his works; for though they appear to become him, an imitation of them is always dangerous, and will prove sometimes ridiculous. "Within that circle none durst walk but he." To me, I confess, his caprice does not lower the estimation of his genius, even though it is sometimes, I acknowledge, carried to the extreme: and however those eccentrick excursions are considered, we must at the same time recollect, that those faults, if they are faults, are such as never could occur to a mean and vulgar mind; that they flowed from the same source which produced his greatest beauties, and were therefore such as none but himself was capable of committing; they were the powerful impulses of a mind unused to subjection of any kind, and too high to be controlled by cold criticism.

It must be remembered, that as this great style itself is artificial in the highest degree, it presupposes in the spectator, a cultivated and prepared artificial state of mind. It is an absurdity therefore to suppose that we are born with this taste, though we are with the seeds of it, which, by the heat and kindly influence of his genius, may be ripened in us.

The style of Michael Angelo, which I have compared to language, and which may, poetically speaking, be called the language of the

Gods, now no longer exists, as it did in the fifteenth century; yet, with the aid of diligence, we may in a great measure supply the deficiency which I mentioned, of not having his works so perpetually before our eyes, by having recourse to casts from his models and designs in Sculpture; to drawings or even copies of those drawings; to prints, which however ill executed, still convey something by which this taste may be formed; and a relish may be fixed and established in our minds for this grand style of invention.

I have endeavoured to stimulate the ambition of Artists to tread in this great path of glory, and, as well as I can, have pointed out the track which leads to it, and have at the same time told them the price at which it may be obtained. It is an ancient 'saying, that labour is the price which the Gods have set upon every thing valuable.

The great Artist, who has been so much the subject of the present Discourse, was distinguished even from his infancy for his indefatigable diligence; and this was continued through his whole life, till prevented by extreme old age. The poorest of men, as he observed himself, did not labour from necessity, more than he did from choice. Indeed, from all the circumstances related of his life, he appears not to have had the least conception that his art was to be acquired by any other means than by great labour; and yet he, of all men that ever lived, might make the greatest pretensions to the efficacy of native genius and inspiration. I have no doubt that he would have thought it no disgrace, that it should be said of him, as he himself said of Raphael, that he did not possess his art from nature, but by long study. He was conscious that the great excellence to which he arrived was gained by dint of labour, and was unwilling to have it thought that any transcendent skill, however natural its effects might seem, could be purchased at a cheaper price than he had paid for it.

If the high esteem and veneration in which Michael Angelo has been held by all nations and in all ages, should be put to the account of prejudice, it must still be granted that those prejudices could not have been entertained without a cause: the ground of our prejudice then becomes the source of our admiration. But from whatever it proceeds, or whatever it is called, it will not I hope, be thought presumptuous in me to appear in the train, I cannot say of his imitators, but of his admirers. I have taken another course, one more suited to my abilities, and to the taste of the times in which I live. Yet however unequal I feel myself to that attempt, were I now to begin the world again, I would tread in the steps of that great master: to kiss the hem of his garment, to catch the slightest of his perfections, would be glory and distinction enough for an ambitious man.

I feel a self-congratulation in knowing myself capable of such sensa-

tions as he intended to excite. I reflect not without vanity, that these Discourses bear testimony of my admiration of that truly divine man, and I should desire that the last words which I should pronounce in this Academy, and from this place, might be the name of—MICHAEL ANGELO.

Salomon Gessner (1730–1788)

The Swiss poet and painter, Salomon Gessner, literally followed the precept of "ut pictura poesis" in his work: his Arcadian poems read like evocations of the paintings of Claude Lorrain, while his landscape etchings breathe the spirit of Theocritus. Gessner's mild classicism was tinged with a delight in the cozy and quaint which today seems more Rococo, or Swiss, than Hellenic. His Death of Abel *(1758) had an international success; contemporary readers enjoyed its sense of unspoiled nature and quiet grace, qualities which can still be felt in the delicate and naïve illustrations which he drew for his works. The* Letter to Mr. Fuesslin on Landscape Painting *(1770), from which the following excerpts are taken, gives an account of Gessner's self-training as an artist. It is surprising to find that, without external compulsion, he voluntarily administered to himself the eclectic disciplines of the Academy, and attempted to adapt to landscape the Mengsian recipe of imitating and combining the particular styles of diverse masters (see page 30). The* Letter *enjoyed a popularity which extended throughout Europe and continued into the 19th century. Constable and other English artists read it in the very defective translation by W. Hooper (1776) which has not been used for the following excerpts:* [10]

From *Letter to Mr. Fuesslin on Landscape Painting* (1770)

My passion for art reawakened, and I resolved, already thirty years old, to see whether I could still reach the point at which I should gain the respect of connoisseurs and artists.

My predilection was for landscape, and I began by drawing diligently. But something happened to me which has happened to many others before: convinced that nature was the best and truest guide of art, I drew exclusively from nature. What difficulties I had, lacking the facility of seizing the various characteristic expressions in landscape subjects, a facility which can be gained only through the study of the best

[10] The text used in the present translation follows "Brief an Herrn Fuesslin ueber die Landschaftsmalerey," in Salomon Gessner's *Schriften*, Zurich, 1772, V, 3 ff. An early and quite inaccurate English translation is to be found in W. Hooper, *New Idylles by Gessner*, London, 1776.

models. I was too intent on following nature closely, and got bogged down in petty details which hurt the effect of the whole. I nearly always missed the right way of rendering the true character of natural objects without servility or timidity. My foregrounds were cluttered with complex and trivial forms, my trees were timidly drawn and not well ordered in their main masses; tasteless overwork rendered everything disharmonious. In a word, I had not yet trained my eye to see nature as a picture, and had not learned at what point the limitations of art require that something be added or taken away from nature. Thus I discovered that, in order to train myself, I must first follow the best artists. My experience recalls the mistake into which early artists fell when, lacking good examples, they tried to raise art up from its infancy: they kept so close to nature that they often showed the merest accessories as distinctly as the main features. In a later period, artists of genius recognized this fault and tried to avoid it by familiarizing themselves with the rules of beauty in the disposition and variety of masses, in the arrangement of shadow and light, and so forth.

I decided to follow their example, and to shorten my road, I chose only the best work for my models, only those which were excellent in every way. This careful concentration on the very best ought to be a prime rule for every teacher and student. Nothing is more harmful than mediocrity; we should avoid it more carefully than the simply bad which is easier to recognize. . . .

I found it advantageous in my studies to go from one problem to the next. Those who try to do everything at once have chosen a laborious way; their attention is scattered, and they grow tired from having encountered too many obstacles at once. To begin with, I tried trees, and chose Waterloo as my particular model. . . . The more I studied him, the more I discovered true nature in his landscapes. I practiced his manner until I easily mastered it in designs of my own. Meanwhile I did not neglect to copy other artists whose manner is unlike Waterloo's, but who, nonetheless, are felicitous in their imitation of nature. I exercised after Swanevelt and Berghem, and whenever I found a tree or shrub which particularly attracted my attention, I made a rapid sketch of it. By means of these varied exercises, I gained facility of expression and developed a more individual manner than I had got from following Waterloo. I went on, bit by bit. For rocks I chose the large masses to be found in Berghem and Salvator Rosa; for the truly characteristic aspects of nature, the designs of Felix Meyer, Ermels and Hackert; for folds of terrain, Claude's grassy plains and crepuscular distances, or the flowing undulations of receding hills in Wouvermann which look like velvet when soft light touches their grassy surface; and in the end I returned to Waterloo whose grounds are exactly as he found them in his region:

wholly natural, and therefore difficult to imitate. For sandy or rocky areas overgrown with scattered shrubs, grasses or weeds, I chose Berghem.

How much easier the study of nature now became for me! Having learned to recognize what is peculiar to art, I was now infinitely better able to observe nature and to achieve a suggestive manner whenever plain representation was insufficient. During walks I had formerly often looked in vain for something to draw. Now I always discover something along the way. I may not find a tree which is picturesquely beautiful in all its form, but with an eye accustomed to discovery, I can find even in a bad tree some particular detail, some well-shaped branches, a beautiful cluster of foliage, or a single patch of bark which, if I use them sensibly, will give my work truth and beauty. A pebble can suggest the bulk of a rock: it is in my power to hold it up to the light and to observe on it the most beautiful effects of light and shade, half-shadow, and reflection. . . .

But my landscapes still lacked greatness, nobility, and harmony: their illumination was still too scattered, they lacked a vigorous general effect. I had to find a better way of giving them unity.

From among all the artists of the past, I chose those who seemed to me to be the best with respect to ideas, selection, and disposition. I found simple rusticity in Everdingen's landscapes, among sites which are nevertheless extremely varied . . . Swanevelt's noble thoughts . . . Salvator Rosa's bold wildness; Rubens' audacity in the choice of his sites —these and others I studied in rapid drawings, emphasizing the total effect, since I wanted to give free rein to the imagination. Finally, I limited myself entirely to the two Poussins and to Claude Lorrain. In them, I found true greatness: theirs is no simple imitation of nature. . . . In the two Poussins, poetic genius unites all that is grand and noble. They transport us into periods which history and the poets have made us revere and into countries where nature is not wild, but grandiose in its variety, and where, in a benign climate, every plant attains its healthiest perfection. Their buildings have the beautiful simplicity of ancient architecture, and their inhabitants a noble aspect and demeanor, such as our imagination tells us the Greeks and Romans possessed. . . . Grace and contentment prevail in the regions which Lorrain has painted for us: they awaken the same enthusiasm and calm emotion which is aroused by the contemplation of nature itself. They are rich, without being wild or unquiet, varied yet marked by gentleness and repose. His landscapes are prospects of a happy land in which men live in abundance. . . .

I have one further important recommendation for artists: poetry is the true sister of painting. Do not neglect the best works of the poets; they will refine and elevate your taste and ideas, and furnish your imagination with the most beautiful pictures. Both poetry and painting search for the beautiful and grand in nature; they both follow similar

laws. Variety without confusion governs the design of their works, and a sensitivity to the truly beautiful guides both in the choice of every circumstance, in every picture, throughout the whole of their work. Many artists would choose nobler subjects, and with more taste. Many poets would give more truth, more picturesque expression to their images, if they combined the knowledge of both arts.

COMMON SENSE AND SENSIBILITY

The rise of lay criticism in the late 18th century resulted in part from the widespread belief that artists, like scientists or moral philosophers, must search for objective truth in the verifiable experience of physical nature or human nature. The Academy's claim that art can be learned through rule and method rested on this belief; it implied that the artist's work was a rational pursuit of attainable social ends—not a form of sorcery or a spontaneous overflowing of mental energy. But a further implication, not so happily acknowledged by Academicians, was that any man of sound mind and feeling can judge the essential value of art, namely its truth, regardless of how ignorant of technical matters he might be. For if art had to stand the test of common sense and common feeling, the intelligent layman had as much right to apply the test as the professional artist, the philosopher, or the historian.

Jean-Étienne Liotard (1702–1789) and the "Ignorart"

In his old age, the Swiss portrait painter and pastellist, Liotard, nicknamed le peintre Turc *because of his travels in the Levant and his bizarre affectation of Turkish costume and beard, wrote a handbook for painters,* Traité des principes et des règles de la peinture *(1781), in which he claimed that ignorant laymen are the best critics of art.*[11]

From *Traité des principes et des règles de la peinture*

You should not disregard, but rather consider with care, the criticism of your work by people who know nothing about art: there is always some truth in their observations.

This idea may at first strike you as paradoxical, but you will discover

[11] Liotard's text is published in E. Humbert and A. Revilliod, *La vie et les oeuvres de Jean-Étienne Liotard*, Amsterdam, 1897, pp. 86 ff.

on further reflection that it is true. The reason is simple: the painter works from models which nature offers him. This great book is open to all men. It is not surprising that an artist should neglect some of the innumerable details which it contains, and that this omission should immediately strike the eye of the *ignorart.*

This is the name I apply to men who have never drawn or painted, and who know nothing about painting. I want to prove that the *ignorart* is sometimes a very good judge, and that his judgments about art are often preferable to those of the artists themselves. Those who judge best in matters of truth are surely the best judges. Painters are judges of art. The *ignorart* knows nothing about that, but he knows truth and is a judge of truth. Painters judge truth by the standards of art, and often by the standards of art misunderstood. This keeps them from having a sound judgment of truth, as I shall show by means of striking examples.

The *ignorart* has a very exact idea of everything to be found in nature . . . nearly all painters base their judgment on their own manner of painting: this is perfectly understandable; if they did not think their manner the best, they would change it. That is why they are always ready to condemn others whose manner is contrary to theirs. French painters and some of the Flemings love inventive, facile, spontaneous work. Certain Flemings and Dutchmen put all their pride into giving their pictures the most minute finish. The Italians prefer artists who paint in a broad and handsome manner.

I have heard painters give judgments on art which were false to the point of being ridiculous. While looking at a collection of Flemish and Dutch paintings of the highest quality and finish, including works by Gerard Dou, Mieris, Adrian and Willem Van de Velde, Van der Heyde, Ostade, Wouvermans, Van der Werff, Rembrandt, Rubens, Teniers, and other good painters, one of the most accomplished painters in Rome once said to me: "I find no merit in any of these pictures."

An *ignorart* enters the shop of an art merchant in Paris. He finds a female portrait by Rembrandt next to a *Flora,* a mediocre copy by Coypel. The *Flora* gives him more pleasure than Rembrandt's portrait . . . whose face and hands seem to be covered with scars or the marks of smallpox. A painter of his acquaintance tells him: "Look at this beautiful Rembrandt; never mind that worthless *Flora."* The *ignorart,* looking more closely at Rembrandt's work, answered: "It does seem to me that this picture has strength, since it is so brown. Is there some special merit in this vigor and brownness? Did Rembrandt mix soot with his colors? And why has he given his picture these scars and pockmarks?" Shrugging his shoulders, the painter replied: "I can see that you know

nothing about painting. How could you imagine that a great artist would mix soot with his colors? Old age has darkened them, but I can still see them under these layers of brown, still beautiful, fresh and true . . . these scars and so-called pockmarks are bold and deliberate touches of the brush which express the softness of flesh, and give vigor, truth, and life to this incomparable picture."

The *ignorart* admits that he is wrong, realizing that he knows nothing about painting, and yet his judgment is true. . . . The painter's judgment is colored by his preoccupation with art. Art, misunderstood, triumphs over truth, as with the country lawyer who persuades a peasant that he is wrong, when the peasant in fact is right. . . .

. . . As for my own work, what truth is to be found in it, I cheerfully confess to all my colleagues, I owe to the *ignorart* who often brought me back to truth when I had lost the way. . . .

Do you believe that those famous, biennial exhibitions at the Louvre are intended merely to flatter the artists of the capital, by way of reward for their labors, and to earn them public admiration and applause? Without fear of being contradicted by the gentlemen of the Royal Academy who might read this, I should say, rather, that added to the perfectly natural desire for public approbation, there is another motive, namely the desire to profit from the criticism of a population which has an innate taste for all the arts, and which possesses a fine sense of their beauties and defects.

Denis Diderot (1713–1784)

Diderot turned to art criticism relatively late in his career. When, in 1759, the publicist F. M. Grimm asked him to contribute a review of the current Salon to the Correspondance littéraire, *the periodic manuscript newsletter which Grimm edited for princely subscribers in Germany, Poland, and Russia, Diderot was still without experience in this field. He had exercised his talent as philosopher, novelist, and dramatist, and had for nearly a decade contributed a great variety of articles to the* Encyclopédie, *but, aside from a treatise on ancient encaustic painting and a fairly abstruse article on Beauty (1751), he had not written on questions of art. From 1759 onward, he regularly reviewed the biennial Paris Salons—in 1761, 1763, 1765, 1767, 1769, and 1771, then, after a longer interval, in 1775, and once again in 1781. It was Grimm's commission which opened his eyes and mind to the work of modern artists and caused him to become a practical critic, rather than a theorist of art. "The task you gave me," he wrote in the Introduction to his* Salon of

1765, "has made me fasten my eyes on the canvas and to walk round the marble. I have given my impressions the time to form and to register. I have opened my mind to visual effects and allowed them to sink in. . . . I have learned to understand subtlety of design and truth to nature. I have experienced the magic of light and shadow. I have understood color and acquired feeling for flesh. I have meditated in solitude on what I have seen and heard, and such terms of art as unity, variety, contrast, symmetry, arrangement, composition, character, expression, so ready to come to my lips, but so vague in my mind, have taken on firm definition."

Journalistic criticism of art and periodic reviews of exhibitions were no longer a novelty when Diderot began. La Font de Saint Yenne (1747), Saint Yves (1748), Count Caylus (1750), Fréron, and Grimm himself had preceded him and had helped to create the type which he was to perfect. Many artists of the period resented the intrusion of lay critics, considering it as a form of charlatanry and a threat to their trade. Others, such as the painter J. E. Liotard, held the paradoxical view that the ignorant made the best critics, since their minds were free of prejudice. Diderot himself was anxious to make up for his practical inexperience by consulting the artists and observing their practice. He listened to de La Tour, Chardin, Greuze, Michel van Loo, and Joseph Vernet, he read copiously, and occasionally appropriated the thoughts of others.

His reviews, written under the impact of fresh impressions, are very little burdened with abstract theory. The basis of his judgments was a secular morality which, without clear differentiation between ethics and aesthetics, put a high value on the socially useful, the instructive, and the elevating. He accepted as a matter of common sense that art must follow nature and that to deviate from nature was to fall into error or vice. The artist must discover in external and in human nature the special qualities and correspondences of form and feeling which constitute the truth of art. This truth was not primarily a matter of visual resemblance, but of psychological and moral rightness, and its proof lay in the response of the sensibility, the verdict of the uncorrupted heart. Given this approach, it is not surprising that Diderot's "nature" should strike the modern reader as heavily moralized and overlaid with literary artifice. His descriptions of paintings stress narrative, arrangement, and situation, and sometimes read like scenarios. His bias, reflecting his espousal of contemporary attitudes, kept him from doing justice to Boucher and made him admire the moralized landscapes of Vernet and the sentimental genres of Greuze. But Diderot had too sound an instinct and too much keenness of eye to fall victim to the momentarily interesting. As he gained assurance and experience, the essential pictorial elements in art, particularly light and color, began to preoccupy him more

and more, and in time led him to value the painterly genius of Chardin over the seductive rhetoric of Greuze.[12]

Francois Boucher, "Shepherd Scene," (*Salon* of 1763)

Imagine, in the background, a vase standing on a pedestal and crowned with bundled branches. Place beneath it a shepherd, asleep with his head on the knees of his shepherdess. Scatter about them a shepherd's crook, a little hat filled with roses, a dog, some sheep, a bit of landscape, and Heaven knows how many more details, all piled on top of one another; then paint the whole in the most brilliant colors, and you'll have the *Shepherd Scene* of Boucher.

What a waste of talent and of time! Half the effort would have produced twice the effect. The eye rambles among so many objects, all rendered with equal care; there is no sense of atmosphere, no quiet. Yet the shepherdess has the look of her kind, and the bit of landscape squeezed in near the vase has a surprising delicacy, freshness, and charm. But what does this vase and pedestal mean? What are these heavy branches which top it? Must a writer say all? Must a painter paint everything? Can't he leave anything at all to my imagination? But just try to suggest this to a man who has been spoiled by praise and who is obsessed by his talent; he'll shrug disdainfully, he'll ignore you, and we'll leave him to himself—he is condemned to love only himself and his works. It's a pity, though.

For when this man had just returned from Italy he painted beautifully, his colors were strong and true, his compositions well thought out and yet full of intensity, his execution was broad and impressive. I know some of his earliest pictures which he now calls daubs and would like to buy back in order to burn them.

He has some old portfolios full of admirable works which he now despises. And he has some new ones, all dolled up with sheep and shepherds in the manner of Fontenelle, over which he gloats.

This man is the ruin of our young painting students. As soon as

[12] Diderot's writings on art are contained in their entirety in J. Assézat (editor), *Oeuvres complètes de Diderot,* Paris, 1876, vols. X–XIII. From this source were derived the translation of the excerpts from the *Essays on Painting* and the *Pensées detachées sur la peinture.* The *Salons* are being separately published in a new edition by J. Seznec and Jean Adhémar (Oxford, 1957–1963). The entries concerning Boucher and Chardin were translated from Vol. I (pp. 202 and 222 respectively) of Seznec and Adhémar's publication which comprises the Salons of 1759, 1761, and 1763, while Vol. II is devoted to the Salon of 1765, and Vol. III to the Salon of 1767. The translation of Diderot's description of Greuze's "Ungrateful Son" was taken from Lester G. Crocker (ed.) and Derek Coltman (trans.), *Diderot's Selected Writings,* New York, © The Macmillan Company, 1966, p. 150. Quoted by permission of the publisher.

they are able to hold brush and palette, they begin to sweat over garlanded putti, to paint rosy and dimpled behinds, and to indulge in all sorts of extravagances which are not saved by the warmth, originality, prettiness or magic of their model, but have all of its faults.

J.-B. Greuze, "The Ungrateful Son (A Father's Curse)," (Salon of 1765)

Imagine a room into which scarcely any light can penetrate except through the door, when it is open, or, when the door is closed, through a square opening above it. Let your eyes wander around this dismal room: they will perceive nothing but poverty. In one corner, however, to the right, there is a bed that does not seem too bad; it has been carefully made. In the foreground, on the same side, is a large, black leather confessional which looks fairly comfortable to sit on: seat the ungrateful son's father upon that. Close to the door, place a low cupboard, and beside the failing old man a small table, on top of which is a bowl of soup that has just been brought to him.

Despite the fact that the eldest son of this family should have been the support of his old father, his mother, and his brothers, he has enlisted. Yet even so, he refuses to leave without having extracted further financial assistance from these wretched and unhappy folk. He has come in with an old soldier; he has made his demands. His father is outraged; he does not mince words with this unnatural child who has forsaken his father, his mother, and his responsibilities, and who is returning insults for his father's reproaches. We see the son in the center of the picture; he has a violent, insolent, angry air; his right arm is raised against his father, over the head of one of his sisters; he is standing very upright, his raised hand expressing a threat; he has his hat on; his gesture and his expression are equally insolent. The good old man, who has loved his children but never permitted any of them to show him disrespect, is making an effort to rise from his chair; but one of his daughters, kneeling in front of him, is clutching the bottom of his coat in an attempt to restrain him. Surrounding the young rake are his eldest sister, his mother, and one of his little brothers. His mother has her arms around his body; he brutally disengages himself and spurns her with his foot. The mother looks crushed and grief-stricken; the eldest sister has also come between her brother and her father; judging by their attitudes, both mother and sister seem to be trying to conceal the two men from each other. The sister has seized her brother by his coat; they way she is pulling at it speaks for itself: "What are you doing, wretch? You are spurning your mother, you are threatening your father. Get down on your knees and beg forgiveness." Meanwhile, with one hand covering his eyes, the little brother is weeping; with his other hand, he is hanging on to his elder

brother's arm and trying to drag him out of the house. Behind the old man's chair, the youngest brother of all is standing with a frightened, bewildered look. At the opposite end of the room, near the door, the old soldier who enlisted the son and then came back with him to his parents' home is leaving, his back turned to what is happening, his saber under his arm, his head lowered. And I almost forgot to add that in the foreground, in the midst of all this tumult, there is a dog whose barks add to the uproar.

Everything in this sketch is skillful, well ordered, properly characterized, clear: the grief, even the weakness of the mother for a child she has spoiled; the violence of the old man; the various actions of the sisters and young children; the insolence of the ungrateful son; and the tact of the old soldier, who cannot help but be shocked at what is going on. And the barking dog is an example of Greuze's quite special gift for inventing meaningful details.

J.-B.-S. *Chardin* (Salon of 1763)

Here is the real painter; here is the true colorist.

There are several small paintings by Chardin at the Salon. Nearly all represent fruits and the accessories of a meal. They are nature itself; the objects seem to come forward from the canvas and have a look of reality which deceives the eye.

The one you see as you walk up the stairs is particularly worth your attention. On top of a table, the artist has placed an old Chinese porcelain vase, two biscuits, a jar of olives, a basket of fruit, two glasses half-filled with wine, a Seville orange, and a meat pie.

When I look at other artists' paintings, I feel I need to make myself a new pair of eyes; to see Chardin's I only need to keep those which nature gave me and use them well.

If I wanted my child to be a painter, this is the painting I should buy. "Copy this," I should say to him, "copy it again." But perhaps nature itself is not more difficult to copy.

For the porcelain vase is truly of porcelain; those olives are really separated from the eye by the water in which they float; you have only to take those biscuits and eat them, to cut and squeeze that orange, to drink that glass of wine, peel those fruits and put the knife to the pie.

Here is the man who truly understands the harmony of colors and reflections. Oh, Chardin! What you mix on your palette is not white, red, or black pigment, but the very substance of things; it is the air and light itself which you take on the tip of your brush and place on the canvas.

After my child had copied and recopied this work, I should set

him to work on the same master's *The Gutted Skate*. The subject is repellent, but here is the very flesh of the fish, its skin, its blood—the sight of the thing itself would not affect you otherwise. . . .

This magic is beyond comprehension. There are thick layers of paint, laid one on top of the other, which interpenetrate from the bottom to the top layer. In other places, it is as if a vapor had been breathed on the canvas; in others still, as if a light foam had been thrown on it. Rubens, Berghem, Greuze, Loutherbourg could explain this technique better than I, for all of them could make your eyes feel its effect. Come close, and everything becomes confused, flattens out and vanishes; move back, and everything takes shape once again and recomposes itself.

I have been told that Greuze, on entering the Salon and noticing the painting by Chardin which I have just described, looked at it and walked on, heaving a deep sigh: this eulogy is briefer and better than mine.

Who will pay for Chardin's paintings when this rare man will be no more? And I ought to tell you that this artist possesses excellent common sense and discusses his art marvellously well.

To hell with Apelle's famous Curtain and with Zeuxis' Grapes! It is not difficult to fool an impatient artist, and animals make bad critics of painting. We have seen the birds at the Royal gardens butting their heads against the most badly painted perspectives. But Chardin can deceive you and me whenever he wishes.

From *Essays on Painting* (1766)

Following his review of the Salon of 1765, Diderot wrote Essais sur la peinture *as a demonstration of the theoretical bases of his criticism and as proof of his qualifications as a critic. Cast in the form of letters addressed to Grimm, the* Essais *appeared in the manuscript* Correspondance littéraire *during the last months of 1766. When they were at last published in print, in 1796, Goethe, strongly impressed, drew Schiller's attention to them, and was inspired to write a critique of Diderot's notion of "truth of nature," opposing to it his own idea of a particular "truth of art" ("Diderots Versuch über die Malerei,"* Propylaeen, *I, 2, 1799).*

Nature does nothing incorrectly. Every form, whether beautiful or ugly, has its cause; and of all creatures in existence there is not one which is not as it necessarily must be.

Look at that woman who lost her eyes in her youth. The eyelids have not been pressed forward by the growth of the eyeball, they have sunk back into the cavity of the eye and become smaller. The upper

lids have pulled down the eyebrows, the lower lids have slightly raised the cheeks; the upper lip has been affected by this and has risen. Every part of the face has been altered to some degree, depending on its distance from or nearness to the injured part. But do you think that the face only was affected, and that the neck, the shoulders, the breast were spared? It may seem so to your eyes or mine. But call Nature, show her this neck, these shoulders, this breast, and Nature will say: "This is the neck, these are the shoulders, this is the breast of a woman who lost her eyes when she was young."

We say of a man who passes us in the street that he is badly built. Yes, according to our poor rules, but not according to Nature. We say of a statue that it has the most beautiful proportions. Yes, according to our poor rules, but what about Nature's?

Let me . . . put a veil over the Medici Venus, in such a way as to expose only the tip of her foot. If Nature were called upon to complete the figure, starting from this tip of a foot, you might be surprised to find a hideous, misshapen monster come into being under her pencil. I should be surprised if it were otherwise. . . .

If I were initiated into the mysteries of art, I might know to what extent the artist must submit to conventional rules of proportion, and I would tell you. But this I know, that Nature's despotism overrules them, and that the age and circumstance of the subject force us to modify them in a hundred different ways. I have never heard a figure called badly drawn, when it showed clearly by its outward form the subject's age, habits and aptitudes for performing his daily tasks. For it is these functions which determine the figure's size, and the true proportions of its limbs, taken singly or as a whole. Thus I see before me the child, the grown man, the oldster, the savage, the civilized man, the magistrate, the soldier, and the porter. The hardest thing to draw would be the figure of a man of twenty-five who had suddenly sprung from the ground and done nothing as yet; but that man is a figment of the imagination.

Childhood approaches caricature, and the same could be said for old age. The child is a fluid, shapeless mass trying to develop itself. The old man is also shapeless, but dry and tending to reabsorption and annihilation. It is only in the interval between these two ages, after the onset of manhood and before the end of virility, that the artist submits to the purity and rigorous precision of the form before him, and that a little more or a little less in the conduct of the contour produces or destroys beauty.

But you will tell me: however the age or occupation may alter the form, yet the organs remain. To be sure, and that is why one has to know them, I admit. It is the reason for studying anatomy.

The study of anatomy has its advantages, no doubt, but isn't there

a danger that it will stick too much in the artist's mind, that it will make him want to show off his knowledge, that it will lead his eye astray from the outward surface, and that, in spite of skin and flesh, it will make him think only of the muscle, of where it springs from, and how it is fixed and joined. He may dwell on all this too much, become dry and hard, and remind us of his confounded muscle-man even in his female figures. Since I can only show the exterior form, I should prefer to be taught to see it well, and to be spared this vile knowledge which I must forget.

They say that we study anatomy to sharpen our observation of nature; but experience shows that, after studying it, it is hard to see nature as she really is.

. . . Those seven years spent at the Academy, drawing from models, do you think them well spent? Shall I tell you what I think of it? I believe that in these seven cruel, laborious years you learn *mannerisms* in drawing. All those stiff, contrived, academic positions, all those gestures coldly and awkwardly struck by some poor devil, always the same poor devil, paid for coming three times a week to undress and be made to pose by a professor—what does all this have to do with nature, its positions, its gestures? What is there in common between the man who draws water from the well in your yard and the academy model who, without actually pulling the weight, awkwardly simulates this action on a studio platform? What is there in common between the man who pretends to be dying and the one who is really expiring in his bed, or is being knocked down in the street? What likeness is there between the model in a fighting pose and the brawler at the crossroads? These men who seem to plead, pray, sleep, reflect, or faint with care, what have they in common with the peasant struck down by fatigue, the philosopher meditating by the fireplace, or the man fainting in the crush of a mob? Nothing, my friend, nothing.

To cap this absurdity, one might as well send students to study the graces with Marcel or Dupré, or some other dancing master. Meanwhile the truth of nature is forgotten. The artist's imagination is filled with false actions, positions, and figures, contrived, ridiculous and cold. His imagination is stocked with them, and from his imagination they rise to fill his canvases. Every time he takes up his pencil or brush, those wretched phantoms appear before him; he cannot forget them or drive them out of his head. I once knew a young man of excellent taste who, before he would draw a line on canvas, used to kneel and pray: "Lord, deliver me from the model." If nowadays you rarely see a picture containing groups of figures without recognizing those academic figures, actions, or gestures which disgust a man of taste and please only those who are ignorant of truth, you must lay the blame on the constant study of academic models.

You will not learn to understand the general harmony of movements at the Academy, that harmony which can be felt and seen, and which pervades the body from head to foot. If a woman allows her head to droop forward, all the limbs feel the force of its weight; if she lifts it and holds it straight, all the machinery of her body participates in the motion.

Yes, there is a kind of art, a great art, even, in posing the model; you should see how proud the professor is of his work. And never fear that he will ever tell that poor devil of a hireling: "My friend, choose your own position, stand in any posture you like." No, he prefers to put him in some strange attitude, rather than to allow him to take an easy and natural posture, and yet that is exactly what he should let him do.

I have been tempted a hundred times to say to the art students whom I passed on their way to the Louvre, with their portfolios under their arms: "My friends, how many years have you been drawing there? Two years? Well, that is more than enough. Leave that shop of mannerism. Go visit the Carthusian monks; there you will see the real attitudes of devotion and repentance. Today is the eve of a great feast: go to the parish church, walk among the confessionals, and you will see the true attitudes of piety and penitence. Tomorrow, go to the tavern, and you will see the true gesticulations of angry men. Frequent public places, observe what passes in the streets, the gardens, the markets and houses, and you will learn what are the real gestures in the actions of daily life. Just look at those two companions of yours who are quarreling; see how their quarrel prompts them to assume certain attitudes, quite unconsciously. Observe them carefully, and you will pity the teachings you get from your insipid professor and the pantomime of your vapid model. I am sorry for you, my friends, knowing that some day you will have to throw away all these painfully learned falsehoods for the simplicity and truth of Le Sueur. And yet that is what you will have to do if you want to amount to anything.

"Attitudinizing is one thing, action another. Attitudes are petty and false, all actions beautiful and true."

This is how I should want a school of drawing to be conducted: after the student has learned to draw with facility after engravings and casts, I shall make him draw the male and the female model for two years. Then I shall expose him to children and adults, mature men and the aged, models of every age and sex, taken from every layer of society, to all of human nature, in short. If I pay them well, the models will crowd to the door of my academy; in a country which condones slavery, I should make them come. In these various models, the professor will make him observe the irregularities which daily work and the habits of life, of social situation, and of age have produced in the forms of their

bodies. My pupil will not see professional models more frequently than once in two weeks, and the professor will leave the choice of the pose to the models themselves. After the drawing session, a skilled anatomist will explain the anatomical structure to my pupil, and make him apply this lesson to the living, moving nude. The student shall not draw cadavers more than twelve times a year. This will suffice to make him realize that flesh over bone is to be drawn unlike flesh not so supported, and that the line in the one case is rounded, angular in the other, and that if he neglects these refinements, the whole will look like an inflated bladder or a ball of cotton.

Strict imitation of nature would do away with mannerisms of drawing and color. Mannerism comes from the teacher, the academy, the school, and even from the Antique.

* * *

If taste is a matter of caprice, if there is no principle of beauty, then what is the source of those delightful emotions which arise so suddenly, so involuntarily, so tumultuously from the depths of our souls, which expand or constrict them, and bring tears of joy, sorrow, and admiration to our eyes at the sight of some great moral action? Away with you, Sophist! You will never convince my heart that it should not tremble or my viscera that they should not be moved.

The true, the good, and the beautiful are closely linked. Add to one of the first two qualities some rare and striking circumstance, and the true will be beautiful, and the good will be beautiful. . . .

I see a high mountain, covered with a dark, ancient, deep forest. I see and hear the thunderous cascade of a torrent. Its waters dash against the sharp ridges of a rock. The sun is setting, and it transforms into diamonds the drops which hang from the ragged edges of the stone. Further on, the waters, having overcome the obstacles which hindered them, are gathered into a vast, wide channel which leads them at last toward a mill where under the weight of great mill stones the common food of man is ground. I see the mill, I see its wheels whitened by the foam, and between the willows I catch sight of the roof of the miller's cottage: I withdraw into myself and fall into revery.

Yes, the forest which takes me to the beginning of the world is a beautiful thing; yes, that rock, an image of constancy and duration, is a beautiful thing; yes, these drops scattered by the sun's rays and diffracted into sparkling, liquid diamonds are beautiful; and, certainly, the noise, the thunder of a torrent, which breaks the vast silence and solitude of the mountain and brings a shock, a secret terror to my soul, is beautiful.

But those willows, that cottage, those animals grazing nearby, is not my pleasure increased by the sight of these useful things? And what a difference there is, in this respect, between the ordinary spectator and the philosopher! For his reflective insight sees the forest tree transformed into a ship's mast which will some day be proudly reared against the winds and gales; he sees the crude metal in the depths of the mountain fused in the ardent furnace and cast into the machines which fertilize the earth or kill its inhabitants; he sees in the rocks the stones of which will be built the palaces of kings or the temples of gods. . . .

Thus imagination, sensibility, and knowledge increase our pleasure. Neither nature, nor art which copies her, mean anything to a cold or stupid man; and they mean very little to the ignorant. . . .

Experience and study, these are the preliminary requirements, both for the maker and for the judge of art. And I also require that they possess sensibility. . . .

From *Pensées détachées sur la peinture* (1776–1781)

The Pensées détachées *are a gathering of aphoristic fragments, written for the most part about 1776–1777, with later additions, which Diderot may originally have intended to combine into a systematic treatise. They reflect recent impressions, gained during travels in Holland, Germany, and Russia in 1773–1774 when he visited the galleries of Leyden, Düsseldorf, Dresden, and Saint Petersburg. They also reflect the influence, as Paul Vernière has pointed out,[13] of the German historian and critic, Christian Ludwig von Hagedorn, whose* Betrachtungen über die Malerei *(1762) Diderot had read in translation. From Hagedorn, he took not only anecdotes and learned quotations, but also observations concerning effects of color and of light which corresponded to his own increasing interest in the purely visual qualities of painting.*

Every work of sculpture or painting must be the expression of a great principle, a lesson for the spectator—otherwise it remains mute.

* * *

Two qualities essential for the artist: morality and perspective.

* * *

[13] Denis Diderot, *Oeuvres esthétiques* (ed. Paul Vernière), Paris, Garnier Frères, n.d. (1959), pp. 743 ff.

In every imitation of nature, there is a technical and a moral element. The judgment of the moral element belongs to all men of taste, that of the technical to the artists only.

* * *

Whatever the bit of nature you contemplate, be it wild or cultivated, poor or rich, deserted or populous, you will always find in it two enchanting qualities: truth and harmony.

* * *

Transport Salvator Rosa to the icy regions near the pole, and his genius will embellish them.

* * *

Frighten me, if you will, but let the terror which you inspire in me be tempered by some grand moral idea.

* * *

One finds poets among the painters, and painters among the poets. The sight of the paintings of the great masters is as useful to an author as is the reading of great literature to a painter.

* * *

A question which is not as ridiculous as it may seem: is it possible to have pure taste, when one's heart is corrupt?

* * *

Everything common is simple, but everything simple is not common. Simplicity is one of the chief characteristics of beauty; it is essential to the sublime.

* * *

Originality does not exclude simplicity.

* * *

One composition is meager, though it has many figures; another is rich, though it has few.

* * *

Paint as they spoke in Sparta.

* * *

Talent imitates nature, taste guides choice; nevertheless, I like rusticity better than affectation, and would give ten Watteaus for one Teniers. I prefer Virgil to Fontenelle, and like Theocritus better than both; though he may lack the elegance of the first, he is truer, and free from the affectation of the other.

* * *

I am no Capucin, but I confess that I should gladly sacrifice the pleasure of seeing attractive nudities, if I could hasten the moment when painting and sculpture, having become more decent and moral, will compete with the other arts in inspiring virtue and purifying manners. It seems to me that I have seen enough tits and behinds. These seductive things interfere with the soul's emotions by troubling the senses.

* * *

The moment an artist thinks of money, he loses his feeling for beauty.

* * *

All that has been said about elliptical, circular, serpentine and undulating lines is absurd. Everything has its own line of beauty, and that of the eye is not the same as that of the knee.

And supposing that the undulating line were the human body's line of beauty, among a thousand undulating lines, which is the best?

* * *

Begging Aristotle's pardon, I think it is false criticism to deduce exclusive rules from the most perfect works of art, as if the ways of pleasing were not numberless. There is hardly a rule which genius cannot successfully breach. The band of slaves, to be sure, while admiring, will shout sacrilege.

* * *

It is possible that no one has ever told the pupils of any school that the angle of reflection of light, like that of other bodies, is equal to the angle of incidence.

* * *

Given the point of highest light and the general arrangement of the picture, I imagine a multitude of reflected rays which intercross, and cross the direct light. How does the artist manage to straighten out this confusion? And if he does not care, how can his composition please me?

* * *

I arise before the sun. I let my eyes wander over a landscape enlivened by mountains which are clothed in green; great, tufted trees rise from the heights, vast fields spread out below, and these fields are traversed by the windings of a river. Over there stands a castle, here a thatched hut. I see a shepherd approaching from the distance, followed by his flock. He has hardly emerged from the hamlet, and the dust still hides his animals from my sight. All this silent and rather monotonous scene has its peculiar drab and material colors. Meanwhile the sun appears, and everything is suddenly transformed through numberless exchanges of light; it is another picture altogether, in which there remains not a leaf, not a blade of grass, not a dot of the first. Look me in the eye, Vernet, and tell me: are you the sun's rival? can you match this marvel with your brush?

* * *

2

Revolution

INTRODUCTION

The Enlightenment generated the energies which brought about its own dissolution. The momentum of reform which it had started increased to a point at which it could no longer be controlled. The reformers found themselves irresistibly drawn into the vortex of revolution by the current of their own ideas. In the arts, this process can be followed in the progressive radicalization of two main strands of thought, both of which had their roots in the philosophy of the Enlightenment: naturalism and idealism, the scientific and the ethical components of this philosophy, which were represented in the arts by the advocates of realism on the one hand and those of classicism on the other. What caused them to become revolutionary was their gradual dissociation from the rational framework of social function and their elevation to the level of absolutes. The documents gathered in the following pages illustrate the development of revolutionary naturalism and of revolutionary classicism, and describe the impact of this development on individuals and institutions.

NATURE AND GENIUS

The view that art is the product of acquired knowledge and skill came under attack, in the middle of the 18th century, from writers who stressed the importance of unconscious drives, inspiration, and interior vision in the making of art. According to them, the true work of art is not a construction, but an original creation. The artist, driven by inner necessity, creates as the tree bears fruit, ignorant of rules, indifferent to society. The vital power which acts through him does not imitate nature, it belongs to nature itself, it is natural genius, *and its works have the qualities which are found in nature's authentic creation—organic unity and life.*

An early expression of this quasi-biological conception of creative art occurs in Edward Young's Conjectures on Original Composition *(1759):*

An Original may be said to be of *vegetable* nature; it rises spontaneously from the vital root of genius; it *grows,* it is not *made;* Imitations are often a sort of *manufacture,* wrought up by those *mechanics, art* and *labour,* out of pre-existent materials not their own. . . . Modern writers have a *choice* to make

. . . they may soar in the regions of *liberty,* or move in the soft fetters of easy *imitation.*[14]

The living plant came to be a favorite image for the expression of this conception of art, just as the well-functioning machine had been an emblem of the Enlightenment. A special beauty began to be discovered in those forms of nature or of art which, though lacking regularity and smoothness, possessed the vigor and character expressive of organic growth. Shakespeare and Gothic architecture profited from this change in taste. Some writers advanced the view that art was not a product of cultural development, but of human nature itself, and therefore more likely to be found in the naïve, primitive, "natural" man than in the creature of polished society. What had begun as a critique of the excesses of the Enlightenment gradually turned into an attack on culture itself. The widespread recoil from overcivilization had its most influential spokesman in J. J. Rousseau who introduced a treatise on education (Émile, 1762) with the lament:

Everything is good as it comes from the hands of the Author of Nature; everything degenerates in the hands of man. He forces one country to nourish the productions of another; one tree to bear the fruits of another. He mingles and confounds the climates, the elements, the seasons; he mutilates his dog, his horse, his slave; he overturns everything, disfigures everything; he loves deformity and monsters; he will have nothing as Nature made it, not even man; man must be trained for man's service; he must be shaped to suit his fashion, like a tree in his garden.[15]

In Germany, English notions of vegetable creation and Rousseau's idea of primitive virtue became combined in a theory of historical and cultural evolution. J. G. Herder studied the growth of language, literature and art as the characteristic expression of national genius. Other German writers of the decades between 1770 and 1790 carried the new naturalism to its anarchical extreme. The ironic nickname of "Storm and Stress" (from the German Sturm und Drang) *has come to be applied to them in particular, but it fits equally well many of their contemporaries in England and France, young poets and artists who claimed the freedom to express their impulses and intuitions, contemptuous of polite manners and refinements, hostile to rules and even to reason itself. The international movement of radical naturalism which Storm and Stress exemplified was, in fact, romanticism in the earliest of its various shapes.*

Johann Wolfgang Goethe (1749–1832)

As a youth, Goethe had wavered between art and poetry. In his student years in Leipzig, he took lessons from the painter Oeser who,

[14] M. W. Steinke, *Edward Young's "Conjectures on Original Composition" in England and Germany,* New York, 1917, pp. 45–47.
[15] J. J. Rousseau, *Émile, ou de l'éducation,* Paris, Firmin-Didot, 1851, p. 1.

fifteen years before, had been Winckelmann's artistic mentor. He continued throughout his later life to think and to express himself in terms of visual experience, and to consider aesthetic questions from the point of view of the artist, rather than that of the poet.

Goethe arrived in Strassburg in 1770, in his twenty-first year. The immense cathedral rising from among narrow lanes made on him "a most peculiar impression, which stayed with me, obscurely, since I was for the time being unable to account for it." This first shock of surprise and the subsequent falling away of his prejudices against the "barbarian" Gothic were the personal experiences which eventually led him to write the essay On German Architecture—D. M. Ervini a Steinbach, *1773. It is noteworthy that Goethe received the stimulus for this tribute to German tradition, to native genius, and to national art on the soil of France, then the mainstay of cosmopolitan culture and center of the Enlightenment. The dominant intellectual influence on him during his sojourn in Strassburg was Johann Gottfried Herder (1744–1803), one of the leaders of the Storm and Stress. Herder directed Goethe's interest to national poetry, to folk song and myth, and to transcendent genius, as personified by Shakespeare. Herder's* On the Origins of Language *(1772) was probably in Goethe's mind when he wrote the essay on German architecture, but his ostensible aim was to take issue with a much older book, the Abbé Laugier's* Observations sur l'architecture *(1753). His choice of this antagonist seems odd: the Abbé's cautious appreciation of the Gothic may actually have helped Goethe to crystallize his own thoughts; Laugier's comparison of Gothic forms with the forms of plant life, at any rate, anticipated Goethe's rather similar interpretation. But these affinities remained unacknowledged in the essay. Goethe, needing the Frenchman as an adversary, sharply debated his theory of the origin of architecture and his insistence on the importance of the column as an original and essential architectural element. The middle section of the essay, which contains Goethe's attack on Laugier's neoclassical notions, has been largely omitted from the translation which follows, because it does not actually bear on the real theme. Goethe's deeper intention in writing his tribute to Erwin von Steinbach was not, after all, to offer an historical or technical appraisal of the Gothic, but to issue a manifesto about creative genius, and about the organic unity and national character of art. His main assertions concerned the parallel between artistic creation and organic growth, one of the guiding ideas of Storm and Stress. The cathedral tower seemed to him a tree, a work of genius, and hence of nature, rather than an artificial composition. And the genius through whom nature had worked in creating the Gothic tower was German: the characteristic Gothic form, Goethe erroneously thought, derived from a national, German source, and was therefore beyond the comprehension of the French critic.*

Goethe later omitted this youthful article from the body of his collected works, and revised or repudiated most of the ideas which it expressed; but these ideas were to be taken up again by later generations and to exert a shaping influence on the beginnings of romantic art theory and art history. The passionate tone of the essay, and its rough, abrupt, untrammeled style—a torment to the translator—are themselves manifestations of turbulent genius and a document of the emotional climate of Storm and Stress.[16]

From *On German Architecture—D. M. Ervini a Steinbach,* 1773

When, dear Erwin, I walked on your grave, looking for the stone which would tell me ANNO DOMINI 1318, XVI. KAL. FEBR. OBIIT MAGISTER ERVINIUS, GUBERNATOR FABRICIAE ECCLESIAE ARGENTINENSIS, so that I might pour out my veneration for you at this holy place, I could not find it, and none of your compatriots could show it to me. My soul was deeply saddened, and my heart—younger, warmer, more foolish, and better than now—promised you a monument in marble or sandstone, whatever I might be able to afford, when I should come into the quiet enjoyment of my possessions.

But what use monuments! you have built the most magnificent of all to yourself, and if the ants which crawl around it do not care for your name, this is a fate which you share with the Architect who raised mountains into the clouds.

Few men have conceived a Babel-thought in their soul, whole, grand, and compellingly beautiful down to its smallest parts, like God's trees. Fewer still have met with a thousand willing hands to excavate the rock and conjure up steep heights, and have been able at their death to tell their sons: "I shall stay with you in the works of my spirit; carry this beginning on into the clouds."

What need do you have of a monument! and from me! When the mob uses holy names, it is superstition or blasphemy. At the sight of your colossus, sickly dilettantes will suffer fits of vertigo, but strong souls will understand you without an interpreter.

Therefore, excellent man! before I launch my little patched-up boat onto the Ocean once again, more likely to meet with death than fortune, I shall carve your name into a beech as slender as your tower, here in this grove verdant with the names of my loves. And I shall suspend by its four corners this handkerchief full of gifts, not unlike that cloth filled with clean and unclean beasts which was lowered from the clouds to the Apostle. These flowers, blossoms, leaves, dry grass and moss,

[16] Translated, with minor omissions, from *Goethes Werke* (Sophien Ausgabe), Weimar, 1896, I. Abtheilung, XXXVII, 137 ff.

and mushrooms sprung up overnight, gathered for my botanical diversion on a walk through plain country, I shall now let rot in your honor.

"It is in petty taste," says the Italian, passing by. "Childishness," drawls the Frenchman and triumphantly drums on his snuffbox in the Greek style. But what gives you the right to scorn?

Didn't the genius of Antiquity, rising from its grave, enslave your spirit, Dago? Crawling through mighty ruins to beg their proportions, you patched together villas from sacred fragments, and now consider yourself the guardian of art's secrets, because you can explain gigantic buildings inch by inch. Had you given way to feeling, rather than measurements, you would have been touched by the spirit of the mighty piles at which you gaped. Then you would not merely have imitated what the Ancients did, and did beautifully, your own designs would have become compelling and true, and living beauty would have sprung from them.

Instead, you gave to your want a coating of seeming truth and beauty. You were impressed by the magnificent effect of columns, you wanted to use columns, too, and you walled them in. You also wanted columns standing in rows, and you encircled the forecourt of St. Peter's with marble porticos which lead nowhere. And Mother Nature, who hates and despises everything inappropriate and unnecessary, made your rabble prostitute this magnificence by using it as a public sewer, so that you must avert your eyes and hold your nose when passing this marvel.

The world goes on: the artist's whim serves the egoism of the rich; travel writers gape, and our wits or so-called philosophers spin principles and histories of art from flimsy fairy tales, while real men are murdered by the demon in the forecourt of art's sanctuary.

Principles hurt genius more than examples. Individual men before him may have worked out the particular details, but from his soul these parts first spring, grown into one eternal whole. Schools and principles, by contrast, paralyze our powers of insight and action. . . .

Our houses . . . are formed by four walls on four sides . . . they are made up of surfaces which, the wider they spread and the more boldly they rise, depress our spirit with their unbearable monotony. But fortunately the genius who inspired Erwin von Steinbach comes to our rescue: "Enrich and animate the immense wall which you shall raise to the sky, let it rise like a lofty, wide-spreading tree of God, declaring with a thousand branches, a million twigs, and with leaves numerous as the sands of the sea, the glory of the Lord, its Master."

When I first went to the cathedral, my head was filled with general notions of taste. I honored by hearsay the principles of the harmony of masses and purity of forms, and was the declared enemy of the confused capriciousness of Gothic ornament. Under the heading of Gothic, as in a dictionary article, I had compiled all the synonymous misunderstand-

ings concerning the ill-defined, the disordered, unnatural, pieced-to-
gether, patched-up, and overladen which had ever passed through my
mind. No wiser than a people which calls "barbaric" all the world it
does not know, I called *gothic* whatever did not fit my system. I made no
distinction between the contorted, painted puppets and decorations with
which our noble bourgeois fancify their houses and the awesome relics
of our older German architecture. Certain bizarre curlicues in them
made me join the common cry of "Smothered in ornament!" and I
shuddered as I went to look at the misshapen, bristling monster.

What unexpected emotions overcame me at the sight of the cathe-
dral, when finally I stood before it! One impression, whole and grand,
filled my soul, an impression which, resulting from the harmony of a
thousand separate parts, I could savor and enjoy, but neither explain
nor understand. They say that such are the joys of heaven. And I re-
turned often, to taste these heavenly-earthly pleasures, and to embrace
the gigantic spirit of our elder brothers in their works. How often have
I gone back to contemplate this dignity and magnificence from every
side, at every distance, and in every kind of light. It is burdensome to
a man's mind to find the work of his brother so exalted that he must
bow and worship before it. How often has the friendly, calming twilight
soothed my eyes, worn out from too much looking; for in the twilight the
countless parts melted into one great mass which confronted my soul
in grandiose simplicity and gloriously set free my powers of enjoyment
and comprehension. It was then that the genius of the great builder
became revealed to me in subtle intuitions. "Why are you surprised," he
whispered to me, "all these masses were necessary. Don't you also find
them in all the earlier churches of my town? I have merely brought their
arbitrary dimensions into harmonious proportions. See how, above the
main portal which dominates the two lesser ones, the wide circle of the
window opens, corresponding to the nave of the church, when it might
have been merely an opening to let in the daylight. See how, high above,
the belfry demands smaller windows! All this was necessary, and I gave
it beautiful form. But oh! when I float through the dark, steep openings
at this side which seem vacant and useless—into their soaring forms I
put the secret power which was to have lifted into the sky the two towers
of which only one, alas, now stands, sadly, without the five-peaked
crown which I meant to give it, so that the surrounding provinces might
pay homage to it and to its royal brother!" And so he left me, and I
sank into sympathetic sadness, until the birds of morning which nest
in the tower's thousand openings joyfully greeted the sun and roused me
from my sleep. How fresh the tower shone in the light of the fragment
morning! How joyfully I reached out toward it, seeing its grand harmo-
nious mass alive in its countless parts: everything formed, down to the

smallest fiber, everything serving the whole, as in works of eternal nature, the massive, immense structure rising lightly skyward; everything about it diaphanous, yet built for eternity. I owe it to your teaching, genius! that I no longer feel dizzy at your depth, and that into my soul has fallen a drop of the joyful quiet of the spirit who can contemplate a creation such as this and say, God-like: "It is good."

No wonder it makes me angry, divine Erwin, when a German art scholar, misled by envious neighbors, ignores his own advantage and belittles your work with the misunderstood term "Gothic." He should rather thank God that he can declare: this is German architecture, seeing that the Italian cannot boast of an architecture of his own, and the Frenchman even less. And if you will not grant our nation its priority, try to prove that the Goths really did build like this—you won't find it easy. In the end, if you cannot show that there was a Homer before Homer, we shall gladly let you tell the story of petty successes and failures, and go on worshipping before the work of the master in whose creation the scattered elements were first joined into one living whole. And you, our dear brother in the search after truth and beauty, close your ears to all the verbiage about art: come, enjoy and look. Take care not to desecrate the name of your noblest artist, and hurry to behold his excellent work. If it gives you a disagreeable impression, or none at all, then good-bye to you, let the horses be hitched, and off to Paris!

But let me join with you, dear fellow, standing there deeply moved, trying to resolve a conflict in your soul, feeling at one moment the irresistible power of this great whole, and calling me a dreamer the next for seeing beauty where you only see power and rough vigor. Don't let a misunderstanding separate us, don't let the effeminate doctrine of modern aesthetics spoil you for the meaningful and rugged, lest you acquire a sickly taste for the insignificant and smooth. They want you to believe that the arts owe their beginning to our supposed urge to beautify our surroundings. That is not true! or strictly holds true only for burghers and artisans, not for philosophers.

Art is creative long before it becomes beautiful, and yet is truly great art, truer and greater, in fact, than the beautiful. For there is a creative nature in man which becomes active as soon as his existence is assured. When he has no cares or fears, the Demigod, productive in his repose, reaches out for matter into which to breathe his spirit. The savage transforms coconuts, feathers, and even his own body into weird images, strange-featured and high-colored. And though his work will consist of the most arbitrary forms, it will be coherent, despite its lack of proportion, because one sensibility shaped it into a characteristic whole.

This art of the characteristic is the only true art. Whatever it

produces, prompted by intense, individual, and original feeling, careless or oblivious of everything foreign to it, has wholeness and vitality. It does not matter whether it was begot by rude savagery or civilized sensibility. You will find it in innumerable gradations among nations and individuals. The higher the soul rises toward an awareness of the proportions which alone are beautiful and eternal, whose main accords can be demonstrated but whose secrets can only be felt and in which the God-like, vital genius bathes in blissful harmony, the more these beauties enter into the spirit and seem to become one with it, so that it will not be satisfied by anything else nor create anything else, the more happy and magnificent is the artist, and the more deeply we bow before him, worshipping him as the anointed of God.

No one can topple Erwin from his eminence. Here is his work: approach it and discover the deepest feelings of truth and beauty of proportions, sprung from a plain and vigorous German soul, alive in the confinement of the dark, priest-ridden Middle Ages.

But what about our own age? It has renounced its genius and sent out its sons to gather foreign plants which will be their ruin. The frivolous Frenchman, an even worse pilferer, at least has the wit of giving his loot some appearance of unity. He is currently busy building a marvellous temple for his St. Magdalen with Greek columns and German vaults. And I have seen one of our artists who had been commissioned to design a portal for an old German church produce the model of a stately antique colonnade.

I don't want to harp on my hatred for our painters of cosmetic dolls. They have caught the eye of our women with their theatrical poses, lying complexions, and garish clothes. Upright Albrecht Dürer, mocked by the novices, I much prefer your most wood-cut figure.

But even you, men of high excellence, who have received the gift of enjoying the highest beauty and who now descend to proclaim your blessedness, even you are harmful to genius. For genius does not want to be uplifted and carried away on the wings of any other, not even on those of Dawn itself. His own powers which first unfolded in the child's dream and were exercised in adolescence send him forth, strong and agile like a mountain lion on the prowl. That is why he is usually trained by Nature: the pedagogues cannot give him the scope which he needs, to act and to enjoy in accordance with his present strength.

Hail to you, Youth, born with a keen eye for proportion, adept at seizing every shape. When one by one the joys of life awaken round you and you feel the ecstatic delight which comes after labor, fear, and hope, like the vintner's lusty shout when the autumn's abundance fills his vessels, like the lively dance of the mower after he has stuck the idle sickle into the roofbeam; when the powerful impulse of desire and suf-

fering animates your brush with greater vigor; when you have striven, suffered, and enjoyed enough, and had your fill of earthly beauty, and have earned your rest in the arms of the goddess, and are worthy to experience in her bosom what gave a new birth to the divine Hercules— then receive him, Heavenly Beauty, mediator between gods and men, so that, greater than Prometheus, he may bring the bliss of the gods down to earth.

Wilhelm Heinse (1746–1803)

A representative of the generation of Storm and Stress, like the young Goethe, his contemporary and friend, Heinse embodied the survival of Baroque attitudes into the period of Neoclassicism. His Letters *from the Düsseldorf Gallery (1776–77) recall in feeling and language Goethe's slightly earlier praise of the Cathedral of Strassburg (see page 72). Both Heinse and Goethe celebrated the creative power of genius, both responded to the energetic and vital in art, both saw in art the manifestation of a life-force comparable to that which acts in nature. But while Goethe found the prototype of creative genius in the shadowy figure of the medieval builder, Erwin von Steinbach, Heinse found it in the much more concrete, historical personality of Rubens, of whose paintings his* Letters *give splendidly colored and animated descriptions. His strong sensuality responded most keenly to the sight of the naked body. In this he recalls Winckelmann, but, unlike Winckelmann, he did not think it necessary to idealize physical beauty; actual sight, touch, and taste were enough for him. His bent was wholly antiphilosophical and untheoretical. Beauty to him was no remote perfection, but a direct sensation deeply relished: "on the tongue clear Hochheimer of '66 vintage, and for the love-warmed fingertips the breast of a young Circassian girl."* [17]

Excerpts from the *Diaries*

Winckelmann and that sterile crowd speak like men possessed, like madmen, when they say that one ought to study and imitate only the Ancients. Actually, what they believe to be their chief goal is merely an easy trick for finding a few natural beauties. They paint and draw only in the midst of plaster phantoms—what nonsense! As if the beauties

[17] The translations from the diaries and letters of Heinse are based on J. J. W. Heinse, *Sämmtliche Werke,* Leipzig, Insel, 1903–1925. The diary excerpts are taken from VIII, Part I, 386, 493, 536, and 555 of this publication; the excerpts from the letters from IX, 338 and 345. For the translations from *Ardinghello,* I have used the edition by Heinrich Laube, published in Leipzig in 1839. The translated passages will be found on pp. 14, 36, 254, 259, 262, and 274 of that edition.

which are in the Apollo, the Laocoon, and the Medici Venus were not around us all the time. Simpletons! Nature is rich and inexhaustible. We are surfeited with the things which the Greek masters saw and recorded in their art, we want something different. Bury yourselves in your hellish emptiness, gnaw and nibble enviously on your Greek models until you die; let's be rid of you, nasty vermin!

The joys and pleasures of superior men decide questions of art, not the pedantry of school masters. Where is the proof that this statue or that sets the rule of art? Nature is the norm which governs this or that statue, and nature is manifold and has many kinds of perfection, you dreary monomaniacs! And yet arms and legs won't become monstrous, and everything in nature will retain its proper proportions.

This is the reason why men of profound mind, when looking at pictures, often have thoughts which never crossed the mind of the poor, drudging painter.

* * *

Every form is individual, there exists none which is abstract. It is impossible to imagine the purely ideal figure of a man or woman, infant or old man. A young Aspasia, Phryne or Lais can be raised to a Venus, Diana or Athena . . . but an abstract, merely perfect woman, un-affected by climate or culture, is no more than a phantom, worse even than the fictitious heroine of a novel who at least must speak some particular language and use words which can be understood. And those unbearably empty faces and figures are called high and true art by wretches who have learned their trade with the aid of plaster casts and now look down with contempt on those more vigorous men who carry their own century's beauty in their living hearts.

* * *

I do not know whether the Laocoon group is really as beautiful as they say. The more I look at it, the more artificial and choreographic it seems to me. The snakes appear to have been trained, one of them to creep down through the arms, the other to crawl up between the legs, weaving the father and his two little sons into a marble fan. And so that this fan might have a handle, Daddy has been propped up on an altar. I can't find all that extravagant sublimity in his face, and in the faces of the two boys I see grimacing, rather than natural expression.

* * *

In the arts, one must early form the habit of seeing no more than what is actually present. This habit is harder to acquire than one might

think, but without it one cannot become a good judge. This is why our phantasists, young and old, read marvels into a vignette, though it usually doesn't contain one bit of its supposed meaning. This, too, is why any mediocre statue of Apollo reminded Winckelmann of everything he had read about the god in Homer, Pindar, and Junius, and made him gush dithyrambic praise so as to give fools the goose-bumps. We should try to treat painting and sculpture as objects, not merely as signs.

Letters from the Düsseldorf Gallery (1776–1777)

There once was a man who, under the most fortunate constellation of sun and moon, wind and weather, made the wonderful and mysterious leap from chaos into being. And when he had arrived, in fresh strength, Mother Night cared for him like a tender woman.

And he was born, and grew.

The light of the rising day gradually illuminated his senses. And he held on to every good thing near him, one after the other, with the love and warmth a groom feels for his bride. Thus he won all who were near him and made them his own. He grew into boyhood and adolescence, and his nature became richer.

He possessed too much to keep all; he had to give away part of his self, to his girls and friends, and to their girls and friends, and to others living in undeserved neglect, having received few of God's gifts.

And how did he do it?

Not through words. For words seemed to him too much taken from the surfaces of things, too much made up for humdrum relationships, too generalized, worn and crippled, and of such old usage that most of us mechanically memorize them and carry them with us as dead capital, not knowing where we got them. He felt that the finest fruits of his mind when mouthed turned into empty husks, into monotony, and he lost all desire to make use of this means. Instead, he chose another, more joyful way of rendering every thing in its full individuality, namely the magic of pictorial illusion, the most natural among the arts and—after sculpture, which is too confining—the first and noblest. He learned the language of day and night, of color, light and shadow; he already knew the line of life. He then tried the distant and ideal, borrowed from school masters who knew their grammar sufficiently well, and tried his hand at doing dogs and cats, girls, boys, birds and trees, keeping busy at all hours.

After he had mastered this, he went to study in the great school of Italy. He read and studied the works of the Greeks of two thousand

years ago which he found in Venice, in Florence, and in Rome, Queen-Mother of the World. He copied the most beautiful of them, and sang Buonarotti's odes and Caravaggio's folk songs; then studied the works of Titian and his predecessors, listened to the excellent comedies and tragedies, the bucolic plays and operas staged by the great Italian masters, and relished their epics.

For seven years, he carried on in this way, making acquaintances and friends among various noblemen, giving lessons, lecturing, and composing a song full of life and strength. Then he went home, with a bag full of money and with many other precious things besides.

Here he made himself comfortable again, rested, slept, and went about among his own dear relatives, their rooms, cloisters, and fields, among the meadows and willows, in the horse stables, among hills, forests and valleys, groves and plains, near brooks and lakes, a man so dear, so good and loyal, and endowed with such gifts of fortune and mind that he could not fail to become the favorite of his people. He spoke only the language of his natural self, using it with the mastery and insight with which Homer and Aristophanes had spoken theirs. His fame spread to all countries.

And the name of this man is *Rubens*. . . .

* * *

The Flight of the Amazons. A terrible battle of the sexes, to be savored fully only by those who have explored nature's remoter aspects.

A picturesque melee; the victory has finally been decided. The luckless heroines must yield to overwhelming force, they are beaten, and the enemy pursue them across the bridge. The rear guard, perhaps the bravest of all, are taken prisoners or are being furiously slaughtered, but some turn back and slaughter their pursuers. It is a scene of war's delight, made to gladden the heart of a hero: lust after sweat and danger, and with girls who dare to attack men with swords, who are wild, cruel, and yet charming rebels against nature's law. A rare and fearfully beautiful spectacle. At the left of the painting, the scene begins with a distant rush of escaping women and horses. Two brown battle chargers follow, leaping riderless from the bridge. The first so shy and wild that, with its mane fluttering in the wind, it grits its teeth and breathes steam from its nostrils; the other bolts, maddened by the battle. Behind them an Amazon who holds in both hands the head of a general whom she has decapitated on the bridge. His rump still lies there, bleeding into the water . . . The picture is a work of heroic power, recalling Theseus' time: nothing in it is overloaded, every illusion is achieved which colors can accomplish. Power in male shoulders, in arms and fists grasping

murderous weapons, in chests and knees, in the rearing, the leap and rush of horses. Looks of fire and heat of pursuit, fury and desperate revenge in flight; highest female courage: hacking, stabbing, tearing down . . . intensest life in the confusion of battle, in the baleful light of a broken morning sky.

The Amazons' flesh is not inert; their bodies are steeled, noble, full of strength and fire. Befitting the Circassian climate and antique usage, they are lightly dressed in an undergarment and a small red mantle draped from the left shoulder which, as they fall into the water, generally drops away, its straps broken or cut, revealing everywhere the motion of beautiful limbs. . . .

From *Ardinghello, or the Happy Isles* (1787)

Heinse's Ardinghello *was one of the first novels to have an artist as its hero and to be centered on questions of art. Its setting is Italy of the late Renaissance and its plot a jumble of swordplay and erotic adventure, interrupted from time to time by passionate discussions of painting or sculpture. The story concludes with the departure of the surviving characters, male and female, for the happy isles of Paros and Naxos, where they will live in beauty, nudity, and sexual freedom.* Ardinghello *is an extraordinary blend of picturesque history and Utopian vision, into which are woven descriptions of Titian's* Venus *of Urbino, of Raphael's frescoes in the Vatican, of the* Laocoon, *the* Medici Venus, *and many other works of classical or Renaissance art which had impressed Heinse during his Italian voyage of 1781–1783. The anarchical, amoral, biased attitudes which the book expresses strike the modern reader as "romantic," compared to the writings of Diderot, for example. But it is also apparent that Heinse's taste in art is much closer to that of Reynolds than that of Blake (see page 150), and that an unfathomable gulf separates him from the piety and sentiment of Wackenroder's* Art-Loving Friar, *that archromantic manifesto, which appeared only ten years after his book (see page 177).*

[Ardinghello speaks:] I am a Florentine painter, and I am staying here [in Venice] to glory in Venetian flesh, having had too much of Tuscan skeletons. Titian commands the essential part of painting without which all the rest is nothing. There are other things in painting, to be sure, but they are unwholesome and sickly—no matter whether you think them heavenly and excellent, or merely deceitful trickery. To be a really great painter, one must work like Titian. Common opinion decides in this matter, not the opinion of artists. Titian sways all who

are not themselves painters, and he even sways the painters when it comes
to the main business of painting—which is truth of color, just as drawing
is the main point of drawing. Painting is painting, drawing is drawing.
Painting cannot exist without truth of color, it could more easily do
without design.

The painter concerns himself with surfaces, and these are revealed
by color. The essential qualities of the object as such mean much less
to him. . . . Drawing is only a necessary evil, proportions are easily
determined: color is the goal, the beginning and end of art. Obviously, I
am only speaking of the material aspects. It would be ridiculous to value
the scaffolding more than the building, or to prefer drawing, an inven-
tion of human frailty, to the substance. The hollow and the round, the
dark and the light, the hard and the soft, the young and the old—how
are they to be expressed if not through color? Form and expression can-
not exist without it. The sharpest, most severe lines of Michelangelo are
mere dream and shadow compared to the noble life in a head by Titian.

* * *

Among the Greeks and Romans, the temple was usually destined
for only one of their many gods. It was a dwelling, made to serve him
when he came down from Olympus to visit the region, like a king
travelling from his residence to some provincial castle. The temple's
dimensions, therefore, were not large, and the columns were propor-
tioned accordingly. Every citizen sacrificed individually, and on feast
days only the priests and priestesses entered, while the people stood out-
side. . . .

Our churches, by contrast, are places of assembly in which all the
inhabitants of a town will often stay for hours on end. A solemn Gothic
cathedral, designed by intelligent barbarians, contains immense open
spaces in which the voice of the priest becomes thunder and the people's
chant a sea-storm, praising the Father of the Universe and shaking the
boldest unbeliever, while the organ, the tyrant of music, roars like a
hurricane plowing deep seas. To a man of sound feeling, such a cathedral
will put the Greek temple, that mere enlargement of a petty dwelling, to
shame—yes, even the loveliest Venus temple by the most tasteful Athenian.

* * *

The best subjects for artists, surely, are animals and plants, grasses
and trees; these they can represent, but human beings they ought to
leave to poets. Landscape will in time replace all other kinds of painting.
And thus it will become possible to surpass the Greeks—by treating sub-
jects which they missed.

Men are never impressed by inert matter; all lack of motion suggests death.

* * *

All art which is merely pictorial sooner or later makes its lover and possessor suffer the torments of Tantalus. The most beautiful image, even a Praxitelean Venus, eventually turns into a lifeless shadow. It does not stir or move, and therefore returns to the dead stone or the oil and pigment from which it was made. Strongly vital human beings are the first to sense this. I believe that, if the golden age of the Greeks had lasted longer, they would have ended up by throwing their statues into the sea, to rid themselves once for all of this deadness and immobility.

* * *

To render life in its full intensity is the most difficult task for all the arts, the pictorial as well as the poetical and musical: storm in nature, murder between man and man, soul-union between man and woman, or the separation and loneliness of loving souls. Mere industry is capable of representing the inanimate; only greatness can render life. Those who were not illuminated by the torch of divinity at the start of their existence will achieve neither a work of high art, nor a sublime action. Beauty is life in form and in movement. Nothing is beautiful which is lifeless or unrelated to life.

Why is the *Torso*, why are the *Horse-Tamers* of Monte Cavallo, why is our *Venus* beautiful? Because they show the highest perfection of human force in the happy enjoyment of its existence. Why *Apollo*, why the *Gladiator?* Because their life is shown effectively at the apex of its power. Why *Laocoon*, why *Niobe?* Because they, too, embody a splendid life, succumbing to stronger power. The poet suggests it with words, the artist gives the very surface of living reality.

* * *

The sun had splendidly set, leaving behind it a most beautiful red sky. "If I were a landscape painter," cried Demetrius, "I should paint nothing but skies for a whole year, especially sunsets. What magic, what infinite melodies of light and dark, of cloud-shapes and serene blue! It is nature's poetry. Mountains, palaces, castles, pleasure groves, constant fireworks of light beams, shapes of giants, war and strife, alternating with ever new delights, as the orb of day sinks amidst blazing fires."

Johann Kaspar Lavater (1741–1801)

The Swiss "physiognomist" Lavater taught that character could be read in the formations of face, body, and handwriting. His science was an attempt to give practical application to the pan-naturalism and vitalism of Storm and Stress. Lavater's Physiognomical Fragments for the Promotion of the Knowledge and Love of Mankind *(1775–1778, 1802), from which the following excerpts are taken, went through numerous editions in the original German, and in French and English translations; it was one of the most influential books of its time. Though not primarily concerned with matters of art, Lavater's essays had a special interest for artists, since they dealt with the interpretation of visual appearance and were based on pictorial evidence. The physical body of man and the work of the artist were, according to Lavater, extensions of the creative personality and derived ultimately from the same vital energies. Thus the shape of a nose, the slant of a line of writing, or the style of a painting possessed individual, expressive character and offered themselves to the same kind of diagnostic interpretation.*[18]

From *Physiognomical Fragments* (1775–1802)

On the Congruity of the Human Form

In organization, nature continually acts from within to without, from the center to the circumference. The same vital power that makes the heart beat gives the finger motion: that which roofs the skull arches the finger nail. Art is at variance with itself; not so nature. Her creation is progressive. From the head to the back, from the shoulder to the arm, from the arm to the hand, from the hand to the finger, from the root to the stem, the stem to the branch, the branch to the twig, the twig to the blossom and fruit, each depends on the other, and all on the root; each is similar in nature and in form. No apple of one branch can, with all its properties, be the apple of another; not to say of another tree. . . . Each part of an organized body is an image of the whole, has the character of the whole. The blood in the extremity of the finger has the character of the blood in the heart. The same congeniality is found

[18] The passage on the "Congruity of the Human Form" is taken from Thomas Holcroft's translation of Johann Kaspar Lavater, *Essays on Physiognomy* (8th edition), London, 1853, p. 179; the passage on "Genius" from the German text as given in *J. C. Lavater's Physiognomik*, new edition, Vienna, 1829, IV, 82 ff.

in the nerves, in the bones. One spirit lives in all. Each member of the body is in proportion to that whole of which it is a part. . . . One form, one mind, one root, appertain to all. Therefore is each organized body so much a whole that, without discord, destruction, or deformity, nothing can be added or diminished. Everything in man is progressive; everything congenial; form, stature, complexion, hair, skin, veins, nerves, bones, voice, walk, manner, style, passion, love, hatred. One and the same spirit is manifest in all. . . .

Nature makes no emendations, she labors from one to all. Hers is not disjointed organization; not mosaic work. The more of the mosaic there is in the works of artists, orators, or poets, the less are they natural; the less do they resemble the copious streams of the fountain; the stem extending itself to the remotest branch. . . .

The human body is a plant; each part has the character of the stem. Suffer me to repeat this continually, since this most evident of all things is continually controverted, among all ranks of men, in words, deeds, books, and works of art.

It is therefore that I find the greatest incongruities in the heads of the greatest masters. I know no painter of whom I can say he has thoroughly studied the harmony of the human outline, not even Poussin; no, not even Raphael himself. Let anyone class the forms of their countenances, and compare them with the forms of nature; let him for instance draw the outlines of their foreheads, and endeavor to find similar outlines in nature, and he will find incongruities which could not have been expected in such great masters.

Genius

What is genius? . . . Where there is effectiveness, power, action, thought and feeling which cannot be learned or taught, there is genius, the most apparent and least describable thing, felt but unspoken, like love!

The characteristic of genius and of all its creations is, in my opinion, *apparition* . . . like the apparition of an angel, it comes not, but is suddenly present, leaves not, but is gone. Like the apparition of an angel, it moves us to the marrow; its immortality rouses the immortality in us; it vanishes, but continues to act after it is gone, leaving us in sweet trembling, in tears of fright, and the pallor of joy. . . . Call it fertility of mind . . . call it elasticity of the soul or senses, and of the nervous system which, alert to all impressions, reacts to them with a rapid charge of vital individuality; call it inherent, natural energy of soul, call it creative power. . . . That which has not been learned or borrowed, which cannot be learned or borrowed, the intimately indi-

vidual, the inimitable, the divine is genius, the inspired is genius, and is called genius by all nations, in all periods, and will be called thus so long as men think, feel, and speak. Genius flashes, genius creates, it does not contrive, it creates! just as it cannot be contrived, but simply *exists*. . . . Inimitability is the characteristic of genius. Instantaneity, revelation, apparition, *being:* a gift not of man, but of God or Satan.

Henry Fuseli (1741–1825)

Fuseli's early years were spent among the leaders of the movement of Storm and Stress; he knew both Lavater and Goethe. In 1764, he went to England, where he lived by his pen and made himself known as the translator of Winckelmann and Lavater (see pages 5, 86). With Sir Joshua Reynolds' encouragement, he resolved to become an artist, entrusting his education to his own genius and to the inspiring example of Michelangelo. During a long stay in Italy, in 1770–1778, he gained a thorough knowledge of the history of art which, added to his vast literary erudition and command of many languages, made him the most learned artist of his time. He returned to London in 1779 where he remained, until the end of his long life, an exotic but respected figure in the world of art, holding the positions of professor and keeper of the Royal Academy. He managed to be on good terms with both the academicians and the Academy's archenemy, William Blake, who wrote of him:

> The only Man that e'er I knew
> Who did not make me almost spew
> Was Fuseli: he was both Turk & Jew—
> And so, dear Christian Friends, how do you do? [19]

Despite his academic domestication, he retained from his days of Storm and Stress the aura of untamed genius and spread mild terror among his students. One of them, the painter Benjamin Robert Haydon (see page 241) has left an account of a visit to Fuseli's studio in 1805:

Prince Hoare told me that he had seen Fuseli, who wished me to call on him with my drawings. Fuseli had a great reputation for the terrible. His sublime conception of Uriel and Satan had impressed me when a boy. I had a mysterious awe of him. Prince Hoare's apprehensions lest he might injure my taste or hurt my morals, excited in my mind a notion that he was a sort of gifted wild beast.

My father had the same feeling, and a letter I received from him

[19] G. Keynes, *Poetry and Prose of William Blake,* London, Nonesuch, 1927, p. 855. The epigram is contained in the Rossetti MS among notes related to the *Descriptive Catalogue* of 1809.

just before my calling concluded with these words: ". . . God speed you with the terrible Fuseli."

This sort of preparation made everything worse, and I was quite nervous when the day arrived. I walked away with my drawings up Wardour Street . . . and blundered on, till without knowing how or remembering why I found myself at Fuseli's door! . . . I jerked up the knocker so nervously that it stuck in the air . . . then drove it down with such a devil of a blow that the door rang again. The maid came rushing in astonishment. I followed her into a gallery or show room, enough to frighten anybody at twilight. Galvanized devils—malicious witches brewing their incantations—Satan bridging chaos, and springing upwards like a pyramid of fire—Lady MacBeth—Paolo and Francesca—Falstaff and Mrs. Quickly—humor, pathos, terror, blood, and murder, met one at every look! I expected the floor to give way—I fancied Fuseli himself to be a giant. I heard his footsteps and saw a little bony hand slide round the edge of the door, followed by a little white-headed lion-faced man in an old flannel dressing gown tied round his waist with a piece of rope and upon his head the bottom of Mrs. Fuseli's work basket.

"Well, well," thought I, "I am a match for you at any rate, if bewitching is tried"; but all apprehension vanished on his saying in the mildest and kindest way, "Well, Mr. Haydon, I have heard a great deal of you from Mr. Hoare. Where are your drawings?" In a fright I gave him . . . a sketch of some men pushing a cask into a grocer's shop—Fuseli smiled and said, "By Gode, de fellow does his business at least with energy." [20]

From *Aphorisms on Art*

Although they were published only in 1831, six years after Fuseli's death, the Aphorisms *go back, in their original conception, to 1788. In that year, Fuseli had made an English translation of Lavater's* Regeln zur Selbst- und Menschenkenntnis, *changing the title to* Aphorisms on Man. *This was to be followed by a companion volume, written by Fuseli himself and containing aphorisms on art. A complete manuscript appears to have existed in 1788, but its publication was prevented by a fire. The second and final version was substantially complete by 1818. It included portions of the first version, augmented by new aphorisms which Fuseli had distilled from his academic lectures. Fuseli considered the* Aphorisms *as his most important literary work.*

To the artists and writers of the Storm and Stress, nature manifested itself in character and expression. These two aspects are not exactly

[20] *Autobiography of Benjamin Robert Haydon* (ed. Edmund Blunden), Oxford, n.d., p. 25.

alike: character is the particular form of an individual thing or creature, the product of a unique process of growth; expression, on the other hand, is the direct manifestation of energy, in other words, of a pervasive force which, if raised to its highest intensity, obliterates individual character. Fuseli acknowledged this distinction in his 89th Aphorism:

The being seized by an enormous passion, be it joy or grief, hope or despair, loses the character of its own individual expression and is absorbed by the power of the feature that attracts it: Niobe and her family are assimilated by extreme anguish; Ugolino is petrified by the fate that sweeps his sons. . . .

Both in his art and in his writings on art, Fuseli dwelt on the elemental forces in nature and in human nature, on conflict, terror, and passion. He eliminated from his work all the traces of the specific and spontaneous which mark individual character, and instead developed a highly stylized language. His literary and his graphic work corresponded closely in this respect. In both, extravagant feeling was expressed in gigantic, "petrified," stereotype forms. This gives to Fuseli's Aphorisms a classicistic flavor which sets them apart from the capricious ramblings of Storm and Stress prose. The Aphorisms are verbal monuments, pyramids and obelisks, raised to startle the reader. They have a stylistic affinity with the overwrought monumentality of the art of the French Revolution (see page 126), a fact which points to the underlying connection between the romantic naturalism and the romantic classicism on the last decades of the 18th century.[21]

3. Art, like love, excludes all competition and absorbs the man.

* * *

8. Arrangement presupposes materials: fruits follow the bud and foliage, and judgment the luxuriance of fancy.

* * *

13. It is the lot of genius to be opposed, and to be invigorated by opposition: all extremes touch each other; frigid praise and censure wait upon attainable or common powers; but the successful adventurer in the realms of discovery leaps on an unknown or long-lost shore, ennobles it with his name, and grasps immortality.

* * *

[21] John Knowles, *The Life and Writings of Henry Fuseli,* London, 1831, III, 63 ff.

14. Genius without bias, is a stream without direction: it inundates all, and ends in stagnation.

* * *

20. Reality teems with disappointments for him whose sources of enjoyment spring in the elysium of fancy.

* * *

22. Determine the principle on which you commence your career of art: some woo the art itself, some its appendages; some confine their view to the present, some extend it to futurity: the butterfly flutters round a meadow; the eagle crosses seas.

* * *

24. Circumstances may assist or retard parts, but cannot make them: they are the winds that now blow out a light, now animate a spark to conflagration.

Coroll.—Augustus and Maecenas are said to have made Virgil: what was it, then, that prevented Nerva, Trajan, Adrian, and the two Antonines, from producing at least a Lucan?

* * *

28. Genius has no imitator. Some can be poets and painters only at second hand: deaf and blind to the tones and motions of Nature herself, they hear or see her only through some reflected medium of art; they are emboldened by prescription.

* * *

30. Mediocrity is formed, and talent submits, to receive prescription; that, the liveried attendant, this, the docile client of a patron's views or whims: but genius, free and unbounded as its *origin,* scorns to receive commands, or in submission, neglects those it received.

Coroll.—The gentle spirit of Raphael embellished the conceits of Bembo and Divizio, to scatter incense round the triple mitre of his prince; and the Vatican became the flattering annals of the court of Julius and Leo: whilst Michael Angelo refused admittance to master and to times, and doomed his purple critic to hell.

* * *

35. Art either imitates or copies, selects or transcribes; consults the class, or follows the individual.

* * *

36. Imitative art, is either epic or sublime, dramatic or impassioned, historic or circumscribed by truth. The first astonishes, the second moves, the third informs.

* * *

42. Beauty alone, fades to insipidity; and like possession cloys.

* * *

47. Creation gives, invention finds existence.

* * *

59. All conceits, not founded upon probable combinations of nature, are absurd. The *caprici* of Salvator Rosa, and of his imitators, are to the fiends of Michael Angelo, what the paroxysms of a fever are to the sallies of vigorous fancy.

* * *

61. Distinguish between boldness and brutality of hand, between the face of beauty and *the bark of a tree.*

* * *

62. All mediocrity pretends.

* * *

66. Ask not, what is the shape of composition? You may in vain climb the pyramid, wind with the stream, or point the flame; for composition, unbounded like Nature, and her subjects, though resident in all, may be in none of these.

* * *

67. The nature of picturesque composition is depth, or to come forward and recede.

Coroll.—Pausias, in painting a sacrifice, foreshortened the victim, and threw its shade on part of the surrounding crowd, to show its height and length.

* * *

71. Second thoughts are admissible in painting and poetry only as dressers of the first conception; no great idea was ever formed in fragments.

* * *

72. He alone can conceive and compose, who sees the whole at once before him.

* * *

103. Fancy not to compose an ideal form by mixing up a mass of promiscuous beauties; for, unless you consulted what was homogeneous and what was possible in Nature, you have hatched only a monster: this, we suppose, was understood by Zeuxis when he collected the beauties of Agrigentum to compose a perfect female.

* * *

105. We are more impressed by Gothic than by Greek mythology, because the bands are not yet rent which tie us to its magic: he has a powerful hold of us, who holds us by our superstition or by a theory of honor.

* * *

114. He who could have the choice, and should prefer to be the first painter of insects, of flowers, or of drapery, to being the second in the ranks of history, though degraded to the last class of art, would undoubtedly be in the first of men by the decision of Caesar.

* * *

118. As far as the medium of an art can be taught, so far is the artist confined to the class of mere mechanics; he only then elevates himself to talent, when he imparts to his method, or to his tool, some unattainable or exclusive excellence of his own.

* * *

120. The ear absorbed in harmonies of its own creation, is deaf to all external ones.

* * *

122. There is not a bauble thrown by the sportive hand of fashion, which may not be caught with advantage by the hand of art.

Coroll.—Shakespeare has been excused for seeking in the Roman senate what he knew all senates could furnish—a buffoon. Paulo of Verona, with equal strength of argument, may be excused for cramming on the foreground of an assembly or a feast, what he knew a feast or assembly could furnish—a dog, an ape, a scullion, a parrot, or a dwarf.

* * *

144. In following too closely a model, there is danger in mistaking the individual for Nature herself; in relying only on the schools, the deviation into manner seems inevitable: what then remains, but to transpose *yourself* into your subject?

* * *

148. The superiority of the Greeks seems not so much the result of climate and society, as of the simplicity of their end and the uniformity of their means. If they had schools, the Ionian, that of Athens and of Sicyon appear to have directed their instruction to one grand principle, proportion: this was the stamen which they drew out into one immense connected web; whilst modern art, with its schools of designers, colourists, machinists, eclectics, is but a tissue of adventitious threads. Apollonius and the sculptor of the small Hesperian Hercules in bronze are distinguished only by the degree of execution; whilst M. Angelo and Bernini had no one principle in common but that of making groups and figures.

* * *

149. Art among a religious race produces reliques; among a military one, trophies; among a commercial one, articles of trade.

* * *

151. The rules of art are either immediately supplied by Nature herself, or selected from the compendiums of her students who are called masters and founders of schools. The imitation of Nature herself leads to style, that of the schools to manner.

Coroll.—The line of Michael Angelo is uniformly grand; character and beauty were admitted only as far as they could be made subservient to grandeur: the child, the female, meanness, deformity were indiscriminately stamped with grandeur; a beggar rose from his hand the patriarch

of poverty; the hump of his dwarf is impressed with dignity; his women are moulds of generation; his infants teem with the man, his men are a race of giants. . . .

* * *

175. Clearness, freshness, force of colour, are produced by simplicity; one pure, is more than a mixture of many.

* * *

176. Colour affects or delights like sound. Scarlet or deep crimson rouses, determines, invigorates the eye, as the war-horn or the trumpet the ear; the flute soothes the ear, as pale celestial blue or rosy red the eye.

* * *

177. The colours of sublimity are negative or generic—such is the colouring of Michael Angelo.

* * *

194. The forms of virtue are erect, the forms of pleasure undulate: Minerva's drapery descends in long uninterrupted lines; a thousand amorous curves embrace the limbs of Flora.

* * *

203. Expect no religion in times when it is easier to meet with a saint than a man; and no art in those that multiply their artists beyond their labourers.

* * *

237. Selection is the invention of the landscape painter.

Immanuel Kant (1724–1804)

Kant's approach to art was theoretical in the extreme. He possessed little feeling for the purely visual pleasures, and had no opportunity to see works of painting or sculpture in Königsberg, East Prussia, where he spent his entire life. This practical inexperience occasionally becomes apparent in his odd categorizations, as when, for example, he divides painting into the following classifications: painting proper, landscape gardening, the decoration of rooms with hangings and furniture, and the "art of tasteful dressing with rings, snuff-boxes, etc." His theory of art,

nevertheless, was not merely an appendage to his philosophical system. It was, on the contrary, the essential link between his theory of knowledge and his theory of morality, for he believed that aesthetic judgment reconciles the necessity of nature and the freedom of the human mind. His ascetic and disciplined intellectuality set him sharply apart from the enthusiasts of Storm and Stress, but he shared with them the rejection of the superficial rationality and empiricism of the Enlightenment, and the search for the original, creative principle underlying reality. Like the men of Storm and Stress, he had been influenced by Rousseau; unlike them, he did not embrace irrationality, but developed a new theory of reason.

In the Critique of Judgment *(1790), the third and last of his Critiques, Kant formulated a system of aesthetics based on strictly logical analysis and remote from any direct experience of art. Yet several of the concepts which he developed, the ideas of the sublime and of creative genius, for example, resembled those which less systematic minds had been propagating for several decades. Abstract reasoning had led him to insights which corresponded to the intuitive experience of artists and to the taste of the time. The main difference between Kant and his contemporaries of the generation of Storm and Stress lay in the fact that what remained unsystematic psychological speculation, sentiment, or enthusiasm in their work was locked, in his philosophy, into the frame of a coherent theory of knowledge. The revolutionary aspect of this theory, which Kant himself likened to the Copernican hypothesis, lay in its radical subjectivism. While the thought of the Enlightenment had been based on the prevailing conviction that knowledge comes from sense perception, Kant maintained that knowledge is internal: truth resides in the immutable idea, it is not carried to the mind in the flow of sense impressions. The grandiose conceptual abstraction of Kant's philosophy possessed an aesthetic appeal to the men who developed the severe, revolutionary classicism of the last decade of the 18th century.*[22]

From *Critique of Judgment* (1790)

Sublimity is in the Mind of the Judging Subject

. . . Where the size of a natural Object is such that the imagination spends its whole faculty of comprehension upon it in vain, it must

[22] From the translation by J. C. Meredith, *Kant's Critique of Aesthetic Judgment*, Oxford, Clarendon Press, 1911, the following passages have been taken: "Sublimity is in the mind . . . ," p. 104; "Sublimity gives pain . . . ," p. 106; "Nature as Might," p. 108; "Fine art is the art of genius," p. 168. The remaining quotation, "Line more important than color," is from the translation by J. H. Bernard, *Kant's Kritik of Judgment*, New York, 1892, p. 75. For a concise paraphrase of Kant's view of the sublime, see Samuel H. Monk, *The Sublime*, Ann Arbor, University of Michigan, 1960, p. 4.

carry our concept of nature to a supersensible substrate (underlying both nature and our faculty of thought) which is great beyond every standard of sense. Thus, instead of the object, it is rather the cast of the mind in appreciating it that we have to estimate as *sublime*.

This makes it evident that true sublimity must be sought only in the mind of the judging Subject, and not in the Object of nature that occasions this attitude by the estimate formed of it. Who would apply the term "sublime" even to shapeless mountain masses towering one above the other in wild disorder, with their pyramids of ice, or to the dark tempestuous ocean, or such like things? But in the contemplation of them, without any regard to their form, the mind abandons itself to the imagination and to a reason placed, though quite apart from any definite end, in conjunction therewith, and merely broadening its view, and it feels itself elevated in its own estimate of itself on finding all the might of imagination still unequal to its ideas.

Sublimity Gives Pain and Pleasure

The feeling of the sublime is, therefore, at once a feeling of displeasure, arising from the inadequacy of imagination in the aesthetic estimation of magnitude to attain to its estimation by reason, and a simultaneously awakened pleasure, arising from this very judgment of the inadequacy of the greatest faculty of sense being in accord with ideas of reason, so far as the effort to attain to these is for us a law.

The mind feels itself *set in motion* in the representation of the sublime in nature; whereas in the aesthetic judgment upon what is beautiful therein it is in *restful* contemplation. This movement, especially in its inception, may be compared with a vibration, i.e., with a rapidly alternating repulsion and attraction produced by one and the same Object.

Nature as Might

Might is a power which is superior to great hindrances. It is termed *dominion* if it is also superior to the resistance of that which itself possesses might. Nature considered in an aesthetic judgment as might that has no dominion over us, is *dynamically sublime*.

If we are to estimate nature as dynamically sublime, it must be represented as a source of fear.

But we may look upon an object as *fearful*, and yet not be afraid *of* it, if, that is, our estimate takes the form of our simply *picturing to ourselves* the case of our wishing to offer some resistance to it, and recognizing that all such resistance would be quite futile.

One who is in a state of fear can no more play the part of a judge of the sublime of nature than one captivated by inclination and appetite can of the beautiful. He flees from the sight of an object filling him with dread; and it is impossible to take delight in terror that is seriously entertained. Hence the agreeableness arising from the cessation of an uneasiness is *a state of joy*. But this, depending upon deliverance from a danger, is a rejoicing accompanied with a resolve never again to put one-self in the way of the danger: in fact we do not like bringing back to mind how we felt on that occasion—not to speak of going in search of an opportunity for experiencing it again.

Bold, overhanging, and, as it were, threatening rocks, thunder-clouds piled up the vault of heaven, borne along with flashes and peals, volcanoes in all their violence of destruction, hurricanes leaving desola-tion in their track, the boundless ocean rising with rebellious force, the high waterfall of some mighty river, and the like, make our power of resistance of trifling moment in comparison with their might. But, provided our own position is secure, their aspect is all the more attrac-tive for its fearfulness; and we readily call these objects sublime, be-cause they raise the forces of the soul above the height of vulgar com-monplace, and discover within us a power of resistance of quite another kind, which gives us courage to be able to measure ourselves against the seeming omnipotence of nature.

Fine Art is the Art of Genius

Genius is the talent . . . which gives the rule to art. Since talent, as an innate productive faculty of the artist, belongs itself to nature, we may put it this way: *Genius* is the innate mental aptitude . . . *through which* nature gives the rule to art.

Every one is agreed on the point of the complete opposition between genius and the *spirit of imitation*. Now since learning is nothing but imitation, the greatest ability, or aptness as a pupil, is still, as such, not equivalent to genius. Even though a man weaves his own thoughts or fancies, instead of merely taking in what others have thought, and even though he go so far as to bring fresh gains to art and science, this does not afford a valid reason for calling such a man of *brains*, and often great brains, a *genius*.

Despite the marked difference that distinguishes mechanical art, as an art merely depending upon industry and learning, from fine art, as that of genius, there is still no fine art in which something mechanical, capable of being at once comprehended and followed in obedience to rules, and consequently something *academic* does not constitute the es-sential condition of the art. For the thought of something as end must

be present, or else its product would not be ascribed to an art at all, but would be a mere product of chance. But the effectuation of an end necessitates determinate rules which we cannot venture to dispense with. Now, seeing that originality of talent is one (though not the sole) essential factor that goes to make up the character of genius, shallow minds fancy that the best evidence they can give of their being full-blown geniuses is by emancipating themselves from all academic constraint of rules, in the belief that one cuts a finer figure on the back of an ill-tempered than of a trained horse. Genius can do no more than furnish rich *material* for products of fine art; its elaboration and its *form* require a talent academically trained, so that it may be employed in such a way as to stand the test of judgment. But, for a person to hold forth and pass sentence like a genius in matters that fall to the province of the most patient rational investigation, is ridiculous in the extreme.

Line is More Important than Color

In painting, sculpture, and in all the formative arts—in architecture, and horticulture, so far as they are beautiful arts—the *delineation* is the essential thing; and here it is not what gratifies in sensation but what pleases by means of its form that is fundamental for taste. The colors which light up the sketch belong to the charm; they may indeed enliven the object for sensation, but they cannot make it worthy of contemplation and beautiful. In most cases they are rather limited by the requirements of the beautiful form; and even where charm is permissible it is ennobled solely by this.

Every form of the objects of sense (both of external sense and also mediately of internal) is either *figure* or *play*. In the latter case it is either play of figures (in space, viz., pantomime and dancing), or the mere play of sensations (in time). The *charm* of colors or of the pleasant tones of an instrument may be added; but the *delineation* in the first case and the composition in the second constitute the proper object of the pure judgment of taste. To say that the purity of colors and of tones, or their variety and contrast, seems to add to beauty, does not mean that they supply a homogeneous addition to our satisfaction in the form because they are pleasant in themselves; but they do so, because they make the form more exactly, definitely, and completely, intuitible, and besides by their charm excite the representation, while they awaken and fix our attention on the object itself.

THE PATHOLOGY OF GENIUS

The generation which came to maturity in the 1770's reacted against the scepticism of the Enlightenment with a fresh curiosity concerning the occult and esoteric. Jakob Boehme's arcane writings and Emanuel Swedenborg's prophecies were widely read; theosophy and mysticism attracted converts; honest men devoted themselves to spiritism and alchemy, while swindlers and miracle-workers went from town to town to exploit the gullible public. Lavater (see page 86), Mesmer, and Cagliostro held the stage in turn. Rosicrucians, illuminati, and Free Masons competed with one another. Experimental science and crass charlatanry flourished side by side. The current of counter-Enlightenment amounted to a revulsion from the more banal forms of rationalism. It also expressed a desire to penetrate beneath the surface of common matter and common sense to the sources of reality. In the arts, the new attitude manifested itself in a growing impatience with academic routine and in the cult of creative genius. Some considered genius as a natural force working through the artist, others thought it to be of supernatural origin, a demonic or divine possession, a form of madness. In some exceptional artists, the visionary powers of genius were observed to assume the involuntary, quasi-objective character of hallucination or ghostly visitation. Such artists saw spirits, and it is difficult to decide today whether these visions resulted from a predisposition not uncommon at the time, and hence to be considered as "normal," or whether they were symptoms of individual derangement.

Franz Xaver Messerschmidt's (1736–1783) "Egyptian Heads"

Messerschmidt began his career brilliantly, as a sculptor serving the Imperial court and the high nobility of Vienna, and as a teacher at the Academy. He had a particular gift for portraiture and was a consummate technician. About 1770, he appears to have suffered an illness which, in the opinion of his colleagues and superiors, unfitted him for teaching, though it did not interfere with his art. He felt persecuted and mistreated, resigned his appointments, left Vienna, and settled in Pressburg. Here, living the life of a hermit, he devoted himself obsessively to the sculpting of a series of sixty-four heads representing his own features contorted into strange grimaces. The extreme eccentricity of these works, and the rumor that Messerschmidt communicated with ghosts, attracted visitors

to his lonely studio. One of these, the publicist C. F. Nicolai, left an account of such a visit, in 1781, which is all the more curious in that it presents "mad" genius as seen through the eyes of an especially prosaic exponent of the Enlightenment.[23]

Messerschmidt was a man of fiery imagination and powerful, sanguine constitution, who, since early youth, had nearly always lived in solitude and perfect chastity. He told me this himself, to prove that he really did see spirits . . . rather than merely imagined them. To me, it seemed to prove just the contrary. . . . I tried to sound out Messerschmidt, to discover how these notions were related in his mind. He spoke reticently, and not very clearly, and it appeared that he had a rather confused notion of his own thoughts. But I managed to get out of him that he was absolutely convinced that spirits did in fact frighten and molest him, especially at night. . . . And he added that he had long been unable to understand why he, who had always lived a chaste life, should have to endure so much torment. . . . But, after much thought on the subject, he had finally perfected a system by means of which anyone could gain control over the spirits. The good man started from the perfectly sound premise that all things in this world stand in a particular relationship to one another and that all effects result from sufficient causes. He expressed this, somewhat vaguely and ambiguously, as follows: all the world is ruled by proportion; if one were able to produce in oneself proportions equivalent or superior to those of another being, then he ought to be able to produce effects equivalent or superior to the effects of the other. From this half-understood principle, compounded with his foolish notion about spirits and his knowledge of art, he made up a seemingly profound system, part nonsense, part method, which, in the manner of people whose reason has been overwhelmed by their imagination, he considered infallible. . . . He believed, furthermore, that the proportions of the head correspond in every detail to the proportions of the various parts of the body. . . . When he felt pains in his abdomen or thigh, he imagined that this resulted from the fact that he was at that moment working on some particular part of the face of a marble or lead bust which corresponded to these particular portions of the lower part of the body. . . . Since his fantasy was filled with spirits, he conceived the idea of a special Spirit of Proportion. Believing, in his vanity, that he had made unheard-of discoveries concerning proportions and their effects, and feeling abdominal pains . . . while on the point of making his

[23] C. Friedrich Nicolai, *Reisebeschreibung durch Deutschland und die Schweiz im Jahre 1781*, VI, 401, quoted by Ernst Kris, "Die Charakterköpfe des Franz Xaver Messerschmidt," *Jahrbuch der kunsthistorischen Sammlungen*, Vienna, NF VI, 1932, 224 ff.

discoveries, he fancied that it was the Spirit of Proportion who, envious of his perfect knowledge, was causing him this pain. Being a determined person, he gathered up his courage to overcome the imaginary evil spirit. He made every effort to penetrate more deeply into the mystery of relationships, in order that he might defeat the spirit, rather than be defeated by him. He went so far with his absurd theory as to imagine that he would attain perfection in this matter if he pinched himself in various parts of the body, particularly under his lower right rib, accompanying this with a grimace correctly proportioned to the pinch. He was confirmed in this madness by an English visitor whom he regarded as the only other person to have understood the system. He told me that this Englishman, unable to express himself in German, had indicated the precise spot on his exposed thigh which corresponded to the part of a head which Messerschmidt was about to execute. This, he said, had given him absolute certainty that his system was unquestionably correct.

He thereupon set to work, pinched himself and grimaced in front of the mirror, and thought that he experienced the marvellous effects of his control over the spirits. Delighted with his system, he resolved to pass it on to posterity by means of portraits of the grimacing proportions. It was his opinion that there were sixty-four basic varieties of grimaces. When I visited him, he had completed sixty different heads, some in marble, others in a mixture of lead and pewter, most of them the size of life. He had spent no fewer than eleven years in this unfortunate labor, working with astonishing patience. All the heads were self-portraits. I saw him at work on the sixty-first head. He would look into the mirror every half minute and assume precisely the grimace he wanted. Considered as works of art, the heads are admirable masterpieces, especially the more natural ones. But the majority represent strangely contorted faces, with lips tightly compressed. I should have been at a loss to explain the reason for these odd distortions, if Messerschmidt had not initiated me into the rules underlying his crazy method. He told me that human beings ought to conceal the red of their lips entirely, because animals never show theirs. A curious reason! I countered by saying that men are not animals. But he had a ready answer: animals, he said, are superior to men in that they see and recognize many aspects of nature which remain hidden to men. . . .

William Blake's (1757–1827) Visionary Portraits

William Blake, from earliest childhood, possessed the gift of spiritual vision. At the age of four, he saw the face of God pressed against the pane of his window, and after the death of his brother, Robert, he often conversed with his spirit and was instructed by him in a new method

of relief etching. Blake's visions, like those of Messerschmidt, were directly relevant to his art. His imagination presented to him the faces and figures of his ghostly visitors in the sharply contoured, strangely stylized forms in which he drew them. What other artists achieved through a conscious effort of arrangement and design, Blake received ready-made. The clarity of his visions confirmed him in his dislike of the "blotting and blurring" Venetians, of Rembrandt and Reynolds.

Blake generally drew his visionary heads at night, often in the company of his friends, John Linnell and John Varley, the astrologer. It was they who supplied Blake's biographer, Allan Cunningham, with the information on which the following account is based.[24]

To describe the conversations which Blake held in prose with demons and in verse with angels, would fill volumes, and an ordinary gallery could not contain all the heads which he drew of his visionary visitants. That all this was real, he himself most sincerely believed; nay, so infectious was his enthusiasm, that some acute and sensible persons who heard him expatiate, shook their heads, and hinted that he was an extraordinary man, and that there might be something in the matter. One of his brethren, an artist of some note, employed him frequently in drawing the portraits of those who appeared to him in visions. The most propitious time for those "angel-visits" was from nine at night till five in the morning; and so docile were his spiritual sitters, that they appeared at the wish of his friends. Sometimes, however, the shape which he desired to draw was long in appearing, and he sat with his pencil and paper ready and his eyes idly roaming in vacancy; all at once the vision came upon him, and he began to work like one possessed.

He was requested to draw the likeness of William Wallace—the eye of Blake sparkled, for he admired heroes. "William Wallace!" he exclaimed, "I see him now, there, there, how noble he looks—reach me my things!" Having drawn for some time, with the same care of hand and steadiness of eye, as if a living sitter had been before him, Blake stopped suddenly and said, "I cannot finish him—Edward the First has stept in between him and me." "That's lucky," said his friend, "for I want the portrait of Edward too." Blake took another sheet of paper, and sketched the features of Plantagenet; upon which his Majesty politely vanished, and the artist finished the head of Wallace.

The friend who obliged me with these anecdotes, on observing the interest which I took in the subject, said, "I know much about Blake—I was his companion for nine years. I have sat beside him from ten at night till three in the morning, sometimes slumbering and sometimes waking,

[24] Cf. Mona Wilson, *The Life of William Blake*, London, Nonesuch, 1927, pp. 256 ff.

but Blake never slept; he sat with a pencil and paper drawing portraits of those whom I most desired to see. I will show you, sir, some of these works." He took out a large book filled with drawings, opened it, and continued, "Observe the poetic fervour of that face—it is Pindar as he stood a conqueror in the Olympic games. And this lovely creature is Corinna, who conquered in poetry in the same place. That Lady is Lais, the courtesan—with the impudence which is part of her profession, she stept in between Blake and Corinna, and he was obliged to paint her to get her away." . . .

He closed the book, and taking out a small panel from a private drawer, said, "This is the last which I shall show you; but it is the greatest curiosity of all. Only look at the splendour of the colouring and the original character of the thing!" "I see," said I, "a naked figure with a strong body and a short neck—with burning eyes which long for moisture, and a face worthy of a murderer, holding a bloody cup in its clawed hands, out of which it seems eager to drink. I never saw any shape so strange, nor did I ever see any colouring so curiously splendid—a kind of glistening green and dusky gold, beautifully varnished. But what in the world is it?" "It is a ghost, sir—the ghost of a flea—a spiritualization of the thing!" "He saw this in a vision then," I said. "I'll tell you all about it, sir. I called on him one evening, and found Blake more than usually excited. He told me he had seen a wonderful thing—the ghost of a flea! 'And did you make a drawing of him?' I inquired. 'No, indeed,' said he, 'I wish I had, but I shall, if he appears again!' He looked earnestly into a corner of the room, and then said, 'Here he is—reach me my things—I shall keep my eye on him. There he comes! his eager tongue whisking out of his mouth, a cup in his hand to hold blood and covered with a scaly skin of gold and green';—as he described him so he drew him.'"

FREEDOM FROM PATRONAGE

Genius does not tolerate patronage. Until the middle of the 18th century, artists had generally courted the wealthy and powerful, and accepted with resignation the occasional humiliations which attended their servile role. But as the century wore on, they showed themselves less willing to sacrifice dignity and independence for material rewards. Instead of appealing to individual benefactors, they now preferred to address themselves to the general public.

William Hogarth's (1697–1764) "The No Dedication," which parodies the language and lists the objects of conventional dedicatory flattery,

gives expression to the new attitude. It was found among his papers after his death, and is supposed to have been written by way of preface for his autobiography or for some projected treatise on art.[25]

The No Dedication

Not dedicated to any Prince in Christendom for fear it might be thought a
> Bold piece of arrogance.
Not dedicated to any man of quality for fear it might be thought too
> affecting.
Not dedicated to any learned body
of men of either of the universities, or the
Royal Society, for fear it might be thought
An uncommon piece of vanity.
Nor dedicated to any particular friend
for fear of offending another.
Therefore dedicated to nobody
But if for once we may suppose
Nobody to be everybody as everybody
Is often found to be nobody, then is this work
Dedicated to anybody
> > By their most humble
> > and devoted, W. Hogarth.

Giovanni Battista Piranesi (1720–1778)

While in Rome, in 1751, James Caulfield, 1st Earl of Charlemont, an ambitious politician, traveller, and patron of the arts, was invited by the great draftsman and antiquarian Piranesi (see page 26) to support the publication of a volume of plates illustrating Roman monuments. Lord Charlemont agreed to accept, and pay for, a dedicatory frontispiece, a common form of sponsorship. In the course of executing the work, Piranesi expanded its size to four volumes. Lord Charlemont, who was consulted, appeared to agree to receive four dedications, instead of one, and to increase his stipend proportionately. But when the work was published, in 1756, under the title of Le Antichita Romane, *Lord Charlemont's agent in Rome offered Piranesi an insultingly small sum. Injured in his pride even more than in his financial interest, Piranesi sent three letters to his patron, all of which remained unanswered. He then erased the dedication to Charlemont and, to justify his conduct, took the unprecedented step of having his letters printed, to exhibit to the public*

[25] Cf. Marjorie Bowen, *William Hogarth*, New York, Appleton-Century, 1936, p. 319.

at large the spectacle of a noble patron's meanness and of an artist's dignity. The following passages are taken from the first of the letters, dated August 25, 1756.[26]

From *Letters to Lord Charlemont* (1756)

. . . I believe that I have completed a work which will pass on to posterity and which will endure so long as there are men curious to know the ruins which remain of the most famous city in the universe. . . . This work is not of the kind which remains buried in the crowded shelves of libraries. Its four folio volumes comprise a new system of the monuments of ancient Rome. It will be deposited in many public libraries throughout Europe, and in particular in that of the Most Christian King. And there is reason to suppose that the name of its author will pass on to posterity together with his work. . . . Is it not a very unpleasant circumstance, then, that having invested my thoughts, talents, work, and purse, that having labored unceasingly for eight years to make this work worthy of Your Lordship, I should now be insulted by a man [Charlemont's agent] who, to do me greater injury, arms himself with the credit which he has with Your Lordship? . . . The time has come, therefore, to think of saving my honor. Should I be forced to suppress the Dedication, I beg Your Lordship not to take this as an offense against your forebears, but as a reparation which is owed to me. For when the story of my life is written, along with that of other artists, I do not want to stand accused of having been a flatterer . . . who was held in low esteem even by those on whom he lavished his praise. If Your Lordship do not loosen my tongue, if you do not render me justice and protect me against calumny . . . then I cannot, as a man of honor, or without making myself ridiculous, call you a protector of the arts and myself an artist who received your protection. And if I have seemed to call you so, in the seventy copies of my work which have already been sold, then I must face the painful necessity of having to accuse my own foolishness and of trying to vindicate myself before the world. For I must ask you to bear in mind that, as a nobleman must consider his ancestors, an artist who will leave his name to posterity must consider his own reputation and that of his descendants. A nobleman is the latest of his name, an artist the first of his; both must act with equal delicacy. If I should ever have to publish this letter, which I should do only with the greatest regret, I implore those who read it, posterity as well as you, My Lord, to believe that I do not lack the deep respect which I owe Your

26 The text is contained in a few copies of *Le Antichita Romane* and in a separate pamphlet which Piranesi published under the title of *Lettere di Giustificazione scritti a Milord Charlemont*, Rome, 1757. The first of Piranesi's three letters, dated August 25, 1756, is the one here quoted in part.

Lordship. I do not claim equality for your name and mine, only for our reputations, for this is something which must be equally precious to all men, of whatever profession they might be. . . .

Reynolds and Blake on Patronage

In delivering the first of his Discourses *(1769), Sir Joshua Reynolds still conformed to the convention of servile praise for royal and aristo-cratic patronage, describing it as a main circumstance "from which honour and prosperity can probably arise" for the artists of the newly founded Academy:* [27]

. . . There is a general desire among our Nobility to be distin-guished as lovers and judges of the Arts; there is a greater superfluity of wealth among the people to reward the professors; and, above all, we are patronized by a Monarch, who, knowing the value of science and of elegance, thinks every Art worthy of his notice, that tends to soften and humanize the mind.

After so much has been done by His Majesty, it will be wholly our fault, if our progress is not in some degree correspondent to the wisdom and generosity of the Institution: let us shew our gratitude in our diligence, that, though our merit may not answer his expectations, yet, at least, our industry may deserve his protection.

A generation later (1808), William Blake, in annotating Reynolds' Discourses *(see page 34), savagely indicted the system of patronage for its economical insufficiency, its social condescension, and its intellectual arrogance.*[28]

Who will Dare to Say that Polite Art is Encouraged or Either Wished or Tolerated in a Nation where The Society for the Encourage-ment of Art Suffer'd Barry to Give them his Labour for Nothing, A Society Composed of the Flower of the English Nobility & Gentry?— Suffering an Artist to Starve while he Supported Really what They, under Pretence of Encouraging, were Endeavouring to Depress.—Barry told me that while he Did that Work, he Lived on Bread & Apples.

O Society for Encouragement of Art! O King & Nobility of Eng-

[27] Robert R. Wark (ed.), *Sir Joshua Reynolds, Discourses on Art,* Huntington Library, San Marino, 1959, p. 3.

[28] G. Keynes (ed.), *Poetry and Prose of William Blake,* London, Nonesuch, 1927, p. 971. A fuller selection from Blake's annotations is given below, page 120.

land! Where have you hid Fuseli's Milton? Is Satan troubled at his Exposure? . . .

Liberality! we want not Liberality. We want a Fair Price & Proportionate Value & a General Demand for Art.

Let not that Nation where Less than Nobility is the Reward, Pretend that Art is Encouraged by that Nation. Art is First in Intellectuals & Ought to be First in Nations.

Continuing his denunciation of patronage in the manuscript of the Public Address *(1810), Blake proclaimed the sovereignty of artists in the language of revolutionary oratory:* [29]

Rubens's Luxembourg Gallery is Confessed on all hands to be the work of a Blockhead: it bears this Evidence on its face. . . . If all the Princes in Europe, like Louis XIV & Charles the first, were to Patronize such Blockheads, I, William Blake, a Mental Prince, should decollate and Hang their Souls as Guilty of Mental High Treason. . . . The wretched State of the Arts in this Country & in Europe, originating in the wretched State of Political Science, which is the Science of Sciences, Demands a firm & determinate conduct on the part of Artists to resist the Contemptable Counter Arts Establish'd by such contemptible Politicians as Louis XIV & originally set on foot by Venetian Picture traders. . . . Imagination is My World; this world of Dross is beneath my Notice & beneath the Notice of the Public. I demand therefore of the Amateurs of art the Encouragement which is my due; if they continue to refuse, theirs is the loss, not mine, & theirs is the Contempt of Posterity. I have Enough in the Approbation of my Fellow laborers; this is my glory & exceeding great reward. I go on & nothing can hinder my course:

and in Melodious Accents I
Will sit me down & Cry I, I.

Asmus Jakob Carstens (1754–1798) and the Prussian Minister

The painter Asmus Carstens, a Danish subject, held a teaching position at the Prussian Academy in Berlin. In 1792, he received a fairly generous travel stipend and other grants which were to enable him to spend three years in Rome at the Prussian state's expense. In return, Carstens undertook to report to the Ministry concerning his progress, and to send some of his work to Berlin for exhibition. He was irritatingly slow in fulfilling both these obligations. After an initial extension of

[29] *Ibid.,* p. 818.

his leave, he at last informed the Ministry that he wished to break his contract with the Academy, in order to remain in Rome indefinitely. The Minister, Baron von Heinitz, thereupon sent him a letter of reproach and dismissal, pointing out to Carstens that "the unilateral cancellation of mutual obligations is not customary anywhere, least of all in Prussia." In his Reply to Baron von Heinitz (February 20, 1796) Carstens protested against the threatened reprisals and asserted the right, or even duty, of artists to further their personal development, regardless of social obligations. The letter documents the emancipation of artists toward the end of the 18th century, not only from official patronage, but also from some of the social and legal restraints which bind other men.[30]

Since you speak of mutual obligations, I must state that I have never been under any obligation to the Academy. Independent of its administration, I gave good instruction in return for a mediocre salary. I am not even a member. If I am obligated to anyone, it is to your Excellency. But this mutual obligation is now dissolved, as, in justice to myself, I have already been obliged to point out. . . .

Besides, I must tell you Excellency that I belong to Humanity, not to the Academy of Berlin. It was never my intention, nor did I ever promise to become the life-long serf of an Academy, in return for a few years' pension granted me for the development of my talent. It is only here [in Rome] that I can properly train myself, surrounded by the best works of art in the world, and I shall continue with all my strength to justify myself in the eyes of the world through my own works. I renounce all benefits, preferring poverty, an uncertain future, and perhaps an infirm and helpless old age, my body beginning already to show signs of debility, in order to do my duty to art and fulfill my calling as an artist. My capabilities were entrusted to me by God; I must husband them conscientiously, so that when He asks me to give an accounting of myself, I shall not have to answer: Lord, the talent which you entrusted to me I have buried in Berlin.

Since I have always known and valued your Excellency as a lover of the truth, I have not hesitated to write the truth freely, and I am ready, if necessary, to assert it in public, to justify myself to the world, as I feel justified in my own conscience.

<div style="text-align:center">

With deepest respect, I remain
Your Excellency's devoted
Carstens.

</div>

[30] Carl Ludwig Fernow, *Das Leben des Künstlers Asmus Jakob Carstens*, Leipzig, 1806, pp. 190 ff. (von Heinitz' letter) and pp. 199 ff. (Carstens' letter).

The Public at Large as Patron of the Arts

The insufficiency of patronage was most painfully felt by history painters whose large compositions were the most costly and laborious to produce, and the most difficult to sell. To make up for the lack or uncertainty of official support, artists occasionally tried to address themselves directly to the public. In England, where official patronage was very limited, it was a common practice for artists to sell reproductive prints of their paintings, or to exhibit individual pictures to the public for a fee. The English engraver Valentine Green (1739–1813) in his Review of the Polite Arts in France . . . Compared with their Present State in England . . . in a Letter to Sir Joshua Reynolds (1782) expressed a common complaint about both these practices which many artists found humiliating: [31]

. . . Neither is it to be expected, that the series of Subjects from the English History, carrying on by Mr. West, of which the *Death of General Wolfe* began, and *the Battles of the Boyne,* and *La Hogue,* are a continuation; nor yet *the Death of the late Earl of Chatham,* by Mr. Copley, should be ascribed to Public Patronage given to Historical Painting. In neither of these instances has it been applied. The first Subjects were presented by the Painters. . . . The second was sent out of the kingdom to a foreigner. The others were Works of Speculation, begun by the Artists themselves, without commission, or the least dependance of their ever being disposed of. If, in any of these cases, the Artists had not been known to possess abilities worthy to have been employed, the question would have been unnecessary for me to put at this time—how it comes to pass, that, in the most peremptory and decided language, it is insisted on, that the most liberal encouragement is given to the English Artists? Is it because a *Guinea* is subscribed to the purchase of a *Print* from those Pictures, for which the Painters, in superaddition to their own speculative labours, venture on the heavy expences attending the laborious operations of Engraving them? Or is it, because from motives of prudence, impelled by the neglect they have experienced, they are unwillingly forced on the expedient of challenging attention, by offering those Works to public view, and setting the price of a *Shilling* on the humiliating Practice? But this Patronage is unique, it belongs only to ourselves; and, in addition to its other merits, is likely

[31] Valentine Green, *A Review of the Polite Arts in France . . . Compared with their Present State in England . . . in a letter to Sir Joshua Reynolds,* London, 1782, p. 49.

to produce this farther brilliant effect, namely, the making Marchands
d'Estampes of our first men of Genius, and reducing the study of their
Professions to *Connoisseurship in proof impressions from Engravings.*

David on Public Exhibitions

*It is curious to note that, nearly twenty years later, the French
painter Jacques Louis David (see pp. 114, 130) used the very examples
which Green had cited in his denunciation of individual exhibitions in
order to justify his own public exhibition of "The Battle of Romans and
Sabines" (1800). David had completed this painting in 1799. Still in par-
tial disgrace, as a former leading Jacobin, and perhaps afraid of chicanery
from the officials in charge of the regular Salon, David decided to offer his
work to public view, for an admission charge, in a special, privately
arranged exhibition at the Louvre. The picture remained on view from
1800 until 1804, earning him the very considerable sum of 65,000 francs.
Since individual exhibitions for the artist's personal benefit were con-
trary to French usage, David felt it necessary to justify himself to his
visitors in a pamphlet from which the following passages are taken. It
might be noted that while such exhibitions remained fairly uncommon
outside France—Carstens had privately exhibited his works to Roman
connoisseurs in 1795, and Blake held an exhibition in London in 1809
(see page 150)—a few French artists imitated David, among them Géricault
(who exhibited his* Medusa *in England), Horace Vernet, and, ultimately,
Courbet.*[32]

Antiquity has ever been the school of modern painters and the
source from which they have drawn the beauties of their art. We try to
imitate the ancients in the genius of their conceptions, the purity of
their design, the expression of their faces and the grace of their forms.
Could we not go one step further and also imitate their customs and
institutions, in order to raise the arts to a state of perfection?

There is nothing new about exhibitions in which the work of a
particular painter is shown to his fellow-citizens for a fee. The learned
Abbé Barthelemy mentions in his *Voyage of the Young Anacharsis* that
the famous Zeuxis collected a fee from those who viewed his works, and
in this way grew so rich that he was able to give many of his master-
pieces to his country, saying that no private individual could afford
them. . . . The custom of public exhibition thus prevailed among the
Greeks; we need not fear that we shall go wrong if we follow them.

[32] The passage is taken from the introduction of the pamphlet which bears the
title *Le Tableau des Sabines, exposé publiquement au Palais National . . . par le
Citoyen David*, Paris, Didot, 1800, p. 1 ff.

In our time, this practice is observed in England. . . . The pictures of the Death of General Wolfe and the Death of Chatham by Benjamin West, our contemporary, have earned him immense sums in that country. One-man exhibitions have been held in England for a long time; it was Van Dyck who introduced them in the last century. The public came in crowds to admire his works, and he managed to amass a large fortune in this way.

Is there not a great deal of justice and wisdom in this arrangement which allows artists to support themselves by drawing on their resources, and to enjoy the noble independence which belongs to genius . . . ? What better way is there of deriving an honorable benefit from the fruits of one's work than to submit it to the judgment of the public, and to expect in return only those rewards which public approval will bestow? If the work is mediocre, the public will soon have judged it so. The artist, having gained neither glory nor fortune, will be taught by this severe lesson to correct his faults and to seek better ways of arresting the public's attention.

Of all the arts which genius practices, painting is surely the one which calls for the greatest sacrifice. It is not unusual for the completion of a history painting to require as many as three or four years of work. I shall not dwell on the preliminary expenditures which painters must incur; the cost of costumes and models alone is very considerable. There can be no doubt that these difficulties have discouraged many artists. It is possible that some of the masterpieces which their genius conceived have been lost to us, because poverty prevented them from being executed. I shall go even further and ask: how many honorable and virtuous painters who would never have lent their brush to any but elevating moral subjects have been forced by want to degrade and lower themselves? They have prostituted their talent for the money of Phryne and Lais. It was their indigence which caused them to become guilty; their talent, destined to elevate morals, contributed to their corruption.

I should be happy if my example were to initiate the custom of public exhibition, thus helping to protect men of talent from poverty and contributing to the return of the arts to their true purpose, which is to serve morality and to elevate the soul. . . . The means for moving the human heart are a great secret, they could give a powerful impetus to the nation's energy and character. Who can deny that the French people have until now remained strangers to art and have lived among the arts without partaking of them? Whenever painting or sculpture achieved a rare masterpiece, it fell immediately into the hands of a rich man, often at a low price; it was jealously guarded by him, as his exclusive property, to be shared only with a few friends and to be denied

to the rest of society. The system of exhibitions would at least allow the public to share the riches of genius, in return for a small fee. The public could then learn about the arts, to which it is not so indifferent as some believe. This would enlighten it and improve its taste. For though the public lacks the experience necessary for deciding about the finer and more difficult points of art, its judgment, which is always inspired by nature and prompted by feeling, can give pleasure and even insight to artists who know how to use it.

How painful and sad it is, for men sincerely devoted to art and to their country, to see many precious works go to foreign nations, when the nation which produced them has scarcely had the chance of becoming acquainted with them. Public exhibitions will tend to preserve master-works for the fortunate country which produced them. . . .

The objection will probably be raised that every nation has its own customs, and that the custom of holding public exhibitions of art has never become accepted in France. To this I can only reply that I am unable to explain the contradictions of human conduct. But I should like to know what dramatic author would not give the greatest possible publicity to his work, or would hesitate to receive part of the admission charge paid by the spectators, in exchange for the emotions and pleasures which he gave to them by his depiction of man's passions and foibles? And I should like to know, too, whether a musical composer, having im-parted soul and life to a lyrical poem, would blush to share with the author of the poem the profits derived from its representation? What is honorable to one profession ought not to be humiliating to another. . . .

AGAINST THE ACADEMY

The English engraver Valentine Green wrote in 1782, after a visit to France, ". . . At the present moment, the foundation of their School of Art cannot be shaken, but with the extremest convulsion of the State: nor will any of its Sovereigns be hardy enough to encounter the odium that would be attendant on any hostile proceedings against an institution whence so much honor has been derived to the nation. At this moment its vigour is unimpaired, and its principles are as active as in the time of the fourteenth Louis, so far as regards its funds, and its cultivation of genius." [33] *The Enlightenment had put the necessity of academic insti-tutions beyond serious question. Criticism of the Academy, nevertheless,*

[33] Valentine Green, *op. cit.*, p. 10.

became more and more frequent in the latter half of the 18th century. It came from two quite different quarters. On the one hand, there were those who disliked the Academy's monopolistic control of the means of education and patronage, who deplored the tyrannical nature of its power, and called for a reorganization of its internal constitution. Some detractors, on the other hand, found fault with the educational methods used by the Academy; a few radical critics went so far as to deny that art could be taught by method and rule and regarded the institution as essentially harmful. Critics of the first kind had a political or economic bias. Their aim was reform and renewal, even if this were to necessitate a temporary suspension of the Academy, such as occurred during the French Revolution. Critics of the second kind were motivated by more fundamental, philosophical, or artistic considerations. Their goal was the Academy's permanent abolition.

Antoine Quatremère de Quincy (1775–1849) on the Academy

An academically trained sculptor, winner of the Academy's Rome Prize, Quatremère de Quincy became an archaeologist and publicist. After the outbreak of the Revolution, he was elected to the Legislative Assembly in which he frequently represented the interest of the artists and the cause of academic reform. His Considérations sur les arts du dessin *(1791), from which the following excerpts are taken, contains a detailed criticism of the academy and an elaborate plan for its improvement.[34] It represents an attitude which is distinctly more moderate than that of Louis David (see page 115).*

There still exists—I almost said: there existed—a sovereignty of artists known under the name of Royal Academy of Painting and Sculpture. Its internal organization seems democratic, but is so only after the fashion of the aristocracy of Venice. This body has the right of giving public instruction in the arts; this is the least of its prerogatives. It also is the final judge of all talents and holds the power of life and death over all reputations. It possesses the ability to increase or reduce the number of its appointments, to open or close its doors at will, to let its enemies languish in obscurity, and to raise its favorites from insignificance. Supreme arbiter of public opinion, simply by virtue of its power to admit or to reject, it stamps with the mark of honor the servile brow which inclines under its yoke, or brands with disgrace the independent who dares to oppose it. Sole dispenser of all fame, exclusive proprietor of all honorific privileges, of all means for gaining a reputa-

34 Antoine C. Quatremère de Quincy, *Seconde Suite aux Considérations sur les arts du dessin,* Paris, 1791; the passages quoted occur on pages 3 and 12.

tion, of all public encouragements, it forces all men of talent to vie for its favor, it tyrannizes taste, it controls all dispositions and imperiously attracts to itself all those who have an inclination for the arts. Since it combines, in vicious union, the characters of school and academy, the right to shape and to reward talent, this body exercises, unopposed, all material and moral power. A truly vicious circle of influence, it attracts public attention to those whom it chooses as its members, and by manipulating public opinion determines the stature of artists. Perpetual seminary of incurable prejudices, it prohibits every debate and suppresses all spirit of innovation. . . .

In my opinion, the main defects of the present Academy are the following three:

1. The despotic authority of a material and moral kind which, by virtue of its power, it holds over the arts and the artists.
2. The pettiness and levelling influence of its teaching on the spirit of students and on the development of their talents.
3. The revolting inequality which results from the privileges, both practical and ideal, which the Academy possesses, and which cause in those who benefit from them, as well as those who are deprived of them, passions that are inimical to the progress of art.

Jacques Louis David (1748–1825) and the Suppression of the Academy (1793)

The events which led to the closing of the French Academy of Painting and Sculpture in August of 1793, at the height of the Jacobin regime, originated in a quarrel among the members over matters of rights and privileges, rather than over principles of art. As early as 1789, the two lower ranks of the membership, the agrées *and the* académiciens, *had begun to contest the authority and special privileges of the* officiers, *the ruling body of the Academy. The painter Louis David (see pp. 111, 130), himself an* académicien, *or member of the middle rank, acted from the start as the elected spokesman of the dissidents. Their aim was at first merely to liberalize, rather than close, the Academy, but the momentum of revolution rapidly magnified the dispute, and drew the opposing factions into the mainstream of political events: what had started as an attempt at organizational reform became an attack on the "citadel of privilege." David was propelled into the center of the political storm.*

With intelligent ruthlessness, the rebellious Academicians went over the heads of their officers and of the Ministry, to address their demands first to the Commune of Paris (February 1790), then to the National Assembly (June 1790), and finally to the Jacobin Club (July 1790). The

*plan of supplanting the "aristocratic" Academy with a revolutionary
Commune of the Arts gradually took shape. In September of 1792, David
entered the National Convention as an elected deputy, and shortly after
began his work on the Committee of Public Instruction, where he set up
a revolutionary art jury, prepared for the establishment of a Central
Museum, and demanded the suppression of the Academy. Invited by
the Academy, in April of 1793, to take his regular turn as professor in
charge of the life class, he answered with ominous brevity: "I once be-
longed to the Academy," signing "David, Deputy of the National Con-
vention." On August 8, 1793, he delivered the following speech before
the Convention, which immediately voted to abolish the Academy.*[35]

If there is someone among you, citizens, who must still be con-
vinced of the absolute necessity of destroying wholesale all the Academies,
those last refuges of aristocracy, then let him give me his attention for a
moment. I promise to dispel his doubts with a few words, and to make
up his mind by appealing to his feelings. Let me demonstrate, to begin
with, what damage the Academies do to art itself, how far they are from
fulfilling the purpose which they have set themselves. Let me unmask the
party spirit which guides them, the vile jealousies of their members,
the cruel methods which they use to stifle nascent talent, and the
monkish revenge which they wreak on the persecuted student to whom,
by mischance, nature has given a talent which removes him from their
tyrannical domination. . . .

Oh, you talents lost to posterity! Great men left in neglect! I will
placate your spirits, you shall be avenged: it was your misfortune,
illustrious victims, to have lived under kings, ministers, Academicians!

I have said that I would demonstrate the damage Academies do to
the art which they profess; I shall keep my word. I shall not bore you,
citizens, with trifling details, with the bad methods of teaching used by
the Academy of Painting and Sculpture. You will be easily persuaded
when I tell you that twelve professors per year, in other words, one for
every month (and every one of them tenured), compete with one another
to destroy the fundamental principles which the young artist has re-
ceived from the daily lessons of his master. Since every one of these
twelve professors approves only of his own principles (as you can well
imagine), the poor student, trying to please each one of them in turn,
must change his manner of seeing and working twelve times a year.
Having learned his art twelve times over, he ends up knowing nothing,
since he does not know what to believe. But, supposing that by some

[35] The text is given in J. L. Jules David, *Le peintre Louis David*, Paris, 1880,
pp. 127 ff.

rare gift from heaven he survives the poor teaching, then this child of so many fathers—on none of whom he can rely—calls down on himself the vile jealousy of all his masters who combine to ruin him. It is the policy of kings to maintain the balance of power; Academies maintain the balance of talent. Woe to the daring artist who steps across the forbidden line: he becomes an alien to the Academicians, his presence profanes the sacred, Druidical grove, and if he does not die on the spot, he is driven off by chicanery.

An example will prove my claim . . .

A young artist named Senechal, who had won the Academy's Rome Prize in sculpture, on his return to Paris lodged with a wealthy man to whose daughter he was to be married, on condition that he would be admitted to the Academy on the strength of his trial piece. Love inspires his chisel, love guides his hand; he produces a masterpiece, but so long as his teacher, so long as the Academy have not inspected it yet, he dares not to be confident of success.

Three commissioners sent by the Academy finally arrive, his master, Falconet, among them, the same Falconet who has written six fat volumes to prove that the horse of Marcus Aurelius in Rome (a recognized masterpiece of antiquity) is inferior to the one he made in Russia. . . . What were his first words? The moment this Falconet sees that the work which his pupil is about to present to the Academy impudently violates the system of the balance of talent, that it has the temerity of overstepping the line of demarcation, he tells him: "Young man, never boast of having been my pupil. Forget it, as I shall forget that I was your master. Your work makes no sense. I feel dishonored by a pupil like you."—and all this in the presence of the griefstricken girl. Tears well up in the eyes of our young man. He leaves under a pretext, he does not return. This causes some alarm. The Academicians, or rather Monsters, depart. But love is ever awake, love searches everywhere: the girl finds him at last; and where, do you suppose?—drowned in the well of her father's house.

Citizens, I could go on giving examples of this kind, but I shall remain silent, to spare your feelings.

In the name of humanity, in the name of justice for those who love art, and, above all, in the name of your love for youth: let us destroy, let us annihilate those sinister Academies. They must not be allowed to exist in the reign of liberty. Academicians, I have done my duty, now speak your sentence.

Following this speech, the painter's grandson, Jules David, reports the Convention adopted the draft of the decree which sealed the fate of the Academy of Painting and Sculpture, and which began:

First Article. All Academies and Literary Societies, licensed or endowed by the Nation, are suppressed. . . .[36]

The Academy had scarcely been abolished when it was reconstituted under the new name of Institut National. *The speed of its rebirth bears out the fact that what had prompted the destruction of the old Academy was not a fundamental hostility to the institution as such, but a determination to change its political composition. David and his followers seem never to have questioned the social utility of academic organization and academic teaching. The Convention decreed the establishment of the* Institut National *in the fall of 1795 and appointed the first members of the new body a few weeks later. David's name was included in the list. He accepted without protest.*

Joseph Anton Koch (1768–1839)

The Tirolese painter Koch exemplified "natural genius" as his generation understood it: born of poor farmers, raised in the sublime setting of the high Alps, he drew his first pictures with charred twigs on the bare rock, and seemed destined by nature to become an artist. The precocious boy received the grant of a free education at the princely Hohe Karsschule in Stuttgart, but his spirit rebelled against the school's tyrannical routines. He made a dangerous escape to Strassburg, then in the grip of the Revolution, and here had his dance round the Tree of Liberty, wearing the red Jacobin cap. When the excitement of revolution had begun to tire him, he wandered for two years among the mountains and waterfalls of the Swiss highlands. In 1794, aided by an English clergyman, he went to Rome to complete his studies. He befriended the dying Carstens (see page 108), and gradually developed a personal style of landscape painting which combined classical motifs, derived from the Carracci and Poussin, with naturalist elements. As he grew older, he became increasingly more pious and conservative and managed to be on friendly terms both with the aging pagans of his own generation and the young artists of the Nazarene brotherhood (see page 190). In his polemical writings, he preserved much of his earlier radicalism and peasant earthiness. The following excerpts are taken from his Moderne Kunstchronik *and* Gedanken über ältere und neuere Malerei *which, though published as late as 1834 and 1862 respectively, were written about 1798–1820.*[37]

[36] The text of the decree is given in J. L. Jules David, *op. cit.*, pp. 129 ff.

[37] Cf. *Kleine Schriften* (ed. D. F. Strauss), Leipzig, 1862, pp. 303 ff., and F. H. Lehr, *Die Blütezeit Romantischer Bildkunst*, Marburg, Verlag des kunstgeschichtlichen Seminars der Universität Marburg, 1924.

On the Decadence of the Academy

Like a swarm of maggots, crawling from a rotting cheese, a count-less mob of artists crawls from the Academies. . . . In these Academies, or Schools of Art and Beauty, reigns a despotism which permits only what can be seen every day to enter into the students' brains. Mindless drawing after plaster casts and models goes on for years; the goal is not truth to nature but an abstract aesthetic mannerism which kills all character. A thousand figures drawn in this manner look as if they had all been formed in the same mould. . . . Such empty busywork is aptly named academic. . . . Many of these lighthouses of art have special composition rooms where the boys who have been tormented for six or seven years with various finger exercises could give their genius free rein —assuming that they are unlucky enough to have genius, and that this has not yet been crushed by their schooling—if they were not held in check by professors hired to keep compositional genius from kicking over its traces. . . .

The methods of study which are used in French and other Euro-pean academies are quite mechanical: most painters take the merest ac-cessories—weapons, chairs, tables, benches—from "nature." They hire carpenters and other artisans to construct models which they then color or gild; and the slavish copies which they paint after these models often look extremely realistic—as if this were of any importance. When painters of this sort have sketched their compositions, they procure sculptural models of all the figures, or sculpt such models themselves, if they can. Then they drape these dolls with garments, put them in a box which is lit through a hole at its top, and line them up in accordance with the composition. They don't draw a finger or a toe without a model. As a result, most of these painters draw correctly, often more correctly than more imaginative artists. Their details look natural, but the whole remains artificial, because it is not animated by the spirit of art. In Poussin's figures one already senses the influence of the lay-figure. His garments and their folds are usually tasteless, as in draped puppets, and the modern French school has no notion of the formation of figures other than what it derives from mannequins.

On Rococo Allegory

Now they unleashed the mythical gods and demi-gods, in addition to the allegorical virtues, to pay compliments to a tiny, effeminate despot. Hercules was made to swing his club and to proclaim that the tyrant,

dozing in the arms of a mistress, was a hero. Minerva and her train of the Arts and Sciences were made to plead for protection before the potentate's bust; the Fates were encouraged to spin out the thread of his life as long as possible. Apollo, as the modern embodiment of the Day of Enlightenment, had to stop his horses in front of a bewigged head, to watch the Graces crowning and caressing it. Cerberus was not allowed to bark, Hecate was banished: only the gods of Love and the goddesses of Beauty were permitted to seat themselves on the swing of vanity. This supposedly magnificent art still fills all the aristocratic palaces dating from that period which gave to its artists such titles as *peintre du cabinet, de la cour,* and so forth.

William Blake (1757–1827)

William Blake shared with Lavater, Fuseli, Heinse, and others of the generation of Storm and Stress an extreme aversion from the Academy. Some time about 1808, he wrote into the margins of his copy of Reynolds' Discourses *a running accompaniment of protest and invective. His remarks cover the first eight* Discourses *and amount to a succinct statement of his view of art; the fact that they follow, with insistent negation, the main lines of Reynolds' argument gives them a certain coherence and progression. Blake's disagreement with Reynolds was fundamental, it stemmed from his conviction that art springs from an inborn faculty, not from acquired knowledge. The Academy therefore appeared to him as a fraud, since it pretended to teach what was in fact not teachable, and as a conspiracy designed to deprive true artists of their livelihood. Blake's annotations and other writings on art frequently have the persuasive brevity of aphorisms. They reveal him as a powerful polemicist, superior to Fuseli in this respect, and very far superior to Lavater, though he evidently borrowed from both of them.*[38]

From *Annotations to Sir Joshua Reynolds' Discourses* (c. 1808)

This man was Hired to Depress Art.

This is the Opinion of Will Blake: my Proofs of this Opinion are given in the following Notes.

* * *

Advice of the Popes who succeeded the Age of Raphael

Degrade first the Arts if you'd Mankind Degrade
Hire Idiots to Paint with cold light & hot shade

[38] The full text of the annotations, related to the pertinent passages in Reynolds' *Discourses,* is given by G. Keynes, *Poetry and Prose of William Blake,* London, Nonesuch, 1927, pp. 970 ff.

Give high Price for the worst, leave the best in disgrace,
And with Labours of Ignorance fill every place.

* * *

Having spent the Vigor of my Youth & Genius under Oppression of Sr Joshua & his Gang of Cunning Hired Knaves Without Employment & as much as could possibly be Without Bread, The Readers must Expect to Read in all my Remarks on these Books Nothing but Indignation & Resentment. While Sr Joshua was rolling in Riches, Barry was Poor & Unemploy'd except by his own Energy; Mortimer was call'd a Madman, & only Portrait Painting applauded & rewarded by the Rich & Great. Reynolds & Gainsborough Blotted & Blurred one against the other & Divided all the English World between them. Fuseli, Indignant, almost hid himself. I am hid.

* * *

The Arts & Sciences are the Destruction of Tyrannies or Bad Governments. Why should A Good Government endeavour to Depress what is its Chief & only Support?

* * *

The Foundation of Empire is Art & Science. Remove them or Degrade them, & the Empire is No More. Empire follows Art & Not Vice Versa as Englishmen suppose.

* * *

To Generalize is to be an Idiot. To Particularize is the Alone Distinction of Merit. General Knowledges are those Knowledges that Idiots possess.

* * *

I consider Reynolds's Discourses to the Royal Academy as the Simulations of the Hypocrite who smiles particularly where he means to Betray. His Praise of Raphael is like the Hysteric Smile of Revenge. His Softness & Candour, the hidden trap & the poisoned feast. He praises Michel Angelo for Qualities which Michel Angelo abhorr'd, & He blames Raphael for the only Qualities which Raphael Valued. Whether Reynolds knew what he was doing is nothing to me: the Mischief is just the same whether a Man does it Ignorantly or Knowingly. I always consider'd True Art & True Artists to be particularly Insulted & Degraded by the Reputation of these Discourses, As much as they were

Degraded by the Reputation of Reynolds's Paintings, & that Such Artists as Reynolds are at all times Hired by the Satans for the Depression of Art—A Pretence of Art, To destroy Art.

* * *

Reynolds's Opinion was that Genius May be Taught & that all Pretence to Inspiration is a Lie & a Deceit, to say the least of it. For if it is a Deceit, the whole Bible is Madness. This Opinion originates in the Greeks' Calling the Muses Daughters of Memory. The Enquiry in England is not whether a Man has Talent & Genius, But whether he is Passive & Polite & a Virtuous Ass & obedient to Noblemen's Opinions in Art & Science. If he is, he is a Good Man. If Not, he must be Starved.

* * *

The following annotations refer to passages in Reynolds' Discourse III *(see page 36).*

A work of Genius is a Work "Not to be obtain'd by the Invocation of Memory & her Syren Daughters, but by Devout prayer to that Eternal Spirit, who can enrich with all utterance & knowledge & sends out his Seraphim with the hallowed fire of his Altar to touch & purify the lips of whom he pleases." MILTON.

* * *

The following Discourse is particularly Interesting to Blockheads, as it Endeavors to prove That there is No such thing as Inspiration & that any Man of a plain Understanding may by Thieving from Others become a Mich. Angelo.

* * *

Without Minute Neatness of Execution The Sublime cannot Exist! Grandeur of Ideas is founded on Precision of Ideas.

* * *

The man who on Examining his own Mind finds nothing of Inspiration ought not to dare to be an Artist; he is a Fool & a Cunning Knave suited to the Purposes of Evil Demons.

* * *

The Man who never in his Mind & Thoughts travel'd to Heaven Is No Artist.

* * *

Artists who are above a plain Understanding are Mock'd & Destroy'd by this President of Fools.

* * *

What has Reasoning to do with the Art of Painting?

* * *

Knowledge of Ideal Beauty is Not to be Acquired. It is Born with us. Innate Ideas are in Every Man, Born with him; they are truly Himself.

* * *

The man who says that we have No Innate Ideas must be a Fool & Knave, Having No Con-Science or Innate Science.

* * *

One Central Form composed of all other Forms being Granted, it does not therefore follow that all other Forms are Deformity.

* * *

All Forms are Perfect in the Poet's Mind, but these are not Abstracted nor Compounded from Nature, but from Imagination.

* * *

What is General Nature, is there Such a Thing? what is General Knowledge? is there such a Thing? Strictly Speaking All Knowledge is Particular.

* * *

[*In his* Discourse III, *Reynolds had written (see page 43): "Albert Dürer, as Vasari has justly remarked, would, probably, have been one of the first painters of his age . . . had he been initiated into those great principles of the art which were so well understood and practiced by his contemporaries in Italy." Blake's answer strikingly recalls Wackenroder's earlier (1796) protest against this patronizing attitude toward Dürer (see page 182).*]

What does this mean, "*Would have been*" one of the first Painters

of his Age? Albert Dürer *Is,* Not would have been. Besides, let them look at Gothic Figures & Gothic Buildings & not talk of Dark Ages or of any Age. Ages are all Equal. But Genius is Always Above The Age.

* * *

The Two Following Discourses IV and V are Particularly Calculated for the Setting Ignorant & Vulgar Artists as Models of Execution in Art. Let him who will, follow such advice. I will not. I know that The Man's Execution is as his Conception & No better.

* * *

Why should Titian & The Venetians be Named in a discourse on Art? Such Idiots are not Artists.

* * *

A History Painter Paints The Hero, & not Man in General, but most minutely in Particular.

* * *

There is No Such a Thing as A Composite Style.

* * *

If Reynolds could not see variety of Character in Raphael, Others Can.

* * *

Reynolds cannot bear Expression.

* * *

Fresco Painting is the Most Minute. Fresco Painting is Like Miniature Painting; a Wall is a Large Ivory.

* * *

Reynolds Thinks that Man Learns all that he knows. I say on the Contrary that Man Brings All that he has or can have Into the World with him. Man is Born Like a Garden ready Planted & Sown. This World is too poor to produce one Seed.

* * *

Demonstration, Similitude & Harmony are Objects of Reasoning. Invention, Identity & Melody are Objects of Intuition.

* * *

God forbid that Truth should be Confined to Mathematical Demonstration!

* * *

Burke's Treatise on the Sublime & Beautiful is founded on the Opinions of Newton & Locke; on this Treatise Reynolds has grounded many of his assertions in all his Discourses. I read Burke's Treatise when very Young; at the same time I read Locke on Human Understanding & Bacon's Advancement of Learning; on Everyone of these Books I wrote my Opinions, & on looking them over find that my Notes on Reynolds in this Book are exactly Similar. I felt the Same Contempt & Abhorrence then that I do now. They mock Inspiration & Vision. Inspiration & Vision was then, & now is, & I hope will always Remain, my Element, my Eternal Dwelling place; how can I then hear it Contemned without returning Scorn for Scorn?

* * *

Rembrandt was a Generalizer. Poussin was a Particularizer.

* * *

Bad Pictures are always Sir Joshua's Friends.

RADICAL IDEALISM

The sense of tension which was an attribute both of revolutionary naturalism and Neoclassicism resulted from a dissonance between the social reality within which artists had to live and work and the ideal for which they strove. This produced a conflict between their interior and exterior lives which often led to severe maladjustment, and occasionally to madness. It caused artists to dissociate themselves from ordinary society and to sever their connections with institutions and patrons. Instead, they dedicated themselves to the pursuit of moral or aesthetic absolutes, to Beauty, Virtue, or Nature, substituting the goal of purity for that of social utility. Some artists attached themselves to revolutionary

political causes, as did David; others formed ideal communities or sects; the majority preferred to work in solitude, untainted by compromise, conceiving vast projects without hope of realizing them. The grandiose, cold geometry of the architectural plans of E. L. Boullée and C. N. Ledoux in the period of 1780–1800 perfectly exemplifies this purity and radicalism born of dissociation. The poet Friedrich Schiller (1759–1805), in his Letters on the Aesthetic Education of Man *(1793–1795), gave the following description of the ideal artist:* [39]

It is true, the artist is the son of his time, but alas for him, if he is likewise its pupil, or even favorite. Let a kind divinity snatch the suckling betimes from his mother's breast, nourish him with the milk of a better age, and let him come to maturity beneath a distant Grecian sky. Then when he has become a man, let him return, a foreign shape, into his century; not to delight it with his appearance, but terrible, like Agamemnon's son, to purify it. He will take his material, indeed, from the present, but borrow his form from a nobler time, nay, from beyond all time, from the absolute, unchangeable unity of his being. Here, from the pure ether of his divine nature, runs down the fountain of Beauty, undefiled by the corruption of races and times, which fret far beneath him in troubled whirlpools. Whim can dishonor his material, as it has ennobled it, but the chaste form is removed from its vicissitudes. . . . Humanity has lost its dignity, but art has rescued and preserved it in significant marbles; truth survives in the midst of deception, and the original will be restored from the copy.

But how can the artist protect himself from the corruption of his age, which on all sides surround him? By despising its judgment. Let him look upwards to his dignity and the law, not downwards to his prosperity and his wants. Alike free from the vain activity, that would fain leave its traces on the fleeting moment, and from the impatient enthusiasm, that applies the scale of the absolute to the paltry product of time, let him leave to the understanding, which is here at home, the sphere of the actual; but let him strive to evolve the ideal from the union of the possible with the necessary. This let him express in fiction and truth, in the play of his fancy and in the gravity of his deeds, in all sensible and spiritual forms, and cast it silently into infinite time. . . .

Claude Nicolas Ledoux (1736–1806)

The architect Ledoux sought to develop a radical new form of architecture, combining elements of classicist style with a severe ra-

[39] Translated by J. Weiss, in Friedrich Schiller, *Upon the Aesthetic Culture of Man, in a Series of Letters, 1795,* Boston, 1845, Letter IX.

tionality of planning and an imaginative, symbolical use of geometric forms. Through the influence of Madame du Barry, he received several important official commissions in Paris and in the provinces, and was also named inspector of the Royal Saltworks, in which capacity he undertook the grandiose plan and partial construction of the factories at Chaux. Much more than an industrial complex, Chaux was in effect to be the blueprint for an ideal city in which the demands of social purpose, technical function, moral significance, and formal beauty were to be equally realized. Deprived of his functions in 1789, imprisoned during the Revolution, Ledoux recorded his achievements and his further ideas in a book entitled Architecture Considered from the Point of View of Art, Morality, and Legislation *of which the first and only volume appeared in 1804. The following excerpt accompanies the design for a building of extremely eccentric shape (Figure 1) which was never executed.*[40]

Workshop for the Manufacture of Hoops

All forms are contained in nature. Those which are entire give strong effects; others are the products of disordered fantasy. The Barbaric periods gave birth to monstrosities; in the more enlightened periods, fashionable errors misled the masses. Forms were often adulterated, their character denatured; false wits imagined that they could produce variety of design by playing daring tricks with details. Some used bundled columns to support the pointed vaults of our churches; others imported the filigree palaces of the East Indies; still others reproduced the corrupt and degenerate lines brought into the world by the caprice of Genius. They have deceived us, by confusing the principle with its illusory consequences.

On what firm base can we settle the inconstancy of human desire? I shall seat it on the solid throne of propriety. I shall place it on the fixed pivot round which revolves the elliptical vault. Oh, what feelings, what situations!

The artist imprints his work with the sentiments which guide him. Seeing Nature embellish its large contours, he feels that his expressive means must follow the subject which he treats, and that the expression must be unambiguous. Taste, in fact, is impartial if it is pure.

Diversity of needs will elaborate the plans and multiply the contrasts; the details contained within the design will widen the scene and place between sun and earth the shadows which will enhance it. What

[40] C. N. Ledoux, *L'architecture considérée sous le rapport de l'art, des moeurs, et de la legislation,* Paris, 1804 (reprinted 1961), I, 178 and plate 88.

Figure 1

pleasure for the eye, what advantage for education, if houses in town and country were to renounce that tedious uniformity which tires the senses of the traveller who is eager for novelty. We should then no longer see those inert surfaces which look effective only on paper because of their conventional shadings. We should then rid ourselves of Incompetence which blames its own faults on handicapping requirements. Incompetence could then no longer claim, aided by fantastic subterfuge, that it builds in deserts or on wild rocks, and that arid locations offer nothing to the imagination. It could no longer tell us that art is out of place next to gigantic nature which supplants and often crushes it. If Incompetence continued to make these excuses which show the nullity of its ideas, it would admit that it is benighted, that it sees only the dark-

ness in the center of the flame—it would admit to us that sterility, drunk with talent, cannot rival fecundity even in the matter of mere profuseness.

One must admit, nevertheless, that a house which presents a square facade, windows and an entablature conforms more to common habits than one which is not designed according to the stereotype, but which satisfies the same needs. Everything out of the ordinary is at the mercy of the timidity which dampens the excitement of opportunity. I shall even go so far as to say that if one points out an opportunity, one risks losing it. And why should this be so? Administrators, accustomed to making excuses and to putting away plans into their portfolios, are guided by consensus. They cry out against strangeness, in order to avoid public protest. They cover their uncertainty with vacillation. Their narrow-mindedness takes fright; whatever is put up to them turns out to be too costly. They summon the uncertain architect and try to commit him to reassuring comparisons—comparisons! when shall we ever see them, so long as competition is banished and everything is done to extinguish the pure rays which flash from the dawn of Genius? The arts necessarily must regress when they are subjected to narrow principle which neutralizes ideas by aligning them with the cord of Slavery.

All in all, the construction of this building is easy and inexpensive. The workshops, situated on the ground floor, overlook the immense roads of the forest. The living quarters are raised above ground level in order to render them salubrious. The shaped voids at the center and the extremities of the building open the view on massed pine trees which correct the effects of winter, and on oaks, sycamores, and acacias which renew their foliage every spring and, by way of contrast, quieten the surfaces of the masonry. Shallow grooving extends the lines of the circles and weds them to the azure vault of the sky, of which they embrace the shape and magnificence. It may seem unimportant that a workshop seven or eight *toises* in size [one *toise* = ca 6 ft], and located in a remote forest, be impressive. But let us be true to principle. Is there anything which may not offer the eye the attractiveness of useful progress? Does anything exist which could not be electrified by art's animating breath? Certainly not! What should we say of the man who refrained from doing good because he could not trumpet his deed? What should we say? We should blame him for vain ostentation, for having an empty soul, for living in blameworthy isolation. Don't you know that often an idea which is not important in itself, which may even be bizarre, can contain the germ of excellence, so that some slight, felicitous change in it, some addition or subtraction, can make it a model for all?

If this essay can rouse feelings from apathetic slumber, if it can develop sensations which might not have arisen without this boldly conceived and executed preliminary, judge what art will have gained.

Jacques Louis David (1748–1825)

In the last decade of the 18th century, David was the only French artist of incontestably first rank; no other painter in France, with the possible exception of Prud'hon, came near him in ability. The great masters of the preceding age had died or sunk into insignificance; those who were to brighten the 19th century had not yet appeared. David's preeminence in the years of the Revolution was thus a matter of historical circumstance. The void around him was not artificial; it resulted from a pause in the sequence of generations. David's high and lonely position predestined him to play some role in the events of his time; the fact that he was attracted to power, loved the drama of public life, and had a marked talent for organization gave him an influence such as few artists have ever possessed.

Twice in his life, under Robespierre and under Napoleon, David occupied a place close to the center of political power. An ardent Jacobin, he was elected Deputy to the Convention in September of 1792, presided over this body during January of 1793, and cast his vote for the execution of Louis XVI. At the height of the Terror, he served as the leading member of the Committee of Public Instruction. In this latter position, he was relentlessly active: his share in the abolition of the Academy has already been noted (page 115); he helped, in addition, to develop a grandiose project for the embellishment of Paris, set up a National Jury of the Arts, organized the Central Museum (see page 162), voted credits for the purchase of paintings by Rubens and Poussin, and designed the uniforms of the Republican functionaries. Although he did not bear the title, he was in fact the minister of art in the revolutionary government; more than that, he served as the official representative of the world of art in the councils of the Revolution and acted as impressario of the immense public pageants which were the Revolution's most original device for the political indoctrination of the masses. As an orator and propagandist, David carried the classicist style to an extreme which he avoided in his painting. His Cyclopean improvisations recall the fantasies of such architects of the period as Ledoux and Boullée. But he was an intensely practical man; his fantasies tended toward concrete ends. He applied the suggestions of style and the language of symbols not to aesthetic but to political purposes. Because of its very nature, much of David's work for the Revolution remained ephemeral; its influence, nevertheless, was deep. His designs for the Republican festivals realized, more completely than work in the more conventional media could have

done, the special possibilities which lay in neoclassicism. They seemed to portend the long-awaited regeneration of art through a return to significant content and popular function.

David exercised his leadership through practical example and public attitude. Instinct had a large share in his art and his politics. As a theoretician he was insignificant. He reacted strongly and emotionally to concrete situations, and though he was inclined to rationalize, he lacked firm principle. This helps to explain the inconsistencies in his conduct, the shifts in style and in political allegiance (see page 173), which some have blamed, unjustly, on a weakness of character.

David Designs the Republican Uniform (1792)

The Scottish physician John Moore (1729–1802), a resident in Paris during the early part of the Revolution, reports: [41]

David, the celebrated painter, who is a Member of the Convention and a zealous Republican, has sketched some designs for a republican dress, which he seems eager to have introduced; it resembles the old Spanish dress, consisting of a jacket with tight trowsers, a coat without sleeves above the jacket, a short cloak, which may either hang loose from the left shoulder or be drawn over both: a belt to which two pistols and a sword may be attached, a round hat and feather, are also part of this dress, according to the sketches of David; in which full as much attention is paid to picturesque effect as to conveniency. This artist is using all his influence, I understand, to engage his friends to adopt it, and is in hopes that the Municipality of Paris will appear in it at a public feast, or rejoicing, which is expected soon. I said to the person who gave me this account, "that I was surprised that David, who was so great a patriot, should be so anxious about an object of this kind."

He answered, "that David had been a painter before he was a patriot."

Part of this dress is already adopted by many; but I have only seen one person in public completely equipped with the whole; and as he had managed it, his appearance was rather fantastical. His jacket and trowsers were blue; his coat, through which the blue sleeves appeared, was white with a scarlet cape; his round hat was amply supplied with plumage; he had two pistols stuck in his belt, and a very formidable sabre at his side: he is a tall man, and of a very warlike figure; I took him for a Major of Dragoons at least. On enquiry I find he is a miniature painter.

[41] John Moore, *A Journal during a Residence in France*, London, 1793, II, 433.

David Undertakes the Training of Two Youths Whom Nature has Destined for Art

On January 14, 1792, a Deputy from the Department du Drone presented to the National Assembly the twin brothers Joseph and Pierre Franque, simple shepherds, who had shown a precocious, natural gift for art. In their native mountains, the children had carved stones, engraved human figures, and drawn landscapes. When they were offered an education at the expense of the Department du Drone, it became evident that there was no teacher in the district who was capable of instructing them. Representative Dumas moved in the National Assembly that the twins be handed over to David for the completion of their training. This proposal was adopted. Shortly thereafter, the Moniteur Universel *of February 9, 1792, published the following letter by the artist:* [42]

Mr. President: I have been asked by the Assembly to teach the principles of art to two children whom Nature seems to have destined to be painters, but to whom Chance has denied the means for acquiring the necessary knowledge. I am overjoyed to be chosen to be the first teacher of these youths who could be called Children of the Nation, since they owe everything to her. Let me say again: I am overjoyed. My heart feels this joy, I cannot express it well in words, since my art consists of deeds, not words. Give me but a little time, and my assiduous care will prove how highly I value the honor of having been chosen. This will be my prize. I do not suppose that the Assembly will want to lessen the honor it has shown me, by offering a salary for the care which I shall give to the instruction of these adopted children. The love of money has never penetrated into my heart, to affect that love of glory which I value above all.

[signed] David.

David Commemorates the Martyrs of the Revolution

On January 20, 1793, Michel Lepelletier de Saint-Fargeau, a member of the Convention who, like David, had voted for the death of Louis XVI, was assassinated by a former officer of the guards. The Convention voted him the honors of the Pantheon. On March 29th, David presented his painting of the dead Lepelletier to the Convention. This work, now lost, was the first of his three commemorative portraits of martyrs of the

[42] J. L. Jules David, *Le peintre Louis David*, Paris, 1880, p. 139.

Revolution, the other two being the portraits of Marat and of Barra. The following is the text of David's presentation speech: [43]

Citizens-Representatives,

Every one of us is accountable to his country for the talents which he has received from Nature. Though these may differ in kind, their aim must be the same for all. True patriots should eagerly seize every opportunity for enlightening their fellow citizens and for presenting to them sublime examples of heroism and virtue.

This I have tried to do in offering to the National Convention my painting of Michel Lepelletier who was slain by cowards for having voted the Tyrant's death.

Citizens, the Supreme Being who distributes His gifts among all His children has decreed that I should express my sentiments and thoughts through the medium of painting, rather than through that sublime voice of eloquence which is raised among us here by the Children of Liberty. Respectfully heeding His immutable decree, I remain silent, but I shall have fulfilled my task if my picture will some day cause an aged father to speak thus to his numerous family assembled around him: "Come, children, look at the Representative who was the first to die in order that you might have Liberty. Look at his features: how serene they are! It is because those who die for their country die blameless. Do you see that sword hanging over his head, suspended by a single hair? This, dear children, is to show how much courage it took for Michel Lepelletier and his generous colleagues to send to the scaffold the infamous Tyrant who had so long been our oppressor: for at the slightest movement, this hair might break and all would die! Do you see the deep wound? . . . Are you crying, children, and turning your faces away? But look at this wreath, it signifies Immortality. The Fatherland holds it in readiness for each of its children; learn to be worthy of it, the occasions will not be wanting for those of great soul. If Ambition ever whispers to you of dictators, tribunes, and arbiters, or tries to usurp the smallest particle of the people's sovereignty, or if Cowardice should propose a king—then fight, or die like Michel Lepelletier, rather than consent. The laurel wreath of Immortality, my children, will then be your reward."

I beg the Convention to accept this homage of my feeble talent; should you deign to receive it, I will consider myself richly rewarded.

After the assassination of Marat, on July 13, 1793, David was again called upon to exercise his patriotic talent. His pupil and biographer, Etienne Delécluze, gives the following description of the event: [44]

[43] David, *op. cit.*, p. 150.
[44] David, *op. cit.*, p. 155.

The day after the assassination of Marat, the anniversary of the 14th of July, a deputation presented itself before the Convention to express the people's sorrow. Its spokesman, a certain Guirault, said: "Oh, shameful crime! a patricidal hand has struck down the most fearless defender of the people. He had dedicated himself to Liberty. Our eyes still search for him among you, Representatives! Oh, horrible spectacle! he lies on his death bed. Where are you, David? You have given to posterity the image of Lepelletier dying for his country. There is still another picture for you to do. . . ."

"Yes, I shall do it," cried David, deeply moved.

David's Project for the Immortalization of Barra and Viala (July 28, 1794)

This was the last of the revolutionary ceremonies planned by David. It was never carried out. Robespierre fell, one day before it was to be held. David himself was accused and imprisoned; he narrowly missed accompanying the Jacobin leaders to the guillotine on the very day for which this celebration had been planned. The previous patriotic spectacle organized by David, and the last to be realized, the Feast of the Supreme Being (June 8, 1794), had cast Robespierre in the role of high priest— a circumstance which possibly hastened his downfall.

Barra and Viala, the heroes who were to have been commemorated in the projected ceremonies were youths, still in their teens, who had been killed in the civil war in the Vendée. David had begun a painting of the death of Barra; the fall of the Jacobins prevented its completion. The following excerpts are taken from David's plans for the ceremonies, for which he sought, and received, the Convention's formal approval: [45]

At three o'clock in the afternoon, an artillery salvo discharged from the Eastern end of the Ile de la Cité announces the beginning of the ceremonies.

The people immediately assemble in the Jardin National; the members of the Convention make their entry into the amphitheater, attired in their official garb as Representatives of the People. Each member carries in his hands the symbol of his mission. They are preceded by a military band. The musicians chant a refrain suitable to the occasion.

At the conclusion of this song, the President of the Convention ascends the tribune and delivers a speech in which he describes to the people the heroic traits of Barra and Agricol Viala, their filial piety, and, in short, the reasons for which they have been accorded the honors of the Pantheon. He then hands over the urn containing Viala's ashes to

[45] David, *op. cit.*, p. 214.

the deputation of children, selected from all the Sections of Paris and of the same age as our young Republicans, i.e., between eleven and thirteen years.

The mortal remains of Barra, contained in the other urn, are to be handed over to the mothers whose children have died gloriously in defense of our Liberty. . . .

At precisely five o'clock, a second artillery salvo is heard. The deputations of mothers and children begin to march, divided into two columns. The procession is preceded by a large contingent of drummers, the lugubrious and majestic sounds of whose instruments express the surging emotion of a great people assembled for the most august of ceremonies.

Each column is to be headed by paintings of Barra and Viala representing their actions. . . . The column on the right will consist of the deputations of children, that on the left of the deputations of mothers. The space between the columns will be occupied by theatrical performers, arranged in six groups, in the following order: the first group is to consist of instrumental musicians, the second of singers, the third of male dancers, the fourth of female singers, the fifth of female dancers, the sixth of poets who will recite verses composed by them in honor of the voung heroes.

Next follow the Representatives of the People, surrounded by brave soldiers who have been wounded in the defense of their country. The President of the Convention gives his right hand to one of them, who has been chosen by lot, his left hand to the mother of Barra and her daughters. The masses of the people close the march.

From time to time, the drummers will sound a funereal drum roll, and the band will play a mournful tune. The singers will express our grief with plaintive melodies, the dancers with lugubrious or martial pantomime.

The columns come to a halt. There is complete silence. Suddenly, all the people raise their voices in unison, to cry three times: "They have died for their country."

On arriving at the Pantheon, the two columns will group themselves in a wide half-circle, in such a way as to leave a passage between them for the members of the Convention who will station themselves on the steps of the Temple. The children, musicians, singers, dancers, and poets will stand on the side of Viala, the mothers, and the women singers and dancers on the side of Barra.

In the meantime, the two urns are to be placed on an altar in the center of the square. Round this altar, the young dancers will perform a funeral dance expressive of deepest grief; they will scatter cypress branches on the urns. At the same time, the musicians and the singers

will mourn, with their music, the ravages of fanaticism which have
deprived us of these young Republicans.

Renewed silence follows the cries of grief. The President of the
Convention steps forward, kisses the urns, and, raising his eyes to the
heavens, bestows the honor of immortality on Barra and Agricol Viala
in the presence of the Supreme Being and of the people. In the name
of the grateful Fatherland, he places them in the Pantheon, the doors of
which open at this instant.

Suddenly, the scene changes. Grief is replaced by public rejoicing,
and the people, three times over raise the shout: "They are immortal!"

The great bells toll, and the games begin.

The drummers beat out a warlike rhythm, the female dancers
execute a joyous step, scattering flowers on the urn, causing the cypress
branches to become invisible. The male dancers strike martial attitudes
to the accompaniment of the music, celebrating the glory of the heroes,
and the soldiers go through military manoeuvres. . . .

The President closes the doors of the Temple and gives the signal
for the departure. . . .

The Sect of the "Primitifs"

During the late 1790's, while working on the Battle of Romans and
Sabines *(see page 111), David strove for a purer, more "Greek" style than
he had achieved in his earlier classicist compositions. The severity and
simplicity of early Greek art particularly appealed to him, and in drawing
the attention of his pupils to the beauties of archaic style, he made them
aware of similar qualities in the "primitive" work of Giotto, Fra An-
gelico, and Perugino. Several of his pupils of that time seized on his sug-
gestion and exaggerated it to the point of caricature. Known variously
as* Barbus *("Beards"),* Penseurs, *or* Primitifs, *these young artists, not con-
tent with introducing archaisms into their work, were determined to apply
the ethic of extreme simplicity and purity to their daily conduct and ap-
pearance. They seem to have produced little, but the character and aim
of their association is of some interest. Their artistic program marks a
radicalization of neoclassicism to the point of near-abstraction. Their
social eccentricity illustrates a tendency, fairly widespread at the time,
toward the formation of Utopian brotherhoods or quasi-monastic com-
munities. The following account of the* Primitifs *was written by the
painter Etienne Delécluze (1781–1863), their colleague and contemporary
in the studio of David.*[46] *It was composed in 1832, and carries a polemical*

[46] E. Delécluze, *Louis David, son école et son temps,* Paris, 1855, pp. 420 ff.
Delécluze's article had originally appeared in *Le Livre des Cent-et-Un,* a miscellany
published by Ladvocat, Paris, 1832, VII, 61. Cf. also G. Levitine, "The Primitifs and
their Critics in the Year 1800," *Studies in Romanticism,* Boston University, I (Summer
1962), No. 4, p. 209.

point, directed against the Jeunes France, *the Bohemians of a later generation, who bore a superficial resemblance to the* Primitifs. *(Frances Trollope described them as having "long and matted locks that hang in heavy, ominous dirtiness. . . . The throat is bare, at least from linen; but a plentiful and very disgusting profusion of hair supplies its place.")* [47]

I have known two generations of bearded friends, the first from 1799 to 1803, the second, if I remember correctly, from 1827 until this present year of 1832. . . .

It is well known that the revolution in the arts and in the study of classical antiquity which swept Europe preceded, by a few years, the great political Revolution in France. Heyne's and Winckelmann's searching studies of the writings and monuments of antiquity had restored the prestige of the Greeks and Romans. We can assume that this predisposed the political revolutionaries of 1789 to try to govern, and even to clothe, us in the manner of the Spartans and Romans. Whatever the actual reason, the fact remains that the craze for imitating the Ancients took hold of the most energetic and active minds, if not necessarily the best. The pictorial arts, theater, literature, and even household furnishings were influenced by this mania for copying the Romans, followed by the craze for imitating the Greeks. It was shortly after the Terror that Greek vases of the type called "Etruscan" became better known to artists, and it was precisely in this period that there arose the taste for Greek forms and ornament in women's fashions and in the decoration of interiors, down to the most ordinary utensils.

My earliest bearded friends were of this time. Until then, they had shaved and dressed like everyone else. But the moment arrived when David, whose pupils they were like myself, exhibited his picture of the *Battle of the Romans and Sabines*. Although this painting won the admiration of the public, it did not receive the wholehearted approval of some of the master's disciples. At first, these youngsters hazarded only slight criticisms. Gradually, they became more severe, and finally decided that, despite a few praiseworthy attempts to follow Greek models, the painting contained nothing of the simplicity, grandeur, or primitiveness —this last being the key term—which are to be found in Greek vase painting; and immediately these heretical pupils started calling David Van Loo, Pompadour, and Rococo. . . .

David could not tolerate such criticisms, particularly from his own students. Without making a scene, he found ways of telling those who no longer agreed with his teaching that they should stop disturbing the studies of their former colleagues.

It was then that they formed the sect which was to be called the "Thinkers" or "Primitives." Without defining, for the time being, the odd

[47] Frances Trollope, *Paris and the Parisians in 1835*, New York, 1836, p. 124.

principles which they intended to follow in their painting, they agreed to adopt the Greek costume, and particularly that of the archaic Greeks, in order to preserve themselves from the mannered and hypocritical ways of modern society. To them, Pericles was just another Louis XIV, living in a century already tinged with decadence. In short, they modelled their clothes after those worn by the figures on Sicilian vases, believed to be the most ancient of all, and let their hair and beards grow.

There were only a few, about five or six, who had the will and the means to indulge in this caprice, but they made quite a stir. There must still be some people in Paris who remember having seen two bearded young men walking the streets around 1799, the one dressed like Agamemnon, the other like Paris in his Phrygian robe. Although I was friends with both of them, I was closer to Agamemnon who visited me fairly often, to the great amazement of the porter and my neighbors.

Agamemnon was about twenty years old at that time. He was tall and thin, with bushy hair and beard; his eye was fiery, and he wore an expression which was both passionate and kind and which made him seem imposing, and at the same time attractive. There was something about him which reminded one of Mohammed and of Christ, both of whom he deeply revered. He was keen-witted and had an easy, copious and graceful eloquence. . . . As for his costume, it was quite simple, consisting of a large tunic which reached down to his ankles and a voluminous cloak which he would draw over his head in times of rain or sun. I have seen few actors, not even excepting Talma, who wore this kind of costume with greater ease and grace than my friend Agamemnon. . . .

I saw him only once or twice in his studio, an enormous room cut diagonally by a canvas thirty feet long. In the dark triangle behind the canvas were the straw on which he slept and a few household articles; the other triangle constituted the studio proper. There I watched my friend Agamemnon preparing his palette which measured four feet across, working on his canvas on which he had begun to draw the subject of Patroclus sending Briseis back to Agamemnon, the king of kings. . . .

It was his opinion that, in order to put an end to harmful doctrines and prevent the spread of false taste, only three or four statues from the museum of classical art should be preserved, and he advocated setting fire to the picture gallery, after removal of no more than a dozen works. The basic tenet of his system was to study classical art and to work only from nature. But he looked on imitation as a very subordinate means of art, and on sublime beauty as art's true and only aim. . . .

His literary tastes were every bit as exclusive as his artistic doctrines. Just as in Greek art he valued only the vase paintings, statues and reliefs of the most archaic style, so he found genuine, substantial and indisputable worth only in the Bible and the poems of Homer and

Ossian. He related everything to these three eminences, and gave attention to other writings only when they reflected these three monuments of literature. Agamemnon had overcome the disadvantage of a neglected education through discriminating and intensive reading. He was well versed in the Old and New Testament; he had read, besides translations of Homer, nearly all Greek writers of the best period; and he had practically memorized the French translation of Ossian's poems. . . .

At that time, no one doubted their authenticity. Some people, like my friend Agamemnon, found them sublime and admirable; others found them monotonous and occasionally boring. I was of this latter opinion. Having quoted abundantly from the poems of Fingal. . . . He told me with the grave authority and fervor of a prophet: "Homer is admirable, but Genesis, the story of Joseph, Job, Ecclesiastes, and the Gospels are far superior to Homer, no doubt about that. But I assure you," he added with rising emphasis, "that Ossian's grandeur surpasses all of them, and for this reason: he is truer and, mark my words, more *primitive!*" . . . My perplexity only heightened my friend Agamemnon's assurance; wrapped in his cloak and stroking his long beard, he seemed to be focusing all his reflections on one point, to reduce them to a single thought and one concise and firm sentence—"Homer? Ossian?" he asked himself, "the sun? the moon? That's the question. Actually, I think I prefer the moon; it is simpler, more noble, more *primitive!*"

Such were, more or less, the opinions and sayings of the grand master of the bearded men of Paris in the last years of the eighteenth century. . . .

The sect of the "Thinkers" or "Primitives" was the forward edge of the society of that time, the time of the Directory and Consulate. After the end of the Terror, the taste for ancient art had temporarily displaced the religious sentiments and the social or literary distractions which had occupied the souls and minds of people prior to the revolution. France was treating herself to a show of paganism. All classes of society mingled at the theater and other pleasure haunts. In the parks, women dressed in the Greek manner displayed the grace and beauty of their forms to public admiration. All the young men, rich and poor alike, daily exposed their naked bodies along the banks of the Seine, and tested their strength and skill in swimming. Athletic contests were held in the Bois de Boulogne on summer evenings; on holidays, there were foot races, horse races, and chariot races in the Champ de Mars, all in the Greek style. At civic ceremonies, one observed high priests reminiscent of Chalchas and maidens like those of the Parthenon frieze; and more than once I have come across sacrificial offerings of pitch-pine, substituting for incense, burning on the lawns of the Champs Elysées before pasteboard replicas of the temples of Paestum. In those days, all classes

of society mingled, walked, laughed, and danced together under the auspices of the only true aristocracy then recognized in France, beauty.

The story of the beard of my friend Agamemnon is, in effect, a concise summary of the time in which this young man lived, for he died young, and his end coincided with the end of the saturnalia of the Directory.

After Agamemnon's death, all the members of his sect shaved their beards, put on their hose and shabby jackets. Bonaparte had already arrived on the scene with sword and tri-cornered hat.

Revolutionary Vandalism

The wholesale destruction of works of art which occurred during the French Revolution resulted partly from neglect or pillage, partly from deliberate political action. The revolutionary leaders regarded works of art as public symbols: palace and church in their view stood for tyranny and priestcraft, and therefore seemed the proper targets for popular vengeance. Monuments in the Gothic style particularly stirred the wrath of patriots, because they recalled the days of feudalism. Cathedrals suffered execution, like kings, in symbolical punishment for ancient crimes.

Large-scale destruction of religious and monarchical monuments began in 1792. During August of that year, the Scottish physician John Moore (1729–1802) reported from Paris: [48]

Above the great gate of the church of Notre Dame, are the figures in stone of twenty-six Kings of France, from Childebert the First to Philip August. I was told that in this general fury against kings, all those venerable personages had been hewn to pieces by the people. I had the curiosity to go to the cathedral on purpose, to see whether absurd zeal had been carried this length, and had the satisfaction of finding this royal society safe and uninjured by any hand but that of Time.

The ridiculous gigantic statue of St. Christopher, with the Bon Dieu upon his shoulders, which I remember to have stood formerly within the church, is now removed; but I believe the revolution cannot claim the merit of this improvement, as it was made before it began.

Not long after, in September of 1792, Moore was able to observe actual vandalism at Chantilly: [49]

A party of national guards, detached by order of the Commune de Paris, has been here; they only left Chantilly this morning: they carried

[48] John Moore, *op. cit.*, I, p. 85.
[49] John Moore, *op. cit.*, I, p. 325.

with them, in waggons, a vast quantity of stuff proper for soldiers' tents which was in this place. A party which was here some time ago, but since the 10th of August, carried away all the horses of every kind which remained in the stables, also a statue of Louis XIV which was within the castle. They also overset and broke in pieces the fine figures which ornamented the front of the magnificent stables: they treated in the same manner the equestrian statue of Henry de Montmorency, Constable of France in the time of Henry IV. The materials of those, being metal, were carried by the same party in waggons to Paris. They had the brutality, before they set out, to knock off the head of the beautiful pedestrian statue of the Great Condé, which stood in the grand staircase of the castle.

David Proposes a Monument to the French People (1793)

On November 7, 1793, Louis David (see pages 111, 115 and 130) proposed to the Convention that the debris of royal monuments be put to patriotic use: [50]

Unable to usurp God's place in the churches, the kings took possession of their portals. Here they put their effigies, no doubt so that the people's adoration should come to a stop at the entrance of the sanctuary. Accustomed to laying their hands on everything, they had the presumption of competing with God Himself for the incense which men offered Him. You have overthrown these insolent usurpers; laughed to scorn, they now litter the soil which they once stained with their crimes.

Let a monument be raised within the confines of the Commune of Paris, close to the church which the kings once made their Pantheon, to be a reminder to our descendants and the first trophy erected by the Sovereign People in its victory over the tyrants. Let the dismembered fragments of these statues form a lasting monument of the kings' downfall and the people's glory. Let the traveler who passes through this reborn country take back to his homeland the useful lesson: "Once I saw kings in Paris; when I returned, they were no more." (Applause.)

I propose, therefore, that a monument be erected in the square of the Pont Neuf. It is to represent the Giant People, the People of France.

Let this statue, imposing in its strength and simplicity, be inscribed in large letters, on the forehead: *Light;* on the chest: *Nature* and *Truth;* on the arms: *Strength, Courage.* Put in one of its hands the statues of Liberty and Equality embracing one another and ready to traverse the world, in order to show that they are founded on the genius and virtue

[50] E. Delécluze, *op. cit.,* p. 156.

of the people. And let this statue of the people stand upright and hold in its other hand that terrible club with which the ancients armed their Hercules.

It is up to us to raise such a monument. Other peoples who loved liberty have raised similar ones before us. Not far from our borders lie the bones of the tyrants' slaves who attacked the liberty of the Swiss. Piled into pyramids, they now threaten those impudent kings who would dare to desecrate the land of free men.

Thus we shall pile up in Paris the effigies of the kings and their vile attributes, to serve as the pedestal for the emblem of the French people.

David's suggestion did not go unheeded. At the following Salon (1795), the sculptor C. Dumont exhibited the model for a colossal statue of The Victorious French People, Presenting Liberty and Equality.

Method for the Destruction of Gothic Churches (1800)

At the Salon of 1800, an architect by the name of Petit Radel, Inspector-General of Civil Structures, exhibited a design which the official catalogue describes as follows: [51]

516. DESTRUCTION OF A CHURCH IN THE GOTHIC STYLE, BY MEANS OF FIRE

In order to minimize the dangers which this kind of operation entails, the piers are to be hollowed, near their bases, at a height of two stone courses. As stones are removed, half their volume is replaced by dry wood. This is continued throughout. Kindling is then inserted, and fire set to the wood. When enough of the wood has burned, it gives way under the weight of the masonry, and the whole structure collapses in less than ten minutes.

NEW IMAGES AND SYMBOLS

The translation of pure thought into picture was a particular problem for certain artists of the period around 1800 whose ideas were too unfamiliar, complex, or abstract to be cast into conventional forms. Two main possibilities were open to them: an indirect expression of their thought through the medium of traditional kinds of images, or a direct

[51] *Explication des ouvrages de peinture et dessins . . . exposés au Musée Central des Arts,* Paris, 1800, p. 82.

*expression through new images. Most artists, understandably, preferred
to express themselves with the help of subjects, symbols, and stylistic
devices taken from tradition. David, for example, often used classical
history or myth to deliver comments on the political reality of his time.
His painting of the* Battle of Romans and Sabines *(see page 111) was
meant to symbolize the need for reconciliation after fratricidal conflict,
its classical style and subject were the vehicle for a specific, modern
meaning. But there were other artists who believed that idea and image
could not be considered separately, and who felt that every idea demanded
its own, particular form. To express themselves, they attempted to devise
a personal pictorial language, either by recomposing elements from
traditional iconography into new configurations, or by fusing thought
and image in one spontaneous vision.*

Philipp Otto Runge (1777–1810)

*The painter Runge was born in the North German harbor town of
Wolgast, the son of a merchant and ship builder. He grew up among
relatives and friends who combined a strong Protestant piety with a
wide-ranging interest in literature and philosophical speculation. After
two unsatisfactory years at the Academy in Copenhagen (1799–1801),
spent in submission to the routines of neoclassical pedagogy, he went to
Dresden which was then a main center of the young Romantic move-
ment, to train himself further through independent study. He met
Ludwig Tieck, the friend of Wackenroder and Friedrich Schlegel (see
pages 176, 186), whose writings he already knew. Tieck introduced him to
the mystical teachings of Jakob Boehme which were to influence the symbolism
of his work, in much the same way in which they had influenced the thought
and work of William Blake.*

*Runge's letters of this time (1801–1802) show him on the verge of a
great decision. Although he had not yet produced any significant, original
work, he felt strong enough not only to shake off academic conventions,
but to undertake the creation of a wholly new kind of art. He had in
mind an art of personal revelation which would express with compelling
force and clarity his own, scarcely utterable intimations of God, and of
the workings of God in nature and in the human soul. For this he
needed a new pictorial language. Unlike the retrospective romantics (see
page 190) who bowed to the authority of Catholic traditions and savored
the sweet severity of archaic style, the Protestant Runge believed that
the spirit and form of earlier art were dead. The new religion could
not be expressed in the old hieroglyphics. What past art had given only
at second hand, through descriptive representation and borrowed subject
matter, Runge, with incredible boldness, resolved to express directly,*

through symbolical imagery and meaningful color. Runge's conception of art as a form of language recalls Wackenroder (see page 183), but while Wackenroder thought of art as one of the "miraculous languages" spoken by God, Runge sought for an art of unlimited communication between human beings. He gave the name of landscape *to the art which he envisioned, to distinguish it from history painting, but the works in which he tried to realize his idea were actually figurative allegories placed in settings which either approached conventional landscape, like the sky and meadow of his* Morning, *or verged on abstract pattern, like the floral arabesques of his drawings of the* Times of Day.

The special difficulty which confronts the kind of expression which Runge attempted is that it must convey, through relatively simple forms, the very complex experience to which Runge always referred only as "feeling," though he evidently had in mind philosophical or religious insights imbedded in a current of strong emotion. His approach to the solution of the problem was partly intuitive, partly methodical, and even scientific, as in his elaborate researches into color which won him Goethe's respect. He failed to achieve in his work the complete unity of form and spirit which his idea demanded. His symbols struck contemporaries as obscure (see page 189). At the time of his very early death, his painting was still a patchwork of allegory and portrait, realist detail and abstract arrangement, expressive color and classicist contour. But the profundity and daring of his conception of art place him, with Blake who was his closest intellectual relative, among the most original minds of his time.

Runge's writings, including the letters from which the following excerpts are taken, were published in 1840 by his brother Daniel who tried to smoothe Runge's difficult language, but let stand many tangled sentences which resist exact translation.[52]

[1801]

Since my youth, I have often longed to convey to others, through words, signs, or whatever else might serve, something of the feeling which in my best hours animates me with a serene and stirring life. I thought: even if no one really cares about your feeling, there must be another who shares it. And if one could tell the other of it, this emotion of our soul should become as palpable as a handshake and a glance. I valued the thought more than laborious learning, since it seemed to me that this was, after all, the actual aim of science and art. But I found few people who understood me. In the beginning, I thought that people

[52] *Hinterlassene Schriften von Philipp Otto Runge,* edited by Daniel **Runge,** Hamburg, 1840, I, 3 ff. (letter of 1801); 5 ff. (letter of February 1802); 7 ff. (letter of March 7, 1802); 16 ff. (letter of November 7, 1802). See also Gunnar Berefelt, *Philipp Otto Runge, zwischen Aufbruch und Opposition, 1777–1802,* Uppsala, **Alm**quist and Wiksell, 1961.

really did understand, but pretended not to, for fear of seeming childish. Then I found that they really did not want to be children. . . . Several years ago, I discovered that there exist certain words through which men can deeply understand one another. But these words have nearly passed out of use; only their letters are preserved, as rare curiosities. People sometimes imitated and rearranged them, since they had heard that, long ago, these letters had been writing, which made them wonder whether the signs could still yield a sound. The secret lay evidently not in mere arrangement. When they opened the Egyptian tombs and found them full of hieroglyphics, people complained that these were incomprehensible. I was not surprised. What is the use of tombs, if not to bury all, the spirit as well as the living form of the hieroglyphics? And is it really certain that we understand the paintings of the Italian masters? It seems to me that people want only to understand the letters, not the words which they form. Many have in time become writers who simply like lettering —a thing which makes as much sense as a copy clerk promoted to a minister of state, simply because of his ability to make clean copies of decrees. . . .

I concluded that true art consisted of expression . . . but it needs something to express. The living force which created heaven and earth, and of which our living soul is the image, must stir and move and flourish in us, so that we may discover how much love there is in ourselves and all around us. Once we come to see and believe it, this hidden love will be found to gaze at us benevolently from every flower and color, from behind every fence and shrub, from behind the clouds and the most distant stars. I think that it must be a great joy to find a language within ourselves to express this feeling, even if only for family talk. How good to live in a family in which one can converse in this language, only fools would not enjoy it. I think that the Apostles, the great musicians, the great poets and painters really wanted to form such a family. The Apostles did succeed in this, the others only in part. . . .

[February 1802]

Art of all periods teaches us that humanity changes, and that a period, once past, never returns. Whatever gave us the disastrous idea of trying to bring back the art of the past? In Egyptian art, we see the hard, iron roughness of the human race. The Greeks deeply felt their religion, and it dissolved into works of art. Michelangelo marked the highest point in the development of composition; in the *Last Judgment* historical composition reached its final limits. Raphael already painted many compositions which can no longer be called purely historical. The *Sistine Madonna* in Dresden is clearly only a state of feeling, expressed in the form of a familiar figure. And since Raphael's time, there has been no true history painting. All beautiful compositions now tend toward

landscape, so, for instance, Guido Reni's *Aurora*. But until now no landscape artist has given his landscapes a true significance, or endowed them with allegorical meaning and intelligible, beautiful ideas. But don't we all see spirits in the clouds at sunset? Doesn't this inspire quite definite thoughts in our soul? Is it not true that a work of art comes into being only at the moment when we feel ourselves united with the universe? Can't I capture the vanishing moon, as I might capture a vanishing figure which has awakened a thought in me, and couldn't both, moon or figure, become art? And what artist who had really sensed this, and who had been awakened by nature (which we see clearly only in ourselves, in our love, and in the sky) could fail to seize the right subject for the expression of his feeling? How could he possibly lack a subject? . . . What is the use of reviving old art? The Greeks carried formal and bodily beauty to its highest point at a time when their gods were declining. The artists of modern Rome went farthest in the development of historical painting at a time when the Catholic faith was perishing. In our time, too, something is about to die. We stand on the brink of all the religions which have come down from the Catholic. The abstractions are fading away: everything is becoming more airy and light than before, everything gravitates toward landscape. The artists search for something definite in this vagueness and do not know where to start. Some, mistakenly, go back into history, and become confused. But could we not reach the point of highest perfection in a new kind of art, in this art of landscape, and perhaps reach a higher beauty than existed before? I want to express my life in a series of works; when the sun sets and the moon gilds the clouds, I shall capture the fugitive spirits. Perhaps we shall not live to see the day of this art's full beauty, but we will devote our life to its fulfillment. No common thought shall enter our soul. We can attain this high level of beauty only if we cherish the beautiful and good with fervent love. We must become children again to reach perfection.

[To his brother Daniel, March 9, 1802]

I once reflected on how the world might be overturned by a war, and on how such a war might come about, for I saw no other way. But war has turned into a science, and real war has ceased—there is no nation now which could massacre all of Europe and the civilized world, as the Germans once massacred the Romans when that nation had lost its vitality. In other words, I could see no other way than a general Judgment Day on which the earth would open up to devour the whole human race, leaving no trace of humanity's achievements up to the present day.

These thoughts were prompted by some melancholy remarks which Tieck made recently when he was ill, remarks about the spread of culture

which led to the notion of a Judgment Day. And I began to reflect on how this high culture of ours cannot be brought to its senses, except by such extreme means . . . And it seemed evident to me that, after art had reached the peak of its development in a given period (after the Olympian Zeus was carved, or the *Last Judgment* painted), it always went into a decline and dissolved, in order to reach out again toward another, perhaps even more beautiful stage of development. And I asked myself: are we now on the point of burying such a period?

I was lost in amazement, I could think no further. I sat down before my picture, and all my earlier thoughts about it passed through my soul. I thought about its growth, about the feelings which always overcome me when I see the moon or the setting sun, about the divination of spirits, and the destruction of the world.

When the sky above me teems with stars, when the wind blows through the vastness of space, and the wave breaks in the immense night; when above the forest the reddish morning light appears, and the sun begins to illuminate the world; when the valley steams, and I lie tossing in the grass which sparkles with dew; when every leaf and blade of grass teems with life, and the earth comes to life and stirs beneath me, and everything harmonizes in one great chord: then my soul rejoices and soars in the immeasurable space around me. There is no high or low, no time, no beginning or end. I hear and feel the living breath of God Who holds and supports the world, in Whom everything lives and acts—this is our highest feeling: God.

The deepest awareness in our soul—that there is a God above us; that everything once came into being, existed, and perished; that everything is now coming into being, existing, and perishing all around us; that in time everything will come into being, will exist, and will perish again; that there is no rest, no standing still; that the living soul within us came from Him and will return to Him, and will continue to exist when heaven and earth are no more—this is the clearest and most certain awareness of our self and our eternity.

We sense that something mercilessly severe and terrifyingly eternal confronts a sweet, everlasting, boundless love in furious conflict, comparable to the contrast between hard and soft, rock and water. We see them everywhere, in large and small, in general and particular forms. They are the essential realities of the world and deeply rooted in the world. They come from God, and only God is above them. They oppose one another in hard antagonism at the birth of every thing, whether it be a work of God, of man or of nature. The harsher their conflict, the more distant is a thing from perfection. The more they unite, the closer does every thing approach perfection. When it has reached the highest perfection, the spirit returns to God, and the inert material components

destroy one another in the very core of their existence. Heaven and earth perish, and from their ashes the world rises anew. The two forces are renewed and purified, in order to unite and to destroy one another again. We sense this eternal transformation within ourselves, in the world around us, in every lifeless object, and in art.—Man comes into the world helpess, unconscious, at the mercy of fate. Against this terrible menace, maternal love, the highest form of beauty, enters into combat, and unites the wild passions with sweetest love and innocence. At the point of perfection, man recognizes his kinship with the whole world. . . .

When we are carried away by feelings which make our senses tremble to their very depths, we search for concrete symbols which others have found before us, and try to match them to our feeling. In a moment of highest felicity, we may then impart our feeling to others. But if we try to prolong the moment, we overstrain it; the spirit escapes from the borrowed symbol, and we can no longer establish this connection within ourselves, unless we recapture the original intensity of feeling, or become children again. Everybody goes through this cycle in which we suffer recurrent death, and the more often we experience it, the deeper and stronger our feeling becomes. Thus art comes into life and dies, when the spirit has returned to God, leaving only lifeless signs behind.

This sense of our kinship with the whole universe; this jubilant delight of our soul's strongest and most vital spirit; this single chord which strikes every heartstring; this love which holds us and carries us through life; this sweet being besides us, who lives in us and in whose love our soul glows: all these compel and drive us to express ourselves. We hold fast to the peaks of this experience, and this causes certain ideas to arise in us.

We express these ideas in words, sounds, or images, and in this way arouse similar feelings in the hearts of our fellows. All are affected by the truth of this feeling, all feel bound up in this communion, all who feel His presence praise the one and only God, and this causes religion to come into being.—We associate these words, sounds, or images with our strongest feeling, our awareness of God, and with the certain knowledge of our eternal existence which we derive from our sense of coherence with the whole. In other words, we apply these feelings to the most important and vital beings around us, and, by seizing upon the most characteristic traits of these beings, upon those which are most in harmony with our feeling, we create symbols of our thoughts about the world's great forces. . . .

We use these symbols when we want to make others understand great events, beautiful thoughts about nature, and the lovely or terrible sentiments in our soul. . . . We search for events which suit the character of the feelings we want to express, and when we have found them, we have chosen the *subject matter* of art.

When we link this subject with our feeling, we arrange the symbols of natural forces or of our feelings in such a way that they effectively characterize themselves, the subject, and our feeling: this is *composition*.

When we have gained a clear and coherent understanding of the forms of the creatures which we have chosen as our symbols, we can derive their characteristic contour and appearance from their basic essence, from our feeling, and from their natural consistency. We observe their forms in all positions, directions, and expressions, we study every detail of the whole from nature and in relation to the entire composition, the general effect, the particular action, as well as the action of the whole work. We make these forms larger or smaller according to the laws of perspective, study the accessory details and the details of the background in accordance with nature and the subject: and this is *design*.

As we observe the colors of sky and earth, the changes of color produced in human beings by emotions and feelings, the color effects in vast natural phenomena, the relationships and symbolical implications of colors, we give to each object its proper color, establishing its harmony with our original feeling and with the various symbols and objects: this is *coloration*.

We increase or decrease the purity of colors, depending on how close or distant each object is to appear, or how large or small is the volume of air which separates the object from the eye: and this is *value*.

We study the body color of each object and the effect of strong or soft light on it, and of the shadows or lights cast on it by neighboring objects: this is *hue*.

We seek to find the nuances of color which result from the interaction of colored objects and from the fusion of colors through the intervention of light and atmosphere, and we try to determine thoroughly this unifying color key and ultimate accord of our sensations; this is *tone* —and the end.

Art's quest is most beautiful when it issues from and again merges with what is common to all mankind. I want to list here the requirements of a work of art, not merely in the order of their importance, but also in the order in which they must be cultivated by the artist:

1. our awareness of God;
2. our self-awareness in relation to the whole. And, following from these two
3. religion and art, which is the expression of our highest feelings in words, sounds, or images. In the pictorial art, we first look for
4. the subject; then
5. the composition,
6. the design,
7. coloration,

8. value,
9. hue, and
10. tone.

Is it not curious how clearly, how distinctly we sense our life when we watch heavy black clouds rushing past the moon, when we see their edges gilded by the moon or see them swallowing the moon altogether? It then seems to us as if we could write the story of our life in images such as these. And is it not true that since Buonarotti and Raphael there has not been any genuine history paintings? Even Raphael's picture at our gallery [the *Sistine Madonna* in Dresden] approaches landscape—landscape, to be sure, understood in a new way.

[November 7, 1802]

Our delight in flowers comes directly from Paradise. We always associate an inner meaning with flowers, in other words, a human form. And only that is a true flower which we have in mind in our state of joy. When we see our own life reflected in nature, we understand that this is how true landscape art will be realized, as something quite distinct from human action or historical composition.

Flowers, trees, figures will then become intelligible—and we shall have begun to understand color! Color is the ultimate in art. It is still and will always remain a mystery to us, we can only apprehend it intuitively in flowers.—Colors are based on the symbol of Trinity: light or white, black or dark are not colors; light is the good, dark is evil (I am thinking of Creation); we cannot grasp light, and we ought not grasp the dark. Then came the time when man was granted Revelation, and color entered the world: blue, red, and yellow. Light is the sun into which we may not look. But when it descends to the earth and to man, the sky turns red. Blue inspires a certain reverence in us. It is the Father, and red is the Mediator between earth and heaven. When both disappear, then fire lights up the night for us, it is yellow, the Consoler who was sent to us;—the moon, too, is yellow.

William Blake (1757–1827)

*In 1809, Blake arranged an exhibition of his "Poetical and Histori-
cal Inventions" at the house of his brother, James. Private exhibitions
were not uncommon in England, and even on the continent artists, such
as David, had recently begun to present their work to the public directly,
without submitting to the sponsorship of official bodies (see page 111).
Blake's exhibition failed, being "singularly remote from ordinary sym-
pathies, or even ordinary apprehensions," in the words of his biographer,*

Alexander Gilchrist. Many years after, in 1852, Crabb Robinson re-membered having gone to see the "exhibition of Blake's original paint-ings in Carnaby Market, at a hosier's, Blake's brother. These paintings filled several rooms of an ordinary dwelling-house, and for the sight, a half-crown was demanded of the visitor, for which he had a catalogue. This catalogue I possess, and it is a very curious exposure of the artist's mind. I wished to send it to Germany and to give a copy to Lamb and others, so I took four, and giving 10 s., bargained that I should be at liberty to go again. "Free! as long as you live," said the brother, astonished at such a liberality, which he had never experienced before, nor I dare say did afterwards. . . . There were about thirty oil-paintings, the colour-ing excessively dark and high, the veins black, and the colour of the primitive men very like that of the Red Indians." [53] *The few press notices of the exhibition were savagely hostile. Leigh Hunt's* Examiner *called the catalogue "a farrago of nonsense, unintelligibleness and egre-gious vanity, the wild effusions of a distempered brain."*

The Descriptive Catalogue, *which accompanied the exhibition, and the* Public Address, *written in 1810 after the fiasco, gave a concise state-ment of Blake's belief in innate ideas as the source of art, his defense of clear contour against the "blots & blurs" of the Venetians and Flemings, and his theory of art's prehistoric beginning. Extravagant though they seemed, his "wild effusions" expressed ideas current in Blake's time. His condemnations of colorism and of visual realism simply overstated a common neoclassical attitude, and his interest in primitive origins paral-leled that of the sect of the* Primitifs *in France (see page 136). Blake was the Winckelmann of a patriarchal antiquity that was no more flagrantly a figment of the imagination than the Homeric and Ossianic ages in which his more rational contemporaries believed. There is a general resemblance, furthermore, between Blake's conception of the imagina-tion and the notion of genius, as it had been formulated by the writers of the Storm and Stress and, earlier, by Young (see page 71). Yet it was not quite the same. While these writers had described genius as a vital, productive power, Blake regarded it as a receptive faculty, comparable to physical sight in that visions appear to it, but are not made by it. In this respect, Blake's imagination recalls the God-sent visions which Wacken-roder (see page 179) attributed to artists. But to Blake the imagination was an abiding capability, not an occasional miracle. He agreed with Lavater's description of genius as a powerful awareness, a burning certitude which is present in the consciousness, unexplained and un-*

[53] Quoted in R. Kazin (ed.), *The Portable Blake,* New York, The Viking Press, Inc., 1955, p. 677; see also Mona Wilson, *The Life of William Blake,* London, Nonesuch, 1927, p. 210, and Thomas Sadler, *Diary, Reminiscences, and Correspondence of Henry Crabb Robinson,* London, Macmillan & Co., Ltd., 1869.

questionable. It was Blake's special happiness that this experience came to him through ready-formed images which did not require further translation. On this point, he differed from Runge who was in other ways his German counterpart.[54]

From A *Descriptive Catalogue* (1809)

Preface

The eye that can prefer the Colouring of Titian and Rubens to that of Michael Angelo and Raphael, ought to be modest and to doubt its own powers. Connoisseurs talk as if Raphael and Michael Angelo had never seen the colouring of Titian or Correggio: They ought to know that Correggio was born two years before Michael Angelo, and Titian but four years after. Both Raphael and Michael Angelo knew the Venetian, and contemned and rejected all he did with the utmost disdain, as that which is fabricated for the purpose to destroy art.

Mr. B. appeals to the Public, from the judgment of those narrow blinking eyes, that have too long governed art in a dark corner. The eyes of stupid cunning never will be pleased with the work any more than with the look of self-devoting genius. The quarrel of the Florentine with the Venetian is not because he does not understand Drawing, but because he does not understand Colouring. How should he, he who does not know how to draw a hand or a foot, know how to colour it?

Colouring does not depend on where the Colours are put, but on where the lights and darks are put, and all depends on Form or Outline, on where that is put; where that is wrong, the Colouring never can be right; and it is always wrong in Titian and Correggio, Rubens and Rembrandt. Till we get rid of Titian and Correggio, Rubens and Rembrandt, We never shall equal Raphael and Albert Dürer, Michael Angelo, and Julio Romano.

* * *

No man can believe that either Homer's Mythology, or Ovid's, were the production of Greece or of Latium; neither will any one believe, that the Greek statues, as they are called, were the invention of Greek Artists; perhaps the Torso is the only original work remaining; all the rest are evidently copies, though fine ones, from greater works of the Asiatic Patriarchs. The Greek Muses are daughters of Mnemosyne, or Memory, and not of Inspiration or Imagination, therefore not authors of such

[54] G. Keynes, *Poetry and Prose of William Blake,* London, Nonesuch, 1927, pp. 778 ff., pp. 795 ff. ("The Ancient Britons"); p. 801 ("The spiritual Preceptor" and "Satan calling up his Legions"); p. 805 ("Ruth").

sublime conceptions. Those wonderful originals seen in my visions, were some of them one hundred feet in height; some were painted as pictures, and some carved as basso relievos, and some as groupes of statues, all containing mythological and recondite meaning, where more is meant than meets the eye.

The connoisseurs and artists who have made objections to Mr. B.'s mode of representing spirits with real bodies, would do well to consider that the Venus, the Minerva, the Jupiter, the Apollo, which they admire in Greek statues are all of them representations of spiritual existences, of Gods immortal, to the mortal perishing organ of sight; and yet they are embodied and organized in solid marble. Mr. B. requires the same latitude, and all is well. The Prophets describe what they saw in Vision as real and existing men, whom they saw with their imaginative and immortal organs; the Apostles the same; the clearer the organ the more distinct the object. A Spirit and a Vision are not, as the modern philosophy supposes, a cloudy vapour, or a nothing: they are organized and minutely articulated beyond all that the mortal and perishing nature can produce. He who does not imagine in stronger and better lineaments, and in stronger and better light than his perishing and mortal eye can see, does not imagine at all. The painter of this work asserts that all his imaginations appear to him infinitely more perfect and more minutely organized than any thing seen by his mortal eye. Spirits are organized men. Moderns wish to draw figures without lines, and with great and heavy shadows; are not shadows more unmeaning than lines, and more heavy? O who can doubt this!

Number V. *The Ancient Britons*

In the last Battle of King Arthur, only Three Britons escaped; these were the Strongest Man, the Beautifullest Man, and the Ugliest Man; these three marched through the field unsubdued, as Gods, and the Sun of Britain set, but shall arise again with tenfold splendor when Arthur shall awake from sleep, and resume his dominion over earth and ocean.

The three general classes of men who are represented by the most Beautiful, the most Strong, and the most Ugly, could not be represented by any historical facts but those of our own country, the Ancient Britons, without violating costume. The Britons (say historians) were naked civilized men, learned, studious, abstruse in thought and contemplation; naked, simple, plain in their acts and manners; wiser than after-ages. They were overwhelmed by brutal arms, all but a small remnant; Strength, Beauty, and Ugliness escaped the wreck, and remain for ever unsubdued, age after age. . . .

The Strong Man represents the human sublime. The Beautiful Man represents the human pathetic, which was in the wars of Eden divided into male and female. The Ugly Man represents the human reason. They were originally one man, who was fourfold; he was self-divided, and his real humanity slain on the stems of generation, and the form of the fourth was like the Son of God. How he became divided is a subject of great sublimity and pathos. The Artist has written it under inspiration, and will, if God please, publish it; it is voluminous, and contains the ancient history of Britain, and the world of Satan and of Adam. . . .

It has been said to the Artist, "take the Apollo for the model of your beautiful Man, and the Hercules for your strong Man, and the Dancing Faun for your Ugly Man." Now he comes to his trial. He knows that what he does is not inferior to the grandest Antiques. Superior they cannot be, for human power cannot go beyond either what he does, or what they have done; it is the gift of God, it is inspiration and vision. He had resolved to emulate those precious remains of antiquity; he has done so and the result you behold; his ideas of strength and beauty have not been greatly different. Poetry as it exists now on earth, in the various remains of ancient authors, Music as it exists in old tunes or melodies, Painting and Sculpture as it exists in the remains of Antiquity and in the works of more modern genius, is Inspiration, and cannot be surpassed; it is perfect and eternal. Milton, Shakespeare, Michael Angelo, Raphael, the finest specimens of Ancient Sculpture and Painting and Architecture, Gothic, Grecian, Hindoo and Egyptian, are the extent of the human mind. The human mind cannot go beyond the gift of God, the Holy Ghost. To suppose that Art can go beyond the finest specimens of Art that are now in the world, is not knowing what Art is; it is being blind to the gifts of the spirit. . . .

The strong Man acts from conscious superiority, and marches on in fearless dependence on the divine decrees, raging with the inspirations of a prophetic mind. The Beautiful Man acts from duty and anxious solicitude for the fates of those for whom he combats. The Ugly Man acts from love of carnage, and delight in the savage barbarities of war, rushing with sportive precipitation into the very jaws of the affrighted enemy.

The Roman Soldiers rolled together in a heap before them: "Like the rolling thing before the whirlwind"; each showed a different character, and a different expression of fear, or revenge, or envy, or blank horror, or amazement, or devout wonder and unresisting awe.

The dead and the dying, Britons naked, mingled with armed Romans, strew the field beneath. Among these the last of the Bards who were capable of attending warlike deeds, is seen falling, outstretched among the dead and the dying, singing to his harp in the pains of death.

Distant among the mountains are Druid Temples, similar to Stone Henge. The Sun sets behind the mountains, bloody with the day of battle.

The flush of health in flesh exposed to the open air, nourished by the spirits of forests and floods in that ancient happy period, which history has recorded, cannot be like the sickly daubs of Titian or Rubens. Where will the copier of nature as it now is, find a civilized man, who is accustomed to go naked? Imagination only can furnish us with colouring appropriate, such as is found in the Frescos of Raphael and Michael Angelo: the disposition of forms always directs colouring in works of true art. As to a modern Man, stripped from his load of cloathing he is like a dead corpse. Hence Reubens, Titian, Correggio and all of that class, are like leather and chalk; their men are like leather, and their women like chalk, for the disposition of their forms will not admit of grand colouring; in Mr. B.'s Britons the blood is seen to circulate in their limbs; he defies competition in colouring.

Number VIII.

The spiritual Preceptor, an experiment Picture.

The subject is taken from the Visions of Emanuel Swedenborg, Universal Theology, No. 623. The Learned, who strive to ascend into Heaven by means of learning, appear to Children like dead horses, when repelled by the celestial spheres. The works of this visionary are well worthy the attention of Painters and Poets; they are foundations for grand things; the reason they have not been more attended to is because corporeal demons have gained a predominance; who the leaders of these are, will be shown below. Unworthy Men who gain fame among Men, continue to govern mankind after death, and in their spiritual bodies oppose the spirits of those who worthily are famous; and, as Swedenborg observes, by entering into disease and excrement, drunkenness and concupiscence, they possess themselves of the bodies of mortal men, and shut the doors of mind and of thought by placing Learning above Inspiration. O Artist! you may disbelieve all this, but it shall be at your own peril.

Number IX.

Satan calling up his Legions, from Milton's Paradise Lost; a composition for a more perfect Picture afterward executed for a Lady of high rank. An experiment Picture.

These Pictures, among numerous others painted for experiment, were the result of temptations and perturbations, labouring to destroy

Imaginative power, by means of that infernal machine called Chiaro Os-
curo, in the hands of Venetian and Flemish Demons, whose enmity to the
Painter himself, and to all Artists who study in the Florentine and Roman
Schools, may be removed by an exhibition and exposure of their vile
tricks. They cause that every thing in art shall become a Machine. They
cause that the execution shall be all blocked up with brown shadows.
They put the original Artist in fear and doubt of his own original con-
ception. The spirit of Titian was particularly active in raising doubts
concerning the possibility of executing without a model, and when once
he had raised the doubt, it became easy for him to snatch away the vision
time after time, for, when the Artist took his pencil to execute his ideas,
his power of imagination weakened so much and darkened, that memory
of nature, and of Pictures of the various schools possessed his mind, in-
stead of appropriate execution resulting from the inventions; like walking
in another man's style, or speaking, or looking in another man's style
and manner, unappropriate and repugnant to your own individual char-
acter; tormenting the true Artist, till he leaves the Florentine, and adopts
the Venetian practice, or does as Mr. B. has done, has the courage to
suffer poverty and disgrace, till he ultimately conquers.

Rubens is a most outrageous demon, and by infusing the remem-
brances of his Pictures and style of execution, hinders all power of in-
dividual thought: so that the man who is possessed by this demon loses
all admiration of any other Artist but Rubens and those who were his
imitators and journeymen; he causes to the Florentine and Roman
Artist fear to execute; and though the original conception was all fire
and animation, he loads it with hellish brownness, and blocks up all its
gates of light except one, and that one he closes with iron bars, till the
victim is obliged to give up the Florentine and Roman practice and adopt
the Venetian and Flemish.

Correggio is a soft and effeminate, and consequently a most cruel
demon, whose whole delight is to cause endless labour to whoever suffers
him to enter his mind. . . .

Number XV.

Ruth.—A Drawing.

The distinction that is made in modern times between a Painting
and a Drawing proceeds from ignorance of art. The merit of a Picture
is the same as the merit of a Drawing. The dauber daubs his Drawings;
he who draws his Drawings draws his Pictures. There is no difference
between Raphael's Cartoons and his Frescos, or Pictures, except that the
Frescos, or Pictures, are more finished. When Mr. B. formerly painted in
oil colours his Pictures were shown to certain painters and connoisseurs,

who said that they were very admirable Drawings on canvass, but not Pictures; but they said the same of Raphael's Pictures. Mr. B. thought this the greatest of compliments, though it was meant otherwise. If losing and obliterating the outline constitutes a Picture, Mr. B. will never be so foolish as to do one. Such art of losing the outlines is the art of Venice and Flanders; it loses all character, and leaves what some people call expression; but this is a false notion of expression; expression cannot exist without character as its stamina; and neither character nor expression can exist without firm and determinate outline. . . .

The great and golden rule of art, as well as of life, is this: That the more distinct, sharp, and wirey the bounding line, the more perfect the work of art, and the less keen and sharp, the greater is the evidence of weak imitation, plagiarism, and bungling.

From *Public Address* (1810) [55]

Men think they can Copy Nature as Correctly as I copy Imagination; this they will find Impossible, & all the Copies or Pretended Copiers of Nature, from Rembrandt to Reynolds, Prove that Nature becomes to its Victim nothing but Blots & Blurs. Why are Copiers of Nature Incorrect, while Copiers of Imagination are Correct? this is manifest to all.

* * *

The English Artist may be assured that he is doing an injury and injustice to his Country while he studies & imitates the Effects of Nature. England will never rival Italy while we servilely copy what the Wise Italians, Raphael & Michael Angelo, scorned, nay abhorred, as Vasari tells us.

* * *

A Jockey that is anything of a Jockey will never buy a Horse by the Colour, & a Man who has got any brains will never buy a Picture by the Colour.

* * *

No Man of Sense ever supposes that copying from Nature is the Art of Painting: if Art is no more than this, it is no better than any other Manual Labor; anybody may do it & the fool often will do it best as it is a work of no Mind.

[55] G. Keynes, *op. cit.*, pp. 808 ff.

3

Restoration

C. Købke, Young Artist Studying Casts of the Elgin Marbles,
1830, Hirschsprungske Samling, Copenhagen

INTRODUCTION

The revolutionary enthusiasm of the last decades of the 18th century had pervaded every sphere of life, raised every hope, and released immense energies. Nearly all the artists of the time, whatever their nationality, class, or personal bent, were stimulated by it, Blake in Felpham no less than David in Paris, or Carstens in Rome. "A fresh morning gradually dawned for all these artists," Carus wrote in his life of Friedrich, "the volcanic tremors which transformed Europe after 1789 reverberated in peculiar ways in the arts as well as the sciences. . . ." [1] But the earliest signs of fatigue and retreat already began to appear before 1800, and, by 1810, the movement of reaction had become general. Exhausted by revolutions and wars, tired of the quest for liberty, afraid of further experiment, men sought peace in a return to stable institutions and old beliefs. It was not only the historical circumstance of Napoleon's downfall, it was a general readiness and resignation which permitted the systematic reconstruction, after 1815, of church and monarchy, and of a great variety of authoritarian institutions besides, the discredited academies among them. But the movement of reaction did not only revive prerevolutionary ideas and institutions, it converted to its own ends many of the innovations of the revolutionary period. Thus the study of national origins and traditions, begun by the libertarians of Storm and Stress, was continued in the interest of state and monarchy by conservative nationalists; the Museum, a creation of the Enlightenment and the Revolution, became a mainstay for the promoters of retrospection and revival. In the arts, the time about 1815 marks a division between two eras. Although the main movements, classicism as well as romanticism, seemingly continued uninterrupted, and actually grew into their more popular and familiar forms only after that date, the vital and innovative phase of their development had in fact come to an end by 1815. What followed directly was an aftermath of limited and imitative art, given over to refinements of style and sentiment. The progressive work of Constable and Turner, Gericault and Delacroix derived from other sources and signalled a fresh start.

[1] C. G. Carus, "Friedrich der Landschaftsmaler," *Kunstblatt,* 1840, p. 357.

REVIVAL OF INSTITUTIONS

The period following the Revolution witnessed the rapid growth of state-sponsored institutions and the return of state patronage. This development was most spectacular in France, where the revolutionary government already had created the prototype of the modern national museum and had begun to centralize the administration of the arts. Napoleon availed himself of these beginnings, and was able to assemble within a very short time the greatest museum collection which had ever existed, while organizing simultaneously a system of state patronage of the arts which equalled the most ambitious enterprises of Renaissance popes and Baroque monarchs. The other European nations, particularly England (see page 240), Russia, Spain, Austria, Bavaria, and Prussia followed the French example, though more slowly and on a more modest scale.

The Central Museum

During the latter half of the 18th century, princely collections of art throughout Europe gradually acquired the character of public museums. In Paris, a portion of the royal collections was opened to the public at the Luxembourg as early as 1750. For several decades thereafter, ambitious projects were made for a more complete installation of the king's pictures in the long gallery of the Louvre. By 1781, the opening of the great museum seemed imminent. The English engraver, Valentine Green, reported: [2]

The Parisian Academy is now assembling the works of all their great masters; and by a thorough renovation of them, in whatsoever parts they may have been impaired by time, or accident, they will set them before an applauding people with all their original splendor. . . . To give honourable reception to those Pictures and Statues, the upper apartments of the New Louvre are under preparation; and through the whole extent of that magnificent palace, a length of upward of 1300 feet . . . new lights are introduced from its roof and sides, in addition to those it originally possessed . . . in order to produce a regular, impartial, and equal distribution of light. In addition to those works of the French School, will be collected, the numerous and valuable Pictures, which for want of room, are huddled together in the most unfavourable manner,

[2] Valentine Green, *A Review of the Polite Arts in France,* London, 1782, p. 25.

in and about the Palace of Versailles, to the amount of some thousands, by the best Italian, and other Masters, and of the first order. . . .

But the project of a central, national museum of the arts was not to be realized for yet another decade. The Revolution finally achieved, with dazzling speed and on the most impressive scale, what the monarchy had so sluggishly begun. The first revolutionary foundation was the Museum of French Monuments which was begun in 1790 for the purpose of gathering together the confiscated art properties of the church, and to preserve from further damage the fragments of vandalized ecclesiastical and royal monuments. The collection was in charge of the painter Alexandre Lenoir (1762–1839) who converted what might have been a simple depot into a well-organized, public museum of sculpture. In the preface of the museum's catalogue (1810), he described his intention: [3]

The destruction of monuments of art was an inevitable consequence of the political disorders. It is only too well known to what excesses a misguided multitude can be brought whose fury is all the more redoubtable for being inspired by the idea of wrongs to be avenged. In those stormy times, the officials of the government showed a great deal of zeal and prudence. They surrounded themselves with virtuous citizens who, to this day, merit the praise of the public, because of their intelligence and probity. . . . The National Assembly, having decreed the nationalization of the property of the clergy, charged its Committee for Confiscations with the conservation of works of art which fell under this heading. M. de Larochefoucauld, the president of the Committee, gathered together several scholars and artists to undertake the selection of those monuments and books which were to be preserved. The municipality of Paris, charged with the execution of the National Assembly's decree, on its part also appointed scholars and artists to assist the Committee for Confiscations. The scholars thus appointed formed a commission known as the *Commission des monuments.* Next, a convenient location had to be found for the storage of the treasures that were to be saved from destruction. The Committee for Confiscations chose the monastery of the Petits-Augustins to house the sculptures and paintings, and the monasteries of the Capucins, the Jesuits, and the Cordeliers for the books and manuscripts. The Commission published expert instructions concerning methods for the preservation of the precious objects which it intended to collect. I was attached to this commission at the time (October 12, 1790) and entrusted in particular with the collection, arrangement,

[3] Alexandre Lenoir, *Museum of French Monuments* (J. Griffith, trans.), Paris, 1803, p. XVI. See also Cecil Gould, *Trophy of Conquest,* Faber and Faber, London, 1965, for an account of the development of French national museums in the period of the Revolution and the Empire.

and conservation of sculptural monuments. . . . Animated by a true love of art, I did more than that. I gathered together all the monuments which misguided fury had mutilated or destroyed. I shall pass over the difficulties, the annoyances, the obstacles, and even dangers which I had to overcome in order to assemble some five hundred monuments of the French monarchy, to put them in order, to restore, classify, describe, and reproduce them by means of engravings. . . .

The public display in Paris of hundreds of sculptures from the old churches and monasteries of France gave a powerful stimulus to the revival of interest in medieval and Christian art. Lenoir's careful historical arrangement of his collection increased its value for scholars, the romantic style of his display fascinated artists and the general public. An English traveller who visited the Museum in 1802 wrote of his impressions: [4]

This morning we spent three or four delightful hours in the *Musée National des Monuments Francais*—an institution which was projected and organized by Citizen Lenoir. To his industry and sagacity the Republic is indebted for the restoration of upwards of five hundred Gallic monuments, which he has arranged in the several apartments of the convent. By classing these specimens of art according to the ages in which they were respectively produced, he has contrived to give an excellent elucidation of the state of sculpture in France, at every period, from the decline of the Roman empire to the end of the reign of Louis XV. In the distribution of the several classes, Lenoir has evinced a considerable degree of judgment. The dim religious gloom of the apartments destined for the reception of the recumbent figures of the saints and warriors of the middle ages, lends the rude efforts of art an interest which they do not in themselves possess. The more exquisite productions of the time of Francis I and the well-wrought sculpture of the age of Louis XIV are disposed in the lightsome halls, where their beauties will be best discerned. In the garden of the convent, which is planted with acacias and willows, he has deposited several ancient tombstones. Here the English traveller will not fail to distinguish the simple monument of Abelard and Heloise. The windows and cloisters are ornamented with painted glass, transported from the glowing windows of a thousand churches, which the bigoted intolerance of modern philosophy had doomed to devastation and pillage.

Alexandre Lenoir clearly recognized the importance of the museum as a place of study for artists, and he accurately predicted that museums

[4] Rev. William Shepherd, *Paris in Eighteen Hundred and Two*, London, 1814, pp. 83 ff.

*would some day rival, and perhaps replace, the Academy. The oppor-
tunity for independent study which the new museums offered was to have
a more radical and lasting effect on the future of artist-training than the
temporary suppression of the Academy during the Revolution. Lenoir
wrote in 1803:* [5]

Versed from my infancy in the art of drawing, I became convinced
that collections were of more service to the progress of the arts than
schools, where the pupils never see any works of art. . . . A museum . . .
ought to have two objects in view, the one political, the other that of
public instruction. In a political point of view, it should be established
with sufficient splendor and magnificence to strike the eye and attract the
curious from every quarter of the globe, who would consider it as their
duty to be munificent amongst a people friendly to the arts; in point of
instruction, it ought to contain all that the arts and sciences combined can
produce toward the assistance of public teaching: such were the museums
of the ancients, whose memory we still respect.

If, for the success of the arts, it were ever necessary to do away with
the academies, formed on an imperfect basis, the progress of the arts
would demand that a clear and easy method of teaching be instituted to
enable students to consult the great masters with facility. Such means
of study naturally present themselves in a museum chronologically ar-
ranged, where youth will find, by the comparisons which they themselves
make, certain and proper models to direct their studies.

The Musée Napoleon

*After the fall of the French monarchy in 1792, the revolutionary
government rapidly carried out the old project of transferring the royal
collections to the Louvre. While the sculptural monuments were being
assembled at the Petits-Augustins under Lenoir's care, some five hundred
paintings from the king's collection and from the secularized churches
were brought to the Louvre, which was formally opened to the public
on August 10, 1793. Shortly thereafter, the national museum received
a huge addition, in the form of the spoils of the Belgian campaign of
1794. It was during this campaign that the policy of systematic art loot
in the conquered territories was first instituted by the French government.
Commissioners, attached to the army command, carried out the selection
and removal of works of art from churches and princely collections for
the benefit of the museum. The system was continued on an even larger
scale during Napoleon's campaigns in Italy in 1795–1797. The finest*

[5] Alexandre Lenoir, *Description historique et chronologique des monumens* . . .
réunis au Musée des Monumens Francais, Paris, 1803; see also L. Courajod, *Alexandre
Lenoir, son journal et le Musée des Monuments Francais,* Paris, 1878.

*paintings and sculptures were taken from the churches and collections of
Parma, Modena, Milan, Bologna, Verona, and Venice, from the Papal
collections in the Vatican, and the royal collections in Turin. The ship-
ments reached Paris during 1797 and 1798. Napoleon wished to mark the
entry of these captive works of art into the Louvre, soon to be called
Musée Napoleon, by a great procession, styled after the triumphs of
Roman conquerors, but also reminiscent of the Republican festivals
which David had organized for Robespierre (see page 134). The following account
was written by a pupil of David, the painter Etienne Delécluze (1781–1863):*[6]

It was resolved to arrange a triumphal entry on that day (July 27,
1798, the anniversary of Robespierre's fall) for all the crates containing
the manuscripts, books, statues, and paintings from the library and
museum of the Vatican. For this purpose, the crates were placed on
enormous carts, drawn by richly caparisoned horses, and to these treasures
of art, treasures of another kind were added, to give the procession a
character of encyclopedic completeness. . . . The whole long train was
divided into four sections. At the head advanced the crates filled with
manuscripts and books. Next came those which contained the most in-
teresting mineral products of Italy, among them the Veronese fossils.
To complete this museum of natural history on wheels, there were iron
cages holding lions, tigers, and panthers, surmounted by huge palm
branches, carobs, and other exotic plants brought to France by our naval
officers.

These were followed by a long file of carts filled with crated paint-
ings, inscribed with the titles of the most famous works, such as Raphael's
Transfiguration, and Titian's *Christ.* . . . Finally, on specially con-
structed, heavy carts followed the sculptures and marble groups: the
Apollo of Belvedere, the *Nine Muses,* the *Antinous,* three or four statues
of *Bacchus,* the *Laocoon,* the *Gladiator,* and other specimens of the best
antique sculpture. These carts and their precious cargoes bore numbers
and were bedecked with laurel branches, bouquets and wreaths of flowers,
and with flags taken from the enemy. Inscriptions in French, Latin, and
Greek identified the divinities and other personages represented by the
statues, or celebrated the glorious achievements of the Army and of its
general to whom we owed these prodigious riches.

Each of the four sections was preceded by detachments of cavalry
and infantry, with drummers and bands, and by the members of the
Institute whose field of specialization corresponded to each of the four
sections, accompanied by scholars and artists. Behind them marched
actors, chanting hymns of joy. . . . This immense procession traversed

6 E. Delécluze, *Louis David, son école et son temps,* Paris, 1855, pp. 206 ff.

all of Paris, to pass in review at the Champ de Mars, before the five members of the Directory who stood at the Altar of the Fatherland, surrounded by the ministers of state and high officials of the government, the generals of the garrison, and an immense crowd of spectators who had come to witness a public ceremony which aroused the liveliest and most sincere enthusiasm. As can be imagined, this enthusiasm was especially strong among the artists. . . .

One man only held a contrary opinion, and had the courage to express it—David. . . . Etienne [the author] resolved to question him about it. "Bear in mind, dear Etienne," said David, "that the arts are not naturally loved in France; the taste for them is artificial. You can be sure that, in spite of all the enthusiasm which we see these days, the masterworks from Italy will soon be regarded only as curiosities. The site of a work of art, the distance one must travel to see it contribute singularly to our notion of its worth. This is particularly true of the paintings which one hung in churches. They will lose much of their beauty and effect when they are no longer seen in the places for which they were made. The sight of these masterpieces will perhaps produce scholars, men like Winckelmann, but artists—no!"

After the Peace of Amiens, in 1802, which opened the French frontiers, many Englishmen and Germans took the road to Paris expressly to see the spoils of Flanders and Italy at the Louvre. Among the English artists who made the voyage were Turner, Flaxman, Opie, Farington, Hoppner, and Shee; the American Benjamin West and the Swiss Fuseli came from London, the architect Gilly and the brothers Schlegel from Germany. Some of the visitors found the sheer number and variety of the exhibited works confusing. The painter Martin Shee (1769–1850) wrote: [7]

The extraordinary assemblage of works of Art deposited in the Louvre at Paris appears in this respect on the first view quite embarrassing. All is confusion and astonishment, the eye is dazzled and bewildered, wandering from side to side, from picture to picture; like a glutton at a feast, anxious to devour everything, till the intellectual stomach, palled and oppressed by variety, loses the pleasure of taste, and the power of digestion.

The German publicist, J. F. Reichardt, expressed the more common sentiment of admiration: [8]

[7] Martin A. Shee, *The Elements of Art*, London, 1809, p. 174.
[8] J. F. Reichardt, *Vertraute Briefe aus Paris, geschrieben in den Jahren 1802 und 1803*, Hamburg, 1805 (second edition), I, 124 ff.

I have already spent several delightful mornings in the magnificent *Musée Central des Arts,* in incredibly rich galleries filled with ancient sculptures and with paintings of all the schools. It is a pity, however, that the light which enters the gallery from two sides makes it impossible to see the paintings properly. Large pictures in particular can almost never be encompassed in one glance. It is necessary to find the proper light for each of their various parts by moving from one to the other. . . . In the immense gallery which extends a great distance without interruption, we find, to begin with, the best painters of the French school. Here the works of Lebrun, Poussin, and Lesueur fascinate the lover of art above all. Vernet is represented by some of his most beautiful works, but I think that I have seen better pictures by Claude Lorrain elsewhere, though there is a *Sunset* here which must surely be among his most important works.

The collection of Netherlandish and German paintings which follows is especially rich in beautiful Van Dycks and Rembrandts, and in splendid masterworks by Rubens. Contemplating these last, I was initially put off at finding so many of them hung side by side. Lovers of art who are familiar with this master's work will understand the reason why. There are also numerous, excellent works by our worthy Dürer and by Holbein here, but these masters can be better studied in Basel, Nuremberg, Augsburg, and other German cities, just as Van der Werff is better represented in Düsseldorf.

It was only when entering the last section of the gallery, which houses the Italian school, that I felt I had reached my destination. What an abundance of the most beautiful, most magnificent works of art, and, in the majority of them, what elevation and beauty of artistic character! With what deep pleasure one finds here the works of Albano, the Carracci, of Correggio, Domenichino, and Guercino, more complete than anywhere else in the world. And yet, after enjoying these paintings for hours on end, one has still to see the work of the divine Raphael. This highest pleasure has intentionally been saved for the last. Marvellous works by this master are shown here, and several more, of even larger format, will soon be put on view. These are still in the hands of restorers, for, unfortunately, many of the works brought from Italy have suffered barbarous treatment, despite all the loudly-trumpeted claims of care and precaution.

. . . Today, I yielded to a temptation to sneak into the restorer's shop. The guardian of the key proved corruptible. Heavens! what delights, what inexpressible delights I experienced in looking at Raphael's inconceivably beautiful *Transfiguration.* This, the most exalted masterwork of art, the greatest which the excellent, divinely inspired Raphael executed with his own hand, and which, when it was still in Italy, could

be seen only in the miserable gloom of a church—I saw it here in the light of noon, the best possible illumination. And I was able to contemplate it alone, locked into its room for hours on end. I have not enjoyed a work of art so keenly since last I sat before the same master's magnificent *Madonna* in the Gallery of Dresden. . . .

Several hundred of the best Italian paintings still fill the racks of damaged pictures. Most of them are in sad condition. A *Holy Family* by Raphael is in such a ruinous state that it is difficult to believe it can ever be restored in such a way as to satisfy the eye of the connoisseur. . . .

The antique sculptures seem to have been more carefully handled during shipment. Some of the most important pieces, however, the *Laocoon,* for instance, have suffered damage which, though not serious, is quite noticeable. . . . Many of the sculptures, including the *Apollo of Belvedere,* are placed too high. His feet are roughly at the spectator's eye level, and his divine body can only be seen from below. In Italy, he also stood too high, but at least was better illuminated. Here he received light from a window at his side which descends to a point lower than his feet. To see the statue well in its true character, one must climb on a stool opposite. In Italy, the statue was seen to best advantage by torch light, a form of illumination which has not yet come into fashion in Paris.

The annoying Roman custom of covering the private parts of antique statues with metal fig-leaves, tinted green, has not been followed here, but the obtrusive Papal inscriptions have been imitated. The pedestal of the *Apollo of Belvedere,* for instance, carries a bronze plaque with a lengthy inscription which Bonaparte himself fastened to the statue when he first inspected it here:

The Statue of Apollo which Rises upon this Pedestal
Was Found at Antium at the End of the Fifteenth Century, and
Placed in the Vatican by Julius II at the Beginning of the Sixteenth.
Conquered in the Fifth Year of the Republic by the Armies of Italy
Under the Orders of General Bonaparte,
It was Placed here on the 10th of April, 1800,
In the First Year of his Consulate.

Throughout the reign of Napoleon, the Museum continued to grow, enriched by the spoils of the successive campaigns in Germany and Spain, and by further acquisitions from Italy. After Napoleon's first abdication, in 1814, the question of restitution remained unresolved, but after his final defeat at Waterloo, in 1815, the Allies swiftly dismantled the Musée Napoleon, *despite the protests of the French government and the resistance of the Museum's energetic director, Vivant Denon. The re-*

moval of the works of art aroused a long and bitter quarrel over the morality and legality of this particular venture in museum building, and over the general issue of the museum's usefulness to students of art. The following account, written in 1814 by a British visitor to Paris, reflects these controversies: [9]

As I walked along the Gallery of Pictures, I looked out from the windows on the Place du Carousel. It was a court day at the Tuileries, and the Gardes du Corps of Louis were lounging over the balcony of the Palace, while crowds were assembled to see the ministers and nobility, who went to pay their respect to His Majesty. A few months before, and all this was happening in favor of Napoleon. . . . His N's and his monuments are everywhere about, but he himself is removed! And this temple of taste, and these palaces—many years have not elapsed since they were the scenes of savage ferocity and wanton carnage. Through this gallery a French King and his family flew, pursued by murderers, never more to return to a royal residence.—These multitudes, that are now pressing round pictures and chattering criticism on works of taste, were formerly equally occupied and amused with an exhibition of dancing dogs under the guillotine!

It is only such a people as this, that could have collected what is amassed together in Paris, and it is only such a people as this that could vaunt of such a collection, amassed under such peculiar circumstances, in the tone and language which they use. Others have gone to the seats of these sacred monuments to admire and venerate—but they went to pack and transport. Their armies advanced, burning houses and violating women; and in their rear came the members of the Institute to worship fine art and commit sacrilege in its temples. . . . A worse mistake cannot be committed than the supposition that facilities are chiefly useful to the cause of taste and science. . . . Let the student be exposed to hazards . . . let him incur difficulties; they will, if he be worthy of his pursuit, encrease his ardour. . . . Let the student be led in a painful pilgrimage to the honour of his divinity, from Paris to Germany, from Germany to Rome, from Rome to Florence. The sacred flame will be fanned by the motion, and his mind be informed and corrected by observation.

Magnificent galleries of foreign productions do little or no credit to the mind of a country, and perhaps it would not be too much to say that they are positively injurious to the mind. The Greeks had no galleries of Egyptian art;—if they had, we should not have received from their artists the precious bequests which have survived to this day. . . .

[9] John Scott, *A Visit to Paris in 1814*, London, 1816, pp. 246 ff.

The following account of the removal of the looted works of art from the Louvre was written by a British officer who witnessed the operation in 1815: [10]

At the first entrance of the armies in Paris, and very shortly after the contribution levied through the Prefect of the Seine, by Blucher, a requisition was made by the same vieille moustache, to have some pictures and a statue, that had been taken from Prussia, restored. Some of the pictures had ornamented the apartments of the Queen of Prussia, and were then in the Palace of St. Cloud; the bronze statue was in the gallery of the Museum. Denon, the director, demurred to this proposal; he was consequently arrested by some Prussian soldiers. . . . With such arguments there could be no debate. The pictures, among which were two of Correggio, and the statue, were packed up, as well as some others claimed by the King, as belonging to Aix la Chapelle and Cologne, and sent off. The French hoped that this was the last attack on their riches. It may be easily conceived their surprise and chagrin, when a fresh claim started up toward the latter end of August from the new King of the Belgians, for the pictures that were taken from the churches in that country, and this claim was supported by our minister in Paris. . . .

The ice, once broken, a general restitution seemed resolved on, and Canova, the celebrated sculptor, arriving from Rome, hastened the measure to a conclusion, as he claimed the protection of the British government. The attack now became general. The guardianship of the galleries was virtually taken from the French, and a guard of British troops stationed there, who prevented the French, with few exceptions, from entering—possibly in the fear that they might take their revenge by mutilating the pictures. These were easily removed and packed up, but it was a different affair with respect to the statues. It was said that the French did not require any orders from the Government to avoid giving assistance, as not one of them would lend a hand. I went frequently in during the process of packing, and saw several men there at work, who bore all the appearance of Parisian workmen, but the guardians of the Museum positively asserted that these were not Frenchmen, but foreigners settled in Paris. Being in coloured clothes, I insinuated myself among the groups of Frenchmen that occupied the space in front of the Louvre, and its approaches, and was much edified at the expressions of mingled rage, shame, and grief; if we had partitioned France among the allies, and made all the inhabitants tributary serfs, there could have been scarcely greater consternation. . . . Everyone has heard the story of the girl who fell in love with the Apollo; the grief and sorrow of both men and women for its departure were of the deepest character,

[10] Anonymous, *Cogitations of a Vagabond*, London, 1838, pp. 175 ff.

and nearly equalled that of the passion of the young lady. Some of the artists who were allowed to be present when this inimitable statue was put into its case, shed tears, and kissed the hand of marble. All the feelings . . . reached their climax when the train of carriages with the packages moved off, under an escort of our 52nd light infantry. . . . The pictures, as I have said, were more manageable, and some of them were taken out of the frames and rolled up, but the celebrated one of the Transfiguration being painted on wood, could not be easily stowed away. The workmen, in lowering it down, let it slip out of their hands, and it fell on the floor. The fall caused the dust out of innumerable worm holes in the back of the picture to fly out, and for a moment to hide the picture itself. A cry of horror broke from the spectators, imagining that it was smashed to pieces; fortunately, they were deceived. . . .

The Reorganization of State Patronage under Napoleon

The scope and style of Napoleon's management of the arts are apparent in the detailed administrative memorandum which he sent, on August 6, 1805, to Pierre Daru, Intendant-General of the Imperial Household: [11]

It will be necessary to do something about the small park of Versailles . . . the grill must be repaired, guards and door keepers must be installed. Money has been set aside for the repair of the walls of the small park. Have the fountains and gardens of the Petit Trianon put in as good a shape as they have ever been in. . . .

As for the encouragement to be shown to the arts: the Imperial Library is under the authority of the Minister of the Interior, at whose disposal I have put 200,000 francs for the purpose this year; I do not know why the Minister of Finance has been unwilling to pay him this sum. A large part of the budget of the Imperial Household is spent on furnishings, paintings, the decoration of palaces, all of which amounts to an encouragement of the arts. With this in mind, the Intendant-General must exercise all his care and ingenuity to promote whatever might serve to stimulate industry, give encouragement to the arts, and excite the zeal of artists. David receives rather considerable sums for the arts. My librarian has made me subscribe to numerous engravings and books. I shall not refuse whatever you believe to be necessary for the encouragement of artists, but I do not want this to be considered as an obligation. The manufactories of Savonnerie, of the Gobelins, and of Sèvres must be made to function in such a way as not to burden the budget of the Imperial Household, in other words, their cost must be

[11] *Correspondance de Napoléon Ier*, Paris, 1862, XI (An XIII), 78, No. 9050.

repaid in the form of goods. Whenever embellishments are undertaken in one of the palaces, the interests of the arts and of industry must be considered, this is something which is still neglected at present. The Museum is operated at my expense, it costs a large sum of money; this, too, is an encouragement given to the arts. All these things are being done incoherently. It will be necessary to take hold of all these activities, to pay the various people involved personally, to look them over, and know their functions. I want you to know that I intend to direct the arts particularly toward those subjects which will help to perpetuate the memory of the events of the past fifteen years. It is amazing that I have not been able to persuade the Gobelin tapestry works to leave Holy Writ alone and to put their artists to work at last on the many deeds which have recently distinguished the army and the nation. When you have the time, please give me an itemization of the statues, engravings, paintings, etc., which I have ordered. I imagine that M. Ségur who has the money for the execution of the Coronation Book will have started this work by now. It is an important undertaking. The work of M. Denon who is touring the Italian battle fields to prepare topographical drawings and maps . . . will open still another opportunity for artistic enterprise. . . .

David in the Service of Napoleon

David achieved the transition from regicide to courtier with remarkable ease and speed. From 1797 onward, he enjoyed the protection of Bonaparte who had recognized, with a sharp eye for strategic advantage, the important part which the arts could play in the seizure of power. By flattering David, then still in half-disgrace, he won for his cause the most influential artist of France and, at the same time, a prominent ex-Jacobin willing to be rehabilitated. It was Napoleon's plan to complete, on the grandest scale, the design for state sponsorship and control of the arts which the revolution had only sketched in outline. He found in David a deeply experienced helper, chastened by recent misfortune, but still fiercely ambitious. Immediately after Napoleon's accession to the imperial throne, in 1804, David was appointed to the position of premier peintre. *As such, he tried—with little success —to persuade Napoleon to invest him with the rights and privileges which Le Brun had enjoyed as court painter to Louis XIV. Only ten years had passed since the fall of Robespierre. David, once the friend of Marat, now took his stand at the foot of Napoleon's throne and dedicated his great talent to the restoration of monarchical traditions.*[12]

[12] J. L. Jules David, *Le peintre Louis David*, Paris, 1880, pp. 417 ff.

To M. de Fleurieu, Intendant-General to His Majesty, etc. [June 30, 1805]

Dear Sir,

As you read the enclosed proposal which I am asking you to submit to His Majesty, I flatter myself that you will not find my demands exaggerated; the functions which it defines are those which have always been attached to the position of *premier peintre.*

Since the time of Louis XIV, the Direction of Arts and Manufactures has always been in the charge of the Superintendant-General of Buildings. Colbert worked with the king, Le Brun worked with Colbert. With regards to the arts, I should be what Colbert was, if His Majesty deigns to accept my request. You would be the intermediary between the artists and the Throne, and I should be the artists' spokesman with you. This, Mr. Intendant-General, is the hierarchical order which was indicated to me and which I have scrupulously followed. . . .

[signed] David

To His Majesty, Emperor of the French and King of Italy.

Sire:

All the greatness which has shed its luster on your accession to the throne, all the astounding virtues which you unite within yourself and of which every single one would suffice to make a hero—all of these would be lost in the darkness of time, were it not for the arts, and the tribute of gratitude which they owe to you. You have bequeathed to them all your thoughts and all your actions; now history, poetry, painting, sculpture, and architecture have the mission to transmit them to posterity. . . .

Your First Painter, whom Your Majesty has honored with one of the most eminent positions in the arts, begs you to define the functions of his position, in order that he may gloriously complete, under your august protection, the salutary revolution which he has brought about in the arts.

Deeply confident of that kindness of which Your Majesty has deigned to give me such conspicuous marks, I have the honor of submitting to you the following draft:

Article I: Under the supervision of the Intendant-General of the Imperial Household, the First Painter will initiate and direct the execution of all enterprises connected with the arts of design, painting, sculpture, and engraving which are destined for His Majesty's various establishments, such as the Musée Napoleon, the Museum of Versailles, the manufactories of the Gobelins, of Sèvres, Savonnerie, and Beauvais.

Article II: The First Painter will examine all works of art which are proposed for exhibition at the Louvre and at whatever other places His Majesty should designate.

Article III: Whenever His Majesty wishes to have paintings, statues, engravings or tapestries executed, the Intendant-General will transmit his orders to the First Painter who, in collaboration with the Intendant, will designate the artists worthy of carrying out His Majesty's intentions.

Article IV: When it is necessary to advance funds to artists carrying out orders received from the Intendant-General through the agency of the First Painter, the First Painter will notify the Intendant of this fact who will authorize the appropriate sums in response to the First Painter's request.

Article V: The First Painter will be charged with the presentation to the Intendant-General of those paintings, statues, drawings and other works of art the acquisition of which he wishes to propose for the enlargement and completion of His Majesty's collections or the decoration of His Majesty's palaces.

Article VI: The First Painter who is an expert in antiques and in the decorative arts will collaborate with the Intendant-General in presenting to His Majesty projects for the encouragement of the arts and for the improvement of those manufactures which His Majesty deigns to take under his immediate protection.

Article VII: When His Majesty visits exhibitions or the establishments under the control of the administration of the arts, the First Painter will accompany him, as he will do on those occasions when His Majesty on his travels wishes to have a record made of memorable occurrences concerning himself.

Article VIII: The First Painter will be accorded official lodgings as member of the Imperial Household. His stipend. . . .

> I am, Sire,
> Your Majesty's submissive and Faithful subject
> David.

The Presentation of the Coronation Picture (1807)

David was among the artists whom Napoleon charged with the task of commemorating the notable events of his reign. In 1804, he was commissioned to record the Coronation in a painting of monumental dimensions. Etienne Delécluze (1781–1863) has left the following account of the ceremony which marked the completion of the picture in 1807: [13]

[13] E. Delécluze, *op. cit.*, pp. 312 ff.

David spent nearly four years on the execution of his painting of the Coronation. Toward the end of this time, Napoleon sent frequent messengers to him, to find out how far the work had progressed. When David felt satisfied that he had spent all the resources of his talent on this picture, he went in person to tell the Emperor that he had completed his task. Shortly after, the monarch appointed the day on which he would visit the studio of his First Painter.

When that day came, Napoleon, the Empress Josephine, and their entire family, accompanied by the officers of the court and ministers of state, took the road to the Rue de Saint-Jacques. . . . For some time, there had been much talk in Parisian society about the way in which David had arranged the main part of his composition. The courtiers in particular criticized the position he had given the Emperor, and blamed the artist for having made the Empress the heroine of the picture . . . all who were jealous of David's fame and favor entertained the malicious hope that Napoleon would criticize this arrangement and thus discredit the whole conception of the work. . . . They ought to have relied on the prudence and touchiness of the sovereign, and realized that he had calculated and prearranged everything, in concert with his First Painter. . . .

When the entire court had assembled in front of the painting, Napoleon, his head covered, walked back and forth before the thirty-foot long canvas, examining every detail with the most scrupulous attention, while David and his assistants stood immobile and silent. . . . Finally, still looking at the picture, Napoleon said: "Well done, David, very well done! You have correctly guessed my own intention, in representing me as a French gentleman. I am grateful to you for having given future centuries a proof of my affection for the woman with whom I share the burdens of government." At this moment, the Empress Josephine approached the Emperor from the right, while David stood, listening, on his left. Taking two steps toward David, Napoleon lifted his hat, bowed his head slightly, and said in a strong voice: "David, I salute you." "Sire," replied the painter, deeply moved, "I receive your salute in the name of all the artists, happy to be the one to whom you deign to address it."

Napoleon did not always treat the First Painter so kindly, as the following note by him shows: [14]

Saint-Cloud, July 2, 1806

Monsieur Daru, I have just seen my portrait by David. This portrait is so bad, so full of faults, that I refuse to accept it, and will not

[14] *Correspondance de Napoleon Ier*, Paris, 1862, XII (1806), 617, No. 10432.

have it sent to any city, and in particular not to Italy where it would give
a very bad account of the French school.

<div align="right">Napoleon.</div>

CHRISTIAN REVIVAL

*Religious art declined in the period of Enlightenment and almost
disappeared in the time of the Revolution. It revived in the work of
some of the early romantics, notably that of Blake and Runge (see pages 142 ff.)
who considered art as a form of worship. Blake wrote in 1820:*[15]

> A Poet, a Painter, a Musician, an Architect: the Man or Woman
> who is not one of these is not a Christian.
> You must leave Father and Mother and House and Lands if they
> stand in the way of Art.
> Prayer is the Study of Art.
> Praise is the Practice of Art. . . .

*The religious content of the work of Runge and Blake was of an
altogether unorthodox and original kind, philosophical rather than
church-oriented, free from any traditional associations, and expressible
only in the forms of new symbols. The passage from Blake, quoted above,
continues: "The outward Ceremony is Antichrist." By contrast, the
churchly art which reappeared about 1800 drew its inspiration specifically
from the historical traditions and ritual of Catholicism. When Goethe
wrote of Strassburg Cathedral, in 1772, it was to praise the natural genius
of its builder (see page 72). The promoters of Christian revival about 1800 saw in
the Gothic church a symbol of piety. Their return to traditional Christian forms of
art was initially prompted by aesthetic and sentimental, rather than strictly
religious considerations. In some ways, it continued the search for sources and
origins which had begun with the movement of Storm and Stress. This connection
is evident in the writings of Wackenroder which are still free from systematic bias
for a particular period, creed, or style, but express a general appreciation of
simplicity of feeling and naïve truthfulness of representation.*

Wilhelm Wackenroder (1773–1798)

*Wackenroder's short life passed away in flight from the humdrum
common-sense of the milieu to which he was born as the son of a high*

[15] Part of the inscription of the etching of *Laocoon*, ca. 1820, cf. G. Keynes,
Poetry and Prose of William Blake, London, Nonesuch, 1927, p. 764.

Prussian official. He was made to study law at the universities of Erlangen and Goettingen, but his interest and feeling inclined him to art, to poetry and to music. On holiday excursions through the Catholic principalities of central Germany, he came under the spell of the surviving Baroque. Italian opera at Bayreuth, orchestral masses at Bamberg and Dresden, the picture galleries in the palaces of Kassel and Pommersfelden roused him to a keen response, undimmed by Protestant puritanism or by the modern, neoclassical taste. Two visits to Nuremberg turned his fantasy to the national Gothic past, and to the world of Albrecht Dürer. He was tempted to try his hand at art, but his sensibility was receptive, rather than creative: he compared himself to the Aeolian harp which only sounds when the animating breeze moves its strings. In 1796, on a visit to Dresden, he surprised his friend, Ludwig Tieck, with a collection of essays on art which he had just composed. Impressed by their original-ity, Tieck persuaded him to have them published, and contributed several improvisations of his own, written in imitation of Wackenroder's man-ner. The Outpourings from the Heart of an Art-Loving Friar *appeared at Christmas of the same year (with the date of 1797). The book was an immediate success, particularly among the younger artists, and its influ-ence continued for a generation. Echoes of the* Art-Loving Friar *occur in the writings of Tieck, Friedrich Schlegel, the Nazarenes and their followers, down to the time of Ludwig Richter (see page 190) and Joseph Führich. Goethe, to whom the style of the book was as disagreeable as its content, had his lieutenant in matters of art, Heinrich Meyer, attack Wackenroder and his imitators in a widely-read article, "Neu-Deutsche religiös-patriotische Kunst" (1817).*[16]

Wackenroder wrote his book for artists, but he formulated no prin-ciples or recipes. Most of his chapters present exemplary lives by means of anecdotes or incidents borrowed from Vasari, Sandrart, and other old sources. Wackenroder's view of art had affinities with that of Blake. Art, according to him, comes from feeling, not from conscious mastery. The ability to create is a special grace, a seed laid by the hand of God into the artist's soul. Analysis and criticism lead nowhere. It is not his will or his skill, but his openness to inspiration which raises the artist above ordinary men. Wackenroder therefore stressed the artist's attitude, his prayerful expectancy and submission, not his knowledge. His friar is not merely a picturesque accessory to the book's message, but, as a man of de-votion, the close relative of the artists whose pieties he recounts.

The archaic tone and stylized simplicity of the book had a strong appeal to young Germans who, similar to the Primitifs *in France (see*

[16] Heinrich Meyer, "Neu-Deutsche religiös-patriotische Kunst," *Kunst und Al-tertum,* 1817, I, Heft 2, 5 ff. and 133 ff. See also Paul Weizsäcker (ed.), *Kleine Schriften zur Kunst,* in *Deutsche Literaturdenkmale des 18. und 19, Jahrhunderts,* XXVII, 97.

page 136), savored the language of Ossian, the Bible, and the ancient chronicles. Like illuminated pages from an old missal, the stories charm by their naïve brightness of hue—a quality which does not survive translation. But, despite his taste for the archaic, Wackenroder was free from any systematic prejudice for medieval or early Renaissance art. His Art-Loving Friar was not a monk of the middle ages, but of the 18th century, and in Wackenroder's own experience of art the Baroque had played a crucial part. He had come to believe that all true art, including that of the Negro and the Indian, expresses God's design. His collaborator, Ludwig Tieck, even went so far as to insert into the expanded version of the book which appeared after Wackenroder's death an essay on Watteau, heresy to an age which despised Watteau, but of the sort which Wackenroder in his wide tolerance would probably have approved.[17]

From *Outpourings from the Heart of an Art-Loving Friar* (1797)
Some Words on Universality, Tolerance, and the Love of Mankind in Art

Art can be considered as the flower of human feeling. From the different parts of the earth it rises toward Heaven in an everlasting variety of forms, and to our Father, Whose hand holds the globe and all it bears, only a single harmonious fragrance emanates from this seed.

He finds in every work of art, in every part of the world, a trace of that heavenly spark which went out from Him, through the breast of man, into man's own, lesser creations, from which it sends its gleams back to the great Creator. The Gothic is as pleasing to Him as the Greek temple, and to Him the rough war-chant of savages sounds as sweet as the art of choral and church song. . . .

In their foolishness, men do not understand that our sphere holds antipodes, and that they themselves are antipodes. They always think of themselves as being at the center of everything, and their spirit lacks wings on which to circle the globe and embrace its wholeness in one glance.

They think of their feeling as the central point of all beauty in art and pronounce their verdicts without realizing that they have no authority to act as judges, and that those whom they condemn could judge them in their turn.

Why don't you damn the Indian for speaking his language, rather than ours?

And yet you damn the Middle Ages for not having built Greek temples!

Try to enter into the souls of others, and to understand that you

have received your spirit as a gift from the same hand as those brothers of yours whom you misjudge. Try to understand that every creature can express himself only by means of the powers which it has received from Heaven, and that everyone must create in his own image. . . .

If God's hand had dropped the seed of your soul on African desert sand, you would proclaim to the world, as the very essence of beauty, the glossy black of your skin, your snub-nosed face and curly hair, and you would ridicule or hate the first white man you met. Had your soul flowered a few hundred miles farther east, on Indian soil, you would sense the spirit of those curious, many-armed idols which are a mystery to us, but you would not know what to make of the Medici Venus. . . .

The ABC of reason is subject to the same laws in all nations of the world, though in some places it is applied to a very wide, in others to a narrow, range of subjects. The feeling for art, too, is only one single ray of heavenly light, but in the various parts of the world it is diffracted into a thousand different hues by the many-faceted prism of the senses.

Beauty—strange, marvellous word! One ought to invent new words to describe every particular sensation and every individual work of art. For in each lives a different color, and to each responds a different nerve in man's makeup.

But you want to develop a tight system from this word, by intellectual artifice, and would compel all men to suit their feelings to your prescriptions and rules—and yet you have no feeling yourselves.

Whoever believes in *system* has banished universal love from his heart. Intolerance of feeling is more bearable than intolerance of mind, *superstition* preferable to *belief in system* . . .

Oh, let all mortals and all nations under the sun enjoy their own beliefs and happiness! Be glad when others are glad, even if you cannot sympathize with what they hold dearest and highest.

As sons of this century, we are privileged to stand on the summit of a high mountain from which we survey many countries and periods spread out at our feet. Let us make use of our good fortune, let our gaze sweep serenely over these periods and peoples, and let us try to recognize in their ways of feeling and working the essential, human element.

Every creature strives for the highest beauty, but it cannot leave its self behind, and thus must seek beauty in its own self. Every mortal eye has its particular experience of the rainbow, to each the surrounding world reflects a different image of beauty. But universal, original beauty, which in moments of ecstatic vision we may name, but which we can never explain in words, is only revealed to Him Who created both the rainbow and the seeing eye.

I began my discourse with Him and I now return to Him, just as the spirit of art, just as all spirit emanates from Him and ultimately

returns to Him, rising through the earth's atmosphere like a sacrificial offering.

In Memory of Our Venerable Ancestor, Albrecht Dürer

Nuremberg! city once world-renowned—how I loved to stroll in your winding lanes, with what child-like affection I looked at your old houses and churches, marked with the strong traces of our old, native art! And how dearly I still love the works of those ancient times, and their pungent, honest language! How they lure me back into that grey century when you, Nuremberg, were the teeming school of our national art and a fertile, abundant spirit of art was alive within your walls, when Master Hans Sachs and the sculptor Adam Kraft, and, above all, Albrecht Dürer and his friend Wilibald Pirkheimer, and so many other men of the highest excellence were still alive! How often have I longed to live in those times, how often relived them in my thoughts when, seated in a corner of Nuremberg's venerable library, in the twilight from a window with small round panes, I brooded over Hans Sachs' tomes, or over other yellowed, worm-eaten papers, or when I walked under daring vaults in somber churches where beams of light from stained-glass windows magically illuminate the monuments and paintings of times long past.

You look at me with surprise, faint-hearted unbelievers! Oh, I know them well, those myrtle forests of Italy, I know the ardor and exaltation of the men of the blessed South—why would you call me back to where my soul dwells in its longings, to the homeland of my life's most beautiful hours—you who see boundaries everywhere, even where there are none? Are not Rome and Germany on the same globe? Has the Heavenly Father not laid roads around the globe which lead from north to south, as well as from west to east? Is one man's life too brief? Are the Alps insurmountable?—Surely, it must be possible for more than one love to live in a man's breast. . . .

Why does it seem to me that modern German artists are unlike those praiseworthy men of former times and, particularly, so unlike you, my beloved Dürer? What makes me think that you practiced painting in a more serious and worthy way than these precious artists of our time? I imagine that I see you meditating before your unfinished picture, while the idea which you want to realize becomes vividly present to your soul. I see you reflecting on what expressions and positions would strike the beholder and move his spirit most powerfully, and then transferring these creatures of your vigorous imagination slowly and faithfully to the panel. But our modern artists do not seem to want us to enter seriously into their representations; they labor for noble lords who do not wish to be moved or uplifted by art, but only dazzled and titillated. Their paintings

are virtuoso performances, filled with many lovely and deceptive colors; they outdo themselves in the clever distribution of light and shade; but their figures seem often to exist only as pretexts for these colors and lights; one might call them a necessary evil.

Woe to this age of ours which uses art as a frivolous toy of the senses, rather than as something serious and sublime. . . .

When Albrecht Dürer wielded his brush, a firm, individual character still distinguished the Germans among the peoples of this part of the world. His paintings express this upright seriousness and strength of the German character faithfully, not only in the faces and external traits, but in their innermost spirit. In our time, this strongly marked German character has become lost, and along with it German art itself. Young Germans now learn all the languages of Europe and are expected to assimilate, through judicious selection, something of the spirit of all the nations: the student of art is taught to imitate Raphael's expression and the color of the Venetian School, Dutch truth and Correggio's magic light, and in this way attain supreme perfection.

Oh, wretched sophistry! Oh, blind belief of our time! Why should it be possible to merge all the various kinds of beauty and all the perfections of the world's great artists? What justifies the belief that we can, by studying them or begging from them, unite their manifold talents in ourselves and thus surpass them all? The time of originality and vigor is past; poor imitation and clever combination now make up for the lack of talent. Cold, smooth, characterless work is the result. German art once was like a God-fearing youth, living within the walls of a small town, cared for by blood relations. Now that it has grown older it is like a man of the world who has rid his soul not only of small-town ways, but also of individual feeling and character.

I should not want the magic Correggio, the sumptuous Paolo Veronese, the overpowering Buonarotti to have painted like Raphael. And I do not at all agree with those who say: "If Albrecht Dürer had only lived in Rome for a while, and learned about true beauty and the ideal from Raphael, he would have become a great painter. It is a great pity, though considering his disadvantage it is remarkable that he got as far as he did." I find no cause for pity, but rejoice, rather, that fate gave Germany this genuine, national painter. Abroad, he would not have remained himself; his blood was not Italian blood. He was not made for the ideal and the noble serenity of Raphael. His delight was in representing men as they really existed all around him, and in this he succeeded admirably.

Yet I was struck when, in my youth, I first saw paintings by Raphael and Dürer hung together in a magnificent gallery; I rejoiced in the discovery that of all the painters I knew these two had a quite specially

close affinity with my heart. What I liked particularly in the work of both was their straightforward, clear, and yet soulful presentation of humanity, so unlike the pretty circumlocutions of other painters. But I did not dare then to reveal my opinion, afraid that everybody would laugh at me, since I knew that most people found the work of the older German painters merely stiff and dry. But I was so full of my new insight on that day that, as I fell asleep, a charming dream came to me and confirmed me in my belief. I dreamt that, midnight having struck, I went from the room in the castle in which I slept and, walking alone through dark halls with a torch in my hand, made my way to the picture gallery. At the door, I heard a faint murmuring sound within. I opened, and started back on finding the whole vast hall illuminated by a strange light. Before several of the paintings stood the venerable artists, in full, bodily presence, wearing ancient costumes such as I had seen in their portraits. One of them whom I recognized told me that on some nights they came down from heaven to walk the picture galleries in the stillness of night, to look at the works of their hands which they still loved. I recognized many Italian painters, but saw only a few Netherlanders. Reverently, I walked through their midst, and lo! here stood, apart from the others, Raphael and Dürer, hand in hand, looking with quiet, friendly calm at their paintings hanging side by side. I did not have the courage to address the divine Raphael; a shyness, born of reverence, sealed my lips. But I wanted to greet my Albrecht, and pour out my love for him, when suddenly my sight grew confused, a loud clamor arose, and I awoke in great agitation. . . .

Not under Italian skies only, not only beneath majestic domes and Corinthian columns does true art flourish. It lives also among pointed arches, in buildings teeming with strange ornament, and beneath Gothic towers.

Peace to your ashes, my dear Albrecht Dürer! May you know how much I love you, and hear that I am, in this alien, modern world, the herald of your name.—Blessed by your golden age, Nuremberg! the only time in which Germany could claim a national art of its own.—But the ages of beauty pass across this earth and vanish, like luminous clouds drifting across the vaulted sky. They are past and forgotten; and small is the number of those who try to recall them lovingly from dusty books and enduring works of art.

Of Two Miraculous Languages and of Their Secret Power

The language of words is a great gift of Heaven. It was one of the Creator's eternal blessings to loosen the tongue of the first man, so that

he might name all the things which the Almighty had placed in the world around him and the visions which He had put into his soul, and thus exercise his mind in playing with the abundance of names. Through words we rule the earth; through words we easily acquire all its treasure. Only the *invisible reality which hovers above us* cannot be brought down into our spirit through the power of words.

We control earthly things when we speak their names, but when we hear of God's infinite mercy or the virtues of the Saints, things which should move us to the depths of our being, our ears are filled merely with empty sound, and our spirit is not uplifted as it ought to be.

But I know of *two miraculous languages* through which the Creator has enabled men to grasp and understand heavenly things in all their power, or at least so much of them—to put it more modestly—as mortals can grasp. They enter into us by ways other than words, they move us suddenly, miraculously, seizing our entire self, penetrating into our every nerve and drop of blood. One of these miraculous languages is spoken only by God, the other is spoken by a few chosen men whom he has lovingly anointed. They are: *Nature and Art.*

Since my early youth, when I first learned about God from the ancient sacred books of our faith, *Nature* has seemed to me the fullest and clearest index to His being and character. The rustling in the trees of the forest and the rolling thunder have told me secrets about Him which I cannot put into words. A beautiful valley enclosed by bizarre rocks, a smooth-flowing river reflecting overhanging trees, a pleasant green meadow under a blue sky—all these stirred my innermost spirit more, gave me a more intense feeling of God's power and benevolence, purified and uplifted my soul more than any language of words could have done. Words, I think, are tools too earthly and crude to express the incorporeal as well as they do express material reality.

This gives me a great occasion to praise the might and kindness of our Maker. He has surrounded us human beings with an infinite number of things, each of which has its own essence and transcends our simple understanding. We do not know what is a tree, or what is a meadow, or a rock; we cannot converse with them in our language; we can communicate only with other human beings. But the Creator has put powers of sympathy with these things into the human heart that enable them to reach it in unknown ways with feelings or intimations, or whatever else one might call them, which are more effective than measured words.

The worldly-wise have gone wrong in their quest for knowledge, laudable though this quest might be in itself; they have tried to uncover the secrets of the Heavens and set them among terrestrial things, in a terrestrial light. And, insisting on their rights, they have boldly tried to

expel the *dark intimations* of these secrets from their hearts.—Is it in man's feeble power to unveil the secrets of Heaven? Does he believe himself capable of bringing boldly into the light what God covers with His hand? Can he arrogantly dismiss the obscure *feelings* which descend to him like veiled angels?—I honor them in deep humility, for it is one of God's great mercies to send us these genuine witnesses of the truth. I fold my hands and adore.

Art is a language unlike that of Nature; but Art, too, has a marvellous power over the human heart and exercises it by equally hidden means. It speaks through the image of men, which is to say that it uses hieroglyphic signs which are familiar and comprehensible to us by their appearance. But it endows these visible forms with something spiritual and supersensual in a way so affecting, so admirable that it can stir us to the roots of our being. Certain paintings of Christ's passion, of the Holy Virgin, or of the lives of the Saints have more thoroughly cleansed my soul and instilled in me more virtuous sentiments than any system of morality or spiritual meditation. Thus I remember a picture of Saint Sebastian, magnificently painted, which shows him naked, bound to a tree, with an angel who draws the arrows from his breast, while another angel brings from Heaven a wreath of flowers for his head. I owe to this painting some very penetrating and lasting Christian sentiments, and even now cannot recall it without tears.

The teachings of learned men exercise our brain, only half of our self. But the two miraculous languages whose power I proclaim touch our feelings as well as our mind; they seem to fuse—I cannot find other words to express it—all parts of our unconscious being into a new, single organ which receives and comprehends in this twofold way the miracles of Heaven. . . .

When I step from the sanctuary of our monastery into the open air, having just contemplated the crucified Christ, and the sun shining from the blue sky embraces me with its warmth and life, and the beautiful landscape of mountains, rivers, and trees charms my eyes, then I see God's own world arising before me, and feel in a very special way the emergence of great things within me. And when from the open air I return to the sanctuary and contemplate the painting of the crucified Christ with earnest piety, then I see another world of God opening before me, and feel in a different way the emergence of great things within.

Art gives us the highest human perfection. Nature, so far as the mortal eye can see, resembles a fragmentary, oracular utterance from the mouth of God. One might say, were it allowed to speak of such things, that God looks on all of Nature and the whole world as we look on a work of Art.

Friedrich Schlegel (1772–1829)

Friedrich Schlegel's youthful ambition was to become the "Winckel-mann of Greek literature." The intolerant exclusiveness of his early Graecomania earned him Schiller's irritation and Goethe's sarcasm. In Schlegel's view, only ancient literature and art possessed beauty whole and absolute. By contrast, the work of the "moderns" (under which term he comprised the art and poetry of Dante's, as well as that of Shake-speare's, time) was incomplete, unquiet, and flawed; its peculiar quality was not beauty, but something to which Schlegel at first applied the term the interesting, in order to indicate its dynamic, emotional character, unlike that of true beauty (which, according to Kant's definition, ought to produce disinterested pleasure). In the gallery of Dresden, he admired the casts of antique sculptures and those paintings of the Renaissance which, because of their spacious and harmonious compositions, reminded him of classical art.

But about 1796, he underwent a fairly abrupt change of feeling. Influenced by his reading of medieval poetry, and perhaps also by Schiller's essay on Naïve and Sentimental Poetry (1795–1796), he began to discover in the work of "modern" masters, even in those of Raphael and Correggio, the traces of a profounder spirituality, expressed in the "magic charm of color" and in sentiment more poignant than classical ideality. To this unclassical, modern sentiment, he now applied the term "romantic." Wackenroder's Outpourings from the Heart of an Art-Loving Friar (see page 177) which Schlegel read shortly after its publication in the winter of 1796–1797, confirmed his religious bias, and awakened in him a taste for the bitter-sweetness of archaic style. A stay in Paris, in 1802–1804, finally accomplished his conversion to a Christian aesthetic, and was followed shortly by his conversion to the Catholic faith. At the Louvre, he had the opportunity of studying and comparing the works of early Italian, Flemish, and German masters which Napoleon's looting expeditions had brought together there (see page 165). Confronted by the paintings of Van Eyck, Memling, Dürer, Perugino, and Bellini, he declared his exclusive preference for art of a Christian content and of strongly marked, national character. Unlike Wackenroder, who had pleaded for universal tolerance, Schlegel asserted that the only way to salvation open to modern painters was through the imitation of medieval Christian art. Though his message was the opposite of Winckelmann's (see page 4), his dogmatism has the familiar ring of that great antiquarian's dictum: "There is but one way for the moderns to become great, and perhaps unequalled; I mean by imitating the ancients." Friedrich

Schlegel recorded his thoughts on Christian art in a series of letters addressed to Wilhelm Tieck in Dresden, Wackenroder's former collaborator. These letters were to have an important influence on the conservative, churchly, and nationalist wing of the German romantic movement. First published in Schlegel's periodical, Europa, *in 1803, their revised and expanded version was included in his* Collected Works *(1823)*[18] *under the title of* Descriptions of Paintings from Paris and the Netherlands, 1802–1804.

From *Descriptions of Paintings from Paris and the Netherlands,* 1802–1804

Before going on, I must make a confession. . . . I am exclusively attuned to the style of the earlier, Christian painters; they are the only ones I understand and comprehend, the only ones of whom I can speak. The French School and the later Italians I do not want to discuss at all; even in the School of the Carracci, I rarely find a painting which affords me a true, artistic experience or an enlargement of my ideas about art. . . . I confess that Guido Reni's often forced and chilly grace does not attract me irresistibly, and that the rosy-red and milky-white flesh tints of Domenichino do not necessarily enchant me. . . . I have no judgment about these painters, unless it be simply this: that painting no longer existed in their time. Titian, Correggio, Giulio Romano, Andrea del Sarto, Palma, and others of their kind were the last of the painters, so far as I am concerned. . . .

No confused heaps of men, but a few, isolated figures, executed with a diligence worthy of the dignity and holiness of that greatest of hieroglyphics, the human body; severe forms, contained in sharp and clearly defined contours; no chiaroscuro of dirt, murk and shadow, but pure relationships and masses of color, like clear accords; garments and clothes which really belong to the figures, and are as simple and naïve as they are; and in the faces, where the light of the divine spirit of painting shines most radiantly . . . that childlike, kindly simplicity which I am inclined to regard as the original character of mankind: this is the style of early painting, the style which pleases me exclusively. . . .

But let us, in conclusion, ask one further question, one which touches intimately on the main purpose of our observations and reflections: is it probable that we shall see in our time the rise or the permanent establishment of a genuinely great and profound school of painting? Outward appearances seem to speak against it, but who is to say that it is impossible? It is true that our period has no painters who can equal the great masters of bygone times, and the reasons for this inferiority seem

[18] The present translation is based on the text as given in Friedrich Schlegel, *Sämmtliche Werke* ("Gemäldebeschreibungen aus Paris und den Niederlanden in den Jahren 1802–1804"), Vienna, 1846, VI, 13 ff. and 164 ff.

fairly clear: one of them is the neglect of technique, particularly in the handling of color, and another, even more important one, the lack of true and deep feeling. Modern artists of a thoughtful and personal bent seem most often to be deficient in productive power, in that certainty and facility of execution which was so wonderful an attribute of earlier artists. When we think of the quantity of great works which Raphael achieved, although he died in early manhood, or consider the iron industry which our honest Dürer displayed in an abundance of inventions and works of various kinds and subjects (although he, too, did not attain old age), we shrink from measuring the art of our time with the standards of that great period. Yet there is an explanation for this difference. Universal education and intellectual versatility are characteristic tendencies of our age. They lead to a scattering of mental energies, and are hard to reconcile with the concentration and sustained intensity which are required for abundant and positive production. This condition affects all intellectual and creative fields in our time, but on the arts it has a particularly decisive influence. Clear senses and deep feeling are the only true sources of high art, yet nearly everything in our time militates against such feeling, pushes it back, splinters it up, buries or sidetracks it, and thus the best part of an artist's life is spent in a preliminary struggle against the spirit of the times and all the unspeakable difficulties which it places in the path of his development. And yet this struggle is necessary in order to uncover the springs of true artistic feeling and to clear them of the rubbish and the distractions of the outer world. . . .

The true source of art and of the beautiful is feeling. Feeling reveals the proper idea and aim of art, and points to the certain knowledge of the artist's intention, though the proof of this lies in practice rather than words. Religious feeling, piety, love and quiet enthusiasm guided the hand of the old masters. Only a few of them possessed in addition, or in its stead, what alone can replace religious feeling in art, namely, profound thought and an earnest philosophical striving. This is quite evident, though in artistic form, in the works of Dürer and Leonardo. It would be vain to attempt the restoration of painting without first reawakening, if not religion itself, at least the idea of religion, through Christian philosophy. But if young artists find this way too long and steep, let them at least study poetry which breathes this spirit. Not Greek poetry—which will only mislead them into strangeness or pedantry, and which they will only read in translations that spoil the ancient grace with the wooden rattle of dactylic meter—it is romantic poetry they ought to read. The best Italian and Spanish poets, in addition to Shakespeare, the more accessible of the older German poets, and those moderns who wrote in the romantic spirit: let these be the constant companions of the young artist. Only they can gradually lead him back into the old land of romance, removing from his vision the blur of prosaic imitation of

the pagan antiquities and of unhealthy art-babble. But the main thing is that the artist be in complete earnest about religious feeling, true piety and living faith. Mere fantasy play with Catholic symbols, lacking in that love which is stronger than death, will never attain the loftiness of Christian beauty.

In what does this Christian beauty consist? It is necessary, above all, to recognize the good and evil in art doctrine. Whoever has not discovered the inward life cannot reveal it gloriously in art. He will float along in the confused, dreamlike stream of a shallow and spiritually vain existence, instead of uplifting us through his art to a higher realm of spirit. He will merely serve false fashion and the empty glitter of illusion, without ever penetrating to the region of true beauty.

Pagan art starts with the perfection of organic form, conceived according to a definite idea of nature. Its development amounts to a vital unfolding of plastic forms; it has the charm of natural, youthful beauty, but this charm is always sensuous, rather than soul-inspired. When ancient art aspires to something higher, it takes on a titanic power and sublimity, or assumes the high seriousness of tragic beauty. This is the extreme limit of its attainment: here it approaches eternity, but here it stops at the closed gate of eternal beauty. Its titanic presumption attempts to storm the heavens and to conquer the divine, but it is forever frustrated, and sinks back in endless sorrow, deeply conscious of its own, hopeless bondage. Pagan art lacks the light of hope; its grief and tragic beauty are a last resort. And it is this light of divine hope, carried on the wings of happy faith and pure love, which gleams from works of Christian art. . . .

It will take a long struggle, and much trial and error, before the way is found on which a reborn art can progress securely toward the goal of religious beauty.

Perhaps we shall fall from one extreme into another: it would not be surprising if the current mania for imitation were to inspire a confident and talented artist to attempt absolute originality. If such an artist would discover that the true purpose of art is the symbolical manifestation of God's secrets, and that everything else is only a means to this end, he might produce remarkable works of an entirely new kind: hieroglyphics, symbolical images, drawn from feelings, insights, or intuitions about nature, arbitrarily put together,* rather than composed according to the

* The meaning of these remarks will be clear to all those who have seen the allegorical drawings of the late Runge. Though these are little more than sketches, they do illustrate the risk which this approach entails; to be sure, it is a risk which only artists of exceptional individuality and ambition are apt to run. All the same, these drawings show what happens when an artist of high talent attempts to paint pure nature-hieroglyphics, in total detachment from time-hallowed traditions, for there is no getting around the fact that these traditions are the firm, maternal soil which artists may desert only at the risk of great danger and irretrievable loss. [Schlegel's note.]

methods of antiquity. A hieroglyphic, a symbol of the divine—this is what every worthwhile painting must be. But should the painter invent his own allegories? Or should he use the old symbols, supplied and sanctified by tradition, which may be all he needs, so long as he understands them well? The first of these alternatives is surely the more dangerous. Its consequences are fairly predictable, especially if it were to be tried by various artists of unequal aptitude; the results would resemble what has lately been happening in poetry. It is safer to follow the old masters completely, particularly the oldest, assiduously imitating the truths and beauties in their works, until these become a second nature to the eye and mind. If, in addition to the most beautiful works of the early Italians, we were also to take the style of the Old German school for a model, mindful of our nationality whose character we should never deny, particularly not in our art, then both possibilities could be realized together: the secure, ancient tradition of comeliness and truth, on the one hand, and the symbolical, spiritually beautiful aspect of art on the other, that aspect to which true poetry and science must lead again when all knowledge of art has been lost. . . . Old German painting is superior to the Italian, not only in its more exact and painstaking technical execution, but also in its longer attachment to the oldest, most marvellous, profound, Christian-Catholic symbols, of which it has preserved a far greater wealth. . . .

There should be no need to insist on the obvious fact that modern artists ought not to imitate the imperfections of the older styles of painting, the emaciated hands, the Egyptian position of the feet, the tight clothing, garish colors, squinting eyes, or the lapses of draftsmanship, and other positive defects and occasional flaws. For to fall from the copying of the antique into the equally insincere imitation of the old German style would merely amount to an exchange of one false mannerism for another. Superficial effects are not the important thing: what matters is the quiet, pious spirit of those old times. This is what should inspire the painter and guide him to pure Christian beauty, so that, like a new dawn, the radiance of this beauty may illuminate the creations of a reviving art.

The Nazarene Brotherhood

Two German students at the Academy of Vienna, Franz Pforr (1788–1812) and Friedrich Overbeck (1789–1869), met in 1808, confided to one another their disgust with the shallow routine of academic instruction, and decided to pursue their further studies together. Soon they were joined by fellow students, Wintergerst, Vogel, Hottinger, and Sutter, artists of modest talent but unlimited idealism, who shared with

them the longing for an ideal, communal life devoted to art, to religion, and to friendship. In many ways, even in certain eccentricities of appearance, they resembled the heretics of French neoclassicism, the Primitifs *(see page 136). But while their French counterparts had modelled themselves on the heroes of Homer and Ossian, the Viennese group adopted Wackenroder's* Art-Loving Friar *as their guide, and observed the monastic vows of poverty, chastity, and obedience. The two leading personalities of the group presented a striking contrast. Pforr was an irascible, unstable, martial spirit, whose original ambition had been to become a painter of battles and who embodied the Germanic and medievalist strain of the romantic movement. His friends liked to think of him as the reincarnation of Dürer. Overbeck had the mildness and gentle piety which Wackenroder's book had attributed to Raphael. Though born a Lutheran, he perfectly represented the churchly, Catholic strain in German romanticism. The friends thought of him as their "priest" and of Pforr as their "master." In August of 1808, Pforr wrote to his friend Passavant:* [19]

We have founded a little club here which is composed of prospective artists who come together for mutual discussion and criticism of each other's work. We meet three times every two weeks. On Mondays, each of us presents drawings or other work. On Saturdays, everyone must bring along a compositional sketch on an assigned subject. On Wednesdays, we meet again. If there is something to show, that's fine, but it is not necessary. We may talk about art, or take a walk. Our meetings last from half past six until after nine o'clock in the evening.

On July 10, 1809, the anniversary of their first meeting, the friends constituted themselves as the Brotherhood of Saint Luke. Pforr wrote in a report to his guardian, on March 21, 1810: [20]

Until now, we had met in a society which would have been dissolved if fate had separated us. On July 10th of last year, we celebrated our first anniversary with a dinner. We discussed the present state of the arts, and keenly felt their decline; all of us offered, with one voice, to do everything in our power to raise them up again. We held each other by the hand, and formed an association which, we hope, will last forever. We agreed that every painting which we might execute should be

[19] F. H. Lehr, *Die Blütezeit romantischer Bildkunst, Franz Pforr, der Meister des Lukasbundes,* Marburg, Verlag des kunstgeschichtlichen Seminars der Universität Marburg, 1924, p. 74. See also M. Howitt, *Friedrich Overbeck, Sein Leben und Schaffen,* Freiburg, 1886, and K. Andrews, *The Nazarenes, A Brotherhood of German Painters in Rome,* Oxford, Clarendon Press, 1964.

[20] Lehr, *op. cit.,* p. 41.

shown to all the members, if possible, and if it were found worthy should be marked with a sign. This sign is to be a small sheet of paper, fastened to the back of the picture, and bearing the image of Saint Luke.

Unlike the Primitifs, *who seem to have spent much of their energy in theoretical argument, the Brothers worked with the diligence of medieval artisans, striving to perfect themselves in meticulous craftsmanship. They held the facile mannerisms propagated by the Academy in contempt and looked for instruction to the early Italian and German masters whose works they found in the Imperial Gallery in the Belvedere. Pforr reported to his guardian:* [21]

We now began to find our technique unsatisfactory; our work did not give us the pleasure which our spirit demanded. I expressed the wish to paint something with the highest possible degree of definition and finish. Overbeck encouraged me, and I painted several half-figures in this way. Once one has done a thing thoroughly he loses his taste for superficial visual effect. We saw the new light, and began to strive for the clarity of definition which can only be achieved through careful finish . . . I chose for my subject *Wallenstein in the Battle of Lützen,* . . . Overbeck, of milder disposition, began a *Raising of Lazarus.* . . .

We were in the midst of our work, when we decided to visit the Imperial Gallery which we had not seen since the formation of our association. On entering, we were struck with amazement: everything seemed changed. We hurried past many pictures which had formerly attracted us, and were irresistibly fascinated by others which had once left us cold. Neither of us dared to tell the other his thoughts, fearing that our judgment might have been warped by a kind of vanity. But when we finally confided in each other, we found to our surprise that we were in full agreement! Paintings by Tintoretto, Paolo Veronese, Maratti, and even works by the Carracchi, by Correggio, Guido, and Titian at which we had once gaped in admiration now made a feeble impression on us. We sensed the cold heart hidden behind the bold brush strokes and the beautiful colors, or found that the artists had aimed no higher than at a stimulation of the senses. But we could hardly tear ourselves away from a *St. Justina* by Pordenone, from several paintings by Michelangelo, Perugino, and the School of Raphael. We found with delight that they confirmed us in our feelings about style. The Netherlandish painters seemed to us to have chosen low subjects, or to have given a low treatment to lofty subjects. What had once seemed natural in their work now looked almost like caricature. We hurried on to the early German masters. How happily they surprised us, with what loveliness

[21] Lehr, *op. cit.,* pp. 36 ff.

and purity their every feeling spoke to us! Much in these paintings had formerly struck us as stiff and awkard. Now we realized that the constant sight of pictures in which every action, however ordinary, was represented by means of the most exaggerated and ridiculously mannered postures had misled our judgment, and had caused us to regard gestures taken from nature as stiff and insufficiently animated. Noble simplicity and definite character now spoke loudly to our hearts: no virtuoso brush work, no bold handling was to be seen; everything presented itself simply, like something grown, rather than painted. We stayed a long time, and finally left the room with a feeling of reverence. Now we came to the hall where the copyists work. What a difference! With wide brushes they systematically applied their colors, mixed according to formula. Brilliance of color was their highest aim, nature their least concern. We were not pleased, and soon hurried on.

These impressions of paintings gave rise to various reflections. We concluded that our conception of art must be correct, since it had brought us closer to the truly great masters. As brush strokes are only a necessary evil and a means to an end, we found it ridiculous to use them ostentatiously and to prize boldness of handling for its own sake. . . . We had confined ourselves for a long time to each other's company, and seen next to nothing of the Academic teachers and other local artists. Now we sought them out, to find someone to follow. But, to our regret, we sought in vain. We only found artists imprisoned in habit and prejudice, too weak to attempt anything which their teachers had not already done. We found a certain manner dominating all which, though varied slightly in the work of this artist or that, always amounted to a deviation from the nature through which artists must strive to attain the ideal. And we could not understand how painters working on sacred subjects could lead such dissolute lives, how they could present the wisdom of Salomon or Socrates in their paintings, while behaving like thoroughly prejudiced, uncivilized people. We marvelled that artists should have the impudence of believing that they were entitled to a style of living which, in other people, would have been considered animal-like depravity. . . .

The equation of life and art, conduct and style, constantly preoccupied the Brothers of Saint Luke. In forming their own lives, they consciously imitated the pure simplicity of line which they admired in early art. Pforr wrote to his friend Passavant, on January 6, 1809: [22]

I feel that I am unfit for the unquiet, large life. A small room, my easel, a few friends, and the necessities of existence satisfy all my wishes.

[22] Lehr, *op. cit.*, pp. 269 ff.

I must confess to you that I should like to achieve something in art, but this is best done in the midst of a quiet, retiring life. I find that the way today's artists rove from one big city to another is quite incompatible with art's need for peace. A quiet, middle class life is best. I know you will not blame me for holding this opinion. . . .

Painters formerly encouraged a devotional attitude by representing pious subjects . . . and now?—A naked Venus and her Adonis, a Diana in her bath, what good can come of such ideas? And why choose subjects so remote that they scarcely hold any interest for us? Why not treat more relevant subjects? The ancient history of the Israelites offers more material than any other. Tell me what other history gives us a more beautiful picture of courage and wisdom, moderation and justice, and of sacrifice for the sake of virtue and the common good than *Maccabees* with its story of the priest Mattathias and his sons. And don't we find in medieval history subjects worthy of being transmitted to eternity? But who will represent them?

In May of 1809, Pforr, Overbeck, Vogel and Hottinger left Vienna to go to Rome. After a brief stay at the Villa Malta on the Pincian Hill, they settled in the nearby monastery of San Isidoro which had recently been secularized. Here they were able to put into practice their ideal of a cloistered community of artists. Pforr wrote about this time: [23]

If you think of me, you will have to look for me in your thoughts in my cell or in the cloister. The monastery has a beautiful location, lonely and quiet, well suited for study. . . . The little cell in which I shall work has a magnificent view across gardens and a thicket of olive trees toward the Apennines; further to the left lies Rome in its grandeur, St. Peter, the Castle of the Angel, and the Vatican in which I can make out the loggias where Raphael painted.

I should like to ask those who would dedicate themselves to art, as one asks those who want to become monks: can you give and keep the vows of poverty, chastity, and obedience? then be welcome.—Poverty! what artist is ever really rich? Chastity in speech and deed he must observe so that his work may be pure, and full obedience he must ever give to art. Art will command him to do one thing, or to avoid another, and gladly he must obey the command, for nothing can replace the joy which art gives him.

It was during the monastic idyll in Rome that, because they wore their hair long and parted in the middle, the Brothers came to be called "Nazarenes," by which nickname they are still known. Pforr died in

[23] Lehr, *op. cit.,* p. 166.

1812. His place was taken by new arrivals from the North, the brothers Schadow and Veit, Peter Cornelius, Julius Schnorr von Carolsfeld, and Friedrich Olivier. In September of 1812, the artists left the convent of Isidoro; the community gradually dispersed. Overbeck remained, as the most constant and, in the end, most influential artists of the group to which he gave the stamp of his personality, although his extreme piety and mellifluously Raphaelite style do not fully represent the range of so-called Nazarene painting. The following essay on The Three Ways *of Art, written about 1810 as a contribution to the Brothers' program of study, characterizes his approach to art and carries a suggestion of his temperament and manner:* [24]

From *The Three Ways of Art* (1810)

Three roads traverse the Land of Art, and, though they differ from one another, each has its peculiar charm, and all eventually lead the tireless traveller to his destination, the Temple of Immortality. Which of these three a young artists should chose ought therefore to be determined by his personal inclination, guided and fortified by reflection.

The first is the straight and simple Road of Nature and Truth. An uncorrupted human being will find much to please his heart and satisfy his curiosity along this road. It will lead him, for better or for worse, through fair, productive country, with many a beautiful view to delight him, though he may occasionally have to put up with monotonous stretches of wasteland as well. But, above these, the horizon will usually be bright, and the sun of Truth will never set. Of the three roads, this is the most heavily travelled. Many Netherlanders have left their footprints on it, and we may follow the older ones among them with pleasure, observing the steadiness of their direction which proves that these travellers advanced imperturbably on their road: not one of these tracks stops short of the goal.—But the most recent footprints are another matter; most of them run in zig-zags to the right and the left, indicating that those who made them looked this way and that, undecided, wondering whether or not to turn back and take another road. Many of these tracks, in fact, disappear into the surrounding wastes and deserts, into impenetrable country. What the traveller on this road must chiefly guard against are the bogs along one side where he may easily sink into mud over his ears, and the sandy wastes on the other side which may lead him away from the road and from his destination. But if he manages to continue along the straight, marked path, he cannot fail to reach his destination. The level country makes this road agreeable to travel, there are no mountains to climb, and the walking is easy, so

[24] Lehr, *op. cit.,* pp. 303 ff.

long as he does not stray to one side or the other, into bog or desert. Besides, there is plenty of company to be found on this road, friendly people, representing all nationalities. And the sky above this country is usually serene. The careful observer will find here everything the earth offers, he need never be bored on this road. And yet, I must warn the young artist not to raise his expectation too high, for, frankly, he will see neither more, nor less than what other people also see, every day, in every lane.

The second road is the Road of Fantasy which leads through a country of fable and dream. It is the exact opposite of the first. On it, one cannot walk more than a hundred steps on level ground. It goes up and down, across terrifying cliffs and along steep chasms. The wanderer must often dare to take frightening leaps across the bottomless abyss. If he does not have the nerve for it, he will become dizzy at the first step. Only men of very strong constitution can take this road and follow it to the end.—Strange are its environs, usually steeped in night; only sudden lightning flashes intermittently illuminate the terrible, looming cliffs. The road often leads straight to a rock face and enters into a dark crevice, alive with strange creatures. Suddenly, a ray of light pierces the darkness from afar, the light increases as one follows it through the narrow crevice, until abruptly the rocks recede and the brightness of a thousand suns envelops the traveller. Then he is seized, as if by heavenly powers, he eagerly plunges into the bright sea of joy, drinking its luminous waters with wild desire, then, intoxicated and full of fresh ardor, he tears himself from the depths and soars upward like an eagle, his eyes on the sun, until he vanishes from sight. Thus joy and terror succeed each other in sharpest contrast. Not the faintest glimmer of the light of Truth penetrates into these chasms, insurmountable mountains enclose the land, and only rarely do fleeting shadows or dream visions which can bear the light of Truth venture to drift across the barriers, where they then seem to stride like giants from peak to peak.

Just as this land is the opposite of the land of Nature in every feature, it is its opposite also with respect to population. In the other land, the road is constantly thronged with travellers; here it is usually empty. Few dare to enter this region, and even these few have little in common with one another, they go their separate ways, each sufficient to himself, none paying attention to the others. Michelangelo's luminous trace shines above all in this darkness. What distinguishes this road from the other is the colossal and sublime. Never is anything common or ordinary seen here, everything is rare, new, unique. Never is the wanderer's mind at peace: wild joy and terror, fear and expectation beset him in turn.

Let those who love strong emotion and lawless freedom travel this road, and let them walk boldly, it is sure to take them most directly to their destination. But those who love gentler impressions, who can neither grasp the colossal, nor bear the humdrum, and who like neither the bright midday light of the land of Nature, nor the stormy night of the land of Fantasy, but would prefer to walk in the gentle twilight, my advice to them is to take the third road which lies midways between the other two: the Road of the Ideal or of Beauty. Here he will find a paradise spread before him where the flower-fragrance of spring combines with autumn's fruitfulness.—To his right rise the mountains of Fantasy, to his left the view sweeps across fertile vineyards to the beautiful plain of the Land of Nature. From this side, the setting sun of Truth sheds its light; from the other, the morning light of Beauty rises from behind the golden mountains of Fantasy and bathes the entire countryside in its rosy haze. Thus sunrise and sunset, Truth and Beauty alternate here, and combine, and from their union rises the Ideal. Here even Fantasy appears in the light of Truth, and naked Truth is clothed in the rose-fragrance of Beauty.

This road, besides, is neither so populous as the first, nor so deserted as the second, and the travellers on it differ from those of the second road by their sociability. One sees them walking in pairs, and friendship and love, their constant companions and guides, strew flowers on their way. Then, too, this road is neither so definitely marked as the first, nor so unkempt as the second. It runs, in beautiful variety of setting, from hill to meadow, from lake shore to orange grove. Every imaginable loveliness contributes to this variety. But in the very charm of this road there lies a danger to the traveller, for it may cause him to forget his destination, and cause him to lose all desire for the Temple of Immortality. Thus it happens that some of the travellers are overtaken by death before they reach the Temple. A loving companion may then carry their body to the Temple's threshold, where it will at once return to life and everlasting youth.

These then, dear brothers in art, are the three roads; chose between them according to your inclination, but test your powers first, by using reason. Whichever road you chose, I should advise you to go forward on it without looking too much to the left or right. . . . the proof that each of the three roads leads to the goal is given by three men who went separate ways and whose names are equally respected by posterity: Michelangelo took the road of Fantasy, Raphael the road of Beauty, and Dürer that of Nature, though he not infrequently crossed over into the land of Beauty.

NATURE-PHILOSOPHY

The revival of orthodox Catholicism and traditional church art was one of the characteristic manifestations of the spirit of Restoration in the early decades of the 19th century. The more liberal, or Protestant, counterpart of that essentially conservative current was the emergence of a philosophy of nature bordering on the one hand on mysticism and pantheism and extending on the other to a point close to the natural sciences. The philosopher F. W. J. von Schelling (see page 200) was its most influential spokesman. To artists in search of a language of pictorial symbols, nature-philosophy opened new ways of expression. It was of special importance to landscape painters, because it promised an opportunity for extending the scope of landscape and raising it from its traditional low rank in the hierarchy of subject matter to the dignity of religious or historical painting. It is noteworthy that C. D. Friedrich painted his first symbolical landscape, the altarpiece for Tetschen Castle (1808), the year after Schelling's widely-read address on the Creative Arts and Nature was published.

Johann Wolfgang Goethe (1749–1832) on Art and Nature

Goethe's personal bent was strongly pragmatic and inclined him to scientific investigation, rather than metaphysical speculation. His writings on art, nevertheless, influenced the nature philosophers through their emphasis on the need for a penetrating study of nature, not confined to its visual aspect, but extending to internal functions. Compared to his own earlier writings (see page 72), in which he had tended to equate art and nature, and had made of the artist an agent of natural energies, Goethe's later, didactic statements on art, such as the Introduction to the Propyläen *(1798), from which the following excerpts are taken, stressed the essential difference between art and nature, and imposed on the artist the obligation to study nature, guided by an awareness of the separate values of art. The* Propyläen *was a periodical founded in 1798, by Goethe and a group of friends, for the purpose of propagating Goethe's ideas on art.*[25]

[25] J. W. Goethe, "Einleitung in die Propyläen," in *Goethes Werke* (Sophien Ausgabe), Weimar, 1896, I Abtheilung, XLVII, 27 ff. The translation here used is the anonymous one published in *Prefaces and Prologues* (*The Harvard Classics*, Charles W. Eliot, ed.), New York, Collier and Son, 1910, pp. 255 ff.

From *Introduction to the Propyläen* (1798)

The highest demand that is made on an artist is this: that he be true to Nature, study her, imitate her, and produce something that resembles her phenomena. How great, how enormous, this demand is, is not always kept in mind; and the true artist himself learns it by experience only, in the course of his progressive development. Nature is separated from Art by an enormous chasm, which genius itself is unable to bridge without external assistance.

All that we perceive around us is merely raw material; if it happens rarely enough that an artist, through instinct and taste, through practice and experiment, reaches the point of attaining the beautiful exterior of things, of selecting the best from the good before him, and of producing at least an agreeable appearance, it is still more rare, particularly in modern times, for an artist to penetrate into the depths of things as well as into the depths of his own soul, in order to produce in his works not only something light and superficially effective, but, as a rival of Nature, to produce something spiritually organic, and to give his work of art a content and a form through which it appears both natural and beyond Nature.

Man is the highest, the characteristic subject of plastic art; to understand him, to extricate oneself from the labyrinth of his anatomy, a general knowledge of organic nature is imperative. The artist should also acquaint himself theoretically with inorganic bodies and with the general operations of Nature, particularly if, as in the case of sound and color, they are adaptable to the purposes of art; but what a circuitous path he would be obliged to take if he wanted to seek laboriously in the schools of the anatomist, the naturalist, and the physicist, for that which serves his purposes! It is, indeed, a question whether he would find there what must be most important for him. . . .

The human figure cannot be understood merely through observation of its surface; the interior must be laid bare, its parts must be separated, the connections perceived, the differences noted, action and reaction observed, the concealed, constant, and fundamental elements of the phenomena impressed on the mind, if one really wishes to contemplate and imitate what moves before our eyes in living waves as a beautiful, undivided whole. A glance at the surface of a living being confuses the observer; we may cite here, as in other cases, the true proverb, "One sees only what one knows." For just as a short-sighted man sees more clearly an object from which he draws back than one to which he draws

near, because his intellectual vision comes to his aid, so the perfection of observation really depends on knowledge. How well an expert naturalist, who can also draw, imitates objects by recognizing and emphasizing the important and significant parts from which is derived the character of the whole!

Just as the artist is greatly helped by an exact knowledge of the separate parts of the human figure, which he must in the end regard again as a whole, so a general view, a side glance at related objects, is highly advantageous, provided the artist is capable of rising to ideas and of grasping the close relationship of things apparently remote. Comparative anatomy has prepared a general conception of organic creatures; it leads us from form to form, and by observing organisms closely or distantly related, we rise above them all to see their characteristics in an ideal picture. If we keep this picture in mind, we find that in observing objects our attention takes a definite direction, that scattered facts can be learned and retained more easily by comparison, that in the practice of art we can finally vie with Nature only when we have learned from her, at least to some extent, her method of procedure in the creation of her works.

Friedrich Wilhelm Joseph von Schelling (1775–1854)

Schelling's nature-philosophy was derived in part from Kant and Fichte, in part from the mystical writings of Jacob Boehme. It strongly influenced the later, naturalist phase of the romantic movement, both in Germany and in England, where Coleridge assimilated and spread many of Schelling's ideas. The special appeal which this philosophy held for artists lay, perhaps, in the central emphasis which it gave to art in the economy of man's intellectual life. Schelling believed that one creative spirit pervades both the physical world and the individual consciousness. Outside man's awareness this spirit is not conscious of itself. It operates mutely and blindly in nature, it becomes reflective in man, and in the artist it becomes consciously productive. Art, in fact, requires that the two opposite components of the mind, the conscious and the unconscious, come together and be reconciled. Of the two, the unconscious is the more important, for the reflective and critical part of the mind, that which is reached by education and academic training, cannot itself produce art. The source of the artist's creativity, "the eternal sun in the realm of the mind," is the unconscious energy which he shares with nature, and which drives him to produce, even against his will. It is his bond with nature which enables him to express or represent things which he does not entirely understand, and to produce forms in his art which, like the forms of nature, have life and carry meaning. His work is not a

calculated abstraction from nature, but a genuine parallel creation. Schelling's debt to the earlier writers on organic creation or "natural genius" is evident (see page 71), but what they had described as a mysterious and exceptional manifestation was in his view an inevitable fact of psychology. The nature-philosophy of Schelling had special relevance for the painters and theorists of landscape, such as Friedrich and Carus. In discounting the neoclassical demand for idealized representation, it encouraged a closer attention to visual reality and to the vital processes occurring in nature.

The following passage is taken from a lecture which Schelling delivered before the Royal Academy of Sciences of Munich, on October 12, 1807, on the occasion of the name-day of Ludwig I, King of Bavaria.[26]

From *On the Relationship of the Creative Arts to Nature* (1807)

Art, according to the most ancient expression, is silent poetry. The inventor of this definition no doubt meant thereby that the former, like the latter, is to express spiritual thoughts—conceptions whose source is the soul; only not by speech, but, like silent nature, by shape, by form, by corporeal, independent works. Art, therefore, evidently stands as a uniting link between the soul and nature, and can be apprehended only in the living center of both. Indeed, since pictorial art has its relation to the soul in common with every other art, and particularly with poetry, that by which it is connected with nature, and, like nature, a productive force, remains as its sole peculiarity; so that to this alone can a theory relate which shall be satisfactory to the understanding, and helpful and profitable to art itself.

We hope, therefore, in considering art in relation to its true prototype and original source, nature, to be able to contribute something new to its theory—to give some additional exactness or clearness to the conceptions of it; but, above all, to set forth the coherence of the whole structure of art in the light of a higher necessity.

But has not science always recognized this relation? Has not indeed every theory of modern times taken its departure from this very position, that art should be the imitator of nature? Such has indeed been the case. But what should this broad general proposition profit the artist, when the notion of nature is of such various interpretation, and when there are almost as many differing views of it as there are various modes of life? Thus, to one, nature is nothing more than the lifeless aggregate of an

[26] F. W. J. von Schelling, "Über das Verhaltnis der bildenden Künste zu der Natur," in *Sämmtliche Werke*, Stuttgart, 1860, VII, 291 ff. The translation used is by J. Elliot Cabot, published in *The German Classics of the 19th and 20th Century*, Albany, German Publication Society, 1913, pp. 106 ff.

indeterminable crowd of objects, or the space in which, as in a vessel, he imagines things placed; to another, only the soil from which he draws his nourishment and support; to the inspired seeker alone, the holy, ever-creative original energy of the world, which generates and busily evolves all things out of itself. The proposition would indeed have a high significance, if it taught art to emulate this creative force; but the sense in which it was meant can scarcely be doubtful to one acquainted with the universal condition of science at the time when it was first brought forward. Singular enough that the very persons who denied all life to nature should set it up for imitation in art!

Nature was to them not merely a dumb, but an altogether lifeless image, in whose inmost being no living word dwelt; a hollow scaffolding of forms, of which as hollow an image was to be transferred to the canvas, or hewn out of stone.

But is the disciple of nature to copy everything in nature without distinction?—and, of everything, every part? Only beautiful objects should be represented; and, even in these, only the beautiful and perfect. Thus the principle was further defined, but it was asserted, at the same time, that in nature the perfect is mingled with the imperfect, the beautiful with the unbeautiful. Now, how should he who stands in no other relation to nature than that of servile imitation, distinguish the one from the other? It is the way of imitators to appropriate the faults of their model sooner and easier than its excellences, since the former offer handles and tokens more easily grasped; and thus we see that imitators of nature in this sense have imitated oftener, and even more affectionately, the ugly than the beautiful.

If we regard in things, not their principle, but the empty abstract form, they will say nothing to our soul; we must put our own heart, our own spirit to it, so that they may answer us. But what is the perfection of a thing? Nothing else than the creative life in it, its power to exist. Never, therefore, will he, who fancies that nature is altogether dead, be successful in that profound process (analogous to the chemical) whence proceeds, purified as by fire, the pure gold of beauty and truth.

There was no change in the main view of the relation of art to nature, even when the unsatisfactoriness of the principle began to be more generally felt; no change, even by the new views and new knowledge so nobly established by Johann Winckelmann. He indeed restored to the soul its full efficiency in art, and raised it from its unworthy dependence into the realm of spiritual freedom. Powerfully moved by the beauty of form in the works of antiquity, he taught that the production of ideal nature, of nature elevated above the actual, together with the expression of spiritual conceptions, is the highest aim of art.

But if we examine in what sense this surpassing of the actual by art

has been understood by most, it turns out that, with this view also, the notion of nature as mere product, of things as lifeless existence still continued; and the idea of a living creative nature was not all awakened by it. Thus these ideal forms could not be animated by positive insight into their nature; and if the forms of the actual were dead for the dead beholder, these were not less so. Were no independent production of the actual possible, neither would there be of the ideal. The object of the imitation was changed; the imitation remained. In the place of nature were substituted the sublime works of antiquity, whose outward forms the pupils busied themselves in imitating, but without the spirit that fills them. These forms, however, are as unapproachable, or more so, than the works of nature, and leave us even colder if we do not bring to them the spiritual eye to penetrate through the veil and feel the stirring energy within.

. . . While the previous method in art produced bodies without soul, this view taught only the secret of the soul, but not that of the body. The theory had, as usual, passed with one hasty stride to the opposite extreme; but the vital mean it had not yet found.

Who can say that Winckelmann had not penetrated into the highest beauty? But with him it appeared in its dissevered elements only: on the one side as beauty in idea, and flowing out from the soul; on the other, as beauty of forms. But what is the efficient link that connects the two? Or by what power is the soul created together with the body, at once and as if with one breath? If this lies not within the power of art, as of nature, then it can create nothing whatever. This vital connecting link, Winckelmann did not determine; he did not teach how, from the idea, forms can be produced.

Nature meets us everywhere, at first with reserve, and in form more or less severe. . . . How can we spiritually melt this apparently rigid form, so that the pure energy of things may flow together with the force of our spirit and both become one united mold? We must transcend form, in order to gain it again as intelligible, living, and truly felt. Consider the most beautiful forms; what remains behind after you have abstracted from them the creative principle within? Nothing but mere unessential qualities, such as extension and the relations of space. . . . It is not mere contiguous existence, but the manner of it, that makes form; and this can be determined only by a positive force, which is opposed to separateness, and subordinates the manifoldness of the parts to the unity of one idea—from the force that works in the crystal to the force which, comparable to a gentle magnetic current, gives to the particles of matter in the human form that position and arrangement among themselves, through which the idea, the essential unity and beauty, can become visible.

Not only as active principle, but as spirit and effective science, must the essence appear to us in the form, in order that we may truly apprehend it. For all unity must be spiritual in nature and origin; and what is the aim of all investigation of nature but to find science therein? For that where there is no understanding cannot be the object of understanding; the unknowing cannot be known. The science by which nature works is not, however, like human science, connected with reflection upon itself; in it, the conception is not separate from the act, nor the design from the execution. Therefore, rude matter strives, as it were, blindly, after regular shape, and unknowingly assumes pure stereometric forms, which belong, nevertheless, to the realm of ideas, and are something spiritual in the material.

The sublimest arithmetic and geometry are innate in the stars, and unconsciously displayed by them in their motions. More distinctly, but still beyond their grasp, the living cognition appears in animals; and thus we see them, though wandering about without reflection, bring about innumerable results far more excellent than themselves: the bird that, intoxicated with music, transcends itself in soul-like tones; the little artistic creature, that, without practice or instruction, accomplishes light works of architecture; but all directed by an overpowering spirit that lightens in them already with single flashes of knowledge, but as yet appears nowhere as the full sun, as in man.

This formative science in nature and art is the link that connects idea and form, body and soul.

It was long ago perceived that in art, not everything is performed with consciousness; that, with the conscious activity, an unconscious action must combine; and that it is of the perfect unity and mutual interpenetration of the two that the highest in art is born. Works which do not have the mark of unconscious science are recognized by the evident absence of life self-supported and independent of the producer; while, on the contrary, where this acts, art imparts to its work, together with the utmost clearness to the understanding, that unfathomable reality in which it resembles a work of nature.

It has often been attempted to make clear the position of the artist in regard to nature, by saying that art, in order to be such, must first withdraw itself from nature, and return to it only in the final perfection. The true sense of this saying, it seems to us, can be no other than this—that in all things in nature, the living idea shows itself only blindly active; if it were the same in the artist, he would be in nothing distinct from nature. But, should he attempt consciously to subordinate himself altogether to the actual, and render with servile fidelity the already existing, he would produce empty masks, but no works of art. He must therefore withdraw himself from the product, from the creature, but only

in order to raise himself to the creative energy and to seize them spiritually. Thus he ascends into the realm of pure ideas; he forsakes the creature, to regain it with thousandfold interest, and in this sense to return to nature. This spirit of nature working at the core of things, and speaking through form and shape as by symbols only, the artist must follow with emulation; and only so far as he seizes this with vital imitation has he himself produced anything genuine. For works produced by aggregation, even of forms beautiful in themselves, would still be destitute of all beauty, since that through which the work on the whole is truly beautiful cannot be mere form. It is above form—it is essence, the universal, the look and expression of the indwelling spirit of nature.

Now it can scarcely be doubtful what is to be thought of the so-called idealizing of nature in art, so universally demanded. This demand seems to arise from a way of thinking, according to which not truth, beauty, goodness, but the contrary of all these, is the actual. Were the actual indeed opposed to truth and beauty, it would be necessary for the artist, not to elevate or idealize it, but to get rid of and destroy it, in order to create something true and beautiful. But how should it be possible for anything to be actual except the true; and what is beauty, if not full, complete being? . . .

If, according to the remark of a discerning critic, every growth in nature has only an instant of truly complete beauty, we may also say that it has, too, only an instant of full existence. In this instant it is what it is in all eternity; besides this, it has only a coming into and a passing out of existence. Art, in representing the thing at that instant, removes it out of time, and sets it forth in its pure being, in the eternity of its life.

Karl Gustav Carus (1789–1859)

Personal physician to the kings of Saxony, Carus was one of the leading men of science in his time. In his intellectual career, the profession of natural science and the love of art intimately complemented one another. His researches in comparative anatomy and in psychiatry sharpened his insight into the symptomatic significance of visual form. With Goethe, he investigated the morphological evolution of plant life; through Goethe, he learned of Luke Howard's systematic study of cloud formation; and from the nature-philosophy of Schelling, he derived the metaphysical framework which allowed him to integrate his scientific, philosophical, and artistic ideas. But it was his long friendship with C. D. Friedrich which caused him to discover in landscape painting the central expression of his diverse interests. He made himself a competent painter and was one of the few close disciples of Friedrich. In 1831 he

published Nine Letters on Landscape Painting, Written in 1815–1824
*in which he applied Schelling's philosophy to Friedrich's practice of
landscape painting, and contributed to this his own awareness of natural
phenomena. The pamphlet is an important document in the history of
early naturalism. Grounded in romantic philosophy, it states a new
view of landscape painting as an art concerned with process and change,
with the significant behavior of matter, rather than the appearance of
inert objects.*[27]

A timeless, limitless, perfect unity underlies all our feeling and
thought, underlies every form of existence and every part of our self. We
know this through a deep, inner awareness for which we can give no ex-
planation or proof, because it is itself the source of all knowledge, proof,
and explanation. Depending on our degree of personal development, this
awareness in us may be obscure or clear. In common speech, we hint at
this infinity within us with the word God.—In reason and in nature this
highest reality appears to us in its internal and external manifestations.
We feel ourselves to be a part of this reality. As creatures both of nature
and of reason, we constitute an entity which contains both nature and
reason, and thus partakes of the divine. This opens two different direc-
tions to our mental life. We may, on the one hand, try to reduce the
multiplicity and infinity of nature and reason to their original, divine
unity. Or we may try to represent the inner creative unity of our selves
in an external multiplicity. In doing the latter, we exercise capability, in
doing the former we show insight. Insight produces knowledge and
science. Capability produces art. In science, man feels himself as being
within God, in art he feels God within himself. . . .

When man, sensing the immense magnificence of nature, feels his
own insignificance, and, feeling himself to be in God, enters into this
infinity and abandons his individual existence, then his surrender is
gain rather than loss. What otherwise only the mind's eye sees, here
becomes almost literally visible: the oneness in the infinity of the
universe. . . .

In considering landscape representations, we must distinguish be-
tween their various kinds in accordance with what they contain of
truth, meaning, and subject.—It is natural that we should consider truth
of representation first, for it furnishes the body of the work of art, so to
speak; only through it is the work realized, transposed from the realm of
arbitrary creation into that reality within which art should function.
What are your feelings when you find in a well executed painting the
faithful representation of the wide, clear distance, a calm or ruffled sheet
of water, the flutter of tender foliage in shrub and tree, and all the

[27] C. G. Carus, *Neun Briefe über Landschaftsmalerei, geschrieben in den Jahren
1815 bis 1824*, Dresden, W. Jess Verlag, 1955, pp. 22 ff.

other forms in which the inexhaustible richness of landscape nature presents itself? . . . You will certainly feel yourself transported into those regions, you will imagine breathing their pure air, you will long to walk beneath those trees, you will imagine hearing the rush of water. Drawn into the sacred sphere of nature's mysterious life, your mind will expand. You will feel the eternally active life of creation, and as everything recedes which is merely individual and weak, you are strengthened and uplifted by this immersion into a higher realm, like Achilles rendered invulnerable by dipping into the Stygian river. But mere truth can never be the highest and most attractive quality of a picture. Consider the example of the mirror: look at nature reflected in its surface, you will find in this reflection all of nature's charms, colors, and forms, and yet, if you compare your impression of the mirror's image with that of a fine landscape painting, what do you find?—Clearly, the latter is inferior in point of truth; the painting does not equal the mirror in the attractiveness of natural forms and the brilliance of colors. And yet, a genuine work of art strikes us as a microcosm, as something existing in and for itself. The mirror image, by comparison, is always only a part, a mere fragment of infinite nature, torn from its organic context, and compressed into an unnaturally narrow compass. It is not, like the work of art, the complete creation of an intellectual energy which is related and comprehensible to us. It is, instead, only a note taken from an infinite harmony. It constantly calls for completion, and therefore never grants us that inward calm which we gain from surrendering ourselves freely to nature or from contemplating a fine work of art.

This explains why simple truth in landscape representation is not sufficient to give us the satisfaction which we demand. . . . We must, therefore, consider yet another requirement, namely that art be expressive of the fact that it owes its existence to the creative activity of the human spirit, and that, sprung from a unity, it must itself be a complete, coherent, and quasi-organic whole. If we grant this, we must also recognize that when the soul experiences a work of art this happens necessarily in a particular state or mood. The work therefore must also express a particular state. We can only achieve this in landscape painting if we approach and interpret nature in a way which is congenial to that mood. This takes us one step further: since a particular significance can be expressed only through the representation of objects, we must conclude that the expression of meanings depends on the proper choice of objects, and formulate the main aim of landscape painting more concretely as *the representation of certain moods of the spirit (significance) by means of the representation of corresponding states in the life of nature (truth).* . . .

What are the special moods expressed in the manifold changes of natural landscape? When we reflect on the fact that these changes are

manifestations of nature's life, we realize that the various moods expressed in them are nothing but the life-states of nature. Life itself is infinite in essence, only its forms are subject to constant change. . . . Every form of individual life exhibits four states which can be defined as: unfolding, maturity, decay, and destruction. Various hybrid states appear when these four basic ones are combined, or when natural development is frustrated by abnormality, when maturity resists approaching destruction, or when from destruction a new development begins. These states can be found in the various manifestations of the life of nature which appear in landscape. The most obvious are the changes of the seasons and of the times of day; morning, noon, evening, and night; spring, summer, autumn, and winter show them very clearly. We also find in landscape the combined states mentioned above, thus in the dimming of the morning light, in a frost on flowering trees, the drying up of plants in the burning sun, a thunderstorm at noon, the moon rising in the night, the bursting of fresh buds from half-dead branches, and countless others which might be mentioned.

Just as the vibration of a string may cause another, similarly tuned, though of lower or higher pitch, to vibrate in unison, congenial states in nature and in the human spirit may interact. Here again we see man's individuality as an integral part of a larger whole. A responsive sensibility will be stirred by the quickening life of nature, by the pure morning light, and the joyous world of spring. It will be gladdened by the serene blue sky of summer and the quiet of the forest's foliage; it will be downcast by the slow death of nature in autumn, and oppressed by the white shrouds of the winter night. . . .

The clear sky, quintessence of air and light, is the true image of infinity, and since our feeling has a tendency toward the infinite, the image of the sky strongly characterizes the mood of any landscape beneath its lofty vault. The sky is, indeed, the most essential and magnificent part of landscape. When clouds or towering mountains restrict the view of this infinity more and more, and finally obscure it altogether, we sense a growing oppression. But when these heavy layers dissolve into small silvery clouds, or when they are pierced by the calm, clear light of the rising moon or sun, then our gloom vanishes, and gives way to thoughts of the victory of the infinite over the finite. . . .

. . . I believe my thoughts about the present state of landscape painting were prompted by a reading of Goethe's observations about the shapes of clouds and his beautiful poem in honor of Luke Howard.[28]

[28] Goethe's poem, *"Howards Ehrengedächtnis"* ("To the Honored Memory of Howard"), published in 1820, celebrated the systematic classification of cloud shapes devised by the British chemist Luke Howard (1772–1864); cf. Howard's *Essay on the Modification of Clouds*, London, 1804.

If you were to ask me what it was about this poem which moved me so powerfully, I should explain it in the following manner: we discover in the course of our lives that perfection occurs only under two circumstances. It may come about, on the one hand, in the state of our original simplicity, when we are directed to the good by an obscure awareness of the divinity in us. And it may occur again when, after having committed many errors, we at last reach a clear understanding of our relationship with God and the world, and, on this basis, consciously achieve that perfection which formerly remained unconscious. This suggests the possibility that art, too, may contain two different kinds of perfection. The first, an original, naïve perfection, I have dealt with in earlier letters. Goethe's poem gave me the idea of the second kind of artistic beauty, namely that which is based on deeper insight. Goethe has left us several other, similar poems, dating from his late period. They express the purest and most perfect, scientific insight into certain processes of life which, having deeply impressed themselves on the poet's soul, were translated by him into poetic perceptions and ideas.

For his poem about the clouds to be written, it was necessary that he undertake long and serious studies concerning atmospheric phenomena. He had to observe, judge, and classify the evidence, until he had gained, not only such knowledge of the formation of clouds as is yielded by simple visual observation, but also those deeper insights which are the real product of scientific inquiry. After he had done this, the eye of his intellect concentrated all the separate strands of the phenomenon, and raised them to the level of art.—Seen in this way, art appears as the highest form of science. In perceiving clearly the secrets of science and clothing them in beauty, it becomes in truth mystical, or, as Goethe would put it, Orphic.

What makes landscape painting possible, if not the vast, material nature all around us?—and what could be more sublime than to capture the secret life of this nature? And is it not true that an artist, deeply moved by his insight into the mysterious interaction of earth and fire, sea and air, will express himself more nobly, will address the beholder's soul with greater clarity and vigor? Let artists impart to us their sense of the secrets of life in nature, so that we, too, will understand that there is nothing lawless, insignificant, or accidental in the drift of clouds, the shapes of mountains, the anatomy of trees, and the motion of the wave, but that there lives in all of them a high significance and eternal meaning.

. . . I have clearly explained how I conceive the ideal of a new kind of landscape painting, but I must add one further remark about the name by which this new art should be known. Considered from the point of view which we have reached, the trivial name of landscape no

longer seems adequate. It suggests a routine of work which I find distasteful. We need another word, and I should like to propose *Erdlebenbild* (Picture of the Life of the Earth) or *Erdlebenbildkunst* (Pictorial Art of the Life of the Earth). These terms convey more of the ideal which I sought to describe than does the older one of landscape.

But as I read what I have written, it occurs to me that there is yet another possible misunderstanding which I ought to eliminate. One might suppose, after what I have written about paintings of the life of the earth, that I have in mind dramatic scenes of monumental size, pictures of the Alps, of storms at sea, of forests in the mountains, volcanoes, and waterfalls. But this is not at all my intention. Such dramatic scenes, properly interpreted, could give us the most sublime form of this new art of the life of the earth. But I maintain that the quietest and simplest aspects of terrestrial life, if only we seize their meaning and the divine spirit in them, can be worthy and beautiful subjects for art.

Caspar David Friedrich (1774–1840)

Friedrich's background resembles that of Runge: he was born in the harbor town of Greifswald on the Baltic Sea, into a large, Protestant, solidly middle-class family. He began his studies at the Academy of Copenhagen (1794–1798) and finished them in Dresden. He met Runge in 1801, and through him entered the romantic circle around Ludwig Tieck. Like Runge, Friedrich showed little curiosity about the world beyond the confines of his North German milieu, and in particular had no desire to visit Italy. His earliest works were careful landscape studies, drawn with thin contours and washed with light sepia tones. Their quiet subtlety of line, their bareness, and their lack of color reveal the share which neoclassicism had in the formation of his style. He began to paint in oil about 1806. In 1808, his Cross in the Mountains, *an altarpiece in the form of a landscape, aroused controversy; in 1810, the year of Runge's death, the exhibition of his* Monk at the Sea *by the Academy of Berlin brought Friedrich passing fame and recognition.*

Friedrich shared with Runge the belief in the priority of spiritual over material reality. The nature which he represented in his landscapes was to him only the physical manifestation of an inward life, a continuous activity which corresponded to the agitation in the artist's mind. In contrast to Runge's arbitrary compositions, in which shreds of reality, torn from different contexts and detached from direct experience, are placed side by side like words in a sentence, Friedrich's landscapes are topographically and psychologically coherent. They record actual experience from a single point of view in space, time, and awareness. In this sense, they are historical, rather than symbolical: they record events oc-

curring in nature, usually phenomena of change in atmosphere and light, and relate these to events in the spectator's inward life

Friedrich can hardly have been influenced directly by the art doctrines of Runge which remained unpublished until 1840. Nor did he ever formulate a coherent doctrine of his own. It is characteristic of his meditative and receptive bent, in contrast to Runge's active philosophizing, that the fullest expression of his views should be contained in a series of aphoristic or critical statements, the Observations on a Collection of Paintings by Living or Recently Deceased Artists *(1830), which were occasioned by his reaction to particular works by contemporary painters. While this circumstance limits the range of his discussion, it focuses it on an important issue and defines Friedrich's position toward the end of his life, about 1830, when these notes were written. The polemic which runs through the* Observations *is directed against two opposite factions of the romantic movement, against the archaizing traditionalist of the Nazarene stamp, whom Runge had also condemned, and against the naturalists who represented the most advanced modernity of the period. Friedrich's* Observations *remained unpublished during his life. Excerpts from them were published by his friend Carus in 1841; the full text was edited by K. K. Eberlein in 1924.*[29]

I am always disgusted when I find a multitude of paintings hung or piled up in a room or hall; the viewer can never see a picture by itself, with portions of four other pictures impinging on his sight. Such a piling up of art treasures must surely lower the value of individual works in the estimation of all who see them thus, particularly when paintings which contradict one another are placed side by side (sometimes intentionally, it seems) in such a way that they defeat, or at least hurt, one another and the effect of all is diminished. . . .

* * *

Close your eye, so that your picture will first appear before your mind's eye. Then bring to the light of day what you first saw in the inner darkness, and let it be reflected back into the minds of others.

* * *

Art is comparable to a child, science to a man.

* * *

[29] "Aeusserungen bei Betrachtung einer Sammlung von Gemälden . . . ," K. K. Eberlein, *C. D. Friedrich, Bekenntnisse,* Leipzig, Klinkhardt und Bierman, 1924, pp. 106 ff.

The heart is the only true source of art, the language of a pure, child-like soul. Any creation not sprung from this origin can only be artifice. Every true work of art is conceived in a hallowed hour and born in a happy one, from an impulse in the artist's heart, often without his knowledge.

*　*　*

The artist's feeling is his law. Pure sensibility can never be unnatural; it is always in harmony with nature. But the feelings of another must never be imposed on us as our law. Spiritual relationship produces artistic resemblance, but this relationship is very different from imitation. Whatever one may say about X.'s paintings, and however much they may resemble Y.'s, they originated in him and are his own.

*　*　*

This man is honored as a painter of great ability and skill, and also as a teacher who has produced many clever pupils on whom he has put his unmistakable stamp. Whether this last is a reason for praise seems questionable. I believe that it could be taken for a criticism, of the stamper as well as of the stamped. It would have been praiseworthy, I think, if the master had not put his stamp on his pupils, but had restrained his vanity and observed and respected, with wise moderation, the inborn individuality and inclination of each of his students. For that which nature has given to each of us in particular is the talent which we must cultivate, and I should like to call out to these students: "Respect the voice of nature in yourselves!"

*　*　*

Does it not take immense obtuseness and conceit to believe that we can force our ideas and opinions on the young? Is it not truly bestial, stupid, and intolerant to put down, or deny to others, whatever happens to be contrary to our ideas? Let everybody express himself in his own way; back up your pupils with advice, do not confront them with orders! For all of us can and should do only those things for which God has equipped our bodies and minds. Heavy-handed instruction slows the mind's progress and disturbs the student's growth and individuality. Lessons unwillingly learned may save us from crude mistakes, but there is the danger that untimely meddling will discourage the quiet growth of true genius.

*　*　*

A painter should not merely paint what he sees in front of him, he ought to paint what he sees within himself. If he sees nothing within, he should not paint what he sees before him, lest his paintings resemble those screens behind which we expect to find the sick or the dead. Mr. X has seen only what all but the blind can see; one should expect artists to see more than that.

*　　*　　*

We are fond of the pious simplicity in early paintings, but we do not want to become simple ourselves, as has happened to some who aped only the faults of these paintings; we want to become pious, and imitate their virtues.

*　　*　　*

. . . To be quite frank: isn't there something disgusting, not to say unappetizing, in the sight of those dried-up Maries holding starved Infant Jesuses and wearing papery garments? They often look as if they had been deliberately ill drawn and put intentionally in faulty foreshortening and perspective. Painters copy all the defects of that period, but the good qualities in its art, the profound, devout, childlike sentiment, cannot be imitated mechanically. This the hypocrites will never get right, even if they carry deception to the extreme of turning themselves into Catholics. What our ancestors did in childlike simplicity, we cannot do against our better knowledge. When grownups shit into the living room like infants, to prove their innocence and lack of guile, people will neither be convinced nor pleased.

*　　*　　*

It is the taste of our time to relish strong colors. Painters outdo one another in applying make-up to cheeks and lips in their paintings; the landscape painters carry exaggeration even further and put make-up on trees, rocks, water and air. . . . By way of contrast, I remember the time when color was almost completely neglected and when oil paintings looked like sepia drawings, because brown was their one, dominant hue. Later, brown was replaced by blue, and this in turn by violet, and finally it was the turn of green, a color which landscape painters had formerly suppressed almost entirely, despite its prominence in nature. Just now, all the colors are being used together. It took about thirty years for men's minds to run through this cycle, and we may be ready to go through another just like it. It is hard on those who can't run along; their work is being overlooked and neglected, for the time being, at any rate.

* * *

Landscape painting these days no longer aims for a spiritual conception of its subject, not even if this were to be combined with the most scrupulous and faithful imitation of nature. The modern demand is for the exact aping of bodies, in other words of lengths, widths, heights, shapes, and colors. For these, in the opinion of modern gentlemen, actually comprehend the spirit, since the spirit can express itself only through them. This is called pure, humble, childlike submission, and sacrifice of personal will. In other words, the painter ought not to have a will, he should simply paint. Even that which the inner eye perceives through the physical eye is considered presumption and reckoned a sin.

* * *

I am far from wanting to resist the demands of my time, except when they are purely a matter of fashion. Instead, I continue to hope that time itself will destroy its own offspring, perhaps quite soon. But I am not so weak as to submit to the demands of the age when they go against my convictions. I spin a cocoon around myself; let others do the same. I shall leave it up to time to show what will come of it: a brilliant butterfly or a maggot.

4

Twilight of Humanism

INTRODUCTION

It is possible to regard the middle decades of the 19th century as the final phase of Renaissance humanism. The great issues which had agitated artists and theorists since the 15th century were still alive, but seemed settled and unproductive of further innovation. In a last recapitulation, the artists of the time passed in review once again the main themes and styles which tradition had sanctified. These artists had by now achieved complete intellectual emancipation; they were free to cultivate their individuality, unhampered by any official dogma. But they chose to express their originality in a language not yet quite their own. Without fearing to compromise his personal integrity, Delacroix could still imitate Rubens or paint Apollo. Without diminishing his freedom, Constable could submit to the discipline of faithful nature study. The worlds of historical tradition and of timeless nature still comprised the whole horizon of the arts. Beyond it, the fantasy dared not yet to reach out in search of that absolute modernity which was beginning to haunt the minds of some few artists and poets.

ART AND NATURE

The origins of early 19th century naturalism go back to the visual illusionism of the Baroque, to Dutch landscape above all. What was novel in the particular form of naturalism which began, about 1815–1825, to replace neoclassicism as the leading modern style, was the quasi-scientific objectivity with which its practitioners tried to rid themselves of preconceptions and old schemata, including those of perspectival projection and balanced composition, along with a host of stereotypes which had formerly suggested rock, foliage, and cloud. In contrast to classicism, with its use of conceptual abstraction, the new naturalist style was based entirely on immediate observation. It carried a note of privacy and intimacy, and in its stress on actual experience avoided the emotional tension and self-conscious pathos which characterized both classicism and the more dramatic forms of romantic art. Its truth was psychological, or even physiological, rather than philosophical.

How severely the older devices, not merely of style, but even of working technique, had cramped the free exercise of the artist's powers

is suggested by the following excerpt from the article on "Drawing," in the Encyclopedia Britannica *(edition of 1797), which advises the painter.*[30]

If he is to draw a landscape from Nature, let him take his station on a rising ground, when he will have a large horizon, and mark his tablet into three divisions downwards from the top to the bottom, and divide in his own mind the landscape he is to take, into three divisions also. Then let him turn his face directly opposite to the midst of the horizon, keeping his body fixed, and draw what is directly before his eyes upon the middle division of the tablet; then *turn his head, but not his body* to the left hand, and delineate what he views there, joining it properly to what he had done before; and, lastly, do the same by what is to be seen upon his right hand, laying down everything exactly, both with respect to distance and proportion.

But the naturalism of the early 19th century was also a reaction against the fashion of the Picturesque, *a creation of the late 18th century which is often, falsely considered as an early manifestation of romanticism. With its recipes for assembling natural scenery from ready-made stage props and ornaments, it was actually an outgrowth of the Academy's curriculum, though unlike other products of the Academy it could be brought to a kind of life. The picturesque inventions of the studio were capable of being translated into actual shrubbery and rockery in the form of English gardens, and it was possible to look at genuine nature as if it were a picturesque composition. To help Englishmen accomplish this feat of the imagination, specialists in picturesque beauty wrote books of guidance. One of these books, the Rev. William Gilpin's* Observations on the River Wye *(1770), contains the following characteristic passages:*[31]

After sailing four miles from Ross, we came to Goodrich-castle; where a grand view presented itself; and we rested on our oars to examine it. A reach of the river, forming a noble bay, is spread before the eye. The bank on the right is steep, and covered with wood; beyond which a bold promontory shoots out, crowned with a castle among trees.

This view, which is one of the grandest on the river, I should not scruple to call *correctly picturesque;* which is seldom the character of a purely natural scene.

Nature is always great in design. She is an admirable colourist also;

[30] E. T. Cook and Alexander Wedderburn, *The Works of John Ruskin,* VI, *Modern Painters,* III, London, G. Allen, 1903, 358.

[31] William Gilpin, *Observations on the River Wye . . . Made in the Summer of the Year 1770* (5th edition), London, 1800, pp. 30 ff.

and harmonizes tints with infinite variety and beauty: but she is seldom so correct in composition, as to produce an harmonious whole. Either the foreground or the background is disproportioned; or some awkward line runs across the piece; or a tree is ill-placed; or a bank is formal; or something or other is not exactly what it should be.—Hence, therefore, the painter who adheres strictly to the composition of nature, will rarely make a good picture. In general, however, he may obtain views of such parts of nature, as with the addition of a few trees or a little alteration in the foreground may be adapted to his rules. . . .

Against this artistic perversion of nature, the romantic naturalists asserted the importance of objectivity; against this slovenly romance, they reacted with close, and sometimes pedantic, attention to fact. Their sobriety was a protest against facile emotionality. The revulsion from the picturesque was felt throughout Europe, and perhaps most strongly in England from where the fashion had originally spread.

John Constable (1776–1837)

Ruskin said of Constable that he "perceives in a landscape that the grass is wet, the meadow flat and the bough shady; that is to say, about as much as, I suppose, might in general be apprehended, between them, by an intelligent fawn and a sky lark"—a remark which perhaps expressed a secret appreciation. Ruskin also wrote that "Unteachableness seems to have been a main feature of his character," paying Constable another unintentional compliment. But he was wrong in concluding that Constable was "nothing more than an industrious and innocent amateur," [32] *for Constable was, in fact, a reflective artist, the most profound of the naturalists, who accomplished the difficult feat of combining in his landscape paintings a scientific penetration into natural phenomena with an undimmed freshness of perception. He professed no systematic doctrine, but his scattered writings reflect a view of the relationship of art to nature which bears some resemblance to Schelling's natural philosophy and to the ideas of Friedrich, his close contemporary (see page 210). In contrast to the Germans, Constable refrained from dramatizing the life of spirit which he, like them, sensed in nature, through outright symbolism or stylistic devices. Instead, he expressed it through a minute observation of the forces which move water and clouds, which govern light and the growth of plants, and whose activity he felt within his own body and mind. The empathic experience which underlay his naturalism*

[32] E. T. Cook and Alexander Wedderburn, *The Works of John Ruskin*, III, *Modern Painters*, I, London, G. Allen, 1903, pp. 172 and 191.

was strikingly similar to that which the chemist Sir Humphry Davy (1778–1829) recorded in a notebook jotting, some time after 1800: [33]

Today, for the first time in my life, I have had a distinct sympathy with nature. I was lying on the top of a rock to leeward; the wind was high, and everything in motion; the branches of an oak tree were waving and murmuring to the breeze; yellow clouds, deepened by grey at the base, were rapidly floating over the western hills; the whole sky was in motion; the yellow stream below was agitated by the breeze; everything was alive, and myself part of the series of visible impressions; I should have felt pain in tearing a leaf from one of the trees.

In feeling and in the quality of observation, this is very close to Constable's sketches, many of which bear notations such as the following:

5th September 1822. 10:00 o'clock Morning. Looking S.E., brisk wind at W. Very bright and fresh grey clouds running fast over yellow bed about half way in the sky.

Constable's letters and lecture notes were collected by his friend and biographer, C. R. Leslie, who wove them into his Memoir of the Life of John Constable, Esq., R.A., *London, 1843 (second, definitive edition 1845), from which the following excerpts are taken.*

"A Pure and Unaffected Manner"

London, May 29th, 1802. My dear Dunthorne, I hope I have now done with the business that brought me to town with Dr. Fisher. It is sufficient to say that had I accepted the situation offered, it would have been a death-blow to all my prospects of perfection in the art I love. For these few weeks past, I believe I have thought more seriously of my profession than at any other time of my life; of that which is the surest way to excellence. I am just returned from a visit to Sir George Beaumont's pictures with a deep conviction of the truth of Sir Joshua Reynolds' observation, that "there is no easy way of becoming a good painter." For the last two years I have been running after pictures, and seeking the truth at second hand. I have not endeavoured to represent nature with the same elevation of mind with which I set out, but have rather tried to make my performances look like the work of other men. I am come to a determination to make no idle visits this summer, nor to give up my time

[33] *Memoirs of the Life of Sir Humphry Davy,* edited by John Davy, London, 1839, quoted in G. Grigson, *The Romantics,* Cleveland, G. Routledge and Sons, 1962, 128.

to commonplace people. I shall return to Bergholt, where I shall endeavour to get a pure and unaffected manner of representing the scenes that may employ me. There is little or nothing in the exhibition worth looking up to. *There is room enough for a natural painter.* The great vice of the present day is *bravura,* an attempt to do something beyond the truth. Fashion always had, and will have, its day; but truth in all things only will last, and can only have just claims on posterity. I have reaped considerable benefit from exhibiting; it shows me where I am, and in fact tells me what nothing else could.

Hampstead, October 23rd, 1821. My dear Fisher, . . . I am most anxious to get into my London painting-room, for I do not consider myself at work unless I am before a six-foot canvas. I have done a good deal of skying, for I am determined to conquer all difficulties, and that among the rest. And now talking of skies, it is amusing to us to see how admirably you fight my battles; you certainly take the best possible ground for getting your friend out of a scrape (the example of the old masters). That landscape painter who does not make his skies a very material part of his composition, neglects to avail himself of one of his greatest aids. Sir Joshua Reynolds, speaking of the landscapes of Titian, of Salvator, and of Claude, says: "Even their *skies* seem to sympathise with their subjects." I have often been advised to consider my sky as *"a white sheet thrown behind the objects."* Certainly, if the sky is obtrusive, as mine are, it is bad; but if it is evaded, as mine are not, it is worse; it must and always shall with me make an effectual part of the composition. It will be difficult to name a class of landscape in which the sky is not the key note, the standard of scale, and the chief organ of sentiment. You may conceive, then, what a "white sheet" would do for me, impressed as I am with these notions, and they cannot be erroneous. The sky is the source of light in nature, and governs everything; even our common observations on the weather of every day are altogether suggested by it. The difficulty of skies in painting is very great, both as to composition and execution; because, with all their brilliancy, they ought not to come forward, or, indeed, be hardly thought of any more than extreme distances are; but this does not apply to phenomena or accidental effects of sky, because they always attract particularly. I may say all this to you, though *you* do not want to be told that I know very well what I am about, and that my skies have not been neglected, though they have often failed in execution, no doubt, from an over-anxiety about them, which will alone destroy that easy appearance which nature always has in all her movements.

How much I wish I had been with you on your fishing excursion in the New Forest! What river can it be? But the sound of water escaping from mill-dams, etc., willows, old rotten planks, slimy posts, and brickwork, I love such things. Shakespeare could make everything poetical;

he tells us of poor Tom's haunts among "sheep cotes and mills." As long as I do paint, I shall never cease to paint such places. They have always been my delight, and I should indeed have been delighted in seeing what you describe, and in your company, "in the company of a man to whom nature does not spread her volume in vain." Still I should paint my own places best; painting is with me but another word for feeling, and I associate "my careless boyhood" with all that lies on the banks of the Stour; those scenes made me a painter, and I am grateful; that is, I had often thought of pictures of them before I ever touched a pencil, and your picture is the strongest instance of it I can recollect; but I will say no more, for I am a great egotist in whatever relates to painting. Does not the Cathedral look beautiful among the golden foliage? its solitary grey must sparkle in it.

[1823]

May 9th. I had many interruptions in my works for the Exhibition, as you know, so that I have no large canvas there. My Cathedral looks uncommonly well; it is much approved of by the Academy. . . . It was the most difficult subject in landscape I ever had on my easel. I have not flinched at the windows, buttresses, etc.; but I have still kept to my grand organ colour, and have, as usual, made my escape in the evanescence of the chiaroscuro. . . . Callcott admires my Cathedral; he says I have managed it well. Wilkie's pictures are the finest in the world. Perhaps the outdoor scene is too black. Fuseli came up to him and said, "Vell, vat dis? is dis de new vay, de Guercina style?" Speaking of me, he says, "I like de landscapes of Constable; he is always picturesque, of a fine colour, and de lights always in de right places; but he makes me call for my greatcoat and umbrella." This may amuse you, when contemplating this busy but distant scene; however, though I am here in the midst of the world, I am out of it, and am happy, and endeavour to keep myself unspotted. I have a kingdom of my own, both fertile and populous —my landscape and my children. I have work to do, and my finances must be repaired if possible. I have a face now on my easel, and may have more.

[1832]

. . . My "Lock" is now on my easel; it is silvery, windy, and delicious; all health, and the absence of everything stagnant, and is wonderfully got together; the print will be fine. . . . I am so harassed and interrupted that I must now conclude almost as abruptly as I did my last. . . .

[1832]

I am much interested with your account of the pictures at Petworth. I remember most of Turner's early works; amongst them was one of

singular intricacy and beauty; it was a canal with numerous boats making thousands of beautiful shapes, and I think the most complete work of genius I ever say. The Claude I well know; grand and solemn, but cold, dull and heavy; a picture of his old age. Claude's exhilaration and light departed from him when he was between fifty and sixty, and he then became a professor of the "higher walks of art," and fell in a great degree into the manner of the painters around him; so difficult it is to be natural, so easy to be superior in our own opinion. . . . Hobbema, if he misses colour, is very disagreeable, as he has neither shapes nor composition. Your mention of a solemn twilight by Gainsborough has awakened all my sympathy; do pray make me a sketch of it of some kind or other, if it is only a slight splash.

As to meeting you in these grand scenes, dear Leslie, remember the Great were not made for me, nor I for the Great; things are better as they are. My limited and abstracted art is to be found under every hedge and in every lane, and therefore nobody thinks it worth picking up; but I have my admirers, each of whom I consider an host. My kindest regards to Mrs. Leslie.

[Undated]

The world is wide; no two days are alike, nor even two hours; neither were there ever two leaves of a tree alike since the creation of the world; and the genuine productions of art, like those of nature, are all distinct from each other.

In such an age as this, painting should be *understood*, not looked on with blind wonder, nor considered only as a poetic aspiration, but as a pursuit, *legitimate, scientific,* and *mechanical*.

From Constable's *Fourth Lecture* (1836)

It was said by Sir Thomas Lawrence, that "we can never hope to compete with nature in the beauty and delicacy of her separate forms or colours—our only chance lies in selection and combination." Nothing can be more true—and it may be added, that selection and combination are learned from nature herself, who constantly presents us with compositions of her own, far more beautiful than the happiest arranged by human skill. I have endeavoured to draw a line between genuine art and mannerism, but even the greatest painters have never been wholly untainted by manner.—Painting is a science, and should be pursued as an inquiry into the laws of nature. Why, then, may not landscape painting be considered as a branch of natural philosophy, of which pictures are but the experiments?

Art and Nature

[1822]

The art will go out; there will be no genuine painting in England in thirty years. This will be owing to pictures driven into the empty heads of the junior artists by their owners, the directors of the British Institution, etc. In the early ages of the fine arts, the productions were more affecting and sublime, for the artists, being without human exemplars, were forced to have recourse to nature; in the latter ages, of Raphael and Claude, the productions were more perfect, less uncouth, because the artists could then avail themselves of the experience of those who were before them, but they did not take them at their word, or as the chief objects of imitation. Could you but see the folly and ruin exhibited at the British Gallery, you would go mad. Vander Velde, and Gaspar Poussin, and Titian, are made to spawn multitudes of abortions: and for what are the great masters brought into this disgrace? only to serve the purpose of sale. Hofland has sold a shadow of Gaspar Poussin for eighty guineas, and it is no more like Gaspar than the shadow of a man on a muddy road is like himself.

[1829]

In art, there are two modes by which men aim at distinction. In the one, by a careful application to what others have accomplished, the artist imitates their works, or selects and combines their various beauties; in the other, he seeks excellence at its primitive source, nature. In the first, he forms a style upon the study of pictures, and produces either imitative or eclectic art; in the second, by a close observation of nature, he discovers qualities existing in her which have never been portrayed before, and thus forms a style which is original. The results of the one mode, as they repeat that with which the eye is already familiar, are soon recognised and estimated, while the advances of the artist in a new path must necessarily be slow, for few are able to judge of that which deviates from the usual course, or are qualified to appreciate original studies.

[Found on a scrap of paper among his memoranda:] My art flatters nobody by *imitation,* it courts nobody by *smoothness,* it tickles nobody by *petiteness,* it is without either *fal de lal* or *fiddle de dee,* how then can I hope to be popular?

From Constable's *Second Lecture* (1836)

But the climax of absurdity to which the art may be carried, when led away from nature by fashion, may be best seen in the works of

Boucher. Good temper, suavity, and dissipation characterised the personal habits of this perfect specimen of the French School of the time of Louis XV, or the early part of the last century. His landscape, of which he was evidently fond, is pastoral; and such pastorality! the pastoral of the opera-house. But at this time, it must be remembered, the court were in the habit of dispersing into the country, and duchesses were to be seen performing the parts of shepherdesses, milkmaids, and dairymaids, in cottages; and also brewing, baking, and gardening, and sending the produce to market. These strange anomalies were played off on the canvases of Boucher. His scenery is a bewildered dream of the picturesque. From cottages adorned with festoons of ivy, sparrow pots, etc., are seen issuing opera dancers with mops, brooms, milk pails, and guitars; children with cocked hats, queues, bag wigs, and swords—and cats, poultry, and pigs. The scenery is diversified with winding streams, broken bridges, and water wheels; hedge stakes dancing minuets—and groves bowing and curtsying to each other; the whole leaving the mind in a state of bewilderment and confusion, from which laughter alone can relieve it.—Boucher told Sir Joshua Reynolds "that he never painted from the life, for that nature put him out."

It is remarkable how nearly, in all things, opposite extremes are allied, and how they succeed each other. The style I have been describing was followed by that which sprung out of the Revolution, when David and his contemporaries exhibited their stern and heartless petrifactions of men and women—with trees, rocks, tables, and chairs, all equally bound to the ground by a relentless outline, and destitute of chiaroscuro, the soul and medium of art.

[1822]

I have been to see David's picture of "The Coronation of the Empress Josephine." It does not possess the common language of the art, much less anything of the oratory of Rubens or Paul Veronese, and in point of execution it is below notice; still I prefer it to the productions of those among our historical painters who are only holding on to the tail of the shirt of Carlo Maratti, simply because it does not remind me of the *schools*. I could not help feeling as I did when I last wrote to you of what I saw at the British Institution. Should there be a National Gallery (which is talked of) there will be an end of the art in poor old England, and she will become, in all that relates to painting, as much a nonentity as every other country that has one. The reason is plain; the manufacturers of pictures are then made the criterions of perfection, instead of nature.

[1835]

. . . I have seen David's pictures; they are indeed loathsome, and

the room would be intolerable but for the urbane and agreeable manners of the colonel. David seems to have formed his mind from three sources, the scaffold, the hospital, and a brothel. . . .

From Constable's *Last Lecture* (1836)

The decline of painting, in every age and country, after arriving at excellence, has been attributed by writers who have not been artists to every cause but the true one. The first impression and a natural one is, that the fine arts have risen or declined in proportion as patronage has been given to them or withdrawn, but it will be found that there has often been more money lavished on them in their worst periods than in their best, and that the highest honours have frequently been bestowed on artists whose names are scarcely now known. Whenever the arts have not been upheld by the good sense of their professors, patronage and honours so far from checking their downward course, must inevitably accelerate it.

The attempt to revive old styles that have existed in former ages may for a time appear to be successful, but experience may now surely teach us its impossibility. I might put on a suit of Claude Lorrain's clothes and walk into the street, and the many who know Claude but slightly would pull off their hats to me, but I should at last meet with some one more intimately acquainted with him, who would expose me to the contempt I merited.

It is thus in all the fine arts. A new Gothic building, or a new missal, is in reality little less absurd than a *new ruin*. The Gothic architecture, sculpture, and painting, belong to peculiar ages. The feelings that guided their inventors are unknown to us, we contemplate them with associations, many of which, however vague and dim, have a strong hold on our imaginations, and we feel indignant at the attempt to cheat us by any modern mimicry of their peculiarities.

It is to be lamented that the tendency of taste is at present too much towards this kind of imitation, which, as long as it lasts, can only act as a blight on art, by engaging talents that might have stamped the Age with a character of its own, in the vain endeavour to reanimate deceased Art, in which the utmost that can be accomplished will be to reproduce a body without a soul.

The Voice of God in Nature

[From a letter written to Mrs. Constable in May 1819, while he was on a short visit to Bergholt:] Everything seems full of blossom of some kind and at every step I take, and on whatever object I turn my eyes, that sublime expression of the Scriptures, "I am the resurrection and the life," seems as if uttered near me.

John Ruskin (1819–1900)

An attack on Turner which appeared in Blackwood's Magazine *in 1836 moved Ruskin, aged seventeen and about to enter college, to compose an angry and eloquent reply. This letter remained unpublished but it started Ruskin on his career as a polemical writer on art. Six years later, a similar circumstance prompted him to begin his first great work of art criticism.*

The summer before last, [*he wrote to his former teacher, the Rev. Osborne Gordon in 1844* 34]—it was on a Sunday, I remember, at Geneva— we got papers from London containing a review of the Royal Academy; it put me in a rage, and that forenoon in church . . . I determined to write a pamphlet and blow the critics out of the water. On Monday, we went to Chamonix, and on Tuesday I got up at four in the morning, expecting to have finished my pamphlet by eight. I set to work, but the red light came on the Dome du Goute—I couldn't sit it—and went out for a walk. Wednesday, the same thing happened, and I put off my pamphlet till I should get a wet day. The wet day didn't come—and consequently, before I began to write, I had got more materials together than were digestible in an hour or two. I put off my pamphlet till I got home. I meditated all the way down the Rhine, found that demonstration in matters of art was no such easy matter, and the pamplet turned into a volume. Before the volume was half way dealt with it hydra-ized into three heads, and each head became a volume. Finding that nothing could be done except on such enormous scale, I determined to take the hydra by the horns, and produce a complete treatise on landscape art. Then came the question, what is the real end of landscape art? and then the conviction that it had been entirely degraded and mistaken, that it might become an instrument of gigantic moral power, and that the demonstration of this high function, and the elevation of the careless sketch or conventional composition into the studied sermon and inspired poem, was an end worthy of my utmost labor—and of no short expenditure of life.

What had begun as a pamphlet swelled into the five massive tomes of Modern Painters, *of which the first volume appeared in 1843, and the remainder in successive installments in 1846, 1856, and 1860. Ruskin's bold claim was, initially, that the modern English painters of landscape,*

34 E. T. Cook and Alexander Wedderburn, *The Works of John Ruskin*, III, *Modern Painters,* I, London, G. Allen, 1903, 666. Compare Ruskin's views with those of Caspar David Friedrich, p. 52, as well as those of Philipp Otto Runge, Vol. I, p. 143.

and in particular Turner, the greatest among them, had surpassed the old masters in truth to nature, in beauty, and in moral significance. This stand on behalf of contemporary art seems to invite comparison with Stendhal's and Baudelaire's advocacy of the modern spirit in art (see page 312), but Ruskin's notion of "modernity" was, unlike theirs, linked to timeless nature and to God, rather than to the historical present. His argument remained painfully suspended between several kinds of truth. A strong, naturalist bias drew him into minute studies of rock, plant, water, and cloud, but his need to moralize experience made him search for values and meanings beyond "low" reality, and he was, in addition, aware of the presence in art of purely formal or expressive qualities which are independent of external nature and moral law. His mind was divided between knowledge and inspiration, plain observation and noble thought, material fact and celestial intimations. This accounted in part for the excessive complexity and richness with which he burdened his writings; he used passages of gorgeous, descriptive poetry to cover the fissure that separated his sense of nature from his convictions about art. The beauty of these passages won him many friends and caused the book to go rapidly through several editions. But his sweeping and, from the pen of so young an author, arrogant condemnation of the old masters caused surprise, even among the English artists whom the book was meant to please. Turner, who held a very different view of Claude Lorrain (see page 252), received Ruskin's tribute with reserve.

In the later volumes of Modern Painters, *the flow of Ruskin's eloquence gradually carried his argument into channels quite different from those along which it had moved at the start. From modern Englishmen, he turned to Titian and Tintoretto, and to the painters of medieval Italy, Fra Angelico, Benozzo Gozzoli, and Giotto. He began to tire of descriptions of natural scenery, and to feel even that "our love of nature had been partly forced on us by mistakes in our social economy." Henceforth he was to devote himself, in such works as the* Seven Lamps of Architecture *(1849) and* Stones of Venice *(1851–1853), to the more formal aspects of art, and to art's religious and social function. But this later phase of Ruskin's thought is beyond our scope. The following excerpts are taken, unless otherwise indicated, from the first volume of* Modern Painters *(1843).[35]*

The Inferiority of the Old Masters

The course of study which has led me reverently to the feet of Michael Angelo and Da Vinci, has alienated me gradually from Claude

[35] E. T. Cook and Alexander Wedderburn, *The Works of John Ruskin,* III, *Modern Painters,* I–V, London, G. Allen, 1903. Reference to the various passages from *Modern Painters* in the following notes will be made under the abbreviation *MP*.

and Gaspar; I cannot at the same time do homage to power and pettiness —to the truth of consummate science, and the mannerism of undisciplined imagination. And let it be understood that whenever hereafter I speak depreciatingly of the old masters as a body, I refer to none of the historical painters, for whom I entertain a veneration which is almost superstitious in degree. Neither, unless he be particularly mentioned, do I intend to include Nicholas Poussin. . . . Speaking generally of the elder masters, I refer only to Claude, Gaspar Poussin, Salvator Rosa, Cuyp, Berghem, Both, Ruysdael, Hobbema, Teniers (in his landscapes), P. Potter, Canaletto, and the various Van somethings and Back somethings, more especially and malignantly those who have libelled the sea.[36]

No doubt can, I think, be reasonably entertained as to the utter inutility of all that has been hitherto accomplished by the painters of landscape. No moral end has been answered, no permanent good effected, by any of their works. . . . Landscape art has never taught us one deep or holy lesson; it has not recorded that which is fleeting, nor penetrated that which was hidden, nor interpreted that which was obscure; it has never made us feel the wonder, nor the power, nor the glory of the universe. . . . That which ought to have been a witness to the omnipotence of God, has become an exhibition of the dexterity of man. . . .

I speak not only of the works of the Flemish school, I wage no war with their admirers; they may be left in peace to count the spicula of haystacks and the hairs of donkeys; it is also of works of real mind that I speak, works in which there are evidences of genius and workings of power, works which have been held up as containing all of the beautiful that art can reach or man conceive. And I assert with sorrow, that all hitherto done in landscape, by those commonly conceived its masters, has never prompted one holy thought in the minds of nations. It has begun and ended in exhibiting the dexterities of individuals, and conventionalities of systems. Filling the world with the honour of Claude and Salvator, it has never once tended to the honour of God.

Does the reader start in reading these last words, as if they were those of wild enthusiasm, as if I were lowering the dignity of religion by supposing that its cause could be advanced by such means? His surprise proves my position. It does sound like wild, like absurd enthusiasm to expect any definite moral agency in the painters of landscape; but ought it so to sound? Are the gorgeousness of the visible hue, the glory of the realized form, instruments in the artist's hand so ineffective, that they can answer no nobler purpose than the amusement of curiosity, or the engagement of idleness? Must it not be owing to gross neglect or misapplication of the means at his command, that while words and tones (means of representing nature surely less powerful than lines and colours) can kindle and purify the very inmost souls of men, the painter can only

[36] *MP* I, p. 84.

hope to entertain by his efforts at expression, and must remain for ever brooding over his incommunicable thoughts?

The cause of the evil lies, I believe, deep-seated in the system of ancient landscape art; it consists, in a word, in the painter's taking upon him to modify God's works at his pleasure, casting the shadow of himself on all he sees, constituting himself arbiter where it is honour to be a disciple, and exhibiting his ingenuity by the attainment of combinations whose highest praise is that they are impossible. . . . Now there is but one grand style, in the treatment of all subjects whatsoever, and that style is based on the perfect knowledge, and consists in the simple unencumbered rendering of the specific characters of the given object, be it man, beast, or flower. Every change, caricature, or abandonment of such specific character is as destructive of grandeur as it is of truth, of beauty as of propriety. Every alteration of the features of nature has its origin either in powerless indolence or blind audacity; in the folly which forgets, or the insolence which desecrates, works which it is the pride of angels to know, and their privilege to love.[37]

The True Ideal of Landscape

Is there then no such thing as elevated ideal character of landscape? Undoubtedly; and Sir Joshua, with the great master of this character, Nicolo Poussin, present to his thoughts, ought to have arrived at more true conclusions respecting its essence. . . . The true ideal of landscape is precisely the same as that of the human form; it is the expression of the specific—not of the individual, but the specific—characters of every object, in their perfection. There is an ideal form of every herb, flower, and tree, it is that form to which every individual of the species has a tendency to arrive, freed from the influence of accident or disease. Every landscape painter should know the specific character of every object he has to represent, rock, flower, or cloud. . . .

In his observation on the foreground of the *San Pietro Martire,* Sir Joshua advances, as a matter of praise, that the plants are discriminated "just as much as was necessary for variety, and no more." Had this foreground been occupied by a group of animals, we should have been surprised to be told that the lion, the serpent, and the dove, or whatever other creatures might have been introduced, were distinguished from each other just as much as was necessary for variety, and no more. . . . If the distinctive forms of animal life are meant for our reverent observance, is it likely that those of vegetable life are made merely to be swept away? . . . But Sir Joshua is as inaccurate in fact, as false in principle. . . . The great masters of Italy, almost without exception,

[37] *MP* I, pp. 21 ff.

and Titian perhaps more than any (for he had the highest knowledge of landscape), are in the constant habit of rendering every detail of their foregrounds with the most laborious botanical fidelity: witness the *Bacchus and Ariadne,* in which the foreground is occupied by the common blue iris, the aquilegia, and the wild rose; *every stamen* of which latter is given, while the blossoms and leaves of the columbine (a difficult flower to draw) have been studied with the most exquisite accuracy.

It is not detail sought for its own sake, not the calculable bricks of the Dutch house-painter, nor the numbered hairs and mapped wrinkles of Denner, which constitute great art, they are the lowest and most contemptible art; but it is detail referred to a great end, sought for the sake of the inestimable beauty which exists in the slightest and least of God's works, and treated in a manly, broad, and impressive manner. There may be as much greatness of mind, as much nobility of manner, in a master's treatment of the smallest features, as in his management of the most vast; and this greatness of manner chiefly consists in seizing the specific character of the object, together with all the great qualities of beauty which it has in common with higher orders of existence.

Again, it does not follow that, because accurate knowledge is *necessary* to the painter, it should constitute the painter; nor that such knowledge is valuable in itself, and without reference to high ends. This is the difference between the mere botanist's knowledge of plants, and the great poet's or painter's knowledge of them. The one notes their distinction for the sake of swelling his herbarium, the other that he may render them vehicles of expression and emotion. . . .

That generalization then is right, true, and noble, which is based on knowledge of the distinctions and observance of the relations of individual kinds. That generalization is wrong, false and contemptible, which is based on ignorance of the one, and disturbance of the other. It is indeed no generalization, but confusion and chaos; it is the generalization of a defeated army into undistinguishable impotence, the generalization of the elements of a dead carcass into dust.[38]

Truth

The word Truth, as applied to art, signifies the faithful statement, either to the mind or senses, of any fact of nature. We receive an idea of truth, then, when we perceive the faithfulness of such a statement. The difference between ideas of truth and of imitation lies chiefly in the following points:

First, Imitation can only be of something material, but truth has reference to statements both of the qualities of material things, and of

[38] *MP* I, pp. 27 ff. For Reynolds' view, see Vol. I, p. 36 above.

emotions, impressions, and thoughts. There is a moral as well as material truth—a truth of impression as well as of form—of thought as well as of matter; and the truth of impression and thought is a thousand times the more important of the two. Hence, truth is a term of universal application, but imitation is limited to that narrow field of art which takes cognizance only of material things.

Secondly, Truth may be stated by any signs or symbols which have a definite signification in the minds of those to whom they are addressed, although such signs be themselves no image nor likeness of anything. Whatever can excite in the mind the conception of certain facts, can give ideas of truth, though it be in no degree the imitation or resemblance of those facts. If there be—we do not say there is—but if there be in painting anything which operates, as words do, not by resembling anything, but by being taken as a symbol and substitute for it, and thus inducing the effect of it, then this channel of communication can convey uncorrupted truth, though it do not in any degree resemble the facts whose conception it induces. But ideas of imitation, of course, require the likeness of the object. They speak to the perceptive faculties only: truth to the conceptive.

Thirdly, and in consequence of what is above stated, an idea of truth exists in the statement of *one* attribute of anything, but an idea of imitation requires the resemblance of as many attributes as we are usually cognizant of in its real presence. A pencil outline of the bough of a tree on white paper is a statement of a certain number of facts of form. It does not yet amount to the imitation of anything. The idea of that form is not given in nature by lines at all, still less by black lines with a white space between them. But those lines convey to the mind a distinct impression of a certain number of facts, which it recognizes as agreeable with its previous impressions of the bough of a tree; and it receives, therefore, an idea of truth. . . . The last and greatest distinction between ideas of truth and of imitation—[is] that the mind, in receiving one of the former, dwells upon its own conception of the fact, or form, or feeling stated, and is occupied only with the qualities and character of that fact or form, considering it as real and existing, being all the while totally regardless of the signs or symbols by which the notion of it has been conveyed. These signs have no pretence, nor hypocrisy, nor legerdemain about them;—there is nothing to be found out, or sifted, or surprised in them;—they bear their message simply and clearly, and it is that message which the mind takes from them and dwells upon, regardless of the language in which it is delivered. But the mind, in receiving an idea of imitation, is wholly occupied in finding out that what has been suggested to it is not what it appears to be: it does not dwell on the suggestion, but on the perception that it is a false suggestion: it derives its pleasure, not from the contemplation of a truth, but from the discovery of a falsehood.

Hence, ideas of truth are the foundation, and ideas of imitation, the destruction, of all art.[39]

Beauty

Any material object which can give us pleasure in the simple contemplation of its outward qualities without any direct and definite exertion of the intellect, I call in some way, or in some degree, beautiful. Why we receive pleasure from some forms and colours, and not from others, is no more to be asked or answered than why we like sugar and dislike wormwood. The utmost subtlety of investigation will only lead us to ultimate instincts and principles of human nature, for which no farther reason can be given than the simple will of the Deity that we should be so created. . . . On these primary principles of our nature, education and accident operate to an unlimited extent; they may be cultivated or checked, directed or diverted, gifted by right guidance with the most acute and faultless sense, or subjected by neglect to every phase of error and disease. He who has followed up these natural laws of aversion and desire, rendering them more and more authoritative by constant obedience, so as to derive pleasure always from that which God originally intended should give him pleasure, and who derives the greatest possible sum of pleasure from any given object, is a man of taste.

This, then, is the real meaning of this disputed word. Perfect taste is the faculty of receiving the greatest possible pleasure from those material sources which are attractive to our moral nature in its purity and perfection. He who receives little pleasure from these sources wants taste; he who receives pleasure from any other sources has false or bad taste.

And it is thus that the term "taste" is to be distinguished from that of "judgment," with which it is constantly confounded. Judgment is a general term, expressing definite action of the intellect, and applicable to every kind of subject which can be submitted to it. There may be judgment of congruity, judgment of truth, judgment of justice, and judgment of difficulty and excellence. But all these exertions of the intellect are totally distinct from taste, properly so called, which is the instinctive and instant preferring of one material object to another without any obvious reason, except that it is proper to human nature in its perfection so to do. . . .

Ideas of beauty are among the noblest which can be presented to the human mind, invariably exalting and purifying it according to their degree; and it would appear that we are intended by the Deity to be constantly under their influence, because there is not one single object in nature which is not capable of conveying them, and which, to the rightly perceiving mind, does not present an incalculably greater number

[39] *MP* I, pp. 104 ff.

of beautiful than of deformed parts; there being in fact scarcely anything, in pure undiseased nature, like positive deformity, but only degrees of beauty, or such slight and rare points of permitted contrast as may render all around them more valuable by their opposition—spots of blackness in creation, to make its colours felt.

But although everything in nature is more or less beautiful, every species of object has its own kind and degree of beauty; some being in their own nature more beautiful than others, and few, if any, individuals possessing the utmost degree of beauty of which the species is capable. This utmost degree of specific beauty, necessarily coexistent with the utmost perfection of the object in other respects, is the ideal of the object.

Ideas of beauty, then, be it remembered, are the subjects of moral, but not of intellectual perception. By the investigation of them we shall be led to the knowledge of the ideal subjects of art.[40]

Greatness in Art

Painting, or art generally, as such, with all its technicalities, difficulties, and particular ends, is nothing but a noble and expressive language, invaluable as the vehicle of thought, but by itself nothing. He who has learned what is commonly considered the whole art of painting, that is, the art of representing any natural object faithfully, has as yet only learned the language by which his thoughts are to be expressed . . . all those excellences which are peculiar to the painter as such, are merely what rhythm, melody, precision, and force are in the words of the orator and the poet, necessary to their greatness, but not the test of their greatness. It is not by the mode of representing and saying, but by what is represented and said, that the respective greatness either of the painter or the writer is to be finally determined.

Speaking with strict propriety, therefore, we should call a man a great painter only as he excelled in precision and force in the language of lines, and a great versifier, as he excelled in precision and force in the language of words. A great poet would then be a term strictly, and in precisely the same sense, applicable to both, if warranted by the character of the images or thoughts which each in their respective languages conveyed.

It is not, however, always easy, either in painting or literature, to determine where the influence of language stops, and where that of thought begins. Many thoughts are so dependent upon the language in which they are clothed, that they would lose half their beauty if otherwise expressed. But the highest thoughts are those which are least dependent on language, and the dignity of any composition, and praise to which it is entitled, are in exact proportion to its independency of language or

40 *MP* I, pp. 109 ff.

expression. . . . We are more gratified by the simplest lines or words which can suggest the idea in its own naked beauty, than by the robe and the gem which conceal while they decorate.

There is therefore a distinction to be made between what is ornamental in language and what is expressive. That part of it which is necessary to the embodying and conveying of the thought is worthy of respect and attention. . . . But that part of it which is decorative has little more to do with the intrinsic excellence of the picture than the frame or the varnishing of it. And this caution in distinguishing between the ornamental and the expressive is particularly necessary in painting; for in the language of words it is nearly impossible for that which is not expressive to be beautiful. . . . But the beauty of mere language in painting is not only very attractive and entertaining to the spectator, but requires for its attainment no small exertion of mind and devotion of time by the artist. Hence, in art, men have frequently fancied that they were becoming rhetoricians and poets when they were only learning to speak melodiously, and the judge has over and over again advanced to the honour of authors those who were never more than ornamental writing masters.

Most pictures of the Dutch school, for instance, excepting always those of Rubens, Vandyke, and Rembrandt, are ostentatious exhibitions of the artist's power of speech, the clear and vigorous elocution of useless and senseless words; while the early efforts of Cimabue and Giotto are the burning messages of prophecy, delivered by the stammering lips of infants.

The picture which has the nobler and more numerous ideas, however awkwardly expressed, is a greater and a better picture than that which has the less noble and less numerous ideas, however beautifully expressed. No weight, nor mass, nor beauty of execution can outweigh one grain or fragment of thought. Three penstrokes of Raphael are a greater and a better picture than the most finished work that ever Carlo Dolci polished into inanity.

Yet although in all our speculations on art, language is thus to be distinguished from, and held subordinate to, that which it conveys, we must still remember that there are certain ideas inherent in language itself, and that, strictly speaking, every pleasure connected with art has in it some reference to the intellect. . . . The term idea, according to Locke's definition of it, will extend even to the sensual impressions themselves as far as they are "things which the mind occupies itself about in thinking"; that is, not as they are felt by the eye only, but as they are received by the mind through the eye. So that, if I say that the greatest picture is that which conveys to the mind of the spectator the greatest number of the greatest ideas, I have a definition which will include as subjects of comparison every pleasure which art is capable of conveying.

If I were to say, on the contrary, that the best picture was that which most closely imitated nature, I should assume that art could only please by imitating nature; and I should cast out of the pale of criticism those parts of works of art which are not imitative, that is to say, intrinsic beauties of colour and form.[41]

The Superiority of the Modern Masters of Landscape

It is strange that, with the great historical painters of Italy before them, the succeeding landscape painters should have wasted their lives in jugglery: but so it is, and so it will be felt, the more we look into their works, that the deception of the senses was the great and first end of all their art. There is, of course, more or less accuracy of knowledge and execution combined with this aim at effect, according to the industry and precision of eye possessed by the master. Claude had, if it had been cultivated, a fine feeling for beauty of form, and is seldom ungraceful in his foliage; but his picture, when examined with reference to essential truth, is one mass of error from beginning to end. Cuyp, on the other hand, could paint close truth of everything except ground and water, with decision and success, but he had no sense of beauty. Gaspar Poussin, more ignorant of truth than Claude, and almost as dead to beauty as Cuyp, has yet a perception of the feeling and moral truth of nature, which often redeems the picture; but yet in all of them, everything that they can do is done for deception, and nothing for the sake or love of what they are painting.

Modern landscape painters have looked at nature with totally different eyes, seeking not for what is easier to imitate, but for what is most important to tell. Rejecting at once all idea of *bona fide* imitation, they think only of conveying the impression of nature into the mind of the spectator. And there is, in consequence, a greater sum of valuable, essential, and impressive truth in the works of two or three of our leading modern landscape painters, than in those of all the old masters put together, and of truth too, nearly unmixed with definite or avoidable falsehood; while the unimportant and feeble truths of the old masters are choked with a mass of perpetual defiance of the most authoritative laws of nature.[42]

Clouds

Nothing can be more painfully and ponderously opaque than the clouds of the old masters universally. However far removed in aerial distance, and however brilliant in light, they never appear filmy or

41 *MP* I, pp. 87 ff.
42 *MP* I, pp. 166 ff.

evanescent, and their light is always on them, not in them. And this effect is much increased by the positive and persevering determination on the part of their outlines not to be broken in upon, nor interfered with in the slightest degree, by any presumptuous blue, or impertinent winds. There is no inequality, no variation, no losing or disguising of line, no melting into nothingness, no shattering into spray; edge succeeds edge with imperturbable equanimity, and nothing short of the most decided interference on the part of tree tops, or the edge of the picture, prevents us from being able to follow them all the way round, like the coast of an island.

And be it remembered that all these faults and deficiencies are to be found in their drawing merely of the separate masses of the solid cumulus, the easiest drawn of all clouds. But nature scarcely ever confines herself to such masses; they form but the thousandth part of her variety of effect. She builds up a pyramid of their boiling volumes, bars this across like a mountain with the grey cirrus, envelopes it in black, ragged, drifting vapour, covers the open part of the sky with mottled horizontal fields, breaks through these with sudden and long sunbeams, tears up their edges with local winds, scatters over the gaps of blue the infinity of multitude of the high cirri, and melts even the unoccupied azure into palpitating shades. And all this is done over and over again in every quarter of a mile. Where Poussin or Claude has three similar masses, nature has fifty pictures, made up each of millions of minor thoughts; fifty aisles, penetrating through angelic chapels to the Shechinah [Divine Glory] of the blue; fifty hollow ways among bewildered hills, each with its own nodding rocks, and cloven precipices, and radiant summits, and robing vapours, but all unlike each other, except in beauty, all bearing witness to the unwearied, exhaustless operation of the Infinite Mind.

And now let us, keeping in memory what we have seen of Poussin and Salvator, take up one of Turner's skies, and see whether *he* is as narrow in his conception, or as niggardly in his space. It does not matter which we take; his sublime *Babylon* is a fair example for our present purpose. Ten miles away, down the Euphrates, where it gleams last along the plain, he gives us a drift of dark elongated vapour, melting beneath into a dim haze which embraces the hills on the horizon. It is exhausted with its own motion, and broken up by the wind in its own mass into numberless groups of billowy and tossing fragments, which beaten by the weight of storm down to the earth, are just lifting themselves again on wearied wings, and perishing in the effort. Above these, and far beyond them, the eye goes back to a broad sea of white illuminated mist, or rather cloud melted into rain, and absorbed again before that rain has fallen, but penetrated throughout, whether it be vapour or whether it be dew, with soft sunshine, turning it as white as snow. Gradually, as

it rises, the rainy fusion ceases. You cannot tell where the film of blue on the left begins, but it is deepening, deepening still; and the cloud, with its edge first invisible, then all but imaginary, then just felt when the eye is not fixed on it, and lost when it is, at last rises, keen from excessive distance, but soft and mantling in its body as a swan's bosom fretted by faint wind; heaving fitfully against the delicate deep blue, with white waves, whose forms are traced by the pale lines of opalescent shadow, shade only because the light is within it, and not upon it, and which break with their own swiftness into a driven line of level spray, winnowed into threads by the wind, and flung before the following vapour like those swift shafts of arrowy water which a great cataract shoots into the air beside it, trying to find the earth. Beyond these, again, rises a colossal mountain of grey cumulus, through whose shadowed sides the sunbeams penetrate in dim, sloping, rain-like shafts; and over which they fall in a broad burst of streaming light, sinking to the earth, and showing through their own visible radiance the three successive ranges of hills which connect its desolate plain with space. Above, the edgy summit of the cumulus, broken into fragments, recedes into the sky, which is peopled in its serenity with quiet multitudes of the white, soft, silent cirrus; and, under these, again, drift near the zenith disturbed and impatient shadows of a darker spirit, seeking rest and finding none.

Now this is nature! It is the exhaustless living energy with which the universe is filled; and what will you set beside it of the works of other men? Show me a single picture, in the whole compass of ancient art, in which I can pass from cloud to cloud, from region to region, from first to second and third heaven, as I can here, and you may talk of Turner's want of truth.[43]

Turner's Image of the Sea

Of one thing I am certain; Turner never drew anything that could be *seen,* without having seen it. That is to say, though he would draw Jerusalem from some one else's sketch, it would be, nevertheless, entirely from his own experience of ruined walls: and [when] . . . he, in the year 1818, introduces a shipwreck, I am perfectly certain that, before the year 1818, he had *seen* a shipwreck, and, moreover, one of that horrible kind—a ship dashed to pieces in deep water, at the foot of an inaccessible cliff. Having once seen this, I perceive, also, that the image of it could not be effaced from his mind. It taught him two great facts, which he never afterwards forgot; namely, that both ships and sea were things that broke to pieces. *He never afterwards painted a ship quite in fair order.* There is invariably a feeling about his vessels of strange awe and danger;

43 *MP* I, pp. 381 ff.

the sails are in some way loosening, or flapping as if in fear; the swing of the hull, majestic as it may be, seems more at the mercy of the sea than in triumph over it; the ship never looks gay, never proud, only warlike and enduring.

But he had seen more than the death of the ship. He had seen the sea feed her white flames on souls of men; and heard what a storm-gust sounded like, that had taken up with it, in its swirl of a moment, the last breaths of a ship's crew. He never forgot either the sight or the sound. . . . He hardly ever painted a steep rocky coast without some fragment of a devoured ship, grinding in the blanched teeth of the surges, —just enough left to be a token of utter destruction. Of his two most important paintings of definite shipwreck I shall speak presently.

I said that at this period he first was assured of another fact, namely, that the *Sea* also was a thing that broke to pieces. The sea up to that time had been generally regarded by painters as a liquidly composed, level-seeking consistent thing, with a smooth surface, rising to a water-mark on sides of ships; in which ships were scientifically to be embedded, and wetted, up to said water-mark, and to remain dry above the same. But Turner found during his Southern Coast tour that the sea was *not* this: that it was, on the contrary, a very incalculable and unhorizontal thing, setting its "water-mark" sometimes on the highest heavens, as well as on sides of ships;—very breakable into pieces; half of a wave separable from the other half, and on the instant carriageable miles inland;—not in any wise limiting itself to a state of apparent liquidity, but now striking like a steel gauntlet, and now becoming a cloud, and vanishing, no eye could tell whither; one moment a flint cave, the next a marble pillar, the next a mere white fleece thickening the thundery rain. He never forgot those facts; never afterwards was able to recover the idea of positive distinction between sea and sky, or sea and land. Steel gauntlet, black rock, white cloud, and men and masts gnashed to pieces and disappearing in a few breaths and splinters among them;—a little blood on the rock angle, like red sea-weed, sponged away by the next splash of the foam, and the glistering granite and green water all pure again in vacant wrath. So stayed by him, for ever, the Image of the Sea.

One effect of this revelation of the nature of ocean to him was not a little singular. It seemed that ever afterwards his appreciation of the calmness of water was deepened by what he had witnessed of its frenzy, and a certain class of entirely tame subjects were treated by him even with increased affection after he had seen the full manifestation of sublimity. . . . Thenceforward his work which introduces shipping is divided into two classes; one embodying the poetry of silence and calmness, the other of turbulence and wrath. Of intermediate conditions he gives few examples; if he lets the wind down upon the sea at all, it is

nearly always violent, and though the waves may not be running high, the foam is torn off them in a way which shows they will soon run higher. On the other hand, nothing is so perfectly calm as Turner's calmness. . . . The surface of quiet water with other painters becomes FIXED. With Turner it looks as if a fairy's breath would stir it, but the fairy's breath is not there.[44]

Turner's Greatness

And now but one word more, respecting the great artist whose works have formed the chief subject of this treatise. I think there is enough, even in the foregoing pages, to show that these works are, as far as concerns the ordinary critics of the press, above all animadversion, and above all praise; and that, by the public, they are not to be received as in any way subjects or matters of opinion, but of faith. We are not to approach them to be pleased, but to be taught; not to form a judgment, but to receive a lesson. Our periodical writers, therefore, may save themselves the trouble either of blaming or praising: their duty is not to pronounce opinions upon the work of a man who has walked with nature threescore years; but to impress upon the public the respect with which they are to be received, and to make request to him, on the part of the people of England, that he would now touch no unimportant work, that he would not spend time on slight or small pictures, but give to the nation a series of grand, consistent, systematic, and completed poems. We desire that he should follow out his own thoughts and intents of heart, without reference to any human authority. But we request, in all humility, that those thoughts may be seriously and loftily given; and that the whole power of his unequalled intellect may be exerted in the production of such works as may remain for ever, for the teaching of the nations. In all that he says, we believe; in all that he does, we trust. It is therefore that we pray him to utter nothing lightly; to do nothing regardlessly. He stands upon an eminence, from which he looks back over the universe of God and forward over the generations of men. Let every work of his hand be a history of the one, and a lesson to the other. Let each exertion of his mighty mind be both hymn and prophecy; adoration to the Deity, revelation to mankind.[45]

The Lesson of the Elgin Marbles

The British ambassador in Constantinople, Robert Bruce, Earl of Elgin, obtained permission from the Ottoman government in 1801 to remove to England a large portion of the sculptures of the Athenian

[44] E. T. Cook and Alexander Wedderburn, *The Works of John Ruskin,* XVIII, *The Harbours of England* (1856), London, G. Allen, 1904, pp. 42 ff.
[45] *MP* I, p. 629.

Parthenon. The fragments which Lord Elgin's agents had brought together reached London in successive shipments during the years between 1802 and 1812. The first group of sculptures was arranged for public exhibition in 1807, in a large shed near Picadilly.

Lord Elgin's plan for providing England with a collection of some of the finest works of classical art had probably been influenced by the spectacular foundation of the Musée Napoleon in Paris. He had formed his collection at great personal expense, and in strenuous competition with French agents. But the reception accorded to his marbles in England turned out tò be distinctly less triumphant than had been the entry of the Apollo of Belvedere and the Laocoon into the Louvre a few years earlier (see page 165). Lord Elgin was denounced as a plunderer, and his sculptures dismissed as inferior Roman copies by Payne Knight, the foremost British antiquarian. Most of the opposition came from amateurs and scholars who found that the sculptures from the Parthenon offended against the rules of Ideal Art. The sculptures did, in fact, discredit neo-classicism. Their vigorous characterization of anatomical detail, their subtly modulated surfaces and strong movement were in sharp contrast to the smoothness, generality, and abstract symmetry of what passed for Greek style. If they were, indeed, Greek works of the best period, then neoclassical art could not be called truly Greek. In the controversy which the marbles aroused, the artists proved to be better judges, on the whole, than the scholars. Even such arch-classicists as Flaxman and Canova acknowledged them to be masterworks; and other artists of reputation, less committed to strict classicism, men such as the aged West and the fiery Haydon, praised them as the greatest works of art ever seen in the British Isles. To their defenders, the Elgin marbles gave proof that the best Greek art, like all truly beautiful art, was oriented to nature, rather than to an abstractly ideal form. The trend toward naturalist art was about to begin throughout Europe, and its first stirrings were felt especially strongly in England. The arrival of the Parthenon sculptures àt this moment, far from arresting this development, strengthened it. To everyone's surprise, the authority of genuine Greek art discredited the neoclassical school, and encouraged those who favored the straightforward imitation of nature, unfettered by conventions of style.[46]

Benjamin Robert Haydon (1786–1846)

Haydon typifies failed genius; the English painter's lofty ambition and precocious self-confidence recall Runge, but his powers as an artist fell tragically short of his ideal (see page 302). He had decided, when still almost a child, to raise history painting to an unprecedented height, and

[46] For an account of the controversy aroused by the marbles, see William St. Clair, *Lord Elgin and the Marbles,* London, Oxford University Press, 1967.

in his Autobiography *relates how, at the age of twenty, he began his first monumental painting:* [47]

Ordered the canvas for my first picture (six feet by four) of "Joseph and Mary resting on the road to Egypt"; and on October 1st, 1806, setting my palette and taking brush in hand, I knelt down and prayed to God to bless my career, to grant me energy to create a new era in art, and to rouse the people and patrons to a just estimate of the moral value of historical painting . . . I arose . . . and looking fearlessly at my unblemished canvas in a species of spasmodic fury I dashed down the first touch.

In 1808, Haydon was engaged on a vast and turgid classical composition of the Assassination of Dentatus. *He wanted his principal figure to be "heroic and the finest specimen of the species I could invent." The obvious model to follow would have been classical sculpture, but Haydon "desired more of nature than I could find in any of the antique figures." It was at this point that the sight of the Elgin marbles in their shed at Lord Elgin's house in Park Lane revealed to him the naturalism in genuine Greek art, in total contrast to the abstract stereotypes of neoclassicism.*[48]

To Park Lane then we went, and after passing through the hall and thence into an open yard, entered a damp dirty pent-house where lay the marbles ranged within sight and reach. The first thing I fixed my eyes on was the wrist of a figure in one of the female groups, in which were visible, though in a feminine form, the radius and ulna. I was astonished, for I had never seen them hinted at in any female wrist in the antique. I darted my eye to the elbow, and saw the outer condyle visibly affecting the shape as in nature. I saw that the arm was in repose and the soft parts in relaxation. That combination of nature and idea which I had felt was so much wanting for high art was here displayed to mid-day conviction. My heart beat! If I had seen nothing else I had beheld sufficient to keep me to nature for the rest of my life. But when I turned to the Theseus and saw that every form was altered by action or repose —when I saw that the two sides of his back varied, one side stretched from the shoulder blade being pulled forward, and the other side compressed from the shoulder blade being pushed close to the spine as he rested on his elbow, with the belly flat because the bowels fell into the pelvis as he sat—and when, turning to the Ilyssus, I saw the belly pro-

[47] *Autobiography of Benjamin Robert Haydon,* ed. Edmund Blunden, London, Oxford University Press, 1927, p. 51.
[48] *Idem.,* pp. 85 ff.

truded, from the figure living on its side—and again, when in the figure of the fighting metope I saw the muscle shown under the one arm-pit in that instantaneous action of darting out, and left out in the other arm-pits because not wanted—when I saw, in fact, the most heroic style of art combined with all the essential detail of actual life the thing was done at once and for ever.

Here were principles which the common sense of the English people would understand; here were principles which I had struggled for in my first picture with timidity and apprehension; here were the principles which the great Greeks in their finest time established, and here was I, the most prominent historical student, perfectly qualified to appreciate all this by my own determined mode of study under the influence of my old friend the watchmaker—perfectly comprehending the hint at the skin by knowing well what was underneath it!

Oh, how I inwardly thanked God that I was prepared to understand all this! Now I was rewarded for all the petty harassings I had suffered.

I felt the future, I foretold that they would prove themselves the finest things on earth, that they would overturn the false beau-ideal, where nature was nothing, and would establish the true beau-ideal, of which nature alone is the basis.

I shall never forget the horses' heads—the feet in the metopes! I felt as if a divine truth had blazed inwardly upon my mind and I knew that they would at last rouse the art of Europe from its slumber in the darkness. . . . I passed the evening in a mixture of torture and hope; all night I dozed and dreamed of the marbles. I rose at five in a fever of excitement, tried to sketch the Theseus from memory, did so and saw that I comprehended it. I worked that day and another and another, fearing that I was deluded. At last I got an order for myself; I rushed away to Park Lane; the impression was more vivid than before. I drove off to Fuseli, and fired him to such a degree that he ran up stairs, put on his coat and away we sallied. I remember that first a coal-cart with eight horses stopped us as it struggled up one of the lanes of the Strand; then a flock of sheep blocked us up; Fuseli, in a fury of haste and rage, burst into the middle of them, and they got between his little legs and jostled him so much that I screamed with laughter in spite of my excitement. He swore all along the Strand like a little fury. At last we came to Park Lane. Never shall I forget his uncompromising enthusiasm. He strode about saying, "De Greeks were godes! de Greeks were godes!"

It is curious that the god-like length of limb in the Greek productions put me in mind of Fuseli's general notions of the heroic, and there is justice in the idea. But as he had not nature for his guide his indefinite impressions ended in manner and bombast. . . .

I drew at the marbles ten, fourteen, and fifteen hours at a time;

staying often till twelve at night, holding a candle and my board in one hand and drawing with the other; and so I should have staid till morning had not the sleepy porter come yawning in to tell me it was twelve o'clock, and then often have I gone home, cold, benumbed and damp, my clothes steaming up as I dried them; and so, spreading my drawings on the floor and putting a candle on the ground, I have drank my tea at one in the morning with ecstacy as its warmth trickled through my frame, and looked at my picture and dwelt on my drawings, and pondered on the change of empires and thought that I had been contemplating what Socrates looked at and Plato saw—and then, lifted up with my own high urgings of soul, I have prayed God to enlighten my mind to discover the principles of those divine things—and then I have had inward assurances of future glory, and almost fancying divine influence in my room have lingered to my mattress bed and soon dozed into a rich, balmy slumber.

The Elgin Marbles before the House of Commons

In 1816, Lord Elgin was at last able to persuade the government to consider the purchase of the Parthenon sculptures for the British nation. A Select Committee of the House of Commons was appointed, on February 15, 1816, to take expert testimony concerning the value of the sculptures. The following are excerpts from the testimony given by artists, the sculptors Joseph Nollekens (1737–1823), John Flaxman (1755–1826), and the painters Sir Thomas Lawrence (1769–1830) and Benjamin West (1738–1820). The marbles were in the end purchased for £35,000, or about half of what they had cost Lord Elgin.[49]

CHAIRMAN OF THE COMMITTEE.—"Mr. Nollekens, are you well acquainted with the collection of Marbles brought to England by Lord Elgin?"—"I am."

"What is your opinion of those Marbles, as to the excellency of the work?"—"They are very fine—the finest things that ever came to this country."

"In what class do you place them, as compared with the finest Marbles which you have seen formerly in Italy?"—"I compared them to the finest in Italy."

"Which of those of my Lord Elgin's do you hold in the highest estimation?"—"I hold the Theseus and the Neptune to be two of the finest things;—finer than any thing in this country."

"In what class do you place the bas-reliefs?"—"They are very fine—among the first class of bas-relief work."

49 Reprinted in J. T. Smith, *Nollekens and his Time,* ed. W. Whitten, London, John Lane, 1917, p. 241 ff.

"Do you think that the bas-reliefs of the Centaurs are in the finest class of Art?"—"I do think so."

"Do you think the bas-relief of the frieze, representing the Procession, also in the first class of the art?"—"In the first class of the art." . . .

"To which of the works you have seen in Italy do you think the Theseus bears the greatest resemblance?"—"I compare that to the Apollo Belvedere and Laocoon."

"Do you think the Theseus of as fine sculpture as the Apollo?"—"I do."

"Do you think it has more or less of ideal beauty than the Apollo?"—"I cannot say it has more than the Apollo."

"Has it as much?"—"I think it has as much."

"Do you think that the Theseus is a closer copy of fine nature than the Apollo?"—"No; I do not say it is a finer copy of nature than the Apollo."

"Is there not a distinction among artists, between a close imitation of nature, and ideal beauty?"—"I look upon them as ideal beauty, and closeness of study from nature."

"Have the Elgin Collection gained in general estimation and utility since they have been more known and studied?"—"Yes."

JOHN FLAXMAN, ESQ., R.A., called in, and examined.

"Are you well acquainted with the Elgin Collection of Marbles?"—"Yes, I have seen them frequently, and I have drawn from them; and I have made such inquiries as I thought necessary concerning them respecting my art."

"In what class do you hold them, as compared with the first works of Art, which you have seen before?"—"The Elgin Marbles are mostly basso-relievos, and the finest works of Art I have seen. . . . and I have every reason to believe that they were executed by Phidias, and those employed under him, they are superior to almost any works of antiquity, excepting the Laocoon and Torso Farnese; because they are known to have been executed by the artists whose names are recorded by the ancient authors. With respect to the beauty of the basso-relievos, they are as perfect nature as it is possible to put into the compass of the marble in which they are executed, and that of the most elegant kind. There is one statue also, which is called a Hercules, or Theseus, of the first order of merit. The fragments are finely executed; but I do not, in my own estimation, think their merit is as great."

"What fragments do you speak of?"—"Several fragments of women; the groups without their heads."

"You do not mean the Metopes?"—"No; those statues which were in the east and west pediments originally."

"In what estimation do you hold the Theseus, as compared with the Apollo Belvedere and the Laocoon?"—"If you would permit me to compare it with a fragment I will mention, I should estimate it before the Torso Belvedere."

"As compared with the Apollo Belvedere, in what rank do you hold the Theseus?"—"For two reasons I cannot at this moment very correctly compare them in my own mind. In the first place, the Apollo Belvedere is a divinity of a higher order than Hercules. . . . In the next place, the Theseus is not only on the surface corroded by the weather; but the head is in that impaired state, that I can scarcely give an opinion upon it; and the limbs are mutilated. To answer the question, I should prefer the Apollo Belvedere certainly, though I believe it is only a copy."

"Does the Apollo Belvedere partake more of ideal beauty than the Theseus?"—"In my mind, it does decidedly; I have not the least question of it."

"Do you think that increases its value?"—"Yes, very highly. The highest efforts of art in that class have always been the most difficult to succeed in, both among ancients and moderns, if they have succeeded in it."

"Supposing the state of the Theseus to be perfect, would you value it more as a work of art than the Apollo?"—"No; I should value the Apollo for the ideal beauty, before any male statue I know."

"Although you think it a copy?"—"I am sure it is a copy; the other is an original, and by a first-rate artist."

"Do you think it of great consequence to the progress of Art in Britain, that this collection should become the property of the public?" —"Of the greatest importance, I think; and I always have thought so as an individual."

"Do you conceive practically, that any improvement has taken place in the state of the Arts in this country since this collection has been open to the public?"—"Within these last twenty years, I think, Sculpture has improved in a very great degree, and I believe my opinion is not singular; I think works of such prime importance could not remain in the country, without improving the public taste and the taste of the artists." . . .

Sir Thomas Lawrence, Knt., R.A., called in, and examined.
"Are you well acquainted with the Elgin Marbles?"—"Yes, I am."
"In what class of art do you consider them?"—"In the very highest."
"In your own particular line of art, do you consider them of high importance as forming a national school?"—"In a line of art which I have very seldom practised, but which it is still my wish to do, I consider that they would; namely, Historical-painting."

"Do you conceive any of them to be of a higher class than the Apollo Belvedere?"—"I do; because I consider that there is in them an union of fine composition, and very grand form, with a more true and natural expression of the effect of action upon the human frame than there is in the Apollo, or in any of the other most celebrated statues."

"You have stated, that you thought these Marbles had great truth and imitation of nature; do you consider that that adds to their value?" —"It considerably adds to it, because I consider them as united with grand form. There is in them that variety that is produced in the human form by the alternate action and repose of the muscles, that strikes one particularly. I have myself a very good collection of the best casts from the antique statues, and was struck with that difference in them, in returning from the Elgin Marbles to my own house."

BENJAMIN WEST, ESQ., R.A.
Questions sent to the President of the Royal Academy, his health not permitting him to attend the Committee; with his Answers thereto.

"Are you well acquainted with the Elgin Collection?"—"I am; having drawn the most distinguished of them, the size of the original marbles."

"In what class of art do you rank the best of these Marbles?"—"In the first of dignified art, brought out of nature upon uncertain truths, and not on mechanical principles, to form systematic characters and systematic art."

"Do they appear to you the work of the same artists?"—"One mind pervades the whole, but not one hand has executed them."

"As compared with the Apollo Belvedere, the Torso of the Belvedere, and the Laocoon, how do you estimate the Theseus or Hercules, and the River God or Ilissus?"—"The Apollo of the Belvedere, the Torso, and the Laocoon, are systematic art; the Theseus and the Ilissus stand supreme in art."

William Hazlitt (1778–1830)

"The true lesson to be learned by our students and professors from the Elgin marbles," Hazlitt wrote in the Examiner, *in 1816, "is that the chief excellence of the figures depends on their having been copied from nature, and not from the imagination." He went on to make the extraordinary claim that Phidias' sculptures "have every appearance of absolute* fac-similes *or casts taken from nature."*

Before he found his vocation as a writer, Hazlitt had studied to be a portrait painter. Throughout his life, he continued to occupy himself

with questions of art, and frequently contributed art criticism to the journals. His long essay on Fine Arts *written for the* Encyclopaedia Britannica *in 1816 (not 1824, as has been supposed) reflects the profound impression made on him by the Elgin marbles, and constitutes at the same time one of the most radical statements of the nascent anti-idealist, naturalist current in the art of the period.*[50]

The great works of art at present extant, and which may be regarded as models of perfection in their several kinds, are the Greek statues—the pictures of the celebrated Italian masters—those of the Dutch and Flemish schools—to which we may add the comic productions of our own countryman, Hogarth. These all stand unrivalled in the history of art; and they owe their pre-eminence and perfection to one and the same principle—*the immediate imitation of nature*. This principle predominated equally in the classical forms of the antique, and in the grotesque figures of Hogarth: the perfection of art in each arose from the truth and identity of the imitation with the reality; the difference was in the subjects—there was none in the mode of imitation. Yet the advocates for the *ideal system of art* would persuade their disciples that the difference between Hogarth and the antique does not consist in the different forms of nature which they imitated, but in this, that the one is like, and the other unlike, nature. This is an error.

What has given rise to the common notion of the *ideal*, as something quite distinct from *actual* nature, is probably the perfection of the Greek statues. Not seeing among ourselves anything to correspond in beauty and grandeur, either with the feature or form of the limbs in these exquisite remains of antiquity, it was an obvious, but a superficial, conclusion that they must have been created from the idea existing in the artist's mind, and could not have been copied from anything existing in nature. The contrary, however, is the fact. The general form both of the face and figure, which we observe in the old statues, is not an ideal abstraction, is not a fanciful invention of the sculptor, but is as completely local and national (though it happens to be more beautiful) as the figures on a Chinese screen, or a copper-plate engraving of a Negro chieftain in a book of travels. It will not be denied that there is a difference of physiognomy as well as of complexion in different races of men. The Greek form appears to have been naturally beautiful, and they had, besides, every advantage of climate, of dress, of exercise, and modes of life to improve it. . . .

[50] A. R. Waller and A. Glover, *Collected Works of William Hazlitt,* London, J. M. Dent, 1903, p. 326 (*Examiner* article) and p. 377 (*Encyclopedia* article). It is instructive to compare Hazlitt's views of the imitation of nature with those of Winckelmann, see Vol. I, p. 6, and of Reynolds, see Vol. I, p. 36.

In general, then, I would be understood to maintain that the beauty and grandeur so much admired in the Greek statues were not a voluntary fiction of the brain of the artist, but existed substantially in the forms from which they were copied, and by which the artist was surrounded. A striking authority in support of these observations, which has in some measure been lately discovered, is to be found in the *Elgin Marbles,* taken from the Acropolis at Athens, and supposed to be the works of the celebrated Phidias. The process of fastidious refinement and indefinite abstraction is certainly not visible there. The figures have all the ease, the simplicity, and variety, of individual nature. Even the details of the subordinate parts, the loose hanging folds in the skin, the veins under the belly or on the sides of the horses, more or less swelled as the animal is more or less in action, are given with scrupulous exactness. This is true nature and true art. In a word, these invaluable remains of antiquity are precisely like casts taken from life. The *ideal* is not the preference of that which exists only in the mind to that which exists in nature; but the preference of that which is fine in nature to that which is less so. There is nothing fine in art but what is taken almost immediately, and, as it were, in the mass, from what is finer in nature. Where there have been the finest models in nature, there have been the finest works of art.

As the Greek statues were copied from Greek forms, so Raphael's expressions were taken from Italian faces, and I have heard it remarked that the women in the streets of Rome seem to have walked out of his pictures in the Vatican.

Sir Joshua Reynolds constantly refers to Raphael as the highest example in modern times (at least with one exception) of the grand or ideal style; and yet he makes the essence of that style to consist in the embodying of an abstract or general idea, formed in the mind of the artist by rejecting the peculiarities of individuals, and retaining only what is common to the species. Nothing can be more inconsistent than the style of Raphael with this definition. In his Cartoons, and in his groups in the Vatican, there is hardly a face or figure which is any thing more than fine individual nature finely disposed and copied.

There is more an appearance of abstract grandeur of form in Michael Angelo. He has followed up, has enforced, and expanded, as it were, a preconceived idea, till he sometimes seems to tread on the verge of caricature. His forms, however, are not *middle,* but *extreme* forms, massy, gigantic, supernatural. They convey the idea of the greatest size in the figure, and in all the parts of the figure. Every muscle is swollen and turgid. This tendency to exaggeration would have been avoided if Michael Angelo had recurred more constantly to nature, and had proceeded less on a scientific knowledge of the structure of the human body;

for science gives only the positive form of the different parts, which the imagination may afterwards magnify as it pleases, but it is nature alone which combines them with perfect truth and delicacy, in all the varieties of motion and expression. It is fortunate that I can refer, in illustration of my doctrine, to the admirable fragment of the Theseus at Lord Elgin's, which shows the possibility of uniting the grand and natural style in the highest degree. The form of the limbs, as affected by pressure or action, and the general sway of the body, are preserved with the most consummate mastery. I should prefer this statue, as a model for forming the style of the student, to the Apollo, which strikes me as having something of a theatrical appearance; or to the Hercules, in which there is an ostentatious and overladen display of anatomy. This last figure, indeed, is so overloaded with sinews, that it has been suggested as a doubt, whether, if life could be put into it, it would be able to move.

[Reynolds] lays it down, as a general and invariable rule, that *"the great style in art, and the most* PERFECT IMITATION OF NATURE, *consists in avoiding the details and peculiarities of particular objects."* This sweeping principle he applies almost indiscriminately to *portrait, history,* and *landscape;* and he appears to have been led to the conclusion itself from supposing the imitation of particulars to be inconsistent with general rule and effect. It appears to me that the highest perfection of the art depends, not on separating, but on uniting general truth and effect with individual distinctness and accuracy. . . .

It might be shown, if there were room in this place, that Sir Joshua has constructed his theory of the *ideal* in art upon the same mistaken principle of the negation or abstraction of a *particular nature.* The *ideal* is not a negative, but a positive thing. The leaving out the details or peculiarities of an individual face does not make it one jot more ideal. To paint history is to paint nature as answering to a general, predominant, or pre-conceived idea in the mind, of strength, beauty, action, passion, thought, etc.; but the way to do this is not to leave out the details, but to incorporate the general idea with the details: that is, to show the same expression actuating and modifying every movement of the muscles, and the same character preserved consistently through every part of the body. Grandeur does not consist in omitting the parts, but in connecting all the parts into a whole, and in giving their combined and varied action; abstract truth, or ideal perfection does not consist in rejecting the peculiarities of form, but in rejecting all those which are not consistent with the character intended to be given, and in following up the same *general idea* of softness, voluptuousness, strength, activity, or any combination of these, through every ramification of the frame.

But these modifications of form or expression can only be learnt from nature, and therefore the perfection of art must always be sought in nature.

INDIVIDUALITY AND TRADITION

With the exception of purely naturalistic landscape painting, nearly all of the art produced in the decades of 1820–1850 derived, in style and theme, from the art of earlier periods. The greatest artists of the time, as well as numberless mediocrities, drew so heavily on traditional material that their work cannot be understood apart from the work of their models or guides. Claude was to Turner, Raphael to Ingres, Rubens to Delacroix far more than a brief stimulus or passing influence. Such dependence on tradition was not unprecedented in the history of art, but what distinguished the particular situation of 19th century art from that of earlier periods of eclecticism was the modern artist's claim to originality and individual freedom. How to reconcile the need for self-expression with the necessity of working within the range of established forms and subjects was a problem which every artist of the time had to face. Personal expression came to be regarded as the individual artist's particular choice, combination, and arrangement of suggestions from the vast repertory of tradition. This accounts for the stylistic disunity of the period which was a serious burden even to the strongest artists, and a fatal handicap to the weak.

Joseph Mallord William Turner (1775–1851)

That an artist of such powerful individuality as Turner should profess academic principles is reason for surprise. But there can be no doubt about Turner's ardent loyalty to the Royal Academy to which, as he said, "I owe everything; for I cannot look back but with pride and pleasure to that time, the halcyon perhaps of my days, when I received instruction within these walls." After his appointment as Professor of Perspective in 1807, it fell to his lot to present the annual short course in his subject, speaking from the same platform from which he had heard Sir Joshua Reynolds deliver his last presidential Discourse *in 1790. By all accounts, Turner was a boring and confused lecturer. It was his custom to treat of perspective in a series of five lectures, to which he added, in 1811, a sixth dealing with* "Backgrounds, Introductions of Architecture and Landscape." *In making this addition (which he dropped from the course in 1816 or 1818), he may have hoped that it might persuade the Academy to establish for him a professorship in landscape painting. The main burden of the lecture on* Backgrounds *is the importance of landscape, not merely as an adjunct to history painting, but*

as an independent branch of the art. There are passages in the lecture in which Turner sheds his usual labored manner and speaks with eloquence and warmth of the great colorists of the Baroque, and of Titian and Claude whom he regarded as his ancestors.[51]

From *Backgrounds, Introductions of Architecture and Landscape* (1811)

. . . The highest honour that landscape has as yet, she received from the hands of Titian, which proves how highly he considered its value not only in employing its varieties of contrast, colour and dignity in most of his Historical Pictures; but the triumph even of Landscape may be safely said to exist in his divine picture of St. Peter Martyr. No thought of narrow subservience enters the Idea or appears in the arrangement of that truly great specimen of his powers and of art.

Amplitude, quantity and space appear in this picture given by the means of Trees opposed to a blue sky and deep sunk Horizon not more than one-sixth of the height of the picture, across which rush the knotted stems of trees with dark brown and yellow foliage, stretching far their leafy honours. And their heads [are] lost in the effulgence of the angels descending to crown the dying Martyr, whose looks are directed upwards, as likewise [are] the flowing garments of the companion endeavouring to escape. Its [the picture's] apparent immensity arises from the quantity of sky, the continual line of trees and last, tho' not least, the low sunk horizon to which the eye always supports itself equal. And therefore the figure as it were rushes out of the picture impelled forward upon you.

To Nicolas Poussin let me direct your observation. His love for the antique prompted his exertion and that love for the antique emanates through all his works. It clothes his figures, rears his buildings, disposes of his materials, arranges the whole of his picture and landscape and gives, whether from indifference or strength of his ground, a colour that often removes his works from truth.

To these proofs of his abilities of Historic grandeur and pastoral subjects we possess another truly sublime in the picture at Ashburnham House of Pyramus and Thisbe. . . . whether we look upon the dark, dark sky sparingly illumined at the right-hand corner by lightening there rushing behind the bending trees and at last awfully gleaming, her power [?] is reborn, its dying efforts upon some antique buildings on the left, while all beneath amid gloom scatter'd foliage and broken ground lies the dying figure of Pyramus. And in the depth and doubt of darkness all is lost but returning Thisbe.

[51] Turner's "Backgrounds" lecture was first published in its entirety by J. Ziff, " 'Backgrounds, Introductions of Architecture and Landscape,' a Lecture by J. M. W. Turner," *Journal of the Warburg and Courtauld Institutes,* 1963, XXVI, 133 ff.

From this effort of conception of contending elements let us consider one where Nature struggles for existence and the last twisting to the overwhelming waters of the Deluge, bearing along Earth's perishable materials under one tone and the residue of Earthy matter is the impression of this famous picture. Richelieu is said to have declared that it absorbed his mind from all worldly concerns and that he could remain before it for hours as his only pleasure. This picture is now in the Louvre and called the Deluge.

For its colour it is admirable. It is singularly impressive, awfully appropriate, just fitted to every imaginative conjecture of such an event. But [it is] deficient in every requisite of line, so ably display'd in his other works, inconsistent in his introductions in the colouring of the figures, for they are positively red, blue, and yellow, while the sick and wan sun is not allow'd to shed one ray but tears.

Pure as Italian air, calm, beautiful and serene springs forward the works and with them the name of Claude Lorrain. The golden orient or the amber-coloured ether, the midday ethereal vault and fleecy skies, resplendent valleys, campagnas rich with all the cheerful blush of fertilization, trees possessing every hue and tone of summer's evident heat, rich, harmonious, true and clear, replete with all the aerial qualities of distance, aerial lights, aerial colour, where through all these comprehensive qualities and powers can we find a clue towards his mode of practice? As beauty is not beauty until defin'd or science science until reveal'd, we must consider how he could have attained such powers but by continual study of parts of nature. Parts, for, had he not so studied, we should have found him sooner pleased with simple subjects of nature, and [would] not [have], as we now have, pictures made up of bits, but pictures of bits. Thus may be traced his mode of composition, namely, all he could bring in that appear'd beautifully dispos'd to suit either the side scene or the large trees in the centre kind of composition. Thus his buildings, though strictly classical and truly drawn from the Campo Vaccino and Tivoli, are so disposed of as to carry with them the air of composition.

But in no country as in England can the merits of Claude be so justly appreciated, for the choicest of his work are with us, and may they always remain with us in this country. The walls of the Louvre can only boast of two by name, which two may with more propriety be called Swanevelt, the plodding tho' not the mean or humble imitator or élève, whose best works have in other countries besides France been honour'd, if honour it can be call'd in depriving him of his just need of merit in calling them Claudes, a compliment that steals from him a good name and leaves him poor indeed.

The Flemish school approaches to individual nature, and only two,

Rembrandt and Rubens, ever dared to raise her above commonality. Rembrandt depended upon his chiaroscuro, his bursts of light and darkness to be *felt*. He threw a mysterious doubt over the meanest piece of Common; nay more, his forms, if they can be called so, are the most objectionable that could be chosen, namely, the Three Trees and the Mill, but over each he has thrown that veil of matchless colour, that lucid interval of Morning dawn and dewy light on which the Eye dwells so completely enthrall'd, and it seeks not for its liberty, but as it were, thinks it a sacrilege to pierce the mystic shell of colour in search of form.

No painter knew so well the extent of his own powers and his own weakness. Conscious of the power as well as the necessity of shade, he took the utmost boundaries of darkness and allow'd but one-third of light, which light dazzles the eye thrown upon some favourite point, but where his judgment kept pace always with his choice surrounded with impenetrable shade still remains.

Rubens, Master of every power of handicraft and mechanical excellence, from the lily of the field to animated nature, disdained to hide, but threw around his tints like a bunch of flowers. Such is the impression excited in his Fête in the Louvre, wholly without shadow compar'd to Rembrandt's mode, obtaining everything by primitive colour, form and execution, and so abundantly supplied by the versatility of his genius with forms and lines, could not be happy with the bare simplicity of pastoral scenery or the immutable laws of nature's light and shade, feeling no compunction in making the sun and full moon as in the celebrated picture of the Landscape with the Waggon, or introducing the luminary in the Tournament, while all the figures in the foreground are lighted in different directions. These trifles about light are so perhaps in Historical compositions, but in Landscape they are inadmissible and become absurdities destroying the simplicity, the truth, the beauty of pastoral nature in whose pursuit he always appears lavish of his powers. Full of colour, the rapidity of his pencil bears down all before it in multitudes of forms, not the wild incursions full of Grandeur as Salvator Rosa, but [the] swampy vernality of the Low Countries.

Without affecting to do anything, Teniers has given us that individuality, which the great genius of Rubens in his Flemish Fête and pastorals always seem'd in search of. Artfully arrang'd and exquisitely touched tho' looking careless, bearing a freshness and silvery tone pervading everywhere thro' all the diversity of colours, tho' scatter'd upon the innumerable figures of the Flemish Marriage Feast at Louther Castle, yet all the tones tend by his consummate management, concentrated, to one figure in white and grey which binds the whole together.

Cuyp, Paul Potter and Adrian van der Velde sought for simplicity below commonality which too often regulated their choice and alas their

introductions, yet for colour and minuteness of touch of every weed and briar long bore away the palm of labour and execution. But Cuyp to a judgment so truly qualified knew where to blend minutiae in all the golden colour of ambient vapour.

Gainsborough, our countryman, rais'd their beauties by avoiding their defects, the mean vulgarisms of common low life and disgusting incidents of common nature. His first efforts were in imitation of Hobbema, but English nature supplied him with better materials of study. The pure and artless innocence of the Cottage Door now in the possession of Sir John Leicester may be esteemed as possessing this class, as possessing truth of forms arising from his close contact with nature, expression, full-toned depth of colours and a freedom of touch characteristically varied with the peculiarities of the vigorous foliage or of decaying nature.

Turner on Varnishing Day

In 1835, Turner exhibited the first version of his Burning of the House of Parliament *at the galleries of the British Institution in London. One of his fellow exhibitors, E. V. Rippingille (1798–1859), has left a description of Turner finishing his picture in the exhibition gallery:* [52]

He was there and at work before I came, having set to at the earliest hour allowed. Indeed it was quite necessary to make the best of his time, as the picture when sent in was a mere dab of several colours, and "without form and void," like chaos before the creation. The managers knew that a picture would be sent there, and would not have hesitated, knowing to whom it belonged, to have received and hung up a bare canvas, than which this was but little better. Such a magician, performing his incantations in public, was an object of interest and attraction. Etty was working at his side [on his picture "The Lute Player"] and every now and then a word and a quiet laugh emanated and passed between the two great painters. Little Etty stepped back every now and then to look at the effect of his picture, lolling his head on one side and half closing his eyes, and sometimes speaking to some one near him, after the approved manner of painters: but not so Turner; for the three hours I was there—and I understood it had been the same since he began in the morning—he never ceased to work, or even once looked or turned from the wall on which his picture hung. All lookers-on were amused by the figure Turner exhibited in himself, and the process he was pursuing with his picture. A small box of colours, a few very small brushes, and a

[52] A. J. Finberg, *The Life of J. M. W. Turner,* Oxford, Clarendon Press, 1961, p. 351.

vial or two, were at his feet, very inconveniently placed; but his short figure, stooping, enabled him to reach what he wanted very readily. Leaning forward and sideways over to the right, the left hand metal button of his blue coat rose six inches higher than the right, and his head buried in his shoulders and held down, presented an aspect curious to all beholders, who whispered their remarks to each other, and quietly laughed to themselves. In one part of the mysterious proceedings Turner, who worked almost entirely with his palette knife, was observed to be rolling and spreading a lump of half-transparent stuff over his picture, the size of a finger in length and thickness. As Callcott was looking on I ventured to say to him, "What is that he is plastering his picture with?" to which inquiry it was replied, "I should be sorry to be the man to ask him." . . .

Presently the work was finished: Turner gathered his tools together, put them into and shut up the box, and then, with his face still turned to the wall, and at the same distance from it, went sideling off, without speaking a word to anybody, and when he came to the staircase, in the centre of the room, hurried down as fast as he could. All looked with a half-wondering smile, and Maclise, who stood near, remarked, "There, that's masterly, he does not stop to look at his work; he *knows* it is done, and he is off."

Theodore Géricault (1791–1824)

From Géricault's early years, about 1810–1815, a schedule of exercises and good intentions survives which gives an insight into his private studies and state of mind: [53]

Draw and paint after the great masters of antiquity.

Read and compose.—Anatomy.—Antiquities.—Music.—Italian.

Take the courses in ancient art, Tuesdays and Saturdays, at two o'clock.

December.—Paint a figure at Dorcy's.—In the evenings, draw after the antique and compose a few subjects.—Occupy yourself with music.

January.—Go to M. Guérin to paint from life.

February.—Occupy yourself solely with the style of the masters and compose, without going out, and always alone.

Though he wrote little and was not at all inclined to theoretical speculation, Géricault left behind a manuscript fragment of observations on the state of painting in France. It is probable that these pages, which

[53] Charles Clément, *Géricault, étude biographique et critique*, Paris, 1868, p. 29.

Géricault evidently intended to develop into a publishable essay or pamphlet, were written during the long months of his fatal illness, in 1822–1824. The diatribe against academic training and the praise of genius which form a major part of the preserved fragment strike a familiar note. But they are more than a rehearsal of notions widely current since the 18th century (see page 71); they reflect personal experience. Géricault's formal training was irregular and brief, but he had sampled the conditions which he describes. For somewhat less than two years, during 1810–1812, he had taken instruction from Pierre Guérin, one of the luminaries of the French school whom he mentions in his essay. Later, in 1816, he had competed unsuccessfully for the academic Rome Prize. But he was essentially a self-taught artist, as were nearly all the best painters of his generation, and in the enthusiasm with which he speaks of the irrepressible self-realization of genius there is a tinge of personal pride.[54]

Academy and Genius

The government has established schools of art which it maintains at great expense and which admit all young people. These schools keep their students in a state of constant emulation by means of frequent competitions, and it would seem, at first sight, as if they were extremely useful institutions, the surest devices for the encouragement of the arts. Neither at Athens nor at Rome did citizens possess better facilities for the study of the sciences and the arts than are offered in France by our numerous schools of all kinds. But I observe with regret that, from the time of their establishment, these schools have had a quite unforeseen effect: instead of giving service, they have done real harm, for while they have produced a thousand mediocre talents, they cannot claim to have formed the best of our painters. These, on the contrary, were among the founders of the schools, or at least were the first to spread the principles of taste.

David, the first among our artists, the regenerator of the French school, owes only to his own genius the successes which have attracted to him the attention of the world. He has borrowed nothing from the schools. On the contrary, they would have been his undoing, if his taste had not shielded him at an early date from their influence, and enabled him to become the radical reformer of the absurd and monstrous system of Van Loo, Boucher, Restout, and the many other painters who in those days were powerful in an art which they only profaned. Italy and the study of the great masters inspired in him the grand style which he has always given to his historical compositions; he became the model and

54 Charles Clément, *op. cit.*, pp. 242 ff.

leader of a new school. His principles soon stimulated the development of new talent which had only been waiting to be fertilized, and several celebrated names soon proclaimed the glory and shared the laurel of their master.

After this first surge, this impetus toward a pure and noble style, enthusiasm was bound to wane, though the excellent lesson already learned was not altogether lost, and the government's efforts tended to prolong the favorable momentum as long as possible. But the sacred fire which alone can produce great things grows every day more dim, and the exhibitions, though numerous—all too numerous—become less interesting every year. We no longer find in them those noble talents which once excited general enthusiasm and to which the public—ever ready to appreciate the beautiful and grand—so eagerly paid its respect. No worthy rivals have yet arisen to confront Gros, Gerard, Guérin and Girodet, and it is to be feared that though these masters are charged with the education of a young and ardently competitive generation, they will take with them, at the end of their long and honorable careers, the regret of not having produced worthy successors. It would be unjust, however, to accuse them of having failed to give all possible care to their pupils. Where, then, lies the blame for this aridity, this want, despite all the medals, Rome Prizes and Academy competitions? I have always believed that a good education must be the necessary basis for the exercise of any profession, and that it alone can give us true distinction in whatever career we may choose. It serves to mature our mind, it enlightens us, and shows us the goal toward which we must strive. We cannot choose a profession without having weighed its advantages and drawbacks. Except in a few, precocious temperaments, our inclinations seldom become definite before the age of sixteen: it is only then that we begin to know what we really want to do and gain the ability to study for the profession which we have chosen because it suited our convenience or because we felt passionately attracted to it. For this reason, I should want the Academy to accept only those who have at least reached the age of sixteen. It should not be the purpose of this institution to create a race of painters, rather, it ought simply to provide true genius with the means for self-development. But, instead, we seem to be raising an entire population of artists. The lure of the Rome Prize and the facilities of the Academy have attracted a crowd of competitors whom the love of art alone would never have made painters, but who might have gained honor in other professions. Thus they waste their youth and time in the pursuit of a success which is bound to elude them, while they could have been more usefully employed on their own or on their country's behalf.

The man of true avocation does not fear obstacles, because he feels

in himself the strength to overcome them. Often they are an additional stimulus to him. The fever which they excite in his soul is not lost, it may enable him to do astounding work.

It is toward men of this kind that the solicitude of enlightened governments should be directed; it is by encouraging, by appreciating, and by using their abilities that we can assure the nation's glory; it is men such as these who will make memorable the century which has discovered them and called them to their task.

But even assuming that all the young people admitted to the schools were gifted with all the qualities which make a painter, is it not dangerous for them to study together for years, subjected to the same influences, copying the same models, and following the same route? How can we expect them to retain any kind of originality? Will they not unconsciously submerge whatever individual qualities they may possess, adapting their own ways of conceiving nature's beauty to one uniformity of sentiment?

The traces of individuality which survive this sort of merging are imperceptible. Thus we come with real disgust upon ten or twelve compositions every year which are of approximately identical execution, are painted from one end to the other with maddening perfection, and contain no originality whatever. Since every one of these competitors has for years denied his own sensations, none has preserved his individuality. A single way of drawing, one kind of color, and arrangements which all conform to one system, down to particulars of gesture and facial expression: everything in these sad productions of our school seems to have sprung from the same source and been inspired by the same soul, assuming that a soul could have perserved its faculties in the midst of such depravity and influenced a work of this kind.

I shall even go further and assert that obstacles and difficulties which repel mediocre men are a necessity and nourishment to genius. They mature and elevate it, when in an easier road it would have remained cold. Everything which opposes the irresistible advance of genius irritates it, and gives it that fevered exaltation which conquers and dominates all, and which produces masterworks. Such are the men who are their nation's glory. External circumstance, poverty, or persecution will not slow their flight. Theirs is like the fire of a volcano which must absolutely burst into the open, because its nature absolutely compels it to shine, to illuminate, to astonish the world. Do you hope to produce men of this race? The Academy, unfortunately, does more than that: it extinguishes those who, to begin with, had a spark of the sacred fire; it stifles them by keeping nature from developing their faculties at its own speed. By fostering precocity, it spoils the fruit which would have been made delicious by a slower maturation.

Géricault at Work on the Raft of the Medusa

The painter Antoine Alphonse Montfort (1802–1884), a pupil of Gros and Horace Vernet, was among the young artists who befriended Géricault when he was painting the Raft of the Medusa, *during the winter of 1818–1819.*[55]

Fortunate enough to have been admitted to Géricault's studio in order to copy a few sketches, at the time when he was executing his picture, I was impressed, first of all, by the intensity with which he worked, and also by the quiet and reflection which he needed. He generally started work as soon as there was enough light and continued without interruption until nightfall. He was often forced to do this by the size of the part which he had begun in the morning and which he had to finish on the same day. This was particularly necessary for him because of his use of a fatty, fast-drying oil which made it impossible for him to continue on the morrow what he had begun the previous day. . . . I was very vividly impressed by the care with which Géricault worked. Being still quite young (I was only seventeen years old), I found it hard to remain still for several hours in succession, without getting up and quite unintentionally making a little noise with my chair. In the midst of the absolute silence which reigned in the studio, I felt that this small noise must have disturbed Géricault. I turned my eyes toward the table on which he stood to reach the height of his figures, working without uttering a word. He would give me a slightly reproachful smile and assure me that the sound of a mouse was enough to keep him from painting.

His manner of working was quite new to me, and surprised me no less than his profound concentration. He painted directly on the white canvas, without a rough sketch or preparation of any sort, except for a firmly traced contour, and yet the solidity of the work was none the worse for it. I noted also with what intense attention he examined the model before touching the brush to the canvas, seeming to advance slowly, when in reality he executed very rapidly, putting one touch after the other in its place, rarely having to go over his work twice. No movement was visible in his body or arms. His expression was perfectly calm; only his slightly flushed face betrayed his mental concentration. Witnessing this external calm, one was all the more surprised by the verve and energy

[55] Charles Clément, *op. cit.*, pp. 138 ff.

of his execution. What salience! Especially in their half-finished state, the various parts of the picture had the look of roughly blocked-out sculpture. Seeing the breadth of this manner, one might have supposed that Géricault used very thick brushes, but this was not at all the case. His brushes were small, compared to those used by various other artists of my acquaintance. This can easily be verified by an examination of several figures in the picture which are entirely executed in hatchings.

When evening came, Géricault laid aside his palette and took advantage of the last rays of daylight to examine his work. It was then that, seated by the stove and his eyes turned toward the canvas, he spoke to me of his hopes and disappointments. Usually he was very little satisfied, but on some days he believed that he had found a way of modeling, i.e., of giving proper relief to his figures, and seemed content. The following day, after a day of work equally well-spent as the previous one, he would confess to us that he was not on the right track and must make fresh efforts. One day, he had gone to see [David's] *Sabines* and *Leonidas*. He returned discouraged. His own work seemed "round" [*rond*] to him, and speaking of the figures of the young warriors, at the right of *Leonidas,* who are shown rushing forward to get their shields, he said to me: "Ah, well! Those are wonderful figures!"—and averted his eyes from his picture.

Eugène Delacroix (1798–1863)

In the entire literature of modern art, Delacroix' Journals and Letters occupy a special place as the most extensive, continuous, and profound record of a great artist's thought. They constitute a human document of the highest significance, which reveals incomparably more about art, the artist, and his period than any merely historical or philosophical account.

Delacroix' activity spanned the interval of forty years between the last works of David and the earliest of Cézanne. When he began, neoclassicism was already moribund, although its lifeless productions still cluttered the Salons. History painting, conventionally regarded as the noblest branch of art, languished for lack of a vital style and of significant themes. The future seemed to lie with the pseudo-romantics, the specialists in sentimental anecdotes, picturesque vignettes, and exotic trifles. Artists lacked a pictorial form in which to express modern experience. David, Gros, and Géricault had experimented with devices borrowed from the Baroque, and particularly from Rubens. Delacroix actually restored the link with tradition. He was the last great European painter to use the repertory of humanistic art with conviction and originality. In his

*hands, antique myth and medieval history, the barricade and Golgotha,
Faust and Hamlet, Scott and Byron, royal tiger and Odalisque yielded
images of equal power. As he grew older, he felt increasingly drawn to
the great Venetians and Flemings, to Veronese and Rubens above all.
His preoccupation with them was not a retreat into the past, but an
acknowledgment that his direction continued the line of a long tradition.
He considered himself not as an imitator, but as the legitimate heir of
Rubens.*

*Delacroix' writings reveal a thorough acquaintance with the theo-
retical literature of art. But his own work was not guided by a systematic
theory, and his practical debt to the theoreticians was small. His specula-
tion tended to be afterthought, rather than program. Late in his life, he
formed the plan of gathering some scattered notes into an alphabetic
Dictionary of Art. He abandoned this project, but its form is revealing.
His observations and opinions owe their consistency to the particular
quality of his mind, not to any coherent doctrine, least of all a doctrine
of Romantic art. Romanticism, throughout most of his mature life, was
a late and feeble strain with which Delacroix, understandably enough,
disliked to be associated. After the deaths of Géricault and Bonington,
the romantic movement in France numbered only one painter of con-
sequence—Delacroix himself. His fellow veterans of the "romantic battle,"
the Devérias, the Scheffers, Schnetz, Lami, Nanteuil and Boulanger, had
declined to insignificance by 1835. Delacroix outgrew this affiliation and
continued on his personal way. Living in an age of rapid urbanization
and industrialization, among men who believed in progress and regarded
him as a rebel, he was a pessimist, suspicious of railways and revolutions,
a conservative in his habits and an aristocrat in his tastes. He suffered
the strange fate of being both misunderstood and celebrated. He felt
alienated from the spirit of his time, and yet represented it more fully
than any other artist. Outwardly, he resembled the stereotype of the
romantic egoist, but he had a strong sense of cultural responsibility, and
his work, while private in some aspects, was grandly monumental and
didactic in others. His interests were eclectic in the extreme. In matters
of religion and philosophy, he sympathized with the rational scepticism
of the Enlightenment. His reading included Virgil, Dante, Shakespeare,
Racine, and Voltaire. His knowledge of past art was extensive; he wrote
articles on Raphael, Michelangelo, Poussin, and Puget among the older
artists, on Prud'hon, Gros, and Charlet among the moderns.*

*His entire life span is documented by a vast correspondence which
began in his childhood and extended to his last days. The preserved
Journals only cover the years of 1822–1824 and 1847–1863. In addition
to these private writings, Delacroix produced 14 published articles be-*

tween 1829 and 1862. The following excerpts are taken from the Journals *and the* Letters.[56]

On Life and Work

SATURDAY, 27 MARCH [1824]

Went early to the studio. Lopez. Pierret came in. Dined with him; read Horace. Longing for poetry but not because of Horace. Allegories. Meditations. Strange condition of man! Inexhaustible subject. Create, create!

WEDNESDAY, 31 MARCH [1824]

I must not eat much in the evening, and I must work alone. I think that going into society from time to time, or just going out and seeing people, does not do much harm to one's work and spiritual progress, in spite of what many so-called artists say to the contrary. Associating with people of that kind is far more dangerous; their conversation is always commonplace. I must go back to being alone. Moreover, I must try to live austerely, as Plato did. How can one keep one's enthusiasm concentrated on a subject when one is always at the mercy of other people and in constant need of their society? . . .

SUNDAY, 4 APRIL [1824]

Everything tells me that I need to live a more solitary life. The loveliest and most precious moments of my life are slipping away in amusements which, in truth, bring me nothing but boredom. The possibility, or the constant expectation, of being interrupted is already beginning to weaken what little strength I have left after wasting my time for hours the night before. When memory has nothing important to feed on, it pines and dies. My mind is continually occupied in useless scheming. Countless valuable ideas miscarry because there is no continuity in my thoughts. They burn me up and lay my mind to waste. The enemy is within my gates, in my very heart; I feel his hand everywhere. Think of

[56] The excerpts from Delacroix' diaries are taken from the translation by Lucy North, *The Journal of Eugène Delacroix*, edited by H. Wellington, London, Phaidon Press, Ltd., 1951, reprinted by permission of the publisher. The passages from Delacroix' letters written in Tangiers were translated from *Eugène Delacroix, Correspondance Générale*, edited by A. Joubin, Paris, Plon, 1936, I, 310 ff. The notes on color were translated from *Eugène Delacroix, sa vie et ses oeuvres*, edited by E. A. Piron, Paris, 1865, pp. 416 ff. For recent studies of Delacroix' theories of art, see C. Sieber-Meier, *Untersuchunges zum 'Oeuvre Litteraire' von Eugène Delacroix*, Bern, Francke Verlag, 1963, and George P. Mras, *Eugène Delacroix's Theory of Art*, Princeton, Princeton University Press, 1966.

the blessings that await you, not of the emptiness that drives you to seek constant distraction. Think of having peace of mind and a reliable memory, of the self-control that a well-ordered life will bring, of health not undermined by endless concessions to the passing excesses which other people's society entails, of uninterrupted work, and plenty of it.

MONDAY, 26 APRIL [1824]

All my days lead to the same conclusion; an infinite longing for something which I can never have, a void which I cannot fill, an intense desire to create by every means and to struggle as far as possible against the flight of time and the distractions that deaden my soul; then, almost always, there comes a kind of philosophical calm that resigns me to suffering and raises me above petty trifles. But here, perhaps, imagination is again leading me astray, for at the slightest mishap it is goodbye to philosophy. I wish I could identify my soul with that of another person.

TUESDAY, 27 APRIL [1824]

An interesting discussion at Leblond's about geniuses and outstanding men. Dimier thinks that great passions are the source of all genius! I think that it is imagination alone or, what amounts to the same thing, a delicacy of the senses that makes some men see where others are blind, or rather, makes them see in a different way. I said that even great passions joined to imagination usually lead to a disordered mind. Dufresne made a very true remark. He said that fundamentally, what made a man outstanding was his absolutely personal way of seeing things. He extended this to include great captains, etc., and, in fact, great minds of every kind. Hence, no rules whatsoever for the greatest minds; rules are only for people who merely have talent, which can be acquired. The proof is that genius cannot be transmitted.

FRIDAY, 7 MAY [1824]

. . . I confess that I have worked logically, I, who have no love for logical painting. I see now that my turbulent mind needs activity, that it must break out and try a hundred different ways before reaching the goal towards which I am always straining. There is an old leaven working in me, some black depth must be appeased. Unless I am writhing like a serpent in the coils of a pythoness I am cold.

YESTERDAY, 14 MAY [1824]

This morning, as I was reading the note on Lord Byron at the beginning of the book, I again felt the insatiable longing to create. Can I

be sure that this would bring me happiness? I believe, at any rate, that it would.

Loneliness is the torment of my soul. The more it expands among friends and in the habits and pleasures of my daily life, the more it seems to elude me and to retire into its inner fortress. A poet who lives in solitude and produces a great deal can enjoy to the full the treasures which we carry in our hearts, but which forsake us when we give ourselves to others. For when we surrender ourselves entirely to the soul it unfolds itself completely to us, and it is then that this capricious spirit grants us the greatest happiness of all, of which this note on Lord Byron speaks—I mean the joy of expressing the soul in a hundred different ways, of revealing it to others, of learning to know ourselves, and of continually displaying it in our works. This is something of which Lord Byron and Rousseau may perhaps have been unconscious. I am. not speaking of mediocre people. But what is this urge not only to write, but to publish one's work? Besides the pleasure of being praised, there is the thought of communicating with other souls capable of understanding one's own, and thus of one's work becoming a meeting place for the souls of all men. For what is the use of the approval of one's friends? It is only natural that they should understand one, and therefore their praise is of no real consequence. Living in the minds of others is what is so intoxicating. I ask myself, why be so discouraged? You can add one more to the number of those who have seen nature in their own way. What they portrayed was made new through their vision and you will renew these things once more. When they painted they expressed their souls, and now yours is demanding its turn.

. . . The very people who believe that everything has already been discovered and everything said, will greet your work as something new, and will close the door behind you, repeating once more that nothing remains to be said. For just as a man in the weakness of his old age believes that nature, and not himself, is degenerating, so men with commonplace minds, who have nothing to add to what has been said already, believe that nature has given only to a few—and these at the beginning of time—the power to say new and striking things. . . . Newness is in the mind of the artist who creates, and not in the object he portrays.

. . . You who know that there is always something new, show it to others in the things they have hitherto failed to appreciate. Make them feel that they have never before heard the song of the nightingale, or been aware of the vastness of the sea—everything that their gross senses can perceive only when someone else takes the trouble to feel it for them. And do not let language trouble you. If you cultivate your soul it will find the means to express itself. It will invent a language of its own far better than the metre or the prose of this or that great writer. What! you

say you have an original mind, and yet your flame is only kindled by reading Byron or Dante! You mistake this fever for creative power when it is really only a desire to imitate. . . .

TUESDAY, 12 OCTOBER [1852]

. . . Why is it that nowadays I never know a moment's boredom when I have a brush in my hand, and feel that if only I had enough strength I should never stop painting, except to eat and sleep? I remember that in the past, at the age when an artist's enthusiasm and imaginative powers are supposed to be at their height, I lacked the experience to profit by these fine qualities and was halted at every step and often discouraged. Nature plays a bad joke on us when she places us in this situation as we begin to grow old. We become completely mature, our imagination is as fresh and active as ever, especially now that age has stilled the mad, impetuous passions of our youth, but we no longer have the same strength; our senses begin to wear out and are more in need of rest than activity. Yet, with all these drawbacks, what consolation we derive from work. I feel so thankful not to have to seek for happiness, as I used to understand the word. What tyranny this weakness of my body has delivered me from! Painting used to be the least of my preoccupations. Therefore we must do the best we can, and if nature refuses to allow us to work for more than a certain length of time we must not ill-treat her, but be thankful for what she still leaves us. We must be less eager in the pursuit of praises that are as empty as the wind, and enjoy work for its own sake, and for those delightful hours when we have the deep satisfaction of realizing that our rest has been earned by a healthy tiredness that keeps our souls in good repair. This in its turn affects the body and prevents the rust of the years from tarnishing the nobler sentiments.

SUNDAY, 20 DECEMBER [1857]

The studio is completely empty, who would ever believe it? Even now that it's all bare and deserted, I still love this place where I used to be surrounded by all kinds of pictures, many of which I enjoyed for their variety and all of them evoking some special memory or feeling. The studio seems twice as big. I still have about ten small pictures to finish and am enjoying the work very much. As soon as I get up, I hurry upstairs to the studio, hardly waiting to comb my hair, and I stay here until dark without one empty moment or desire for the distractions of paying visits, or other so-called entertainments. All my ambition is bounded by these walls. In these last moments I am enjoying the feeling of still being in this room which has known me for so many years, and where I spent so much of the last part of my late youth. I say this, because although I am

now an old man, my imagination and some other faculty (I don't quite know what to call it) still give me the thrills and longings and enthusiasms of the best years of my life. My faculties have never been slaves to uncontrollable ambition, and therefore I am not forced to sacrifice my enjoyment of them and of myself in a vain desire to be envied in some public position. What a futile bauble for a man to play with in his old age! A stupid thing to give his heart and mind to at a time when he should be withdrawing into his memories, or finding some healthy intellectual occupation to console him for all he is losing! He should try to fill his last hours in some other way than with those tedious public affairs over which the ambitious waste so much time merely for the sake of appearing for a few moments in the limelight. I cannot leave this humble place, these rooms, where for so many years I have been alternately melancholy and happy, without feeling deeply moved.

On Form and Composition

SATURDAY, 7 APRIL [1849]

Went with Chopin for his drive at about half-past three.

We talked of music and it seemed to cheer him. I asked him to explain what it is that gives the impression of logic in music. He made me understand the meaning of harmony and counterpoint; how in music, the fugue corresponds to pure logic, and that to be well versed in the fugue is to understand the elements of all reason and development in music. I thought how happy I should have been to study these things, the despair of commonplace musicians. It gave me some idea of the pleasure which true philosophers find in science. The fact of the matter is, that true science is not what we usually mean by that word—not, that is to say, a part of knowledge quite separate from art. No, science, as regarded and demonstrated by a man like Chopin, is art itself, but on the other hand, art is not what the vulgar believe it to be, a vague inspiration coming from nowhere, moving at random, and portraying merely the picturesque, external side of things. It is pure reason, embellished by genius, but following a set course and bound by higher laws.

THURSDAY, 19 MAY [1853]

While I was lunching I read Peisse's article, in which he reviews the Salon as a whole and inquires into the trend of modern art. He is quite right in seeing a tendency towards the *picturesque* which he considers to be a sign of inferiority. Yes, if it were only a question of arranging lines and colours to create a visual effect an arabesque would do as well, but when you add to a composition already interesting on account of its sub-

ject, an arrangement of lines that heightens the impression, a chiaroscuro that grips the imagination, and a colour scheme suited to the characters, you have solved a more difficult problem and, moreover, you are moving on a higher plane. Like a musician, you are adapting to a simple melody the wealth of harmony and its mutations. Peisse calls this tendency *musical,* and he uses the word in a derogatory sense; personally, I think it as praiseworthy as any other.

He has taken his theories about the arts from his friend Chenavard, who considers music an inferior art. Chenavard has the typically French mind which needs ideas that can be expressed in words; when it comes to ideas which language is incapable of describing, he banishes them from the realm of art. But even admitting that drawing is everything, it is clearly not merely a question of form, pure and simple. There may be either grace or vulgarity in this contour, which is all that he demands, and a line drawn by Raphael will have a different charm from one drawn by Chenavard. . . . What is intended for the eyes must be seen; what is intended for the ears must be heard. What has been written as a speech will have far more effect when it comes from the lips of an orator than when it is simply read. A great actor will transform a passage by his delivery. . . .

THURSDAY, 20 OCTOBER [1853]

The type of emotion peculiar to painting is, so to speak, tangible; poetry and music cannot give rise to it. In painting you enjoy the actual representation of objects as though you were really seeing them and at the same time you are warmed and carried away by the meaning which these images contain for the mind. The figures and objects in the picture, which to one part of your intelligence seem to be the actual things themselves, are like a solid bridge to support your imagination as it probes the deep, mysterious emotions, of which these forms are, so to speak, the hieroglyph, but a hieroglyph far more eloquent than any cold representation, the mere equivalent of a printed symbol. In this sense the art of painting is sublime if you compare it with the art of writing wherein the thought reaches the mind only by means of printed letters arranged in a given order. It is a far more complicated art, if you like, since the symbol is nothing and the thought appears to be everything, but it is a thousand times more expressive when you consider that independently of idea, the visible sign, the eloquent hieroglyph itself which has no value for the mind in the work of an author, becomes in the painter's hands a source of the most intense pleasure—that pleasure which we gain from seeing beauty, proportion, contrast, and harmony of colour in the things around us, in everything which our eyes love to contemplate in the outside world,

and which is the satisfaction of one of the profoundest needs of our nature.

Many people will think the art of writing superior to painting precisely because of this simpler means of expression. Such people have never taken pleasure in considering a hand, an arm, or a torso from the antique or by Puget; they appreciate sculpture even less than they do painting, and are strangely mistaken if they imagine that when they have written down the words *foot* or *hand* they have inspired me with an emotion comparable to what I feel when I see a beautiful foot or a beautiful hand. The arts are not algebra, where abbreviation of the figures contributes to the success of the problem. To be successful in the arts is not a matter of summarizing but of amplifying where it is possible, and of prolonging the sensation by every means.

What I have been saying about the *power of painting* now becomes clear. If it has to record but a single moment it is capable of concentrating the *effect* of that moment. The painter is far more master of what he wants to express than the poet or musician who are in the hands of interpreters; even though his memory may have a smaller range to work on, he produces an effect that is a perfect unity and one which is capable of giving complete satisfaction. . . .

On Color

SUNDAY, 15 JULY [1849]

This famous quality, the beautiful, which some see in a curved line and others in a straight, all are determined to see in line alone. But here am I, sitting at my window, looking at the most beautiful countryside imaginable and the idea of a line does not enter into my head. The larks are singing, the river is sparkling with a thousand diamonds, I can hear the rustle of the leaves, but where are any lines to produce such exquisite sensations? People refuse to see proportion and harmony unless they are enclosed by lines. For them, all the rest is chaos, and a pair of compasses the only arbiter.

WEDNESDAY, 5 MAY [1852]

A picture should be laid-in as if one were looking at the subject on a grey day, with no sunlight or clear-cut shadows. Fundamentally, lights and shadows do not exist. Every object presents a colour mass, having different reflections on all sides. Suppose a ray of sunshine should suddenly light up the objects in this open-air scene under grey light, you will then have what are called lights and shadows but they will be pure accidents. This, strange as it may appear, is a profound truth and contains

the whole meaning of colour in painting. How extraordinary that it should have been understood by so few of the great painters, even among those who are generally regarded as colourists!

SUNDAY, 4 FEBRUARY [1847]

Coming home in the omnibus, I watched the effects of half-tones on the horses' backs; that is to say on the shiny coats of the bays and blacks. They must be treated like the rest, as a mass, with a local colour lying half way between the sheen and the warm colouring. Over this preparation, a warm transparent glaze should be enough to show the change of plane for the parts in shadow, with reflected lights. Then, on the parts that project into this half-tone colour, the high lights can be marked with bright, cold tones. This was very remarkable in the bay horse.

SUNDAY, 3 NOVEMBER [1850]

During this same walk, Villot and I noticed some extraordinary effects. It was sunset; the *chrome* and *lake* tones were most brilliant on the side where it was light and the shadows were extraordinarily blue and cold. And in the same way, the shadows thrown by the trees, which were all yellow (*terre d'Italie, brownish red*) and directly lit by the sun's rays, stood out against part of the grey clouds which were verging on blue. It would seem that the warmer the lighter tones, the more nature exaggerates the contrasting grey, for example, the half-tints in Arabs and people with bronzed complexions. What made this effect appear so vivid in the landscape was precisely this law of contrast.

I noticed the same phenomenon at sunset, yesterday evening (13 November), it is more brilliant and striking than at midday, only because the contrasts are sharper. The grey of the clouds in the evening verges on *blue;* the clear parts of the sky are bright *yellow* or orange. The general rule is, *the greater the contrast, the more brilliant the effect.*

25 AUGUST [1854]

During my walk this morning I spent a long time studying the sea. The sun was behind me and thus the face of the waves as they lifted towards me was yellow; the side turned towards the horizon reflected the colour of the sky. Cloud shadows passing over all this made delightful effects; in the distance where the sea was blue and green, the shadows appeared purple, and a golden and purple tone extended over the nearer part as well, where the shadow covered it. The waves were like agate. In the places in shadow you get the same relationship of yellow waves, looking towards the sun, and of blue and metallic patches reflecting the sky.

Of Color Shadow and Reflections

(From scattered notes, probably written in Dieppe in 1854)

The law which governs the greenness of reflections, of shadow edges, or cast shadows, which I discovered previously as applying to linen, applies to everything, since the three [primary] colors in combination are found everywhere. I used to think that they were only in certain objects.

. . . As a plane is composed of little planes, a wave of little waves, so the daylight is modified or decomposed on objects. The law of [color] decomposition which is most apparent, and which first struck me as being the most general, is evident in the sparkle of objects. It was in such things as a breast plate or a diamond that I most clearly noticed the presence of the three united colors. Then there are objects such as cloth, linen, certain aspects of landscape, particularly the sea, in which this effect is very marked. And it did not take me long to observe that it is strikingly present in flesh. I finally became convinced that nothing exists without these three colors. When I find that linen has a violet shadow and green reflections, does that mean, in fact, that it presents only these two colors? Does it not also contain orange by necessity, since there is yellow in the green and red in the violet? . . .

I observe a wall of very red brick in the little corner street. The part lit by the sun is orange red, the shadow very violet, reddish brown, Cassel brown and white.

In rendering flesh, one must paint the simple shadows somewhat violet, and the reflections with somewhat greenish colors. . . .

The true, or least decomposed, flesh color is that which lies next to the high lights, just as in silks, the coats of horses, etc. . . .

I discovered one day that linen always has green reflections and violet shadows.

I perceive that it is the same with the sea, with only this difference that the reflection is very much modified by the great influence of the sky; as for the cast shadows, they are quite evidently violet.

It is probable that I shall find that this law applies to everything. Shadows cast on the ground by anything whatever are violet. . . .

I see from my window the shadows of people walking in the sunlight on the sand of the harbor. The sand of that terrain is in itself violet, but it appears gilded over by the sun. The shadows of these people are so violet that they make the ground appear yellow.

Would it be too bold to say that in the open air, especially under conditions such as I am now observing, reflections ought to be produced by the soil, gilded by the sun, and hence yellow, and by the sky which is blue, and that these two colors between them should necessarily produce a green tone? In the sunlight, these various effects can be observed in their most obvious, almost crude, manifestation; but when they vanish, the color relationships ought to remain the same. If the terrain appears less golden, because the sun is gone, the reflections will appear less green, less lively in short.

I have all my life painted linen with rather true color. I discovered one day, aided by a very clear instance, that shadows are violet and reflections green.

These are observations of which a scientist might well be proud; I am all the more proud of having painted pictures of a good color before I became aware of these laws.

African Impressions

(Letter to J. B. Pierret, from Tangier, 8 February 1832)

. . . My health is good, I only fear a little for my eyes. Although the sun still is not very strong, the bright reflection of the houses, all painted white, tires me excessively. I gradually assume the manners of the country, so as to be able to draw some of these Moors at my ease. They have strong prejudices against the fine art of painting, but a bit of money here and there overcomes their scruples. I take rides around the countryside which give me great pleasure and have enjoyed delicious moments of loafing in a garden at the city gate, beneath a profusion of orange trees in full bloom and covered with fruit. In the midst of this vigorous nature I have sensations which remind me of my childhood. It may be that the dim memory of the southern sun, experienced in earliest youth, is reawakening in me. The work which I am able to do here is nothing compared to what could be done. Sometimes my arms drop with fatigue, and I feel sure that I'll bring home no more than a shadow of all this.

I don't remember whether I told you in my last letter about my reception by the Pasha, three days after our reception at the harbor; perhaps it would only bore you. I also don't think that I wrote to you about a ride we took in the environs of the city, together with the English consul who has a passion for mounting the most difficult horses of this region—which is saying a lot, for even the tamest of these horses are devils. Two of them started a fight, and I witnessed the most ferocious battle you can imagine: the inventions of Gros and Rubens pale beside such

fury. After biting one another in all kinds of ways, climbing on each other, and walking on their hind legs like men, having first thrown their riders, they dashed into a small river in which they continued their combat with incredible fury. It took a devilish effort to pull them out.

(Letter to Fr. Villot, from Tangier, 29 February 1832)

. . . This is a place for painters. Economists and Saint-Simonists would find much to criticize here, from the point of view of the rights of man and equality before the law, but beauty abounds. Not, to be sure, the overpraised beauty of fashionable painting. The heroes of David and his ilk would cut a sad figure, with their rose-tinted limbs, next to these children of the sun. And I am convinced, besides, that the antique costume is better worn here. If some day you can spare a few months, come to the Barbary Coast. Here you will see a nature which in our country is always disguised, here you will feel the rare and precious influence of the sun which gives an intense life to everything. I shall, no doubt, bring home many drawings, but they cannot convey the full impression which this gives.

(Letter to J. B. Pierret, from Tangier, 29 February 1832)

. . . I use a part of my time for work, and another, large part simply for living. The idea of my reputation and of that Salon which I shall miss, as they tell me, never occurs to me. I even feel sure that the many interesting observations which I shall bring away from here will be only of limited use to me. Far from the country where I found them, they will be like trees uprooted from their native soil. I fear that I shall forget these impressions, yet I don't want to make a cold and imperfect record of the living, stirring sublimity which is to be encountered here in every street, and which assaults me with its reality. Imagine, my friend, what it means to see, lying in the sun, walking the streets, adjusting their sandals, Catos and Brutuses, men of Consular bearing, who even have that disdainful air which the masters of the world must have worn. . . . These people own nothing but a coverlet in which they walk, sleep, and are buried, and yet they seem to be as satisfied with this as Cicero must have been with his magistrate's chair. I assure you that you will never be able to judge these impressions by what I shall bring back, because my work will fall far short of the truth and nobility of this nature. Antiquity had nothing more beautiful. Yesterday, a peasant went by, done up like this [drawing]. Here is the getup of a Moor, day before yesterday, to whom we gave twenty *sous*. All of them in white, like Roman senators or the Athenian people in the Panathenaic procession. . . .

On Nature

19 JANUARY [1847]

The Natural History Museum is open to the public on Tuesdays and Fridays. Elephant, rhinoceros, hippopotamus; extraordinary animals! Rubens rendered them marvellously. I had a feeling of happiness as soon as I entered the place and the further I went the stronger it grew. I felt my whole being rise above commonplaces and trivialities and the petty worries of my daily life. What an immense variety of animals and species of different shapes and functions! And at every turn I saw what we call deformity side by side with what seems to us to be beauty and grace of form. Here were the flocks of Neptune, the seals and walruses and the huge fish with their cold eyes and foolish, open mouths; the crustacea and sea-spiders, and the turtles. Next, the loathsome family of serpents, the boa-constrictor with its tiny head and its enormous body coiled elegantly round a tree; the hideous dragon, the lizards, crocodiles and alligators, and the monstrous gavial whose jaws taper sharply and end in a curious protuberance at the nose. Then the animals nearer to our own natural scene, the countless stags, gazelle, elks, buck, goats, sheep, with cloven hoofs, antlered heads, straight horns, and horns that are twisted or coiled; the different kinds of cattle, wild oxen and bison; the camels and dromedaries, the llamas, and the vicuñas which so closely resemble them. And finally the giraffe; Levaillant's specimens are here, all patched up and pieced together; and the famous animal of 1827 himself, who was the admiration of all beholders during his lifetime and gave pleasure to thousands of idlers. He has now paid his debt to nature with a death as obscure as his entrance into the world was glorious. Here he is, at all events, as stiff and clumsy as nature made him. . . .

Tigers, panthers, jaguars, lions, etc.

Why is it that these things have stirred me so much? Can it be because I have gone outside the everyday thoughts that are my world; away from the street that is my entire universe? How necessary it is to give oneself a shake from time to time; to stick one's head out of doors and try to read from the book of life that has nothing in common with cities and the works of man.

5 AUGUST [1854]

Nature is amazingly logical. When I was in Trouville I made a drawing of some fragments of rock the irregularities of which were so

proportioned as to give the impression of a huge cliff when I had set them down on paper; it only needed some suitable object to establish the scale of size. At this very moment, I am writing beside a large ant-hill formed at the foot of a tree, partly with the help of irregularities in the ground, and partly by the patient labour of the ants. Here are gentle slopes and projections overhanging miniature gorges, through which the inhabitants hurry to and fro, as intent upon their business as the minute population of some tiny country which one's imagination can enlarge in an instant. If it is only a mole-hill that I am looking at, I can see if I choose, thanks to the miniature scale of the inhabitants, a vast stretch of country broken up with precipitous crags and steep inclines. A lump of coal or a piece of flint may show in rednced proportions the forms of enormous masses of rock. . . .

When I have been drawing trees, I have often noticed that each separate branch is a miniature tree in itself; in order to see it as such one would only need the leaves to be in proportion.

17 OCTOBER [1853]

Jean-Jacques [Rousseau] was right when he said that the joys of liberty are best described from a prison cell, and that the way to paint a fine landscape is to live in a stuffy town where one's only glimpse of the sky is through an attic window above the chimney-pots. When a landscape is in front of my eyes and I am surrounded by trees and pleasant places my own landscape becomes heavy—too much worked; possibly truer in details, but out of harmony with the subject. When Courbet painted the background of the woman bathing, he copied it faithfully from a study which I saw hanging near his easel. Nothing could be colder; it is like a piece of mosaic. I began to make something tolerable of my African journey only when I had forgotten the trivial details and remembered nothing but the striking and poetic side of the subject. Up to that time, I had been haunted by this passion for accuracy that most people mistake for truth.

On Reality and the Imagination

FRIDAY, 15 APRIL [1853]

To the exhibition of paintings by Courbet. I was amazed at the strength and relief of his principal picture—but what a picture! what a subject to choose! The vulgarity of the forms would not signify, the vulgarity and futility of the idea is what is so abominable, and even that might pass if only the idea (such as it is) had been made clear! But what are the two figures supposed to mean? A fat woman, backview, and

completely naked except for a carelessly painted rag over the lower part of the buttocks, is stepping out of a little puddle scarcely deep enough for a foot-bath. She is making some meaningless gesture, and another woman, presumably her maid, is sitting on the ground taking off her shoes and stockings. You see the stockings; one of them, I think, is only half-removed. There seems to be some exchange of thought between the two figures, but it is quite unintelligible. The landscape is extraordinarily vigorous, but Courbet has merely enlarged a study that can be seen near his picture; it seems evident that the figures were put in afterwards, without any connexion with their surroundings. . . .

O Rossini! O Mozart! O inspired genius in every art, you who draw from things only so much as you need to reveal them to our minds! What would you say before such pictures? O Semiramis! O entry of the priests to crown Ninias!

SATURDAY, 21 MAY [1853]

After dinner they looked at the photographs which Durieu has been kind enough to send me. I persuaded them to try an experiment that I made quite by chance a couple of days ago. After examining the photographs of nude models, some of whom were poor physical specimens, with parts of the body over-developed—not very beautiful to look at—I showed them some engravings by Marcantonio. We felt repelled, indeed almost disgusted, by the inaccuracy, mannerism, and lack of naturalness, in spite of the excellence of the style. It is his only admirable quality, but we were incapable of admiring it at that particular moment. As a matter of fact, if some genius were to use daguerreotype as it should be used he could reach untold heights. Above all, when you look at these engravings, the admitted masterpieces of the Italian School that have exhausted the admiration of every painter, you realize the truth of Poussin's remark that "compared with the Antique, Raphael was an ass." Up to the present, this machine-made art has done us nothing but harm: it spoils the masterpieces for us, without being able to satisfy us completely.

WEDNESDAY, 12 OCTOBER [1853]

When Jenny and I were walking in the forest yesterday and I was praising the forest painting of Diaz, she remarked with her great good sense: "Exact imitation is always colder than the original." It is perfectly true! Conscientiousness over showing only what is seen in nature always makes a painter colder than the nature he believes he is imitating, and for that matter nature is by no means invariably interesting from the point of view of the effect of the whole ensemble. . . . Even though each detail taken separately has a perfection which I call inimitable,

collectively, they rarely produce an effect equal to what a great artist obtains from his feeling for the whole scene and its composition. This is what I meant when I said, a short while ago, that although the use of a model can add something striking to a picture, it can happen only with extremely intelligent artists; in other words, the only painters who really benefit by consulting a model are those who can produce their effect without one. . . .

It is therefore far more important for an artist to come near to the ideal which he carries in his mind, and which is characteristic of him, than to be content with recording, however strongly, any transitory ideal that nature may offer—and she does offer such aspects; but once again, it is only certain men who see them and not the average man, which is a proof that the beautiful is created by the artist's imagination precisely because he follows the bent of his own genius.

This process of idealization happens almost without my realizing it whenever I make a tracing of a composition that comes out of my head. The second version is always corrected and brought closer to the ideal. This is an apparent contradiction but it explains how an over-detailed execution, like that of Rubens for instance, need not detract from the effect on the imagination. The execution is applied to a theme that has been realized in imagination; therefore the superabundance of details that slip in as a result of imperfect memory cannot destroy the far more interesting simplicity that was present in the first exposition of the idea. And as we have already seen in the case of Rubens, the frankness of the execution more than compensates for the disadvantage caused by the superabundance of details. If therefore you can introduce into a composition of this kind a passage that has been carefully painted from the model, and can do this without creating utter discord, you will have accomplished the greatest feat of all, that of harmonizing what seems irreconcilable. You will have introduced reality into a dream, and united two different arts. . . .

On the imitation of nature. This important matter is the starting point of every school and one on which they differ widely as soon as they begin to explain it. The whole question seems to come to this: is the purpose of imitation to please the imagination, or is it merely intended to obey the demands of a strange kind of conscience which allows an artist to be satisfied with himself when he has copied the model before his eyes as faithfully as possible?

3 AUGUST [1855]

Afterwards I went to the Courbet exhibition. He has reduced the price of admission to ten sous. I stayed there alone for nearly an hour

and discovered a masterpiece in the picture which they rejected; I could scarcely bear to tear myself away. He has made enormous strides, and yet this picture has taught me to appreciate his "Enterrement." In this picture the figures are all on top of one another and the composition is not well arranged, but some of the details are superb, for instance, the priests, the choir-boys, the weeping women, the vessel for Holy Water, etc. In the later picture ("The Studio") the planes are well understood, there is atmosphere, and in some passages the execution is really remarkable, especially the thighs and hips of the nude model and the breasts—also the woman in the foreground with the shawl. The only fault is that the picture, as he has painted it, seems to contain an ambiguity. It looks as though there were a *real sky* in the middle of a painting. They have rejected one of the most remarkable works of our time, but Courbet is not the man to be discouraged by a little thing like that.

3 July [1858]

Mercey says a very good thing in his book on the Exhibition: *the beautiful in the arts is truth idealized.* He has cut clean through the argument between the pedants and the genuine artists. He has put an end to the ambiguity which allowed partisans of *the beautiful* to conceal their incapacity for finding *the true.*

On accessories. They have an immense influence on the effect, yet they must always be sacrificed. In a well-ordered picture, there is an infinite number of what I call accessories, for not only are furniture, small details and backgrounds, accessories, but also draperies and figures and even parts of the principal figures themselves. In a portrait where the hands are shown, the hands are accessories; in the first place, they have to be subordinated to the head and often a hand must attract less attention than part of the clothing or background, etc. Why bad painters can never attain to the *beautiful*—that *truth idealized,* of which Mercey speaks—is because, apart from their lack of a general conception of their work with regard to *the truth,* they almost invariably strive to bring out details which should be subordinated, with the result that their accessories distract attention from the general effect instead of enhancing it. . . .

Strasbourg, 1 September [1859]

The most confirmed realist, when he attempts to render nature in a painting, is compelled to use certain conventions of composition or of execution. If it is a question of composition he cannot take an isolated fragment, or even a series of fragments, and make a picture out of them. He is bound to set some limit to the idea if the beholder's mind is not to

hover uncertainly over an area, which has unavoidably been cut out from a larger whole; if it were not so, there would be no art. In a photograph of a view you see no more than a portion cut from a panorama; the edges are as interesting as the centre of the picture and you have to guess at the scene of which you are shown merely a fragment, apparently chosen at random. In such a fragment, the details have as much importance as the principal object and, more often than not, obstruct the view because they occur in the foreground. You need to make more concessions to faults of reproduction in photographs than in works of the imagination. The most striking photographs are those in which certain gaps are left, owing to the failure of the process itself to give a complete rendering. Such gaps bring relief to the eyes which are thereby concentrated on only a limited number of objects. Photography would be unbearable if our eyes were as accurate as a magnifying glass; we should see every leaf on a tree, every tile on a roof, and on each tile, the moss, the insects, etc. . . .

22 FEBRUARY [1860]

Realism. Realism should be described as the antipodes of art. It is perhaps even more detestable in painting and sculpture than in history and literature. I say nothing of poetry, if only because the poet's instrument is a pure convention, an ordered language which immediately sets the reader above the earthly plane of everyday life. To speak of "realistic poetry" would be a contradiction in terms even if such a monstrosity were conceivable. But what would the term "realistic art" mean in sculpture, for example?

A mere cast taken from nature will always be more real than the best copy a man can produce, for can anyone conceive that an artist's hand is not guided by his mind, or think that however exactly he attempts to imitate, his strange task will not be tinged with the colour of his spirit? Unless, of course, we believe that eye and hand alone will suffice to produce, I will not say exact imitations only, but any work whatsoever?

For the word *realism* to have any meaning all men would need to be of the same mind and to conceive things in the same way.

For what is the supreme purpose of every form of art if it be not the effect? Does the artist's mission consist only in arranging his material, and allowing the beholders to extract from it whatever enjoyment they may, each in his own way? Apart from the interest which the mind discovers in the clear and simple development of a composition and the charm of a skillfully handled subject, is there not a moral attached even to a fable? Who should reveal this better than the artist, who plans every

part of the composition beforehand in order that the reader or beholder may unconsciously be led to understand and enjoy it.

The first of all principles is the need to make sacrifices.

Isolated portraits, however perfect, cannot form a picture. Personal feeling alone can give unity, and the one way of achieving this is to show only what deserves to be seen.

Art and poetry live on fiction. Ask a professional realist to paint supernatural beings, those gods, nymphs, monsters and furies, all those entrancing creatures of the imagination! . . .

David's work is an extraordinary mixture of realism and the ideal. The followers of Vanloo had ceased to copy the model, and although their forms were trivial to the last degree, they drew upon their memory and experience for everything. It was an art sufficient for its day. Meretricious charms and emasculated forms devoid of any touch of nature sufficed for pictures that were cast in the same mould, without original invention, and without any of the simple graces by which the works of the primitive schools endure. David began by painting a large number of pictures in this manner; it was the manner of the school in which he was trained. I do not think that he possessed very much originality, but he was blessed with plenty of good sense; above all, he was born at the time when this school was declining and a rather thoughtless admiration for antique art was taking its place. Thanks to this fact, and to such moderate geniuses as Mengs and Winckelmann, he fortunately became aware of the dullness and weakness of the shameful productions of the period. No doubt the philosophical ideas in the air at that time, the new ideas of greatness and liberty for the people, were mingled with his feeling of disgust for the school from which he had emerged. This revulsion, which does great honour to his genius and is his chief claim to fame, led him to the study of the Antique. He had the courage completely to reform his ideas. He shut himself up, so to speak, with the Laocoon, the Antinous, the Gladiator, and the other great male conceptions of the spirit of antique art, and was courageous enough to fashion a new talent for himself—like the immortal Gluck, who in his old age abandoned his Italian manner and renewed himself at fresher, purer springs. He was the father of the whole modern school of painting and sculpture. His reforms extended even to architecture and to the very furniture in everyday use. It was through his influence that the style of Herculaneum and Pompeii replaced the bastard Pompadour style, and his principles gained such a hold over men's minds that his school was not inferior to him, and produced some pupils who became his equals. In some respects he is still supreme, and in spite of certain changes that have appeared in the taste of what forms his school at the present day, it is plain that everything still derives from him and from his principles.

On Rubens

6 MARCH [1847]

After a good night's rest I went back to the studio where I recovered my good humour. I am looking at the "Hunts," by Rubens. The one I prefer is the hippopotamus hunt; it is the fiercest. I like its heroic emphasis, I love its unfettered exaggerated forms, I adore them as much as I despise those gushing empty-headed women who swoon over fashionable pictures and M. Verdi's music.

WEDNESDAY, 12 OCTOBER [1853]

Rubens is a remarkable illustration of the abuse of details. His painting, which is dominated by the imagination, is everywhere superabundant, the accessories are too much worked out. His pictures are like public meetings where everybody talks at once. And yet, if you compare this exuberant manner, not with the dryness and poverty of modern painting, but with really fine pictures where nature has been imitated with restraint and great accuracy, you feel at once that the true painter is one whose imagination speaks before everything else.

THURSDAY, 20 OCTOBER [1853]

Glory to that Homer of painting, the father of warmth and enthusiasm in the art where he puts all others in the shade, not, perhaps, because of his perfection in any one direction, but because of that hidden force—that life and spirit—which he put into everything he did. How strange it is: the picture that perhaps made the strongest impression on me, the "Raising of the Cross" in Antwerp, is not the one where his own peculiar and incomparable qualities shine out most strongly. . . . It is neither by the colour, nor by the delicacy nor the boldness of the execution that this painting surpasses the others, but, strangely enough, it is because of those Italian qualities that do not delight me so much in the work of Italian painters. Here I think it only right to say that I have had exactly the same feeling before Gros's battle pictures and the "Raft of the Medusa," especially when I saw the latter half-finished. There is something sublime in all these works which is partly due to the great size of the figures. The same pictures on a smaller scale would, I am sure, have had an entirely different effect. In both Rubens's picture and in Géricault's, there is an indescribable flavour of the style of Michaelangelo

which adds still further to the impression produced by the size of the figures, and gives them an awe-inspiring quality. Proportion counts for a great deal in the absolute power of a picture. . . .

I must admit, however, that proportion is not everything, for many of Rubens's pictures in which the figures are very large do not give this kind of feeling—to me, the most elevated of all—nor is it solely due to a more Italian quality of style, for pictures by Gros which show no trace of it, and are entirely his own, have this power of projecting me into that spiritual state which I consider to be the strongest emotion that the art of painting can inspire. The impressions that the arts produce on sensitive natures are a curious mystery; when you try to describe them they seem confused but each time you experience them, if only in recollection, they are strong and clear. I firmly believe that we always mingle something of ourselves in the emotions that seem to arise out of objects that impress us. And I think it probable that these things delight me so much only because they echo feelings that are also my own. If, although so different, they give me the same degree of pleasure, it must be because I recognize in myself the source of the kind of effect they produce.

21 OCTOBER [1860]

Admirable Rubens! What a magician! I grow angry with him at times; I quarrel with his heavy forms and his lack of refinement and elegance. But how superior he is to the collection of small qualities that make up the whole stock of other painters! He, at least, had the courage to be himself; he compels you to accept his so-called defects, that come from the impetus with which he is swept along, and wins you over, in spite of precepts that hold good for everyone but himself. Rubens did not correct himself, and he was right. By permitting himself every liberty he carries you to heights which the greatest painters barely attain. He dominates, he overwhelms you with so much liberty and audacity.

I also note that his greatest quality (if you can imagine having to choose one quality in particular) is the astounding relief of his figures, that is to say their astonishing vitality. Without this gift there is no great artist. Moreover, only the greatest succeed in solving this problem of relief and solidity.

On Expression

TUESDAY, 8 OCTOBER [1822]

When I have painted a fine picture I have not given expression to a thought! That is what they say. What fools people are! They would strip painting of all its advantages. A writer has to say almost everything

in order to make himself understood, but in painting it is as if some mysterious bridge were set up between the spirit of the persons in the picture and the beholder. The beholder sees figures, the external appearance of nature, but inwardly he meditates; the true thinking that is common to all men. Some give substance to it in writing, but in so doing they lose the subtle essence. Hence, grosser minds are more easily moved by writers than by painters or musicians. The art of the painter is all the nearer to man's heart because it seems to be more material. In painting, as in external nature, proper justice is done to what is finite and to what is infinite, in other words, to what the soul finds inwardly moving in objects that are known through the senses alone.

THURSDAY, 18 JULY [1850]

"In painting, and especially in portraiture," says Mme Cavé in her treatise, "mind speaks to mind, and not knowledge to knowledge." This observation, which may be more profound than she knows herself, is an indictment of pedantry in execution. I have said to myself over and over again that painting, i.e., the material process which we call painting, is no more than the pretext, the bridge between the mind of the artist and that of the beholder. . . .

WEDNESDAY, 16 OCTOBER [1850]

On pictorial license. The most sublime effects of every master are often the result of *pictorial license;* for example, the lack of finish in Rembrandt's work, the exaggeration in Rubens. Mediocre painters never have sufficient daring, they never get beyond themselves. Method cannot supply a rule for everything, it can only lead everyone to a certain point. Why have no great artists ever attempted to break down this mass of prejudice? They were probably frightened by the magnitude of the task and therefore abandoned the mob to their foolish ideas.

26 MARCH [1854]

Fine works of art would never become dated if they contained nothing but genuine feeling. The language of the emotions and the impulses of the human heart never change; what invariably causes a work to date, and sometimes ends by obliterating its really fine qualities, is the use of technical devices that were within the scope of every artist at the time the work was executed. On the other hand, what usually makes for the material success of most works of art is, I am sure, the use of certain fashionable embellishments of secondary importance compared with the main idea. Those, who by a miracle were able to dispense

with such accessories, have either been appreciated very late and with great difficulty, or else by later generations, who are indifferent to the charm of these particular conventions.

26 June. In Paris. [1857]

On the sublime, and on perfection. These two words may appear almost synonymous. *Sublime* means everything that is most elevated; *perfect,* that which is most complete, most finished. *Perficere,* to realize completely, to crown the work. *Sublimis,* that which is highest, which reaches to the skies.

Some men of talent can only breathe in the highest altitudes and on the peaks. Michaelangelo appears like one who would have been stifled in the lower regions of art. We must attribute to this consistent and unbroken strength the authority which he has exercised over the imagination of all artists. Titian stands in exact contrast with him.

Our own writers, who take improvisation for their muse, will find it hard to reach perfection. They hope to be saved by such lucky accidents as improvisation occasionally brings and to meet the *sublime* by chance, and I say good luck to them.

15 January [1860]

Audacity. It needs great audacity to dare to be oneself, and this quality is particularly rare in a period of decadence like the present. The primitives were bold by nature, almost without being conscious of it, but it really needs the greatest possible audacity to break away from habits and conventions. The men who came first had no conventions to fear, the field was open to them, no tradition fettered their inspiration. In the modern schools, depraved and intimidated as they are by precedents well contrived to curb presumptuous impulses, nothing is so rare as the confidence which alone can beget great masterpieces.

15 January [1861]

To finish requires a heart of steel. You have to make decisions all the time, and I am finding difficulties where I thought there would be none. The only way I can keep up this life is to go to bed early and do nothing whatsoever outside my work, and I am sustained in my resolution to give up every pleasure, and most of all that of seeing the people I love, only by the hope of carrying the work through to completion. I think it will kill me. It is at times like these that one realizes one's weakness and how many incomplete or uncompletable passages there are, in what a man calls a *finished* or *complete* work.

22 JUNE [1863]

[*Written in pencil in a small notebook.*] The first quality in a picture is to be a delight for the eyes. This does not mean that there need be no sense in it; it is like poetry which, if it offend the ear, all the sense in the world will not save from being bad. They speak of *having an ear* for music: not every eye is fit to taste the subtle joys of painting. The eyes of many people are dull or false; they see objects literally, of the exquisite they see nothing.

Charles Baudelaire (1821–1867) on Delacroix

Nothing illustrates more strikingly the prestige of the arts in the middle decades of the 19th century than the deferential attitude of literary men toward artists. Baudelaire and Ruskin, who otherwise bore little resemblance to one another, shared the belief that painting was a quintessential expression of poetic genius. For each, a great painter stood forth as the exemplar of creative activity, a model for poets, philosophers, and scientists. The central position which Turner occupied in the thought of Ruskin (see page 227) and which Delacroix held in Baudelaire's thought was without parallel in earlier times. Diderot's admiration for Greuze or Chardin (see page 57) had never led him to regard them as his mentors. Quite on the contrary, he had always felt entitled to instruct and advise artists, in matters of arrangement, expression, and sentiment, and in his highest praise there had lingered an undertone of the literary man's condescension to the pictorial technician.

Baudelaire began his literary career with Salon reviews (see page 311). Throughout his life, his work as an art critic continued to be one of his central concerns, not a journalistic side occupation. He chose to state, or to imply, his thoughts on poetry in his writings on art and music, rather than in literary criticism. It was his passionate interest in the work of Delacroix, with whom his personal acquaintance seems never to have been close, which most deeply influenced his opinions on art. For him, Delacroix was not simply an artist, but the artist. When Delacroix died, on 13 August 1863, Baudelaire wrote an obituary tribute which is one of the rare portraits of a great artist by a great poet.[57]

Delacroix was passionately in love with passion, and coldly determined to seek the means of expressing it in the most visible way.

[57] Translated by Jonathan Mayne, *The Mirror of Art*, London, Phaidon Press, Ltd., 1955, pp. 308 ff., reprinted by permission of the publisher. Baudelaire's article originally appeared in the periodical *Opinion Nationale*, on September 2, November 14 and 22, 1863. It was later included in the posthumous collection *L'Art romantique* (1869).

In this duality of nature—let us observe in passing—we find the two signs which mark the most substantial geniuses—extreme geniuses who are scarce made to please those timorous, easily satisfied souls who find sufficient nourishment in flabby, soft and imperfect works. An immense passion, reinforced with a formidable will—such was the man.

Now he used continually to say:

"Since I consider the impression transmitted to the artist by nature as the most important thing of all to translate, is it not essential that he should be armed in advance with all the most rapid means of translation?"

It is evident that in his eyes the imagination was the most precious gift, the most important faculty, but that this faculty remained impotent and sterile if it was not served by a resourceful skill which could follow it in its restless and tyrannical whims. He certainly had no need to stir the fire of his always-incandescent imagination; but the day was never long enough for his study of the material means of expression.

It is this never-ceasing preoccupation that seems to explain his endless investigations into colour and the quality of colours, his lively interest in matters of chemistry, and his conversations with manufacturers of colours. In that respect he comes close to Leonardo da Vinci, who was no less a victim of the same obsessions.

In spite of his admiration for the fiery phenomena of life, never will Eugène Delacroix be confounded among that herd of vulgar artists and scribblers whose myopic intelligence takes shelter behind the vague and obscure word "realism." The first time that I saw M. Delacroix— it was in 1845, I think (how the years slip by, swift and greedy!)—we chatted much about commonplaces—that is to say, about the vastest and yet the simplest questions; about Nature, for example. . . .

Eugène Delacroix was a curious mixture of scepticism, politeness, dandyism, burning determination, craftiness, despotism, and finally of a sort of personal kindness and tempered warmth which always accompanies genius. His father belonged to that race of strong men of whom we knew the last in our childhood—half of them fervent apostles of Jean-Jacques, and the other half resolute disciples of Voltaire, though they all collaborated with an equal zeal in the French Revolution, and their survivors, whether Jacobins or Cordeliers, all rallied with a perfect integrity (it is important to note) to the aims of Bonaparte.

Eugène Delacroix never lost the traces of his revolutionary origin. It may be said of him, as of Stendhal, that he had a great dread of being made a fool of. Sceptical and aristocratic, he only knew passion and the supernatural through his forced intimacy with the world of dreams.

There was much of the *savage* in Eugène Delacroix—this was in fact

the most precious part of his soul, the part which was entirely dedicated to the painting of his dreams and to the worship of his art. There was also much of the man of the world; that part was destined to disguise and excuse the other. It was, I think, one of the great concerns of his life to conceal the rages of his heart and not to have the seeming of a man of genius. His spirit of dominance, which was quite legitimate and even a part of his destiny, had almost entirely disappeared beneath a thousand kindnesses. You might have called him a volcanic crater artistically concealed behind bouquets of flowers.

He owed also to himself, far more than to his long familiarity with the world of society—to himself, that is to say to his genius and the consciousness of his genius—a sureness, a marvellous ease of manner, combined with a politeness which, like a prism, admitted every nuance, from the most cordial good nature to the most irreproachable rudeness. He possessed quite twenty different ways of uttering the words *"mon cher Monsieur,"* which, for a practised ear, represented an interesting range of sentiments. For finally it must be said—since to me this seems but one more reason for praise—that Eugène Delacroix, for all that he was a man of genius, or *because* he was a man of *complete* genius, had much of the dandy about him. He himself used to admit that in his youth he had thrown himself with delight into the most material vanities of dandyism, and he used to tell with a smile, but not without a certain touch of conceit, how, with the collaboration of his friend Bonington, he had laboured energetically to introduce a taste for English cut in clothes and shoes among the youth of fashion. I take it that this will not seem to you an idle detail, for there is no such things as a superfluous memory when one has the nature of certain men to paint.

I have told you that what most struck the attentive observer was the *natural* part of Delacroix's soul, in spite of the softening veil of a civilized refinement. He was all energy, but energy which sprang from the nerves and from the will—for physically he was frail and delicate. The tiger intent upon his prey has eyes less bright and muscles less impatiently a-quiver than could be observed when the whole spiritual being of our great painter was hurled upon an idea or was struggling to possess itself of a dream. Even the physical character of his countenance, his Peruvian or Malay-like colouring, his great black eyes (which, however, the blinkings of concentration made to appear smaller, so that they seemed to do no more than *sip* at the light), his abundant and glossy hair, his stubborn brow, his tight lips, to which an unceasing tension of will gave an expression of cruelty—his whole being, in short, suggested the idea of an exotic origin. More than once, when looking at him, I have found myself thinking of those ancient rulers of Mexico, of Montezuma,

whose hand, with sacrificial skill, could immolate three thousand human creatures in a single day upon the pyramidal altar of the Sun, or perhaps of some oriental potentate who, amid the splendours of the most brilliant of feasts, betrays in the depths of his eyes a kind of unsatisfied craving and an inscrutable nostalgia—something like the memory and the regret of things not known. . . . The *morality* of his works—if it is at all permissible to speak of ethics in painting—is also visibly marked with Molochism. His works contain nothing but devastation, massacres, conflagrations; everything bears witness against the eternal and incorrigible barbarity of man. Burnt and smoking cities, slaughtered victims, ravished women, the very children cast beneath the hooves of horses or menaced by the dagger of a distracted mother—the whole body of this painter's works, I say, is like a terrible hymn composed in honour of destiny and irremediable anguish. Occasionally he found it possible to devote his brush to the expression of tender and voluptuous feelings—for certainly he was not lacking in tenderness; but even into these works an incurable bitterness was infused in strong measure, and carelessness and joy—the usual companions of simple pleasure—were absent from them.

I know several people who have a right to say *"Odi profanum vulgus";* but which among them can triumphantly add *"et arceo"*? Too much hand-shaking tends to cheapen the character. But if ever a man had an *ivory tower,* well protected by locks and bolts, that man was Eugène Delacroix. And who has ever had a greater love for his *ivory tower*—that is, for his privacy? He would even, I believe, have armed it with artillery and transported it bodily into a forest or to the top of an inaccessible rock! Who has had a greater love for the *home*—both sanctuary and den? As others seek privacy for their debauches, he sought privacy for inspiration, and once he had gained it, he would give himself up to veritable drunken orgies of work.

. . . Thanks to the sincerity of our admiration, we were able, though still very young, to penetrate the fortifications of that studio where, in spite of the rigours of our climate, an equatorial temperature prevailed, and where the eye was immediately struck by a sober solemnity and by the classic austerity of the old school. We had seen such studios in our childhood, belonging to the late rivals of David—those touching heroes long since departed. One felt instinctively that this retreat could not be the habitation of a frivolous mind, titillated by a thousand incoherent fancies.

There were no rusty panoplies to be seen there, not a single Malayan *kris,* no ancient Gothic scrap-iron, no jewellery, no old clothes, no bric-à-brac, nothing of what indicts its owner of a taste for toys and the desultory wanderings of childish day-dreaming. A marvellous portrait by Jordaens, which he had unearthed somewhere or other, and several stud-

ies and copies, made by the master himself, sufficed to decorate that vast studio, in which a softened and subdued light illumined self-communion.

After a luncheon lighter than an Arab's, and with his palette arranged with the meticulous care of a florist or a cloth-merchant, Delacroix would set himself to grapple with the interrupted idea; but before launching out into his stormy task, he often experienced those feelings of languor, fear and prostration which make one think of the Pythoness fleeing the god, or which remind one of Jean-Jacques Rousseau dilly-dallying, rummaging among his papers and turning over his books for an hour before attacking paper with pen. But as soon as the artist's special magic had started to work, he never stopped until overcome by physical fatigue.

One day, when we happened to be talking about that question which always has such an interest for artists and writers—I mean, about the *hygienics* of work and the conduct of life—he said to me:

"Formerly, in my youth, I was unable to get down to work unless I had the promise of some pleasure for the evening—some music, dancing, or any other conceivable diversion. But today I have ceased to be like a schoolboy, and I can work without stopping and without any hope of reward. And then [he added], if only you knew how unremitting work makes one indulgent and easy to satisfy where pleasures are concerned! The man who has well filled his day will be prepared to find a sufficiency of wit even in the local postman, and will be quite content to spend his evening playing cards with him!"

The truth is that during his latter years everything that one normally calls pleasure had vanished from his life, having all been replaced by a single harsh, exacting, terrible pleasure, namely *work,* which by that time was not merely a passion but might properly have been called a rage.

After having dedicated the hours of the day to painting, either in his studio or upon the scaffolding whither he was summoned by his great decorative tasks, Delacroix found strength yet remaining in his love of art, and he would have judged that day ill-filled if the evening hours had not been employed at the fire-side, by lamp-light, in drawing, in covering paper with dreams, ideas, or figures half-glimpsed amid the random accidents of life, and sometimes in copying drawings by other artists whose temperament was as far as possible removed from his own; for he had a passion for notes, for sketches, and he gave himself up to it wherever he happened to be.

He once said to a young man of my acquaintance: "If you have not sufficient skill to make a sketch of a man throwing himself out of a window, in the time that it takes him to fall from the fourth floor to the

ground, you will never be capable of producing great *machines.*" This enormous hyperbole seems to me to contain the major concern of his whole life, which was, as is well known, to achieve an execution quick and sure enough to prevent the smallest particle of the intensity of action or idea from evaporating.

Jean Auguste Dominique Ingres (1780–1867)

A hostile critic,[58] *writing in 1855, described Ingres as "the absolute representative of that academic spirit which casts all feelings, all faculties into a mould called style. Henceforth there are to be neither good artists nor bad, neither feeble nor strong temperaments, neither spirit nor imagination; the excellence of the mould is to make up for everything."*

But the label of "academic" fits Ingres no better than David, his teacher. He was in his work and personality one of the most vehement individualists of his time, entirely untouched by the characterless routine, compromise and boredom of ordinary academicism. Like his fellow students in David's atelier, the dissident Primitifs *(see page 136), Ingres had striven in his youth to energize and purify classicism. He remained to the end of his life a radical stylist, given to extremes of distortion, abstraction, and archaism, and was for this reason the subject of perennial controversy. His peculiar kind of conservatism stemmed not so much from his worship of Raphael and other masters of the past—in this respect, he resembled Delacroix—but from his obsessive fear that art was about to be destroyed by the vulgarity and mediocrity of the modern world. With naïve egoism, he saw himself as its chosen defender, and felt obligated to accept official positions in the academic establishment for which he, privately, had little real respect. He would have preferred to wield the power of a dictator, like David in 1794, or the moral authority of a high priest, but he had to content himself with teaching. As a professor of the École des Beaux Arts in Paris and as director during 1834–1841 of the French Academy in Rome, he left the mark of his influence on several generations of students. He never attempted a coherent, written statement of his doctrine, but he had the gift of terse and impressive speech. His pronouncements, usually in the form of declarations or laments, and often of convulsive brevity, fell like hammer blows on disciples and enemies alike. They must have seemed memorable, for they were often recorded. Theophile Sylvestre garnished his acid pen portrait of Ingres with authentic quotations (1855), and in later years, former pupils of Ingres, such as Amaury-Duval (1874), recorded the characteristic sayings of their master. The quotations which follow are taken from the choice which Henri Delaborde published in*

[58] Theophile Silvestre, *Histoire des artistes vivants*, Paris, Blanchard, 1856, p. 32.

1870 of passages from Ingres' correspondence and studio talk, as reported by his pupils Edouard Odier and Auguste Flandrin.[59]

In matters of art, I have not changed. Age and reflection have, I hope, strengthened my taste, without diminishing its ardor. I still worship Raphael, his century, the Ancients, and above all the divine Greeks; in music, Gluck, Mozart, Haydn. My library consists of some twenty volumes, immortal masterpieces; with all this, life has its charms. [1818]

* * *

I count on my old age: it will avenge me.

* * *

I agree with LaFontaine: there can be no peace with the wicked! In Paris just now they criticize my influence, they criticize "the tendency which has been noticeable for some time in the work of the pensioners [of the French Academy] in Rome." . . . Certainly, yes, there is some influence. I do not see how a director [of the French Academy in Rome] can help influencing the artistic attitudes of his pensioners. Is my influence good? Yes, excellent! Yes, the best ever! Would these miserable enemies of mine, these crooks and hypocrites, prefer to have bad doctrines prevail? They are still smarting from the deep wounds which the truth and beauty of mine has inflicted on them. Very well, although I have not exactly been spoiled by the public, even by that segment which is enlightened, but not quite enough to share my ideas, I shall make this public the judge between them and me. It is impossible, it is impossible despite everything that the public will not, at long last, prefer me to them. . . .

* * *

There are not two kinds of art, there is only one: it is the one which is based on timeless, natural Beauty. Those who seek elsewhere deceive themselves, and in the most fatal manner. What do these so-called artists mean when they preach the discovery of the "new?" Is there anything new? Everything has been done, everything has been found. Our task is not to invent, but to continue. There is enough for us to do if, following the example of the great masters, we make use of those innumerable types which nature constantly offers us, if we interpret

[59] Henri Delaborde, *Ingres, sa vie, ses travaux, ses doctrines,* Paris, 1870; for a more recent edition, cf. *Ingres, raconté par lui-même et par ses amis,* edited by P. Courthion, Geneva, Pierre Cailler, 1957. See also Amaury-Duval, *L'atelier d'Ingres, Souvenirs,* Paris, 1878, and R. Cogniet, *Ingres, écrits sur l'art,* Paris, La Jeune Parque, 1947.

them with all the sincerity of our hearts and ennoble them through that pure and firm style without which no work has beauty. How absurd to believe that our natural dispositions and faculties can be compromised by the study, or even the imitation of classical works? Man, the original type, remains forever: we need only consult it to see whether the classical artists were right or wrong, and whether we lie or tell the truth when we use the same means as they did.

* * *

It is no longer necessary to discover the conditions and principles of beauty. The important thing is to apply them, and not to let the desire for invention mislead us into losing sight of them. Pure and natural beauty need not surprise us through novelty: it is enough to be beautiful. But men are in love with change, and in art change is often the cause of decadence.

* * *

Phidias achieved sublimity by correcting nature with nature. In fashioning his Olympian Zeus, he used all natural beauties in unison to attain what is badly called Ideal Beauty. This term should be understood as expressing the combination of the most beautiful elements in nature, something which is rarely found in a perfect state. But nothing is above nature when nature is beautiful. The best human effort cannot surpass, nor even equal it.

* * *

Study beauty only on your knees!

* * *

Art lives on elevated thoughts and noble passions. It must have character and warmth. We do not die of heat, but cold kills.

* * *

Draw, paint, above all imitate, even if only still-lives. All imitation from nature is substantial work, and imitation can lead to art.

* * *

Masterworks are not made to astonish. They are made to persuade, to convince, to enter into us through our pores.

* * *

Look at that [pointing to the living model]: it is like the Ancients, and the Ancients are like it. It is an antique bronze. The Ancients did not correct their models. I mean to say: they did not de-nature them. If you sincerely render what is before you, then you will proceed as they did and achieve beauty as they did. If you take a different tack, if you pretend to correct what you see, you will merely contrive something false, equivocal, and ridiculous.

*　　*　　*

When you lack the respect which you owe to nature, when you dare to offend against it in your work, you kick your mother in the stomach.

*　　*　　*

Art is never at a higher level than when it resembles nature so much as to be mistaken for nature itself. Art never succeeds better than when it is hidden.

*　　*　　*

Love truth, for in it is beauty, if you can sense and discern it. Let us train our eyes to see well, to see wisely, that is all I ask. If you want to see this leg as ugly, I know you will find material enough, but I say to you: take my eyes, and you will find it beautiful.

*　　*　　*

Your work will have beauty if it has truth. All your faults come not from a lack of taste or imagination, but from a want of nature. Raphael and this [pointing to the model] are synonymous. And which road did Raphael choose? Raphael was modest, the great Raphael himself was obedient. Let us be humble before nature.

*　　*　　*

The masses are rarely pleased by any other than the lower styles of art, whether it be in painting, poetry, or music. Art's sublimest efforts have no effect on uncultivated minds. A fine and subtle taste is the fruit of education and experience. All we receive at birth is the faculty for creating such a taste in ourselves and for cultivating it, just as we are born with a disposition for receiving the laws of society and conforming to their usages. It is only to this point, and no further, that one may say that taste is natural to us.

*　　*　　*

The ignorant will show as little taste in judging the effect or character of a painting as they would in judging living reality. In life, they wax enthusiastic over violence and emphasis; in art, they always prefer forced or strained attitudes and brilliant color over the noble simplicity and quiet grandeur which we find in the painting of the Ancients.

* * *

There are few persons, informed or ignorant, whose freely expressed thoughts about works of art would not be useful to artists. The only opinions which are totally sterile are those of the half-connoisseurs.

* * *

Drawing is the probity of Art.

* * *

To draw does not simply mean to reproduce contours; drawing does not simply consist of line: drawing is also expression, the inner form, the surface, modeling. What else is there? Drawing includes three quarters and a half of what constitutes painting. If I had to put a sign over my door, I should inscribe it *School for Drawing*, and I am sure that I should produce painters.

* * *

One must always draw, draw with your eyes if you cannot draw with a pencil. So long as you do not balance observation with execution, you will do nothing that is really good.

* * *

If I could make you musicians, you would become better painters. In nature, all is harmony: a little more or a little less disturbs the key and produces a false note. We must learn to sing true with our brush or pencil, as much as with our voice. Truth of form is comparable to truth of sound.

* * *

In consulting the model, observe the relationships of sizes, this is what constitutes its character. Obtain a vivid impression of these size relationships, and render them vividly. If, instead, you hesitate and start pushing them around on the paper, you will achieve nothing worth-

while. You must have the whole figure you want to draw in your eye and mind. The execution should merely be the realization of the preconceived image held in your mind.

* * *

The simpler your lines and forms, the more beauty and strength they will possess. Whenever you divide your forms, you enfeeble them. It is the same as with all fractions.

* * *

Beautiful forms are made of straight surfaces with curvatures. Beautiful forms have firmness and fullness; their details. do not diminish the effect of the larger masses.

* * *

Expression in painting calls for great knowledge of drawing, for expression cannot be good if it has not been formulated with absolute exactness. To seize it only approximately is to miss it altogether and to represent people who fake sentiments which they do not feel. We can attain this extreme precision only through the surest talent for drawing. That is why the painters of expression among the moderns happen to have been the greatest draftsmen—witness Raphael!

* * *

Color is an ornament of painting, but it is no more than a hand-maiden to it, since it does no more than render more pleasing those things which are the true perfections of art.

* * *

There exists no example of a great draftsman whose colors did not exactly suit the character of his design. In the opinion of many, Raphael did not use color. He did not use color like Rubens and Van Dyke, by God! he was very careful not to.

* * *

Do not use colors which are too intense—that is anti-historical. Tend, rather, toward greyness than brilliance, if you cannot be precise, if you cannot hit the perfectly true tone.

* * *

To claim that we can do without the study of ancient art and the classics is either folly or laziness. Yes, anti-classical art, if it can be called art, is nothing but an art of the lazy. It is the doctrine of those who want to produce without having worked, who want to know without having learned. It is an art without faith or discipline, wandering blindly in the darkness and expecting chance to lead it to those places which one may reach only through courage, experience, and reflection.

* * *

To remedy the overflow of mediocrity which has caused the disintegration of the French School, to counteract the banality which has become a public misfortune, which sickens taste and overwhelms the state administration of the arts, fruitlessly wasting its resources, it is necessary to renounce exhibitions. There should be a courageous declaration that only monumental painting will henceforth be encouraged. It should be decreed that we decorate our public buildings and churches whose walls cry out for paintings. These decorations should be entrusted to artists of superior ability who would employ mediocre artists as their assistants. The latter would thus cease to oppress art and become useful. Young artists would be proud to help their masters. Everyone who can hold a brush could be used.

Why do the Italians hold sophisticated ideas about painting? Because they see it everywhere. Who would be against having France become the new Italy? . . .

It is true that exhibitions have become a part of our lives. It is therefore impossible to suppress them. But they must not be encouraged. They destroy art, by making it a trade which artists no longer respect. The exhibitions are no more than bazaars in which mediocrity is impudently flaunted. They are useless and dangerous. . . .[60]

* * *

I wish they would take that painting of the *Medusa* out of the Museum and those two great *dragoons,* its acolytes. Let them put the one into some corner of the Ministry of the Navy, and the two others into the Ministry of War, so that they may no longer corrupt the taste of the public which ought to be accustomed exclusively to things of beauty. We should also be delivered once for all of such subjects as executions and *autos-da-fé;* are these the kinds of things which a sound and moral art ought to represent? Should we admire them? Should such horrors

[60] From a report by Ingres to the Commission Permanente des Beaux Arts, meeting in 1849 to consider methods for jurying the Salon; cf. H. Lapauze, *Ingres, sa vie et son oeuvre,* Paris, G. Petit, 1911, pp. 401 ff.

please us? I do not want to rule out effects of pity or terror, but I should want them to be rendered in the manner of Aeschylus, Sophocles, and Euripides. I don't want that *Medusa* and those other paintings of the dissecting room which show us man only in the form of cadavers and which represent only the ugly and hideous. No, I don't want them. Art should always be beautiful and only teach beauty.

<div align="center">* * *</div>

Théophile Gautier and Charles Baudelaire on Ingres (1855)

The Exposition Universelle, *a world's fair held in Paris in 1855, included an international exhibition of art, the French section of which was devoted largely to the celebration of the work of the two heads of the French school, Delacroix and Ingres. The occasion was less a confrontation than a joint apotheosis of the two aging artists, designed to reconcile the tired remnants of the romantic and classicist factions. The exhibition prompted several notable reviews. The poet Théophile Gautier (1811– 1872) used the opportunity to display a tolerant eclecticism which managed to embrace English anecdotal painting, Chinese bric-a-brac, and Delacroix in one common admiration. His article on Ingres' exhibition, of which the following is an excerpt, amounted to a solemn, official canonization, rather than a critical review, and illustrated Gautier's conversion from the fervid romanticism of the 1830's to the pompous historicism of the era of Napoleon III.*[61]

The first name which comes to mind as we turn to the French school is that of Monsieur Ingres. All Salon reviews, whatever the critic's opinion, invariably begin with him. It is impossible, in fact, not to place him on art's summit, on that throne of gold with ivory steps on which are seated, crowned with laurel, the artists who have accomplished their glory and are ready for immortality. The epithet of "sovereign" which Dante gives to Homer fits Ingres equally well. It has been bestowed on him by the young generation whose life span overlaps his radiant old age. Repudiated at first, long obscured, yet persisting in his direction with admirable constancy, Ingres has now reached the place where posterity will put him: beside the great masters of the 16th century whose soul he, three hundred years later, seems to have received. His has been a noble, an exemplary life, entirely fufilled by art, without a distraction, without faltering or doubt. By his own will, the painter of the *Apotheosis of Homer,* of *Saint Symphorien* and the *Vow of Louis XIII* has walled himself into the

[61] Theophile Gautier, *Les Beaux-Arts en Europe, 1855,* Paris, 1855, pp. 142 ff.

Sanctuary and remained in the ecstatic contemplation of beauty, on his knees before Phidias and Raphael who are his gods. Pure, austere, and fervent, he has spent his time in meditation and in the creation of works which bear witness to his faith. He alone represents in our time the high traditions of history painting, of the ideal, and of style. He has, for this reason, been accused of lacking modern inspiration and of ignoring the world around him, in short, of not belonging to his time. The accusation is perfectly just: Ingres is not, in fact, of his time—he is eternal. He belongs to the realm where the personifications of supreme beauty dwell, in that blue, transparent ether which is breathed by the Sybils of the Sistine Chapel, the Muses of the Vatican, and the Victories of the Parthenon.

Far be it from me to reproach artists who are stirred by contemporary passions and excited by the ideas of their time. There is something in modern life which involves us all, a throbbing emotion which art has a right to formulate, and from which it may derive magnificent works. But I prefer the kind of beauty which is absolute and pure, which belongs to all periods, all countries, all religions, and which unites past, present, and future in common admiration. This kind of art which owes nothing to chance, which is heedless of changing fashions and fleeting interests, seems cold, I know, to unquiet spirits and has no appeal for the masses who do not understand synthesis and generalization. It is great art, nevertheless, immortal art, the noblest effort of the human soul; so, at any rate, the Greeks believed, those divine teachers whose traces we ought to worship on our knees. It is to Monsieur Ingres' honor that he has carried the torch which Antiquity passed to the Renaissance, and that he did not allow it to be extinguished by the many mouths that blew on it. . . .

In contrast to Gautier's eulogy, the chapter which Charles Baudelaire devoted to Ingres in his review of the Exposition Universelle *of 1855 expressed an uncompromisingly anticlassicist aesthetic:* [62]

When David, that icy star, rose above the horizon of art, with Guérin and Girodet (his historical satellites, who might be called the *dialecticians* of the party), a great revolution took place. Without analysing here the goal which they pursued; without endorsing its legitimacy or considering whether they did not overshoot it, let us state quite simply that they had a goal, a great goal which consisted in reaction against an excess of gay and charming frivolities, and which I want neither to appraise nor to

[62] Translated by Jonathan Mayne, *The Mirror of Art*, London, Phaidon Press, Ltd., 1955, pp. 200 ff., reprinted by permission of the publisher. Baudelaire's article on the exhibition appeared, in three parts, in the periodical *Le Pays*, on May 26 and June 3, 1855, and in *Le Portefeuille*, on August 12, 1855. The section devoted to Ingres was suppressed. It was first published in the collection *Curiosités esthétiques*, published posthumously in 1868.

define; further, that they fixed this goal steadfastly before their eyes, and that they marched by the light of their artificial sun with a frankness, a resolution and an *esprit de corps* worthy of true party-men. When the harsh idea softened and became tender beneath the brush of Gros, the cause was already lost.

I remember most distinctly the prodigious reverence which in the days of our childhood surrounded all those unintentionally fantastic figures, all those academic spectres—those elongated human freaks, those grave and lanky Adonises, those prudishly chaste and classically voluptuous women (the former shielding their modesty beneath antique swords, the latter behind pedantically transparent draperies)—believe me, I could not look at them without a kind of religious awe. And the whole of that truly extra-natural world was forever moving about, or rather *posing,* beneath a greenish light, a fantastic parody of the real sun. But these masters, who were once overpraised and today are over-scorned, had the great merit—if you will not concern yourself too much with their eccentric methods and systems—of bringing back the taste for heroism into the French character. That endless contemplation of Greek and Roman history could not, after all, but have a salutary, Stoic influence; but they were not always quite so Greek and Roman as they wished to appear. David, it is true, never ceased to be heroic—David the inflexible, the despotic evangelist. But as for Guérin and Girodet, it would not be hard to find in them a few slight specks of corruption, one or two amusing and sinister symptoms of future Romanticism—so dedicated were they, like their prophet, to the spirit of melodrama.

But today we are faced with a man of an immense and incontestable renown, whose work is very much more difficult to understand and to explain. A moment ago, in connection with those illustrious unfortunates, I was irreverently bold enough to utter the word "freakish." No one, then, could object if, in order to explain the sensation of certain sorts of artistic temperament when placed in contact with the works of M. Ingres, I say that they feel themselves face to face with a *freakishness* far more complex and mysterious than that of the masters of the Republican and Imperial school—whence, nevertheless, it took its point of departure.

Before broaching the subject more seriously, I am anxious to record a first impression which has been felt by many people and which they will inevitably remember the moment that they enter the sanctuary consecrated to the works of M. Ingres. This impression, which is hard to define —and which partakes, in unknown quantities, of uneasiness, boredom and fear—reminds one vaguely and involuntarily of the feelings of faintness induced by the rarefied air, the physical atmosphere of a chemistry laboratory, or by the awareness that one is in the presence of an unearthly order of being; let me say, rather, of an order of being which

imitates the unearthly—of an *automatic* population, whose too palpable and visible extraneity would make our senses swim. It is no longer that childlike reverence of which I spoke a moment ago—that reverence which possessed us in front of the *Sabines*, and of *The Dead Marat*—in front of the *Déluge* or the melodramatic *Brutus*. It is a powerful sensation, it is true—why deny M. Ingres's power?—but of an inferior, an almost morbid variety. We might almost call it a negative sensation, if the phrase were admissible. In fact, as must be owned right away, this famous, and in his own way revolutionary, painter has merits—charms, even—which are so indisputable (and whose origin I shall shortly analyse) that it would be absurd not to record at this point a gap, a deficiency, a shrinkage in his stock of spiritual faculties. The Imagination, which sustained his great predecessors, lost though they were amid their academic gymnastics—the Imagination, that Queen of the Faculties, has vanished.

No more imagination: therefore no more movement. I do not propose to push irreverence and ill-will to the lengths of saying that this is an act of resignation on the part of M. Ingres; I have sufficient insight into his character to hold that with him it is an heroic immolation, a sacrifice upon the altar of those faculties which he sincerely considers as nobler and more important.

However enormous a paradox it may seem, it is in this particular that he comes near to a young painter whose remarkable début took place recently with all the violence of an armed revolt. I refer of course to M. Courbet, who also is a mighty workman, a man of fierce and indomitable will. . . . But the difference is that the heroic sacrifice offered by M. Ingres in honour of the idea and the tradition of Raphaelesque Beauty is performed by M. Courbet on behalf of external, positive and immediate Nature. In their war against the imagination they are obedient to different motives; but their two opposing varieties of fanaticism lead them to the same immolation.

And now, to resume the regular course of our analysis, let us ask what is M. Ingres's goal. It is certainly not the translation of sentiments, emotions, or variations of those emotions and sentiments; no more is it the representation of great historical scenes. . . . What then is M. Ingres seeking? What are his dreams? What has he come into this world to say? What new appendix is he bringing to the gospel of Painting?

I would be inclined to believe that his ideal is a sort of ideal composed half of good health and half of a calm which amounts almost to indifference—something analogous to the antique ideal, to which he has added the frills and furbelows of modern art. It is just this coupling which often gives his works their singular charm. Thus smitten with an ideal which is an enticingly adulterous union between Raphael's calm solidity

and the gewgaws of a *petite-maîtresse,* M. Ingres might be expected to succeed above all in portraiture; and in fact it is precisely in this genre that he has achieved his greatest and his most legitimate successes. . . . Beautiful women, rich and generous natures, embodiments of calm and flourishing health—here lies his triumph and his joy!

But at this point a question arises which has been a thousand times debated, and which is still worth returning to. What is the quality of M. Ingres's drawing? Is it of a superior order? is it absolutely *intelligent?* Anyone who has made a comparison of the graphic styles of the leading masters will understand me when I say that M. Ingres's drawing is the drawing of a man with a system. He holds that nature ought to be corrected, improved; he believes that a happily-contrived and agreeable artifice, which ministers to the eye's pleasure, is not only a right but a duty. Formerly it was said that nature must be interpreted and translated as a whole and in her total logic; but in the works of the present master, sleight-of-hand, trickery and violence are common occurrences, and sometimes downright deception and sharp-practice. Here we find an army of too-uniformly tapered fingers whose narrow extremities cramp the nails, such as a Lavater, on inspection of that ample bosom, that muscular forearm, that somewhat virile frame, would have expected to be square-tipped—indicative of a mind given to masculine pursuits, to the symmetry and disciplines of art. Here again we find a sensitive face and shoulders of a simple elegance associated with arms too robust, too full of a Raphaelesque opulence. But Raphael loved stout arms, and the first thing required was to obey and to please the master. Elsewhere we shall find a navel which has strayed in the direction of the ribs, or a breast which points too much towards the armpit. . . .

Let us note further that, carried away as he is by this almost morbid preoccupation with *style,* our painter often does away with his modelling, or reduces it to the point of invisibility, hoping thus to give more importance to the contour, so that his figures look like the most correct of paper-patterns, inflated in a soft, lifeless manner, and one quite alien to the human organism. Sometimes it happens that the eye falls upon charming details, irreproachably alive; but at once the wicked notion flashes across the mind, that it is not M. Ingres who has been seeking nature, but Nature that has *ravished* M. Ingres—that that high and mighty dame has overpowered him by her irresistible ascendency.

From all that goes before, the reader will easily understand that M. Ingres may be considered as a man endowed with lofty qualities, an eloquent amateur of beauty, but quite devoid of that energy of temperament which constitutes the fatality of genius. His dominant preoccupations are his taste for the antique and his respect for the School. . . .

but it often seems to me that M. Ingres is to antiquity what the transitory caprices of good taste are to the natural good manners which spring from the dignity and charity of the individual. . . .

To sum up, and setting aside his erudition and his intolerant and almost wanton taste for beauty, I believe that the faculty which has made M. Ingres what he is—the mighty, the indisputable, the absolute despot— is the power of his will, or rather an immense abuse of that power. . . .

A thousand lucky circumstances have combined in the establishment of this formidable renown. He has commanded the respect of polite society by his ostentatious love of antiquity and the great tradition. The eccentric, the *blasé* and the thousand fastidious spirits who are always looking for something new, even if it has a bitter taste—all these he has pleased by his *oddness*. But his good, or at all events his *engaging,* qualities have produced a lamentable effect in the crowd of his imitators; and this is a fact that I shall have more than one opportunity of demonstrating.

The Suicide of Benjamin Robert Haydon (1846)

Haydon (see page 241) was a painter whose intellect and idealism far outstripped his rather modest talent as an artist. His Diary *and* Autobiography *are not merely of interest as documents of their time, but contain superb passages which prove that Haydon's real gift was for descriptive writing. But he had set his heart on conquering England for monumental history painting, and in this he utterly failed. In the summer of 1846, crushed by debts and exhausted from forty years of futile struggling, having spent all his energy and hope, he cut his throat.*[63]

June 12. O God carry me through the evils of this day. Amen.

June 13. Picture much advanced, but my necessities are dreadful, owing to my failure at the Hall. In God alone I trust, to bring me through next week safe & capable of paying my way. O God, it is hard, this struggle of 42 years, but thy will & not mine be done, if it save the Art in the end. O God bless me through all my Pictures, the 4 remaining, & grant nothing on Earth may stop the completion of the Six.

June 14. Sunday. Bless me today & through the week. Amen. O God, let it not be presumption in calling for thy blessing on my six works. Let no difficulty on Earth stop or impede their progression, for one moment. Out of nothing thou couldst create Worlds; O God bless me this week with Thy Divine aid. From sources invisible to us raise up Friends, save

[63] W. B. Pope (ed.), *The Diary of Benjamin Robert Haydon,* Cambridge, Harvard University Press, 1960, V, 546 ff.

me from the embarrassments want of money must bring on. O God grant this day week I may be able to thank thee from my soul for extrication, & preserve my health & head & spirit & piety to bear up & vanquish all obstructions. Amen. Amen.

June 16. I sat from 2 till 5 staring at my Picture like an Idiot, my brain pressed down by anxiety and anxious looks of my dear Mary & children, whom I was compelled to inform. I dined, after having raised money on all our Silver, to keep [us] from want in case of accidents, & Rochfort, the respectable old man in Brewer St., having expressed great sympathy for my position, I saw white locks under his cap, I said, "Rochfort, take off your cap." He took it off, & shewed a fine head of silvery hair. "This is the very thing I want; come & sit." He smiled & looked through me. "When?" "Saturday, at 9." "I will, Sir"; and would any man believe I went home with a lighter heart *at having found a model for the hair of the kneeling figure of Alfred?* This is as good [as] anything I remember of Wilkie in my early days.

I came home, & sat as I describe. I had written Sir R. Peel, Duke of Beaufort, Lord Brougham, saying I had a heavy sum to pay. I offered the Duke's Study to the Duke of Beaufort for £50. Who answered first? Tormented by D'Israeli, harrassed by public business, up came the following letter:

Whitehall, June 16, 1846.

Sir,

I am sorry to hear of your Continued Embarrassments.

From a limited fund which is at my disposal I send as a Contribution towards your Relief from those embarrassments the sum of fifty pounds.

I am, Sir
Your obedient Servt.
Robert Peel

B. R. Haydon, Esq.
Be so good as to sign & return the accompanying Receipt.

That's Peel. Will Brougham or Beaufort or Hope or Barry answer?

Dearest Mary, with a Woman's passion, wishes me at once to stop payment & close the whole thing. I will not. I will finish my Six, under the blessing of God, reduce my expences, and hope his mercy will not desert me, but bring me through in health & vigor, gratitude & grandeur of soul, to the end. In him I trust—alone. Let my imagination keep Columbus before my mind for Ever. Amen.

O God bless my Efforts with success, through every variety of Fortune! & support my dear Mary & family. Amen.

In the morning, fearing I should be involved, I took down Books I had not paid for of a young Bookseller with a family, to return them. As I drove along, I thought I might get money on them! I felt disgusted at such a thought, & stopped and told him I feared I was in danger, & as he might lose, I begged him to keep them for a few days. He was grateful, & in the evening came this £50. I know what I believe.

June 18. O God bless me through the Evils of this day. Amen. Great anxiety. My Landlord Newton called. I said, "I see a Quarter's rent in thy face, but none from me." I appointed tomorrow to see & lay before him every iota of my position. Good hearted Newton! I said, "Don't put in an execution." "Nothing of the sort," he replied, half hurt.

No reply from Brougham, Beaufort, Barry, or Hope!—& this Peel is the man who has *no heart.*

I sent the Duke, Wordsworth, dear Fred, & Mary's heads to Miss Barrett to protect. I have the Duke's boots [and] hat, & Lord Grey's coat, & some more heads—tonight I got her letter.

I offered my new Friend Commissioner Evans to paint him Byron musing at Harrow for 50 gs.

June 20. O God bless us all through the evils of this day. Amen.

June 21. Sunday. Slept horribly. Prayed in sorrow and got up in agitation.

June 22. God forgive—me—Amen.

<div align="center">

Finis

of

B. R. Haydon

"Stretch me no longer on this tough World"—Lear.

End—

XXVI Volume.

</div>

At noon on the 22nd his daughter found him in his painting-room "stretched out dead, before the easel on which stood his unfinished picture of Alfred and the first British Jury"—(as though he appealed to British justice still), "his white hairs dabbled in blood, a half-open razor smeared with blood, at his side, near it, a small pistol recently discharged, in his throat a frightful gash, and a bullet-wound in his skull. A portrait of his wife stood on a smaller easel facing his large picture."

THE ARTIST AND HIS CRITICS

The early decades of the 19th century produced a vast amount of art criticism, a large part of it ephemeral and of little value, except for the insight which it gives into contemporary tastes and prejudices. The occasions for nearly all the published criticism were the periodic exhibitions which had become an established institution in many of the capitals and which were usually held under academic auspices. The Paris Salons continued to be the most important exhibitions in terms of frequency, size, and influence. Biennial at the beginning of the century, they became annual events in the 1830's. Their size increased enormously from 1800, when 412 paintings were listed in the official catalogue in addition to some 120 sculptures, prints, and architectural designs, to 1847, by which year the catalogue had swelled to 2,010 paintings and some 300 works in other media. Every Paris Salon, and, to a lesser extent, the other large exhibitions, produced a crop of newspaper articles and longer critical essays which, often published as separate pamphlets or books, tended to grow bulkier from year to year as the exhibitions increased in size; the reviews by Jal of the Salons of 1824 and 1827 number 468 and 544 pages, respectively. The level of criticism varied greatly. Some pamphlets were written for popular appeal, in the form of dialogue or doggerel, and illustrated with farcical vignettes, while others were detailed, scholarly, and carefully illustrated. The tone of most reviews was sharply and systematically partisan.

Géricault on the Critics of the Medusa

At the Salon of 1819, Géricault's Raft of the Medusa *(see page 260) caused a sensation, for reasons which were in part political. The shipwreck which had furnished the idea for the picture had been exploited by the Liberal parliamentary opposition for the purpose of embarrassing the Conservative government. Géricault's choice of the controversial subject for a painting of unusually large dimensions was misinterpreted by many as a deliberate, political manifestation. This fact strongly colored the critical notices of the work, both in the Liberal and the Conservative press. Deeply irritated, Géricault wrote to a friend:* [64]

[64] Charles Clément, *Géricault, étude biographique et critique*, Paris, 1868, pp. 170 ff.

I am more flattered by your four lines and very kind prediction of my future success than by all those newspaper articles which so sagely distribute both insult and praise. Artists must imitate the actors in cultivating a total indifference for everything emanating from journals and journalists. The lover of true glory must seek it sincerely, in the beautiful and sublime, and turn a deaf ear to these merchants of empty smoke.

This year, our newspaper scribblers have reached the height of ridicule. They judge every picture by the political spirit in which it was composed. A Liberal review will praise a certain work for its truly patriotic execution, its national touch. The same work, judged by an Ultra-Conservative, will be merely a revolutionary composition dominated by a general tint of sedition; the faces of its figures will be described as wearing expressions of hatred for the paternal government. I have been accused by a certain *Drapeau blanc* of having slandered the entire Ministry of the Navy by the expression of one of the heads in my picture. The wretches who write such rubbish have certainly never had to go without food for two weeks on end. If they had, they would perhaps realize that neither poetry nor painting could ever fully render the horror and anguish endured by the men on the raft.

Adolphe Thiers' Review of Delacroix' Bark of Dante

At the Salon of 1822, Delacroix' Bark of Dante, the first exhibited work of this very young artist who was then quite unknown to the public, received the following enthusiastic notice from Adolphe Thiers (1797–1877) of the influential Constitutionnel. The journalist and historian Thiers, who later became one of the leading statesmen of France, entertained political relations with Talleyrand whom some believe to have been the father of Delacroix.[65]

It is a pleasure . . . to be able to announce the coming of a great talent among this rising, young generation.

In my opinion, no picture at the Salon more clearly foretells the future of a great painter than M. Delacroix' *Dante and Virgil in Hell*. It is particularly in this work that we can see that thrust of talent, that

[65] A. Thiers, *Salon de Mil-Huit-Cent Vingt-Deux,* Paris, 1822, pp. 56 ff. Thiers' Salon review was published originally in serial form in *Le Constitutionnel*. It is from this version that Baudelaire took the quotation which he included in his review of the *Salon of 1846* (cf. J. Mayne, *The Mirror of Art*, p. 53). As originally published, Thiers' article apears to have had an additional paragraph which the later publication in book form lacks: "I do not believe that I am mistaken when I say that M. Delacroix has been given genius. Let him forward this assurance, let him devote himself to immense tasks, an indispensable condition of talent; and let him take still further confidence when I say that the opinion which I am expressing here is shared by one of the great masters of the school." (Trans. J. Mayne.)

surge of unfolding mastery which revive hopes somewhat dampened by the mediocrity of all the rest.

The bark of Dante and Virgil, ferried by Charon across the river of Hell, moves with difficulty through the crowd of bodies which press around it and try to climb into it. Dante, shown in life, wears the horrid colors of the place; Virgil, crowned with the somber laurel, has the colors of death. The damned souls, condemned to strive forever toward the opposite shore, fasten themselves to the bark. One of them vainly reaches for it and is thrown back into the water by its motion. Another holds on to it and kicks with his foot the others who want to climb in. Two others bite the timbers of the bark as it eludes them. The picture sums up the egoism and despair of Hell. Though it verges on exaggeration, we find in its treatment of the subject a severity of taste and a kind of propriety which elevate a design that severe judges (ill-advisedly, I think) might otherwise have accused of lacking in nobility. The brushwork is large and firm, the color plain and full of vigor, though perhaps a little crude.

The artist possesses, besides that poetic imagination which painter and writer share, that other kind of imagination which might be called the pictorial and which is of a quite different nature. He dashes off his figures, groups them, and twists them about with a boldness that recalls Michelangelo and a fertility of invention that reminds us of Rubens. At the sight of this painting, I am seized by the memory of I know not what great artist. I find in it a wild power, an ardent, spontaneous intensity which is carried along by its own momentum.

Stendhal at the Salon of 1824

Having been exiled from Milan by the Austrians, in 1821, the novelist Stendhal (Henri-Marie Beyle, 1783–1842) spent the following nine years in Paris, where he supported himself by literary hack work. His review of the Salon of 1824, published in the Journal de Paris, *shows him to have been an indifferent critic of individual paintings, but a keen observer of general tendencies in modern art. His practical, cutting common sense and his insistence that art be relevant to contemporary life influenced Baudelaire's art criticism (see page 311).*[66]

Try as I might, I cannot admire M. Delacroix and his *Massacre of Scio.* It always seems to me as if this picture had been started as a scene of the plague and then converted by the artist, with the help of newspaper accounts, into a *Massacre of Scio.* I cannot see in that big living

[66] Stendhal (Henri-Marie Beyle), *Mélanges d'art et de literature,* Paris, 1867, p. 154; p. 179 (on Delacroix); p. 191 (on Constable).

corpse in the middle of the composition anything other than a plague-stricken wretch who has tried to lance his sores, as is shown by the blood which appears on the left side of this figure. Another episode such as art students never fail to include in plague pictures is the child seeking the breast of his dead mother—he can be found in the right corner of M. Delacroix' picture. A massacre needs a butcher and a victim. There should have been a fanatical Turk, as handsome as M. Girodet's Turks, slaying Greek women of angelic beauty and threatening their aged father who will be the next to fall under his blows.

M. Delacroix, like M. Schnetz, has feeling for color; that is something in this time of draftsmen. He looks to me like a pupil of Tintoretto; his figures have movement.

The *Journal des Debats* of day before yesterday found Shakespearian poetry in the *Massacre of Scio*. What causes the picture to be mediocre, in my opinion, is its eccentricity, rather than the insignificance which is to be found in many classical paintings which I could name, but which I shall refrain from attributing to the school of Homer, whose spirit must be amazed by what is said and done in his name. M. Delacroix at any rate has this great superiority over the artists whose big pictures are plastered over the walls of the Salon: the public has at least taken a great interest in his work. That is better than being praised in three or four newspapers which hang on to old ideas and distort new ones because they cannot disprove them.

The English have sent us some magnificent landscapes by Mr. Constable this year. I do not think that we have anything to compare with them. It is their truthfulness which strikes you and draws you to these charming works. Mr. Constable's brushwork is excessively negligent, the planes of his composition are not well studied, and he has refrained from idealization. But his delicious landscape with a dog at the left is the very mirror of nature. It completely outshines a large landscape by M. Watelet which hangs next to it in the large Salon. . . .

A week ago, I went to the rue Godot-de-Mauroi to look for an apartment. I was struck by the smallness of the rooms. Since this was precisely the day on which I had been asked to write on painting for the *Journal de Paris,* my mind was filled with the thought of the honor I should have of addressing myself to the most discriminating public of Europe. I took from my wallet a page on which I had noted the dimensions of the most famous paintings. And, comparing these with the size of the small rooms through which the landlord was showing me, I said to myself with a sigh: "The days of painting are over, only print-making will prosper from now on. Our new style of life has led to the levelling of the great town houses and the demolition of castles; it has made the

taste for pictures obsolete. Only engraving will from now on be useful to the public, and as a result get public support." The landlord looked at me with surprise; I realized that I had been speaking aloud and that he must have taken me for a madman. I hurried away. Scarcely recovered, I was struck by another thought. Guido Reni, one of the lights of the Bolognese school, was a gambler. Toward the end of his career, he painted as many as three pictures a day. A hundred *sequins,* sometimes a hundred and fifty *sequins* was the price he got for them. The more he worked, the more money he made.

In Paris, the more a painter works, the poorer he gets. A personable young artist can easily manage, between exhibitions, to establish relations with the editor of a journal. When next he exhibits his work, never mind how poor its quality or how awkward his heros, he will always find some good paper to praise and to deceive him, because he has such a pleasant manner and would be hurt by the truth. He will find his pictures emphatically noticed, and praised as little masterpieces. But nobody will buy them. And yet in order to paint a picture, he must hire models, and that is more expensive than you think, he must buy paint and canvas, and he must live. A young artist of the modern school can afford to be an artist only by going into debt. . . . Forced to take his works back after the exhibition, he can live only on illusions, on disappointed hopes and on privations, until one day he discovers a sure way to prosper—by stopping to work.

This, surely, is an extraordinary state of affairs in the history of art, and one which, judging by the emphatically positive tone of the exhibition reviews, we should not expect to find. Here as elsewhere, hypocrisy in the realm of ideas leads to unhappiness in real life. The young artist who regains prosperity by throwing his brushes out the window is thirty years old—he has lost the better part of his life, or spent it in developing a useless talent. What should he do . . . ?

These are the dire results of the excessive encouragement given to painting by the budget of the Ministry of the Interior. This is the unexpected result of academic competitions and Rome prizes.

In the prize competitions, aged artists gravely examine the work of young artists, to see whether they have well imitated their style of painting. . . . Think of how ridiculous these competitions are in which a bunch of fifty-year-old artists is called to judge the work of young men. Public opinion scarcely affects these judgments, yet it ought to be possible, if a sincere attempt were made, to find a way of consulting the public. The prize-winning pictures might then actually find purchasers. As things stand now, the public likes only those kinds of painting which it can freely judge.

Who is, in effect, the only painter, in this year of 1824, who thrives

on his own talent and puts no burden whatever on the state budget? It is M. Horace Vernet. . . .

Heinrich Heine on Delacroix' *Liberty on the Barricades*

Delacroix' Liberty, *inspired by the Revolution of 1830, was the popular success of the Salon of 1831, where it figured under Number 311, with the title:* Le 28 Juillet. La liberté guidant le peuple. *The poet Heine (1797–1856) had moved to Paris in May of 1831, largely for political reasons. The following passage is taken from his review of the Salon of 1831, written in September and October of that year for the German press, and published shortly thereafter in French translation. Heine later wrote two further Salon reviews, in 1833 and 1843. His style may have had some influence on Baudelaire's beginnings as a critic.[67]*

I pass over the other not less important works of Horace Vernet, the versatile artist who paints everything, pictures of saints, battles, still-lives, landscapes, portraits, all rapidly, as it were like pamphlets. I now come to *Delacroix,* who has contributed a picture before which there was always a crowd, and which I therefore class among those which attracted the most attention. The sacredness of the subject forbids a severe criticism of the colouring, with which fault might otherwise be found. But despite a few artistic defects, there prevails in the picture a great thought, which strangely attracts us. It represents a group of the people during the Revolution of July, from the centre of which—almost like an allegorical figure—there rises boldly a young woman with a red Phrygian cap on her head, a gun in one hand, and in the other a tricolour flag. She strides over corpses calling men to fight—naked to the hips, a beautiful impetuous body, the face a bold profile, an air of insolent suffering in the features—altogether a strange blending of Phryne, fishwife, and goddess of liberty. It is not distinctly shown that the artist meant to set forth the latter; it rather represents the savage power of the people which casts off an intolerable burden. I must admit that this figure reminds me of those peripatetic female philosophers, those quickly running couriers of love or quickly loving ones, who swarm of evenings on the Boulevards. And also that the little chimney-sweep Cupid, who stands with a pistol in either hand by this alley-Venus, is perhaps soiled by something else as well as soot; that the candidate for the Pantheon, who lies dead on the ground, yesterday may have been selling tickets at the door of a theatre, and that the hero who storms onward with his gun, the galleys in his features, has certainly the smell of the criminal court in his abominable garments. And there we have

[67] Trans. C. G. Leland (pseud. Hans Breitman), *The Works of Heinrich Heine, The Salon,* London, 1893, pp. 24 ff.

it! a great thought has enobled and sainted these poor common people, this rabble, and again awakened the slumbering dignity in their souls.

There is no picture in the Salon in which colour is so sunk in as in the July Revolution of Delacroix. But just this absence of varnish and sheen, with the powder-smoke and dust which covers the figures as with a grey cobweb, and the sun-dried hue which seems to be thirsting for a drop of water, all gives to the picture a truth, a reality, an originality in which we find the real physiognomy of the days of July.

Among the spectators were many who had been actors or lookers-on in the Revolution, and these could not sufficiently praise the picture. "Matin!" exclaimed a grocer, "these gamins fought like giants.". . .

"Papa," asked a little Carlist girl, "who is the dirty woman with the red cap?" "Well, truly," replied the noble parent with a sweetly subdued smile, "I do not find her so ugly—she looks like the most beautiful of the seven deadly sins." "And she is so dirty!" observed the little one. "Well, it is true, my dear," he answered, "that she has nothing in common with the purity of the lilies. She is the goddess of liberty." "But, Papa, she has not on her even a chemise." "A true goddess of freedom, my dear, seldom has a chemise, and is therefore very angry at all people who wear clean linen."

Saying this, he drew his linen sleeve-cuffs still farther over his long idle hands, and said to his neighbour, "Your Eminency, should the Republicans succeed to-day in having some old woman shot by the National Guard at the Porte Saint-Denis, then they would bear the sacred corpse round the Boulevards; the mob would go mad, and we should have a new Revolution."

Charles Baudelaire (1821–1867)

At the end of his life, Baudelaire jotted into a notebook, among other remembrances and intentions: [68] *"To glorify the cult of pictures (my great, my unique, my primitive passion)." The worship of art in effect had dominated his life and work from the time when, at the age of twenty-four, he wrote the* Salon of 1845, *his earliest signed publication. This first essay in art criticism was soon followed by the review of the* Musée Classique *of the* Bazar Bonne Nouvelle (1846) *and the masterly* Salon of 1846. *After a long interruption, Baudelaire resumed art criticism with the review of the exhibition at the* Exposition Universelle *of 1855 (see page 298), the* Salon of 1859, *and, finally, the long articles on Delacroix (see page 285), and on Constantin Guys, the "Painter of Modern Life," both published in 1863.*

[68] From *Mon coeur mis à nu,* cf. Baudelaire, *Oeuvres completes,* Paris (Bibliothèque de la Pléiade, Galimard), 1961, XXXVIII, 1295.

In his writings on art, he never assumed the position of a detached observer, but wrote as a poet who felt directly concerned with artistic matters and whose opinions carried the weight of experience. The function of his criticism within the economy of his own creative life shaped the form and character of his reviews: "You will often find me appraising a picture exclusively for the sum of ideas or of dreams that it suggests to my mind." Of all his critical writings, only the Salon of 1845, *an immature attempt, conformed to an established pattern of salon reviews. Its staccato sequences of brief descriptions or abrupt dismissals, and its frequent, jovial impertinences betray a youthful imitation of the manner of Diderot and Stendhal. From 1846 onward, by contrast, Baudelaire's reviews assumed the character of reasoned philosophical arguments, in which descriptions or analyses of particular works gave way more and more to a theoretical discussion of general questions of art. By the time he wrote his* Salon of 1859, *his most carefully composed review, a single cursory visit to the exhibition gave him material enough for a series of largely theoretical essays. The example of Delacroix constantly dominated Baudelaire's view of art and set the standard by which he measured other artists (see page 285). His conception of art and his exaltation of the individual artist resembled the old notion of creative genius. For him, the source of art was neither external nature, nor any principle of beauty, but solely the individual artist's image-making faculty, his imagination. From this source derived the special beauty and spirit of vital art, its stirring modernity which, in the case of Delacroix, he found to consist of the "unique and persistent melancholy with which all his works are imbued, and which is revealed in his choice of subject, in the expression of his faces, in gesture and in the style of colors."* [69]

On the Heroism of Modern Life (Salon of 1845)

We do not think that we have been guilty of any serious omissions. This Salon, on the whole, is like all previous Salons. . . . For the rest, let us record that everyone is painting better and better—which seems to

[69] All excerpts are from the translation by J. Mayne, *The Mirror of Art,* London, Phaidon Press, Ltd., 1955, reprinted by permission of the publisher. The *Salon of 1845* first apeared in the form of a booklet; for the sections quoted above, cf. J. Mayne, p. 37. The *Salon of 1846* was also originally published as a booklet; for the sections quoted cf. J. Mayne, p. 43 ("What is the Good . . ."); p. 45 ("What is Romanticism?" p. 83 ("On the Ideal . . . "). The *Salon of 1859* first appeared serially in the *Revue Francaise,* during June and July of 1859; for the sections quoted cf. J. Mayne, p. 225 ("Modern Public and Photography"); and p. 236 ("Reign of the Imagination"). Catherine Crowe, whom Baudelaire quotes in this last essay, was a writer on psychical phenomena, whose *The Night Side of Nature, or Ghosts and Ghost Seers,* London 1848, enjoyed some success at the time. For a study of the art criticism of Baudelaire, see Margaret Gilman, *Baudelaire the Critic,* New York, Columbia University Press, 1943.

us a lamentable thing; but of invention, ideas or temperament there is
no more than before. No one is cocking his ear to tomorrow's wind; and
yet the heroism of modern life surrounds and presses upon us. Our true
feelings choke us; we know them well enough. We do not lack for sub-
jects or colors with which to make epics. The painter, the true painter
for whom we are searching, will be the one who can seize the epic quality
of contemporary life and make us see and understand, with brush or with
pencil, how great and poetic we are in our cravats and patent-leather
boots.—Let us hope that next year the true seekers may grant us the
extraordinary joy of celebrating the advent of the *new!*

What is the Good of Criticism? (Salon of 1846)

What is the good?—A vast and terrible question-mark which seizes
the critic by the throat from his very first step in the first chapter that he
sits down to write.

At once the artist reproaches the critic with being unable to teach
anything to the bourgeois, who wants neither to paint nor to write verses
—nor even to art itself, since it is from the womb of art that criticism was
born.

And yet how many artists today owe to the critics alone their sad
little fame! It is there perhaps that the real reproach lies.

I sincerely believe that the best criticism is that which is both
amusing and poetic: not a cold, mathematical criticism which, on the
pretext of explaining everything, has neither love nor hate, and vol-
untarily strips itself of every shred of temperament. But, seeing that a
fine picture is nature reflected by an artist, the criticism which I approve
will be that picture reflected by an intelligent and sensitive mind. Thus
the best account of a picture may well be a sonnet or an elegy.

But this kind of criticism is destined for anthologies and readers of
poetry. As for criticism properly so-called, I hope that the philosophers
will understand what I am going to say. To be just, that is to say, to
justify its existence, criticism should be partial, passionate and political,
that is to say, written from an exclusive point of view, but a point of
view that opens up the widest horizons.

To extol line to the detriment of colour, or colour at the expense
of line, is doubtless a point of view, but it is neither very broad nor
very just, and it indicts its holder of a great ignorance of individual
destinies.

You cannot know in what measure Nature has mingled the taste
for line and the taste for colour in each mind, nor by what mysterious
processes she manipulates that fusion whose result is a picture.

Thus a broader point of view will be an orderly individualism—

that is, to require of the artist the quality of *naïveté* and the sincere expression of his temperament, aided by every means which his technique provides. An artist without temperament is not worthy of painting pictures, and—as we are wearied of imitators and, above all, of eclectics—he would do better to enter the service of a painter of temperament, as a humble workman. I shall demonstrate this in one of my later chapters.

The critic should arm himself from the start with a sure criterion, a criterion drawn from nature, and should then carry out his duty with passion; for a critic does not cease to be a man, and passion draws similar temperaments together and exalts the reason to fresh heights.

Stendhal has said somewhere: "Painting is nothing but a construction in ethics!" If you will understand the word "ethics" in a more or less liberal sense, you can say as much of all the arts. And as the essence of the arts is always the expression of the beautiful through the feeling, the passion and the dreams of each man—that is to say a variety within a unity, or the various aspects of the absolute—so there is never a moment when criticism is not in contact with metaphysics.

As every age and every people has enjoyed the expression of its own beauty and ethos—and if, by *romanticism,* you are prepared to understand the most recent, the most modern expression of beauty—then, for the reasonable and passionate critic, the great artist will be he who will combine with the condition required above—that is, the quality of *naïveté*—the greatest possible amount of romanticism.

What is Romanticism? (Salon of 1846)

Few people today will want to give a real and positive meaning to this word; and yet will they dare assert that a whole generation would agree to join a battle lasting several years for the sake of a flag which was not also a symbol?

If you think back to the disturbances of those recent times, you will see that if but few romantics have survived, it is because few of them discovered romanticism, though all of them sought it sincerely and honestly.

Some applied themselves only to the choice of subjects; but they had not the temperament for their subjects. Others, still believing in a Catholic society, sought to reflect Catholicism in their works. But to call oneself a romantic and to look systematically at the past is to contradict onself. Some blasphemed the Greeks and the Romans in the name of romanticism: but you can only make Romans and Greeks into romantics if you are one yourself. Many others have been misled by the idea of

truth in art, and local colour. Realism had already existed for a long time when that great battle took place.

Romanticism is precisely situated neither in choice of subjects nor in exact truth, but in a mode of feeling.

They looked for it outside themselves, but it was only to be found within.

For me, Romanticism is the most recent, the latest expression of the beautiful.

There are as many kinds of beauty as there are habitual ways of seeking happiness.

This is clearly explained by the philosophy of progress; thus, as there have been as many ideals as there have been ways in which the peoples of the earth have understood ethics, love, religion, etc., so romanticism will not consist in a perfect execution, but in a conception analogous to the ethical disposition of the age.

It is because some have located it in a perfection of technique that we have had the *rococo* of romanticism, without question the most intolerable of all forms.

Thus it is necessary, first and foremost, to get to know those aspects of nature and those human situations which the artists of the past have disdained or have not known.

To say the word Romanticism is to say modern art—that is, intimacy, spirituality, colour, aspiration towards the infinite, expressed by every means available to the arts.

Thence it follows that there is an obvious contradiction between romanticism and the works of its principal adherents.

Does it surprise you that colour should play such a very important part in modern art? Romanticism is a child of the North, and the North is all for colour; dreams and fairytales are born of the mist. England—that home of fanatical colourists, Flanders and half of France are all plunged in fog; Venice herself lies steeped in her lagoons. As for the painters of Spain, they are painters of contrast rather than colourists.

The South, in return, is all for nature; for there nature is so beautiful and bright that nothing is left for man to desire, and he can find nothing more beautiful to invent than what he sees. There art belongs to the open air: but several hundred leagues to the north you will find the deep dreams of the studio and the gaze of the fancy lost in horizons of grey.

The South is as brutal and positive as a sculptor even in his most delicate compositions; the North, suffering and restless, seeks comfort with the imagination, and if it turns to sculpture, it will more often be picturesque than classical.

Raphael, for all his purity, is but an earthly spirit ceaselessly investigating the solid; but that scoundrel Rembrandt is a sturdy idealist who makes us dream and guess at what lies beyond. The first composes creatures in a pristine and virginal state—Adam and Eve; but the second shakes his rags before our eyes and tells us of human sufferings.

And yet Rembrandt is not a pure colourist, but a harmonizer. How novel then would be the effect, and how matchless his romanticism, if a powerful colourist could realize our dearest dreams and feelings for us in a colour appropriate to their subjects!

On the Ideal and the Model (Salon of 1846)

The title of this chapter is a contradiction, or rather an agreement of contraries; for the drawing of a great draftsman ought to epitomize both things—the ideal and the model.

Colour is composed of coloured masses which are made up of an infinite number of tones, which, through harmony, become a unity; in the same way, Line, which also has its masses and its generalizations, can be subdivided into a profusion of particular lines, of which each one is a feature of the model.

The circumference of a circle—the ideal of the curved line—may be compared with an analogous figure, composed of an infinite number of straight lines which have to fuse with it, the inside angles becoming more and more obtuse.

But since there is no such thing as a perfect circumference, the absolute ideal is a piece of nonsense. By his exclusive taste for simplicity, the idiotic artist is led to a perpetual imitation of the same type. But poets, artists, and the whole human race would be miserable indeed if the ideal—that absurdity, that impossibility—were ever discovered. If that happened, what would everyone do with his poor *ego*—with his crooked line? . . .

Although the universal principle is one, Nature presents us with nothing absolute, nothing even complete; I see only individuals. Every animal of a similar species differs in some respect from its neighbour, and among the thousands of fruits that the same tree can produce, it is impossible to find two that are identical, for if so, they would be one and the same; and duality, which is the contradiction of unity, is also its consequence. But it is in the human race above all that we see the most appalling capacity for variety. Without counting the major types which nature has distributed over the globe, every day I see passing beneath my window a certain number of Kalmouks, Osages, Indians, Chinamen and Ancient Greeks, all more or less Parisianized. Each individual is a unique harmony; for you must often have had the surprising

experience of turning back at the sound of a known voice and finding yourself face to face with a complete stranger—the living reminder of someone else endowed with a similar voice and similar gestures. This is so true that Lavater has established a nomenclature of noses and mouths which agree together, and he has pointed out several errors of this kind in the old masters, who have been known to clothe religious or historical characters in forms which are contrary to their proper natures. It is possible that Lavater was mistaken in detail; but he had the basic idea. Such and such a hand demands such and such a foot; each epidermis produces its own hair. Thus each individual has his ideal.

I am not claiming that there are as many fundamental ideals as there are individuals, for the mould gives several impressions; but in the painter's soul there are just as many ideals as individuals, because a portrait is a *model complicated by an artist.*

Thus that ideal is not that vague thing—that boring and impalpable dream—which we see floating on the ceilings of academies; an ideal is an individual put right by an individual, reconstructed and restored by brush or chisel to the dazzling truth of its native harmony.

The first quality of a draftsman is therefore a slow and sincere study of his model. Not only must the artist have a profound intuition of the character of his model; but further, he must generalize a little, he must deliberately exaggerate some of the details, in order to intensify a physiognomy and make its expression more clear. . . .

Drawing is a struggle between nature and the artist, in which the artist will triumph the more easily as he has a better understanding of the intentions of nature. For him it is not a matter of copying, but of interpreting in a simpler and more luminous language.

The introduction of the portrait—that is to say, of the idealized model—into historical, religious or imaginative subjects necessitates at the outset an exquisite choice of model, and is certainly capable of rejuvenating and revitalizing modern painting, which, like all our arts, is too inclined to be satisfied with the imitation of the old masters.

The Modern Public and Photography (Salon of 1859)

During this lamentable period, a new industry arose which contributed not a little to confirm stupidity in its faith and to ruin whatever might remain of the divine in the French mind. The idolatrous mob demanded an ideal worthy of itself and appropriate to its nature— that is perfectly understood. In matters of painting and sculpture, the present-day *Credo* of the sophisticated, above all in France (and I do not think that anyone at all would dare to state the contrary), is this:

"I believe in Nature, and I believe only in Nature [there are good reasons for that]. I believe that Art is, and cannot be other than, the exact reproduction of Nature [a timid and dissident sect would wish to exclude the more repellent objects of nature, such as skeletons or chamber-pots]. Thus an industry that could give us a result identical to Nature would be the absolute of art." A revengeful God has given ear to the prayers of this multitude. Daguerre was his Messiah. And now the faithful says to himself: "Since Photography gives us every guarantee of exactitude that we could desire [they really believe that, the mad fools!], then Photography and Art are the same thing." From that moment our squalid society rushed, Narcissus to a man, to gaze at its trivial image on a scrap of metal. A madness, an extraordinary fanaticism took possession of all these new sun-worshippers. Strange abominations took form. By bringing together a group of male and female clowns, got up like butchers and laundry-maids at a carnival, and by begging these *heroes* to be so kind as to hold their chance grimaces for the time necessary for the performance, the operator flattered himself that he was reproducing tragic or elegant scenes from ancient history. Some democratic writer ought to have seen here a cheap method of disseminating a loathing for history and for painting among the people, thus committing a double sacrilege and insulting at one and the same time the divine art of painting and the noble art of the actor.

As the photographic industry was the refuge of every would-be painter, every painter too ill-endowed or too lazy to complete his studies, this universal infatuation bore not only the mark of a blindness, an imbecility, but had also the air of a vengeance. . . . I am convinced that the ill-applied developments of photography, like all other purely material developments of progress, have contributed much to the impoverishment of the French artistic genius, which is already so scarce.

. . . If photography is allowed to supplement art in some of its functions, it will soon have supplanted or corrupted it altogether, thanks to the stupidity of the multitude which is its natural ally. It is time, then, for it to return to its true duty, which is to be the servant of the sciences and arts—but the very humble servant, like printing or shorthand, which have neither created nor supplemented literature. Let it hasten to enrich the tourist's album and restore to his eye the precision which his memory may lack; let it adorn the naturalist's library, and enlarge microscopic animals; let it even provide information to corroborate the astronomer's hypotheses; in short, let it be the secretary and clerk of whoever needs an absolute factual exactitude in his profession—up to that point nothing could be better.

But if it be allowed to encroach upon the domain of the im-

palpable and the imaginary, upon anything whose value depends solely upon the addition of something of a man's soul, then it will be so much the worse for us!

It is an incontestable, an irresistible law that the artist should act upon the public, and that the public should react upon the artist; and besides, those terrible witnesses, the facts, are easy to study; the disaster is verifiable. Each day art further diminishes its self-respect by bowing down before external reality; each day the painter becomes more and more given to painting not what he dreams but what he sees. Nevertheless *it is a happiness to dream,* and it used to be a glory to express what one dreamt. But I ask you! does the painter still know this happiness? . . .

The Reign of the Imagination (Salon of 1859)

Yesterday evening I sent you the last pages of my letter, in which I wrote, not without a certain diffidence: *"Since Imagination created the world, it is Imagination that governs it."* Afterwards, as I was turning the pages of *The Night Side of Nature,* I came across this passage, which I quote simply because it is a paraphrase and justification of the line which was worrying me: *"By imagination, I do not simply mean to convey the common notion implied by that much abused word, which is only* fancy, *but the* constructive *imagination, which is a much higher function, and which, in as much as man is made in the likeness of God, bears a distant relation to that sublime power by which the Creator projects, creates, and upholds his universe."* I feel no shame—on the contrary, I am very happy—to have coincided with the excellent Mrs. Crowe on this point. . . .

I said that a long time ago I had heard a man who was a true scholar and deeply learned in his art, expressing the most spacious and yet the simplest of ideas on this subject. When I met him for the first time, I possessed no other experience but that which results from a consuming love, nor any other power of reasoning but instinct. . . . Obviously he wished to show the greatest indulgence and kindness to me; for we talked from the very beginning of *commonplaces*—that is to say, of the vastest and most profound questions. About nature, for example: "Nature is but a dictionary," he kept on repeating. Properly to understand the extent of meaning implied in this sentence, you should consider the numerous ordinary usages of a dictionary. In it you look for the meaning of words, their genealogy and their etymology—in brief, you extract from it all the elements that compose a sentence or a narrative: but no one has ever thought of his dictionary as a *composition,* in the poetic sense of the word. Painters who are obedient to the

imagination seek in their dictionary for the elements which suit with their conception; in adjusting those elements, however, with more or less of art, they confer upon them a totally new physiognomy. But those who have no imagination just copy the dictionary. . . .

For this great painter, however, no element of art, of which one man takes this and another that as the most important, was—I should rather say, is—anything but the humblest servant of a unique and superior faculty.

If a very neat execution is called for, that is so that the language of the dream may be translated as neatly as possible; if it should be very rapid, that is lest anything may be lost of the extraordinary vividness which accompanied its conception; if the artist's attention should even be directed to something so humble as the material cleanliness of his tools, that is easily intelligible, seeing that every precaution must be taken to make his execution both deft and unerring.

With such a method, which is essentially logical, all the figures, their relative disposition, the landscape or interior which provides them with horizon or background, their garments—everything, in fact, must serve to illuminate the idea which gave them birth, must carry its original warmth, its livery, so to speak. Just as a dream inhabits its own proper atmosphere, so a conception which has become a composition needs to move within a coloured setting which is peculiar to itself. Obviously a particular tone is allotted to whichever part of a picture is to become the key and to govern the others. Everyone knows that yellow, orange and red inspire and express the ideas of joy, richness, glory and love: but there are thousands of different yellow or red atmospheres, and all the other colours will be affected logically and to a proportionate degree by the atmosphere which dominates. In certain of its aspects the art of the colourist has an evident affinity with mathematics and music. And yet its most delicate operations are performed by means of a sentiment or perception to which long practice has given an unqualifiable sureness. . . . It is obvious that the larger a picture, the broader must be its *touch;* but it is better that individual strokes should not be materially fused, for they will fuse naturally at a distance determined by the law of sympathy which has brought them together. Colour will thus achieve a greater energy and freshness.

A good picture, which is a faithful equivalent of the dream which has begotten it, should be brought into being like a world. Just as the creation, as we see it, is the result of several creations in which the preceding ones are always completed by the following, so a harmoniously conducted picture consists of a series of pictures superimposed on one another, each new layer conferring greater reality upon the dream, and raising it by one degree towards perfection. On the other hand I re-

member having seen in the studios of Paul Delaroche and Horace Vernet huge pictures, not sketched but actually begun—that is to say, with certain passages completely finished, while others were only indicated with a black or a white outline. You might compare this kind of work to a piece of purely manual labour . . .

I have no fear that anyone may consider it absurd to suppose a single education to be applicable to a crowd of different individuals. For it is obvious that systems of rhetoric or prosody are no arbitrarily invented tyrannies, but rather they are collections of rules demanded by the very constitution of the spiritual being. And systems of prosody and rhetoric have never yet prevented originality from clearly emerging. The contrary—namely that they have assisted the birth of originality—would be infinitely more true.

To be brief, I must pass over a whole crowd of corollaries resulting from my principal formula, in which is contained, so to speak, the entire formulary of the true aesthetic, and which may be expressed thus: The whole visible universe is but a storehouse of images and signs to which the imagination will give a relative place and value; it is a sort of pasture which the imagination must digest and transform. All the faculties of the human soul must be subordinated to the imagination, which puts them in requisition all at once. . . . It is clear that the vast family of artists—that is to say, of men who have devoted themselves to artistic expression—can be divided into two quite distinct camps. There are those who call themselves "realists"—a word with a double meaning, whose sense has not been properly defined, and so, in order the better to characterize their error, I propose to call them "positivists"; and *they* say, "I want to represent things as they are, or rather as they would be, supposing that I did not exist." In other words, the universe without man. The others however—the "imaginatives"—say, "I want to illuminate things with my mind, and to project their reflection upon other minds."

But besides the imaginatives and the self-styled realists, there is a third class of painters who are timid and servile, and who place all their pride at the disposal of a code of false dignity. In this very numerous but very boring class we include the false amateurs of the antique, the false amateurs of style—in short, all those men who by their impotence have elevated clichés to the honours of the grand style.

Ruskin on Art Critics

Ruskin's anger at criticisms of Turner's paintings in various British magazines prompted him to begin writing Modern Painters *(see page 227). He remained throughout his life an enemy of the critical press. The following passage from the preface to the second edition of* Modern

Painters (1844) expresses and explains his contempt for journalistic critics.[70]

I do not consider myself as in any way addressing, or having to do with, the ordinary critics of the press. Their writings are not the guide, but the expression, of public opinion. A writer for a newspaper naturally and necessarily endeavours to meet, as nearly as he can, the feelings of the majority of his readers; his bread depends on his doing so. Precluded by the nature of his occupations from gaining any knowledge of art, he is sure that he can gain credit for it by expressing the opinion of his readers. He mocks the picture which the public pass, and bespatters with praise the canvas which a crowd concealed from him.

Writers like the present critic of *Blackwood's Magazine* deserve more respect; the respect due to honest, hopeless, helpless imbecility. There is something exalted in the innocence of their feeble-mindedness: one cannot suspect them of partiality, for it implies feeling; nor of prejudice, for it implies some previous acquaintance with their subject. I do not know that, even in this age of charlatanry, I could point to a more barefaced instance of imposture on the simplicity of the public, than the insertion of those pieces of criticism in a respectable periodical. We are not so insulted with opinions on music from persons ignorant of its notes; nor with treatises on philology by persons unacquainted with the alphabet; but here is page after page of criticism, which one may read from end to end, looking for something which the writer knows, and finding nothing.

[70] From the Preface of the second edition (1844) of *Modern Painters*, E. T. Cook and Alexander Wedderburn, *The Works of John Ruskin*, III, *Modern Painters*, I, London, G. Allen, 1903, p. 16.

Index